The Photographs of Édouard Baldus

MALCOLM DANIEL
with an essay by Barry Bergdoll

THE METROPOLITAN MUSEUM OF ART, NEW YORK

CANADIAN CENTRE FOR ARCHITECTURE, MONTREAL

Published in conjunction with the exhibition *The Photographs of Édouard Baldus: Landscapes and Monuments of France.*

The Metropolitan Museum of Art, New York
October 3–December 31, 1994

Canadian Centre for Architecture, Montreal
January 24–April 23, 1995

Musée National des Monuments Français, Paris
May 13–August 11, 1995

The exhibition in New York and its accompanying catalogue are supported by a generous grant from Springs Industries and are part of The Springs of Achievement Series on the Art of Photography.

Transportation assistance has been provided by Air France.

The exhibition was organized by The Metropolitan Museum of Art, the Réunion des musées nationaux, and the Canadian Centre for Architecture.

The catalogue was produced by The Metropolitan Museum of Art on behalf of the three organizing institutions.

John P. O'Neill, Editor in Chief, The Metropolitan Museum of Art
Emily Walter, Editor
Bruce Campbell, Designer
Matthew Pimm, Production Manager

Map design: American Custom Maps, Albuquerque, New Mexico

LIBRARY OF CONGRESS CATALOGING-IN-PUBLICATION DATA

Daniel, Malcolm R.
 The photographs of Édouard Baldus / Malcolm Daniel ; with an essay by Barry Bergdoll.
 p. cm.
 Includes bibliographical references and index.
 ISBN 0-87099-714-9.—ISBN 0-8109-6487-2 (Abrams)
 1. Baldus, Édouard, 1813–1889. 2. Photographers—France—Biography.
3. Landscape photography—France—History—19th century. 4. Architectural photography—France—History—19th century. I. Baldus, Édouard, 1813–1889.
II. Bergdoll, Barry. III. Title.
TR140.B263D36 1994
770'.92—dc20 94-19297
[B] CIP

Set in Fournier by The Sarabande Press, New York
Printed on 135gsm Gardapat
Separations and printing by Offset-litho Jean Genoud, S.A., Lausanne, Switzerland
Bound by Mayer et Soutter, S.A., Lausanne, Switzerland

Distributed by Harry N. Abrams, Inc., New York

Jacket illustration : *Entrance to the Port, Boulogne*, 1855. The Metropolitan Museum of Art, New York (detail, pl. 37)

Frontispiece: *Cloister of Saint-Trophîme, Arles*, ca. 1861. Canadian Centre for Architecture, Montreal (detail, pl. 80)

Contents

THE SPRINGS OF ACHIEVEMENT SERIES ON THE ART OF PHOTOGRAPHY

Édouard Baldus defined modern landscape and architectural photography in France at a time when the process of photography was itself still evolving. In this first major exhibition of Baldus's work and in the publication of its accompanying catalogue, The Metropolitan Museum of Art gives overdue recognition to a visionary pioneer in the medium.

Springs Industries' sponsorship of the exhibition celebrates the stunning art of Baldus and his dedication to portraying his world for the benefit of future generations as well as his own. It is the most recent addition to the Springs of Achievement Series on the Art of Photography, which now numbers twenty-six exhibitions and catalogues spanning sixteen years. Our objectives, to honor creative expression and to bring to the public outstanding achievements in photographic art, are amply met in this exhibition.

We hope the work of this artist will enhance our understanding of his world, and inspire us to look more closely at our own.

Walter Y. Elisha
Chairman and Chief Executive Officer
Springs Industries

Directors' Foreword

Rarely do we have the opportunity to present the work of an artist acknowledged in his day as among the best in his field but today largely ignored by the general public. The history of photography is a young discipline, however, and many of the most important early photographers are just coming to be known. Such has been the case with Édouard Baldus. Enjoying high patronage and wide acclaim in the 1850s and 1860s, Baldus established a new mode of representing architecture and described the emerging modern landscape with unsurpassed authority. Thus, we present the first major exhibition and catalogue of Baldus's magnificent photographs with the hope that this event will at last place him among the major artists of his time.

Despite Baldus's renown during his lifetime, in the first half of this century his photographs lay idly in topographic picture files and his reputation languished. During the past thirty years, the growing interest in and exploration of the flowering of nineteenth-century French photography has brought the artist renewed attention. A few prescient collectors, notably André and Marie-Thérèse Jammes, recognized his achievement and featured his work in a series of seminal survey exhibitions in the 1960s and 1970s. Now, at the end of the twentieth century, Baldus is confirmed as an artist of the first importance, whose oeuvre offers multiple insights into the conditions of Second Empire France and into photography in its first large-scale public applications.

When Baldus took up the camera in Paris about 1850, he was in the midst of the major crosscurrents that characterized his century. From the upheaval of the Revolution was born a consciousness of the vulnerability of the past, which in turn aroused a veneration for the monuments and relics of old. That unprecedented respect for history was at odds with the massive modernization which also marked the century. The expansion of the middle class, the advances of science and industry, the growth of modern finance and of the powerful reach of the state engendered the notion of societal progress, of a destiny of enrichment, of imperial advancement, and positive change. Between the poles of the old, which constituted a shattered collective identity, and the new, which proposed an uncertain future, was the mobile terrain of the present.

Baldus's first assignment was to gather up the evidence of the past, to document the Gothic cathedrals and Roman monuments of France for a recently established government agency, the Commission des Monuments Historiques. In this Baldus and the other pioneer photographers who were awarded *missions héliographiques* served a crucial function; they synthesized a consensual vision of a shared and enduring past and thereby confirmed a national historical identity. In documenting the construction of the New Louvre, one of the major undertakings of the Second Empire, and in its visionary presentation of monuments, Baldus's work was admired by enthusiasts of the new art of photography and exploited by architects in their work of supervising complex public constructions. Then, unique among his peers, Baldus was called to serve a prince of industry, Baron James de Rothschild. In the resulting album of photographs of the Northern Railroad, the artist knitted together the opposing modalities of history and progress. A second major railroad commission followed a few years later, allowing Baldus to demonstrate his mastery of the modern industrial landscape.

Squaring reverence for antiquity with a celebration of current achievement was a necessity for the nation and one that offered Baldus the opportunity to exercise his acute visual intelligence in the compass of the largest, most significant issues of his day. But not

only did he accommodate the opposing forces, he reconciled them formally and conceptually. His railroad albums are sequential compositions that, page by page, move the viewer through geographic and historical time with a persuasive confidence in the confluence of past and present. While his individual pictures may muse on the decaying architecture of an august past or speed along iron rails disappearing into the distance, these images—expressing the permanence of the past, the viability of the future, or a sweet marriage of the two in the present—are proposed as equivalent incidents in a optical voyage into the enterprise that was modern France.

Formally, the pictures are contemplative arrangements of equipoise, calm, and majesty. In their large arena, old and new, organic and man-made seem quite naturally to make gracious adjustments to one another. While clear in their details and precise in their shapes, the photographs remain broad and delicately atmospheric. And in the best preserved of the prints, the texture of a stone, its relief in light, and the shadow it casts are all exquisitely differentiated yet intimately associated.

This exhibition and the collaboration that produced it also have a history. At the Canadian Centre for Architecture, Baldus was early recognized as a key figure in the history of architectural representation and his photographs were acquired as keystones of the photography collection; during the fifteen years since, CCA has built one of the most important collections of his work. With the opening of the Musée d'Orsay in Paris in 1986, Françoise Heilbrun and the late Philippe Néagu took charge of a large and historically significant collection of Baldus photographs and negatives, and it was they who first carried out serious research on the artist in the early 1980s.

In 1991, the CCA and the Musée d'Orsay began to formulate plans for an exhibition of Baldus's work. Meanwhile, at The Metropolitan Museum of Art, Maria Morris Hambourg's long-standing interest in early French photography found in Malcolm Daniel's knowledge of Baldus, on whom he wrote his doctoral dissertation, the inspiration for a similar proposal. The two exhibition proposals became one, with the collaboration of the three institutions and five curators. In Paris, the Musée National des Monuments Français, with its revitalized program and rediscovered collection of early photographs, provided further stimulation to the project and an ideal venue for the exhibition in France. Happily, this coalescence of curatorial expertise coincided with the rediscovery in the past five years of a large number of exceptionally rich and well-preserved photographs by Baldus, many of which are exhibited here for the first time.

In New York, the exhibition and catalogue are supported by a grant from Springs Industries, longtime supporters of photography, whose generosity we gratefully acknowledge. Likewise, the organizers collectively thank Air France for transportation assistance.

Philippe de Montebello
Director, The Metropolitan Museum of Art

Phyllis Lambert
Director, Canadian Centre for Architecture

Irène Bizot
Administrateur Général de la
Réunion des musées nationaux

9

CURATORS OF THE EXHIBITION

Malcolm Daniel
Assistant Curator
Department of Photographs
The Metropolitan Museum of Art, New York

Maria Morris Hambourg
Curator in Charge
Department of Photographs
The Metropolitan Museum of Art, New York

David Harris
Associate Curator
Photographs Collection
Canadian Centre for Architecture, Montreal

Françoise Heilbrun
Curator in Chief
Department of Photographs
Musée d'Orsay, Paris

Philippe Néagu
Curator
Department of Photographs
Musée d'Orsay, Paris

Dedicated to Philippe Néagu, 1943–1994

Acknowledgments

It is a great pleasure to recognize the many individuals to whom we owe so much of our understanding of Baldus. We signal our special debt to James Borcoman, Peter Bunnell, André Jammes, Eugenia Janis, François Lepage, Richard Pare, and Pierre-Marc Richard, who opened their collections, shared knowledge gleaned from decades of connoisseurship and research, and enthusiastically encouraged our efforts.

Many people have immeasurably enriched our understanding of nineteenth-century photography in general and of Baldus in particular, and others have aided our work on the exhibition in a variety of ways. We warmly thank all of them, and especially Pierre Apraxine, Sylvie Aubenas, Gordon Baldwin, Thierry Boisvert, Werner Bokelberg, Pierre Bonhomme, Joachim Bonnemaison, Marie-Thérèse Boucher, Frish Brandt, Paule Charbonneau-Lepage, Pascal Chassaing, Michèle Chomette, Serge Clin, Guy Coronio, Martine Deschamps, Jean-Denys Devauges, Bodo von Dewitz, Frances Dimond, Virginia Dodier, Robert Elwall, Ute Eskildsen, Jay Fisher, Jeffrey Fraenkel, Thierry Grognet, Ellen Handy, Mark Haworth-Booth, Léon Herschtritt, Robert Hershkowitz, Tom Hinson, Charles Isaacs, Paul Jay, Steven Joseph, Christine Julien, Robert Knodt, Hans Kraus, Yves Lebrec, Gérard Lévy, Valerie Lloyd, Simon Lowinsky, Harry Lunn, Ezra Mack, Michael Malcolm, Bernard Marbot, Catherine Mathon, Jay McDonald, Herbert Mitchell, Anne de Mondenard, Theresa-Mary Morton, Weston Naef, Douglas Nickel, Robert Parker, Alain Paviot, Tamara Préaud, Françoise Reynaud, C. David Robinson, André Rouillé, Larry Schaaf, Joel Snyder, Michel Soubeyran, Dale Stulz, Jean-Louis Taffarelli, Catherine Tambrun, Roger Taylor, Roger Thérond, Julia Van Haaften, Stephen White, Michael Wilson, David Wooters, and Michel Yvon.

To the twenty-four lenders to the exhibition, both individuals and institutions, we are profoundly grateful. Many have parted with their treasures for a full year so that the very best of Baldus could be presented to the public in three countries.

At the Metropolitan Museum, many staff members helped ensure the success of the exhibition. Mahrukh Tarapor guided us toward a happy collaboration and helped secure important loans. Linda Sylling coordinated the logistical aspects of the exhibition with the aid of registrars Herbert Moskowitz and Nina Maruca, who were responsible for the flawless arrangement of registrarial matters. The installation was designed by Michael Batista with graphics by Sophia Geronimus and lighting by Zack Zanolli. The exhibition wall texts and labels were edited by Pamela Barr and produced by Andrey Kostiw. Eileen Travell and Katherine Dahab photographed the U.S. loans. Emily Rafferty, aided by Lynne Winter, helped secure the exhibition's vital sponsorship by Springs Industries. Press affairs were handled by Andrew Ferren. We also thank for their contributions Calvin Brown, David del Gaizo, Nora Kennedy, Raphael Pita, Jeff Rosenheim, Louise Stover, and Alison Zucrow.

At the Canadian Centre for Architecture, we are grateful to the following staff members, who contributed in essential ways to the presentation of the exhibition in Montreal and to the realization of the catalogue: Robert Anderson, Marie-Josée Arcand, François Bastien, Suzelle Baudouin, Marie-Agnès Benoit, Michel Boulet, Guy Doré, Alain Laforest, Sophie Lafrance, Véronique Lê Kim, Helen Malkin, Margaret Morris, Nicholas Olsberg, and Marie Trottier.

In Paris, André Lejeune has earned our special gratitude by over-seeing the many logistical aspects of the Musée d'Orsay's participa-tion. We thank Patrice Schmidt who, in addition to photographing most of the French loans for the catalogue, labored with persever-ance and sensitivity to produce modern salted paper prints from Baldus's original negatives so that we might see the full flood panorama and other images for which no original prints have sur-vived. We also thank Ute Collinet, Anne de Margerie, Guénola de Metz, Radjévi Filatriau, and Agnès Takahashi.

We are enormously indebted to the directors of the participating institutions: Philippe de Montebello at The Metropolitan Museum of Art, Phyllis Lambert at the Canadian Centre for Architecture, Françoise Cachin at the Musée d'Orsay, and Guy Cogeval at the Musée National des Monuments Français.

The catalogue, too, has benefited from the expertise and experi-ence of many people. Emily Walter edited the text with intelligence and sensitivity, assisted by Heidi Colsman-Freyberger, who edited the notes and bibliography. Matthew Pimm produced a beautiful book from a maelstrom of evolving material. Susan Chun shepherd-ed the volume through the planning stages, and Gwen Roginsky offered her expert advice on many aspects of its eventual produc-tion. The book's handsome design, so appropriate to the classic nature of the subject, is the work of Bruce Campbell; Jean Genoud, Daniel Frank, and their team of pressmen captured the seductive surface, rich color, and entrancing detail of Baldus's original pho-tographs. Throughout the planning, writing, and production of the catalogue, John O'Neill has been our guiding spirit, unwavering in his insistence on the highest standards.

In addition, Malcolm Daniel wishes to express his appreciation to Maria Hambourg and Eugenia Janis for their inspiration, their spirit-ed critiques, and their encouragement, and to Darryl Morrison for his devotion throughout the long preparation of the exhibition and catalogue.

The book is dedicated to our late colleague and friend Philippe Néagu, whose many contributions to the history of photography greatly enriched our field. Philippe possessed an immensely literate mind and an original eye, rare attributes that will be as sorely missed as his sly wit, warmth, and modesty.

The organizers of the exhibition are grateful to Air France for having provided transportation assistance.

Finally, we thank Springs Industries for its generous sponsorship of the exhibition in New York and of the catalogue. During its six-teen-year history of supporting photographic exhibitions, Springs Industries has helped present the work of Eugène Atget, Alfred Stieglitz, André Kertesz, and others. On behalf of photography's larger public, we are grateful for Springs' enlightened patronage, which allows us to introduce Édouard Baldus to a wide audience.

Malcolm Daniel

Maria Morris Hambourg

David Harris

Françoise Heilbrun

The Photographs of Édouard Baldus

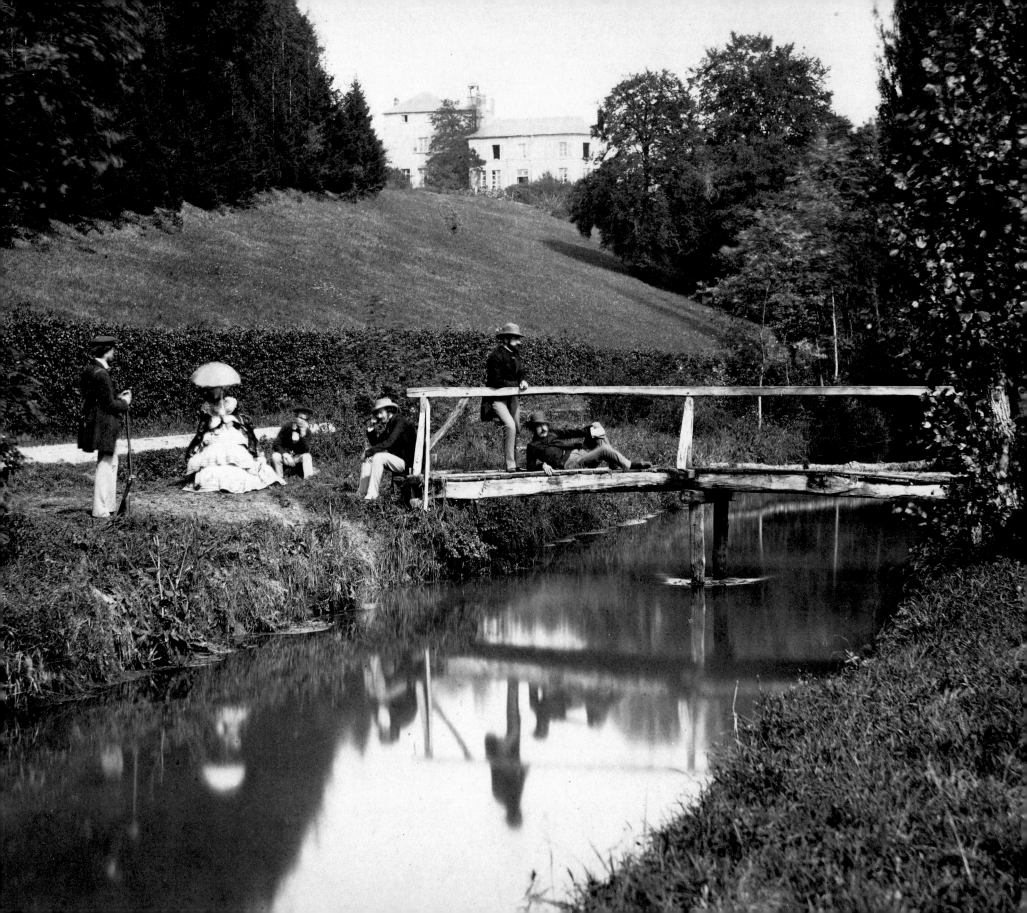

Édouard Baldus, artiste photographe

MALCOLM DANIEL

Edouard Baldus set out from his daughter and son-in-law's house at 16, avenue de Breteuil on the morning of January 22, 1887, and headed for the Commercial Court of Paris to declare bankruptcy.[1] As the seventy-three-year-old artist made his way through the streets of Paris, he saw a city much changed from the days when he had first arrived in the capital nearly half a century earlier, and even from the early 1850s when he had first photographed its chief landmarks. In the intervening years the city's narrow, winding streets and picturesque medieval quarters had given way to the broad axial boulevards, extensive public works, and mammoth civic monuments that transformed Paris during the Second Empire (1852–70) into the grandest and most modern of European cities.

Even in the two decades just past, the shape of Paris had changed, and Baldus's photographs were among the few reminders of the old Hôtel de Ville, the Tuileries Palace, and the Ministry of Finance as they had appeared before their fiery destruction during the Commune in 1871. The political shape of the nation had changed even more radically than its physical appearance during those two decades: the Empire, whose glorious achievements Baldus had celebrated in his work, had been overthrown, and Emperor Napoléon III, who had once sent Baldus's photographs to the reigning monarchs of Europe, had long since died an exile in England.

Thinking back on his life and career that morning, Baldus might have remembered the day in September 1868 when he had first refused and then only grudgingly given his permission for the marriage of his daughter Marie-Joséphine to Charles Waltner, concerned that the projected marriage was not in the best interest of his daughter's happiness.[2] At the time it must have seemed to Baldus that the young Waltner's trade—engraving—could not have been more anachronistic, doomed to obsolescence by the very photographic and photogravure processes Baldus had helped develop over a lifetime; he had felt, perhaps, like a railroad magnate watching his daughter marry a diligence driver. And yet, by 1887 Waltner had indeed become a successful *graveur*, and, ironically, it was Baldus the photographer who had been left behind in the rush of technological advancement and aesthetic change. It was he who now relied on the support of the Waltners.

As he headed toward the court on the Île-de-la-Cité, Baldus might have mused also on the changes photography had undergone in the four decades since he had first taken up the camera. In the most recent issue of the *Bulletin de la Société Française de Photographie* Paul Nadar, son of the great portrait photographer Félix Nadar, had written about the photographs he had made of his father interviewing the scientist Eugène Chevreul on his one hundredth birthday; using new Eastman papers and roll film, he had made truly instantaneous exposures of $^1/_{132}$ of a second.[3] While the day George Eastman would announce the Kodak camera with its hundred-picture roll of film and factory processing was still a year away, the medium's future was already clear: "You push the button . . . we do the rest," would read the Kodak advertisements, making the medium accessible to the amateur as never before. How different from the state of the art during the period of Baldus's greatest activity. In the 1850s the successful photographer had combined the roles of artist, chemist, and entrepreneur—had wrestled to define a mode of visual representation suited to the new medium, had tinkered with myriad

Detail of pl. 54

recipes for negatives, papers, and chemical solutions of all sorts, and had dreamed up new uses for photography and marketed those ideas to government, industry, and the public.

If Baldus was melancholy that January morning, such feelings may well have been tempered by a sense of satisfaction as he looked back on the successes of his career. Like the titans of old, this giant in his art had been overthrown by his own creation; the processes he himself had conceived and the aesthetic he had struggled to shape had grown beyond his control. Once, his photographs had been admired by Queen Victoria and Prince Albert, prized by Napoléon III, lauded by critics, and sought by captains of industry, government ministries, and private collectors. He had shared his vision with the world; now, his declaration of bankruptcy was proof that others had understood that vision and had adopted it as their own.

EARLY YEARS

"Peintre photographe"

Baldus listed his occupation as *peintre photographe* (painter photographer) throughout much of his life, more as an assertion of the artistic origins and high aspirations of his photographic work than as a literal description of his day-to-day activity. Like many of his fellow photographers of the 1850s—Gustave Le Gray, Henri Le Secq, and Charles Nègre among them—Baldus took up the camera after a decade or more of experience at the easel, and soon abandoned his paints and brushes altogether (fig. 1).

It was, in fact, to paint that Baldus first came to Paris, about 1838, from his native Prussia.[4] The second of eight children and the eldest son of Johann Peter Baldus and Elisabeth Weber,[5] Eduard (he changed the spelling to "Édouard" after moving to Paris)[6] was born in Grünebach, forty-five miles east of Cologne, on June 5, 1813, and was baptized in the Catholic church at nearby Kirchen two days later.[7]

Almost nothing is known about the first twenty-five years of Baldus's life. According to a contemporary biographer, Henry

Fig. 1. *Self-Portrait*, 1853. Salted paper print from paper negative, 20.3 × 15.4 cm (8 × 6⅛ in.). Bibliothèque Nationale, Paris

Lauzac, he first embarked on a military career as an artillery officer in the Prussian Army and then turned to painting; exhibited for a number of years in Antwerp; and traveled as an itinerant portrait painter throughout the United States in 1837, enjoying some success in New York.[8] Although Lauzac's information may well have come from the artist himself,[9] his account of the early life cannot be confirmed,[10] and Baldus was not a wholly reliable source, having, for example, listed his place of birth alternately as New York, Germany, and Paris.[11]

Documents from 1856 report that Baldus arrived in Paris to study painting in 1838,[12] and his presence there is confirmed by 1841, the first year in which he submitted work to the annual Salon of painting and sculpture. His four submissions (two religious paintings and two portraits) were all rejected by the jury that year. In 1842 the jury accepted a *Virgin and Child* while rejecting his *Prometheus Delivered by Hercules*, perhaps an overambitious work at more than six and a half feet square. Baldus submitted work to each annual Salon through 1852, but aside from that of 1848, which in the spirit of the new Republic was unjuried, he gained entry only twice more, with a *Child's Head* in 1847 and a *Virgin and Child* in 1850 (see appendix 3).[13] He was, according to Lauzac, self-taught as a painter; he listed no master when submitting work to the Salon and possessed no student card for the Louvre.[14]

Meanwhile, Baldus put down roots in his adopted home. He declared his intention to seek French citizenship, and in September 1845 married a young Frenchwoman from a respected family, Élisabeth-Caroline Étienne.[15] Within four years he was the father of two daughters and a son.[16]

Despite his persistence, Baldus won no critical mention during his decade of Salon submissions. Working outside the École des Beaux-Arts and the atelier system, and only modestly talented, to judge by the slim surviving evidence, Baldus appears to have owed his few painting commissions more to personal connections than to talent. Only after numerous letters, a note of recommendation from the sculptor Jean-Jacques Pradier, and a reminder of his father-in-law's service in the army of Napoléon I did he obtain government commissions to copy paintings in the Louvre in 1849, 1850, and 1851 (fig. 2).[17]

When Baldus arrived in Paris to embark on a career in painting, he entered an art world on the verge of profound change. On January 7, 1839, François Arago, scientist, director of the Paris Observatory, and member of the Chamber of Deputies, addressed his fellow members of the Academy of Sciences and displayed the magically precise images that Louis Daguerre had recorded on a thin mirrorlike layer of silver on highly polished copper plates.

These first photographs seemed all the more miraculous because Arago kept secret the process by which Daguerre had achieved his images, a process that built on the experiments of the late Nicéphore Niépce, with whom Daguerre had joined in partnership nearly a decade earlier.

"Never has the draftsmanship of the greatest masters produced such a drawing," declared the journalist Jules Janin, among the first to appreciate the potential of the new invention.[18] Characterizing the daguerreotype as "divine perfection," but maintaining that "man always remains the master," Janin dreamed of the medium's potential to render the effects of light and atmosphere, record the moon through a telescope or a fly's wing through a microscope, reproduce paintings and architecture, and serve as a model for artists and an aide-mémoire for travelers. With evident and passionate faith in the power of technology to improve man's life, Janin spoke of the daguerreotype with the same visionary zeal with which he discussed

Fig. 2. *Virgin and Child*, after Murillo, 1852. Oil on canvas. Church of Saint-Mamert, Gard

steam power, gaslight, railroads, and the possibility of air travel.[19]

In July 1839 the Chamber of Deputies awarded annuities to Daguerre and the son of Niépce in exchange for placing the process in the public domain, and on August 19 Arago revealed the details of Daguerre's process before a joint session of the Academy of Sciences and the Academy of Fine Arts. The daguerreotype was an immediate success, particularly in portraiture.

There is, however, no evidence to suggest that Baldus ever produced daguerreotypes. Rather, his interest in photography began in 1848 or 1849, with the rise of French interest in paper photography. Contemporaneous with Daguerre's one-of-a-kind images, the Englishman Henry Talbot announced a process that yielded multiple positive prints from a single paper negative. Because of their reproducibility, their paper support, and even, in part, because of their lack of absolute precision, paper photographs were more easily considered a part of the graphic arts.

Louis-Désiré Blanquart-Evrard of Lille was the first in France to publish, in 1847, a treatise on paper-print photography.[20] Although largely dependent on the processes developed in England a decade earlier (which he had learned from a student and collaborator of Talbot), Blanquart-Evrard's technique was sufficiently different to circumvent the Englishman's patent restrictions. Within a few years, other photographers were experimenting with ways to improve the process still further: Le Gray developed a waxed-paper process that yielded a more transparent, less fibrous negative, which in turn produced a sharper positive;[21] Niépce de Saint-Victor substituted albumen-coated glass for the negative support, yielding remarkably detailed images;[22] and in 1851 Le Gray in France and F. Scott Archer in England replaced the layer of albumen with collodion, a technique that combined reproducibility with the clarity of the daguerreotype, and which remained the dominant photographic process until the 1880s.[23]

It was in this atmosphere of experimentation and of rising enthusiasm for paper photography that Baldus began his new career. Lauzac reports that Baldus studied photographic chemistry for four years during the 1840s; most other documents date his initial interest in the medium to 1848 and stress his formation as a painter, with no mention of his research in chemistry.[24] Although we have no record of his earliest work or any indication of who his teacher might have been, he probably began with the published processes of Blanquart-Evrard or Le Gray. By 1851 Baldus had already invented his own variation of the paper negative, a process described in his published treatise of May 1852, *Concours de photographie* (appendix 12). In his experiments, he wrote, he sought "sharpness and clarity of the images, promptness of execution (when necessary), a fairly durable fixing of the negative, and finally, a convenient arrangement of the equipment."[25] With one set of formulas and manipulations Baldus produced a negative suitable for reproducing monuments using exposures of three to five minutes; with a second set he made negatives more appropriate for portraiture, requiring exposures of only five to sixty seconds.[26] The novelty of Baldus's process lay in an initial step, in which the negative paper received a smooth, insoluble, and somewhat light-sensitive coating by being submerged in a bath that included gelatin.

The process was not widely used by others; Baldus's treatise, unlike Le Gray's, was not reprinted, revised, or translated. Nor did Baldus offer formal instruction as Le Gray did; he taught his method directly to only a few students.[27] Nonetheless, the process served him well, and the technical excellence of his paper negatives and of the positive prints made from them was frequently discussed. His negatives were described as having "all the clarity of glass," and his positives as possessing "a depth and vigor of tone."[28] "Who has not asked himself," wrote Stéphane Geoffray, "upon considering the admirable prints of Notre-Dame, the Pantheon and many others by M. Baldus, if they were not obtained on glass! . . . A total absence of grain, a strength and transparency of shadow, a brilliance of light—such are the qualities that recommend the beautiful prints of this skilled photographer."[29] Indeed, so finely detailed are his paper negatives that it is often difficult today to determine whether certain prints are from paper negatives or from glass.

Baldus's switch to photography after so lackluster a career in painting calls to mind Charles Baudelaire's disdainful description of the photographic industry, somewhat later, as "the refuge of all failed painters, too lacking in talent or too lazy to complete their studies," and his denunciation of the craze for photography as having taken on "not only a character of blindness and imbecility, but also an air of vengeance."[30] Where Baudelaire saw a photographer's abandoned career in painting as proof of mediocrity, others, perhaps without justification, deemed it a reason for praise. Jules-Claude Ziégler, for example, too enthusiastically declared that Baldus had "proven himself as a history painter," and that certain painted landscapes by Bayard made one think of Ruysdael.[31] The more relevant point was precisely the opposite: that the achievement of these artists in photography was on an aesthetic level far superior to anything they had accomplished with their abandoned brushes.

Ziégler—himself a painter-turned-photographer—emphasized the role of artistic sensibility in photography, and the terms he used are the same as have been central to the discussion of photography as an art throughout its history: "The choice of viewpoint, of the precise hour when that subject will have the best light, the pose of the model, the determination of the shadows of a statue—all demand the eye and sensibility of the artist. . . . [In these elements] one can easily recognize a print made by a man who is practiced in the fine arts or who is naturally talented."[32] Most important was the power to imagine—to visualize, as well as to recognize—a picture, an ability central to the painter's art.

One day in the late summer or fall of 1851, wedged between a wall of twelfth-century masonry and the ground glass of his huge view camera, Baldus found his artistic imagination in conflict with the limitations of photographic technology. Before him stretched one of the sculptural and architectural masterpieces of medieval France, the north gallery of the cloister of Saint-Trophîme in Arles, constructed in 1165–80. Leading to the shadowed end wall was a floor of stone blocks worn smooth and uneven over seven centuries by the foot-steps of prayerful monks. Above, capping the space, a barrel vault extended the full length of the gallery, capturing reflected light and echoing the sounds of the cloister. To the left a blind arcade and a long bench were sunlit and shadowed in the pattern of the cloister arches opposite. And on the right a corner pier elaborately carved with the figures of Saints Peter, Trophîme, and John the Evangelist began a lively rhythm of paired colonnettes, storiated capitals, and bas-relief piers, all dramatically three-dimensional in the strong sunlight of the cloister garden and the cool shadows of the gallery interior. Here, indeed, was a scene worthy of representation: a physical space of arresting appearance; the type of site that might have been romantically depicted by earlier lithographers; a part of the national patrimony, the protection and restoration of which might later be discussed by a circle of architects and historians gathered around the careful photographic documentation Baldus hoped to make.

And so, one can imagine the frustration Baldus must have felt as he realized that his lens could encompass only a small portion of the total space, that the chemistry of his negatives could record only a limited register of the broad tonal range of lights and darks, and that his negatives (and the resulting prints), though large for the day at 26 × 36 cm (10¼ × 14¼ in.), were too small to convey the scale of the site or to allow vicarious entry into the space.

The solution required both art and artifice. A careful examination of Baldus's photograph shows how he overcame the physical constraints of the task (pl. 1). In this single print Baldus achieved grand scale and wide scope by piecing together a jigsaw puzzle of ten negatives, each focused and properly exposed for its portion of the scene. He minimized the evidence of his handiwork by cutting and joining the negatives along the contours of cornices, columns, or masonry joins (fig. 3) and by retouching the print to mask the seams. Baldus also retouched the paper negatives themselves to add or reinforce details; in fact, the entire upper portion of the print, showing the vaults almost directly above Baldus's head (essential for a true feeling of the space but virtually impossible to photograph), is printed from a hand-painted negative rather than from one made with the

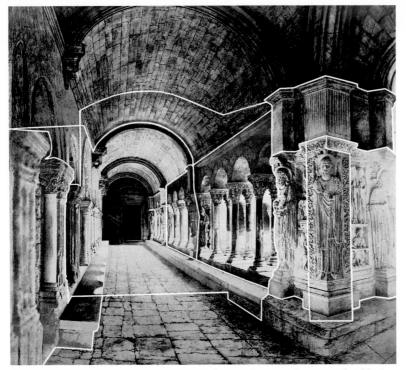

Fig. 3. *Cloister of Saint-Trophîme, Arles* (pl. 1), indicating the joins of Baldus's negatives

camera. Finally, Baldus took his brush to the positive print, clarifying details and accentuating tonal contrasts. "*Peintre photographe*" indeed!

The Mission Héliographique, 1851

In a sense, Baldus's journey to the cloister of Saint-Trophîme began much earlier the same year. In January 1851 he had been among forty photographers, artists, amateurs, and scientists who came together to form the Société Héliographique, the world's first formally constituted photographic association, dedicated to the exchange of information and ideas among its members and to the promotion of photography within society as a whole. By bringing together men who, working in isolation, might struggle for years to

solve a given problem, the new society hoped to hasten the perfection of photography. "The photographer, the painter, the literary man, the scholar, the sculptor, the architect, the optician, and the engraver consult with one another and render mutual service," declared the bylaws.[33]

Baldus was among five members of the fledgling society selected by the Historic Monuments Commission, a government agency, to carry out *missions héliographiques*. He, Le Gray, Le Secq, Hippolyte Bayard, and O. Mestral were sent on photographic excursions, charged with documenting the nation's architectural patrimony with particular emphasis on those structures in need of restoration.[34]

This first government-sponsored photographic survey was initiated on January 10, 1851, when Le Secq presented samples of his photographs to the Historic Monuments Commission. The Commission decided to award him a *mission*, the details of which were to be worked out later.[35] The following week the Commission decided to award similar *missions* to Baldus and Mestral and named a subcommittee to determine the number and nature of the photographs to be made of each monument.[36]

By six weeks later, however, the *missions* had been reconsidered and a competition conducted. "Before awarding such an important and far-reaching commission," wrote Wilhelm von Herford, a student of Baldus, in 1853, "the government announced a competition in which the five best photographers were chosen from among those who had submitted work, and then each of the five was provided with a travel grant of 3,000 francs. Upon his return, each had to present what he had achieved."[37]

As mentioned earlier, Baldus is reported to have first experimented with photography in 1848,[38] and it is logical to assume that the photographs he showed to the Commission's subcommittee in 1851 proved him already to be an accomplished photographer. Although numerous photographs by Bayard and Le Gray from the late 1840s attest to their photographic abilities, and Le Secq is known to have studied with Le Gray as early as 1848, the evidence concerning Baldus's pre-1851 photographic activity is scant. No written docu-

Fig. 4. *Roman Theater, Arles*, before 1851? Salted paper print from paper negative, 15.9 × 20.3 cm (6¼ × 8 in.). Collection of the J. Paul Getty Museum, Malibu, California

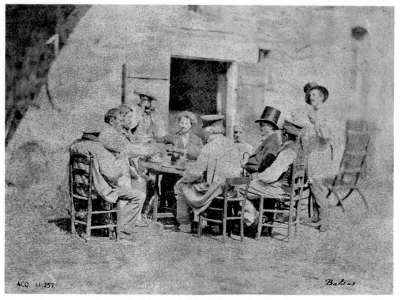

Fig. 5. *Outdoor Gathering*, before 1851? Salted paper print from paper negative, 13.8 × 19 cm (5⅜ × 7½ in.). Bibliothèque Nationale, Paris

ments record any detail of his photographic work during the period 1848–50, and only three surviving images may be proposed as dating prior to the *mission héliographique*.

The first of these is the only image by Baldus dated in the negative, a view of the Chapel of Saint-Croix at Montmajour, inscribed 1849 (pl. 2).[39] If the inscribed date is to be trusted, Baldus would seem to be calling special attention to this image as evidence of a prior familiarity with the monuments of the Midi, a precocious mastery of the physical difficulties of the medium, and the early formation of a personal style. The monument, set back on an empty foreground plain, is shown isolated and centered, its geometric architecture emphasized by sun and shadow—all properties that would come to be characteristic of his mature style of the 1850s.[40] A smaller, undated photograph, of the Roman theater nearby at Arles (fig. 4), and a photograph showing a gathering around an outdoor table (fig. 5), more akin to the 1840s genre scenes of Bayard and

Humbert de Molard than to Baldus's other known work, may also date from before 1851.[41]

In any case, at the end of February 1851 the Historic Monuments Commission judged that Baldus, Le Secq, and Bayard had produced the best photographs of monuments and awarded each a *mission héliographique*.[42] (Only in May was Mestral again awarded a *mission*, along with Le Gray.) The Commission sent Baldus south, to Fontainebleau, through Burgundy, the Dauphiné and Lyonnais, Provence, and a small part of Languedoc, with a list of fifty-one monuments (as well as three paintings) to photograph (fig. 6). In a number of cases multiple views were specified for a single monument.[43] (See appendix 4.)

Seventy-one negatives survive from Baldus's *mission*, including some duplicates and some images formed from more than one negative; they represent just over half the sixty-one views specified on his itinerary.[44] Only a handful of positive prints from them are known,

23

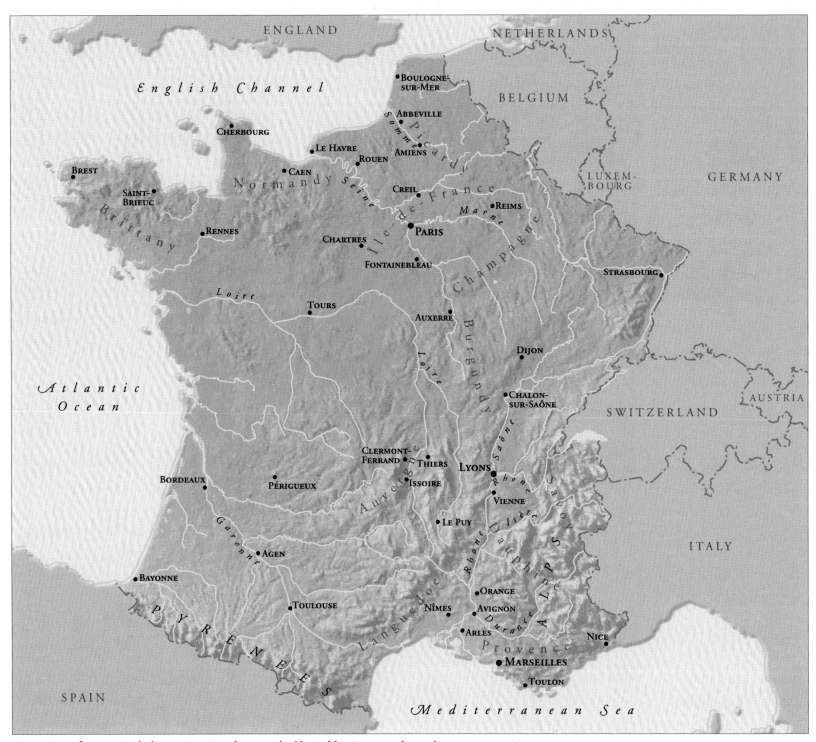

Fig. 6. Map of France, including major sites photographed by Baldus in 1851 and on subsequent campaigns

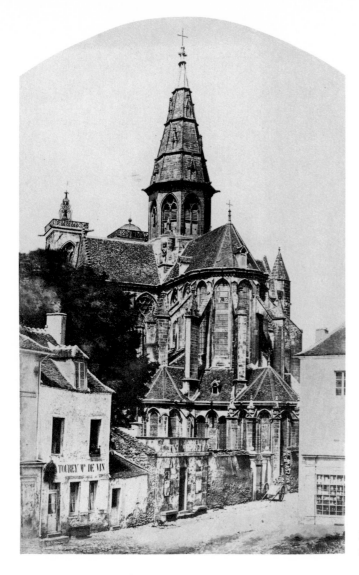

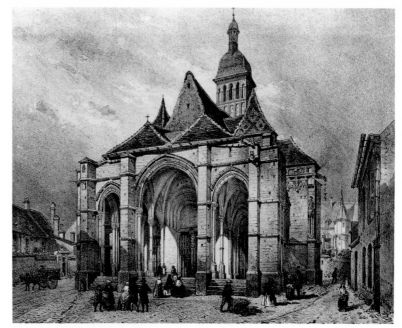

Fig. 8. Hubert Clerget (1818–1899). *Church at Beaune*, 1863. Lithograph. New York Public Library

Fig. 7. *Church of Notre-Dame, Semur*, 1851. Salted paper print from three paper negatives, 40.8 × 25.5 cm (19⅛ × 10 in.). Musée d'Orsay, Paris

however, for the negatives were turned over to the Commission shortly after having been made and were never systematically published. As a result, some of the most beautiful and complex images in this earliest surviving body of photographs by Baldus are known only as negatives, as prints in poor condition, or as albumen prints made in the 1880s. If the specifics of Baldus's print quality of 1851 are thus somewhat vague, we can, nonetheless, confidently characterize his photographic style at the launching point of his career.

Having no precedent in their own medium, early photographers, fresh from the painting studio, naturally looked to existing images of their subjects as models and points of departure for their own picture-making excursions. Many of these were gathered in Baron Isidore Taylor's *Voyages pittoresques et romantiques dans l'ancienne France* (1820–78), a project of enormous ambition.[45] Taylor aimed to produce an encyclopedic collection of views of France's Roman and medieval architectural patrimony, province by province, using

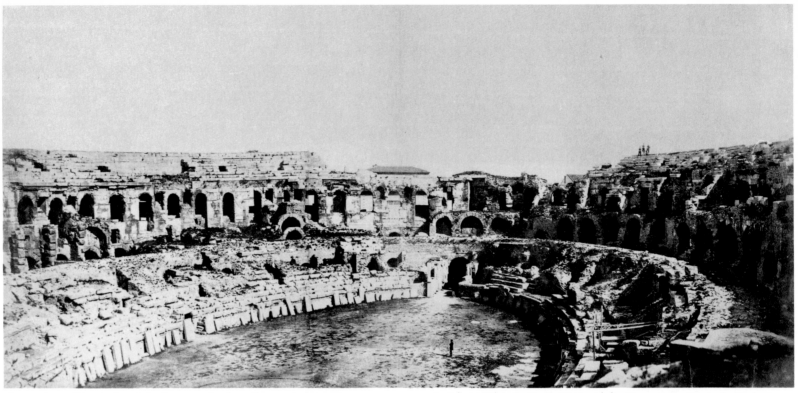

Fig. 9. *Arena, Nîmes*, 1851. Salted paper print from three paper negatives, 43.5 × 92.3 cm (17 1/8 × 36 3/8 in.). Musée National des Monuments Français, Paris

the new and still somewhat experimental medium of lithography. By the time Baldus and his fellow photographers set out on their *missions héliographiques* in 1851, Taylor had, after thirty years, published fifteen volumes of the *Voyages pittoresques*, containing thousands of lithographic views and detailed drawings.

A few of Baldus's *mission* photographs remain close to the tradition of topographic prints, characterized by an oblique point of view that situates the building within the surrounding landscape or townscape. Baldus's views of the Porte d'Arroux in Autun and the Church of Saint-Maurice in Vienne, with carriages, carts, and a café on the plaza just in front, are close in both composition and content to lithographs of the same sites in the *Voyages pittoresques*, and his photographs of the church at Semur-en-Auxois (fig. 7), with a hand-drawn wisp of smoke emanating from the chimney of a nearby

house, and the Church of Saint-Père-sous-Vézelay fit comfortably in this same tradition.[46]

Despite the similarities between certain of his photographs and the work of topographic draftsmen, Baldus followed no single compositional formula in representing the varied subjects on his *mission* list. The flat plane of a church facade, the swelling volume of an apse, and the complex organization of a cloister gallery each demanded a different visual strategy and encouraged Baldus to experiment with various ways of using the camera to resolve his subject in a coherent and satisfying picture.

Church at Beaune (pl. 6), for example, differs dramatically from Hubert Clerget's lithograph of the same site (fig. 8). Although published a dozen years after Baldus's photograph, in a volume of the *Voyages pittoresques* that itself contained photolithographic plates,

Clerget's print follows picturesque conventions established long before 1851. The church is seen from street level, at an angle, its roofline an irregular silhouette of broad, pointed, and rounded peaks. The marks of the lithographic crayon suggest the erosion of stone walls and slate roofs, and the street is peopled with ladies in crinolines, gentlemen with top hats, and a man pushing a barrow of hay. Baldus's photograph, by contrast, has an immediate visual impact. From a slightly elevated position just opposite the facade, Baldus emphasized the symmetry of the peaked roofs and of the tall arches of the porch, directing the eye toward the deeply shadowed central portal. The photograph has a bull's-eye directness heightened by the falling off of lens coverage at the corners.

In other photographs from Baldus's *mission*, figures often pose in front of the monuments, frequently townsfolk, but occasionally two men—one in a top hat, the other in a cap—perhaps the photographer and his assistant. Always conscious of the camera—and how could one help but be in 1851?—they contrast with, and now seem more genuine than, the barking dog, playing child, conversing bourgeois, and hardworking laborer or vendor of the print tradition, a conventional cast of characters that surely seemed natural to the lithographer even when added to the scene by a second artist who specialized in figures.

The strong, formal composition, direct—even assertive—mode of representation, and flawless technique that would later characterize Baldus's fully realized style of architectural photography are already found in this first sustained project.

Perhaps the most dramatic characteristic of Baldus's pictures from the *mission héliographique* is their scale. The cloister of Saint-Trophîme was not the only place on Baldus's 1851 route where the artist found it necessary to form his picture from more than one negative. Standing on the uppermost tier of seats at the amphitheater of Nîmes, he took three pictures of the arena's interior that together form a sweeping panorama more than 92 cm (36 in.) wide (fig. 9);[47] two negatives, side by side, show the entire bulging exterior of the same structure in a print 28.5 × 72.2 cm (11¹/₄ × 28³/₈ in.). In

Avignon, Baldus fit together two negatives—one vertical, one horizontal—to show the massive front of the Papal Palace. At Saint-Restitut, where a crowd gathered before his camera, he employed one negative for the base of the square tower, a second to complete its upper reaches, and a third to incorporate the adjacent Chapel of the Penitents with its portal of classical columns; the entire picture measures 46 cm (18¹/₈ in.) square (fig. 10). Not all Baldus's pictures from the *mission* were of such extraordinary dimensions; some were as small as 19 × 17 cm (7¹/₂ × 6³/₄ in.), and the majority were printed from a single negative, roughly 26 × 36 cm (10¹/₄ × 14¹/₈ in.). But

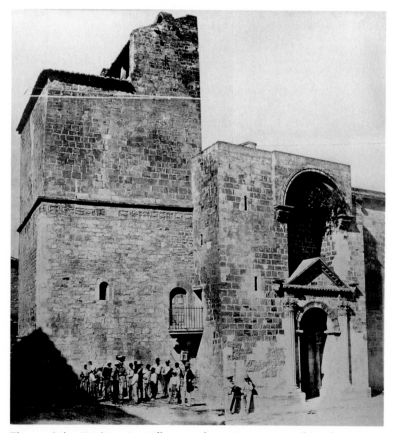

Fig. 10. *Saint-Restitut*, 1851. Albumen silver print, ca. 1880, from three paper negatives, 45.1 × 43.2 cm (17³/₄ × 17 in.). Musée National des Monuments Français, Paris

already evident was a clear desire to create big photographs—pictures that would have a commanding presence on an exhibition wall and that could convey the experience, not just the appearance, of a site.

Baldus had no greater admirer than Ernest Lacan (1828–1879), an early member of the Société Héliographique, editor in chief of the first photographic journal in France, *La Lumière*, from December 1851 to December 1860, and co-founder of the *Moniteur de la Photographie* in 1861.[48] More a publicist for the medium than an art critic, Lacan was the central figure in a circle of photographers, amateurs, and intellectuals passionately committed to the promotion of photography. As the primary writer for the most important photographic journal of the 1850s, he wrote extensively and enthusiastically about each of Baldus's many projects; often, Lacan's words are all that remain of contemporary reaction to Baldus's photographs and, at times, the only record of work now lost. Lacan was not stingy with his praise for other fine-art photographers, but his esteem for the work of Baldus was of a higher order; by contrast, comment about Baldus's work by other authors was usually brief.

In the absence of any formal photographic institution after the dissolution of the Société Héliographique at the end of 1851 and before the founding of the Société Française de Photographie in 1854, Lacan filled the void by sponsoring informal soirées in his home, where photographers showed their work and shared their innovations with colleagues. It was at one such Tuesday evening gathering on April 13, 1852, that Baldus showed photographs of the south of France—presumably his *mission* views—to Lacan and the other artists present: Le Gray, Le Secq, Nègre, Ziégler, Niépce de Saint-Victor, Victor Plumier, and François-Auguste Renard. Lacan, claiming inadequate verbal skills to describe the splendors shown, cited but one of Baldus's works, a photograph of Avignon 50 cm (19⅝ in.) wide (made, no doubt, by piecing together two negatives), "the old Christian city with its Papal Palace as big as a fortified town, its bridge in ruins, its twin rivers, its crenellated walls, its towers, its outskirts." As he closed his portfolio, Lacan continued, Baldus announced that everything he had just shown to the group was "nothing compared with what he would do on his next trip." "Despite our surprise, we believe him," wrote Lacan. "He has enough talent and faith in his art to achieve more than the merely beautiful."[49]

Villes de France Photographiées

Apparently, Baldus believed he could produce a still more impressive series of photographs. He had no doubt gained insight from confronting the challenges involved in photographing the various monuments on his *mission* itinerary and from seeing the results of his work. Perhaps it was already evident, too, that the Historic Monuments Commission had no immediate plans for the publication of the *mission* photographs, and as Baldus seems not to have kept duplicate negatives for his personal use, he would have had to create a new set of negatives to continue as a photographer.[50]

Unlike Charles Nègre, who financed his own *mission* and only afterward attempted to market the results as a series entitled *Le Midi de la France photographié*, Baldus sought to capitalize on the official pleasure with which his *mission héliographique* work had been received and requested government support for his next project in advance.[51] In a letter to the comte de Persigny, minister of the interior, dated May 6, 1852, he proposed that the government subscribe to twenty copies of a vast project entitled *Villes de France photographiées*, consisting of twenty installments; each installment, comprising at least three photographs in-folio (approximately 38 cm [15 in.] in height), would cost 30 francs—not an insignificant sum.[52] Nègre, with his request, wrote a lengthy introduction in which he argued the functional superiority and artistic value of photography and expounded the artist's general purpose, choice of subject, and motivation for producing various types of views.[53] Baldus, by contrast, was not given to expository essays in his business correspondence. In his proposal he provided no list of monuments, either

specific or generic, nor any artistic or intellectual framework for the project; instead, he enclosed a sample installment (now lost) and relied on the self-evident utility and beauty of his photographs to make his case. Within three weeks the project had won ministerial approval. The subscription was to be extended over four fiscal years, beginning in 1853, with the cost per year not to exceed 3,000 francs. Two copies of the full publication were to be provided in bound form.[54]

Baldus may have intentionally chosen not to present a comprehensive plan at the outset. Over the next four years the *Villes de France* would include photographs made in Paris and on excursions to the southeast, central, and northwest regions of France (see appendix 5). Perhaps he hoped from the beginning to extend the project beyond the initial twenty installments, photographing a different part of the country each year. In effect, this is what happened after 1856, but to have said so at the beginning would have risked rejection of an overly grand and expensive undertaking; on the other hand, had he specified a narrower scope his proposed depiction of France might have seemed incomplete. It is equally possible that Baldus simply had no plan in 1852; filled with energy and ambition after his *mission héliographique,* but lacking the means to continue his photographic career, he proposed a vaguely outlined project that allowed him to work as he pleased.

He began with a series of photographs of the capital's chief monuments. Five of the first seven installments of the *Villes de France photographiées* represented Parisian landmarks, including Notre-Dame (pl. 8), the Pantheon, the Tour Saint-Jacques, and the Arc de Triomphe.[55] In carefully composed and exquisitely printed photographs such as *Pavillon de l'Horloge, Louvre, Paris* and *Hôtel de Ville, Paris* (pls. 9 and 10), both from 1852 or early 1853 and included in the *Villes de France,* Baldus first demonstrated a style of architectural photography that would become the classic model for its genre.

Although generally lacking the figures that populated his *mission* pictures, these early Paris views are animated not only by the occasional presence of life's incidental traces—a horse-drawn cart, a quay-side kiosk, or, at the Tour Saint-Jacques (pl. 11), a street vendor's stall and the demolition of buildings that surrounded the Gothic tower—but also by a softly sensuous, even romantic, play of light and shadow, and by a strong articulation of urban space and architectural volume.

In Baldus's photographs of Parisian monuments made a few years later, during the mid-1850s, the artist's style is fully realized. Baldus filled his frame with the facade of Notre-Dame (pl. 56), producing an assertively frontal view somewhere between a drawn architectural elevation and an abstract puzzle. He presented the Pantheon (pl. 57) as a massive and somber silhouette, isolated from its urban context. And with his photograph of the neoclassical Church of the Madeleine (pl. 55), Baldus established a classic scheme of photographic representation. As if conceived as an ideal demonstration of two-point perspective, the photograph shows the edifice filling the picture plane, the structure in perfect three-quarter view, the horizon at midheight, the colonnade a rhythmic procession of measured units. It is difficult to imagine a photograph that would better fulfill its informational function. But Baldus's vision is not clinical; the row of saplings, the top-hatted gentleman seated on a bench, and the armature for temporary decorations all provide footnotes of secondary interest, while the architecture itself becomes a mesmerizing field of intricate detail and subtle light play.

In the September 24, 1853, issue of *La Lumière* Lacan wrote about Baldus's views of Paris, noting their large size and describing their "rare perfection," "tonal beauty," and "incredible fineness of detail."[56]

The Midi, 1853

Baldus set up his large-format camera before the Roman arch at Orange on the very day that Lacan's review appeared and set out to make good on his promise to surpass his own pictures of 1851.[57] For the *mission* he had made two views of the triumphal arch. One shows the monument almost frontally (fig. 11), its visible face in shadow but with sunlight glinting on the far edges of the arched openings; a

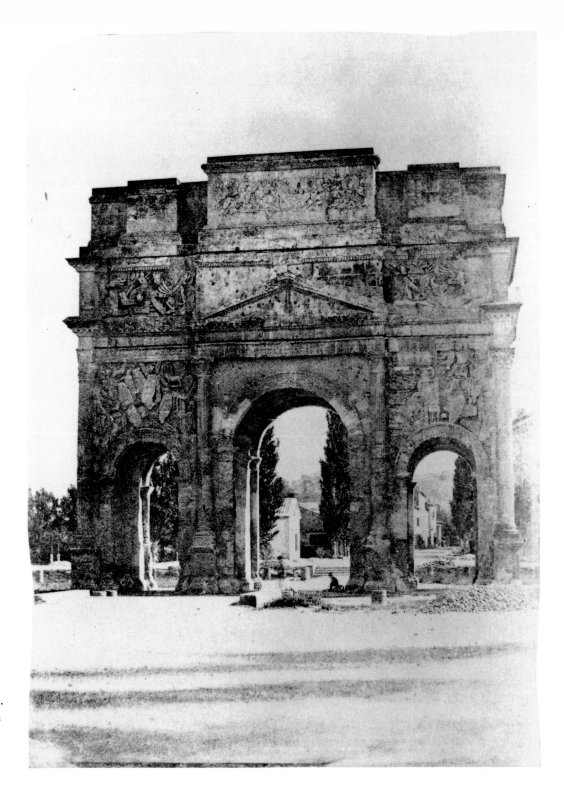

Fig. 11. *Roman Arch, Orange*, 1851.
Gelatin silver print, ca. 1915, from
paper negative, 36 × 26.2 cm
(14¹/₈ × 10³/₈ in.). Musée National
des Monuments Français, Paris

man sits contemplatively on a stone beneath the central arch and another man stands nearby; through the arches, rows of poplars, a few houses, and the nearby hills are visible; the dark and imposing Roman arch frames nature, the contemporary town, and man. This is a scene that might have been depicted by a painter, draftsman, or printmaker. Baldus's other photograph from 1851 shows the arch from the opposite side at a slight angle in strong sunlight (pl. 7). The structure is a massive block of stone, an isolated object, its three arched openings described by flat, intensely dark swaths of shadow that impart a graphic power to the image. Baldus's assistant stands erect at the center of the picture, an inanimate measuring rod rather than the viewer's alter ego. At this single site in 1851, Baldus demonstrated two aesthetic tendencies—the picturesque rendering of a scene and the objectification of an architectural subject—that affected his work in varying degrees throughout his career.

Returning to the site in 1853, Baldus achieved a perfect balance of these two poles. With a three-quarter view and more-subtle lighting conditions, he gave the arch greater sculptural presence, more clearly describing the three apertures, showing the coffered underside of the vaults, and registering the details of fluted Corinthian columns and bas-relief trophies with a subtle and exquisite legibility (pl. 13). Further, by shifting from a vertical to a horizontal format, he allowed more of the surrounding context to appear without permitting it to encroach upon the monument itself. The arch is set within its circle of stone posts; pines and poplars and a line of laundry speak quietly of this spot on the edge of town, and a pile of stones attests to the restoration work being carried out at the site.[58] Achieving this balance between the monument and its surroundings again required Baldus's skill with the brush; he painted on the negative to block out the sky, treetops, and telegraph pole and wires that he deemed distracting. (The bottom of the pole is visible at the left, and the wires can be seen cutting across the arch, where retouching the negative was impossible.)

Baldus's artistic strategy in the Midi thus proved as great a contrast to Nègre's as did his business strategy. Nègre, by his own

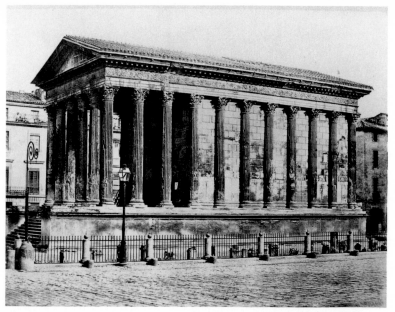

Fig. 12. *Maison Carrée, Nîmes*, 1851. Salted paper print from paper negative, 26.8 × 35.4 cm (10¹/₂ × 14 in.). Musée National des Monuments Français, Paris

Fig. 13. *Maison Carrée, Nîmes*, 1853. Salted paper print from paper negative, 34.8 × 44.4 cm (13³/₄ × 17¹/₂ in.). Musée d'Orsay, Paris

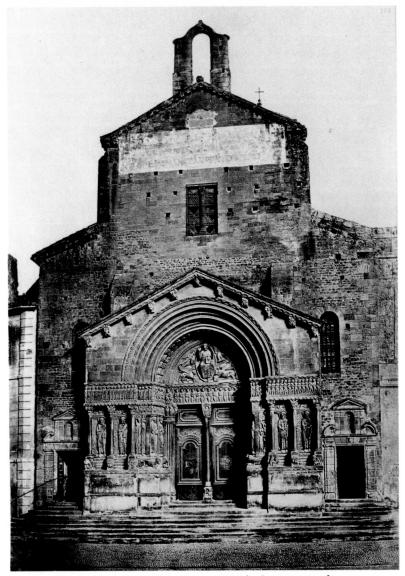

Fig. 14. *Church of Saint-Trophîme, Arles*, 1853. Salted paper print from paper negative, 48.4 × 34.3 cm (19 × 13½ in.). Musée National des Monuments Français, Paris

tured the "imposing effect" and "poetic charm" of the monument.[59] Baldus instead tried at each site to produce a single picture that would sum up both the substance and the spirit of the monument; on occasion, as at the arch in Orange or at the Roman cemetery near Arles (pl. 14), he clearly succeeded.

That balance, however, is not typical of all the pictures Baldus made on his campaign in the Midi in 1853; in most he banished all picturesque elements and presented the monument as an isolated object. In 1851 he photographed the Maison Carrée in Nîmes (fig. 12) at an angle to show both the front and a side of the ancient Roman temple. Buildings seen to the left and right and through the columns of the porch make the monument's urban context clear. In 1853 Baldus set up his camera farther to the right and described the building more as a flat architectural elevation than as a perspective rendering, obscuring the facade in the process (fig. 13). In a still bolder action he painted on the negative to block out all the surrounding buildings, so that the Maison Carrée appears isolated, poised on an acropolis. We see the same technique in the photograph of the facade of Saint-Trophîme in Arles (fig. 14), where, with the stroke of a brush, Baldus razed the upper stories of the episcopal palace and other adjoining buildings in order to present the church front unencumbered, decontextualized, symmetrical, and towering. Because negatives were not equally sensitive to all colors of the spectrum, early photographers commonly inked out their skies, finding a uniform brightness to be a more natural rendition of radiant atmosphere than the mottled tones that appeared on an otherwise properly exposed print. Inking out entire buildings was a different story. The slightly unreal objectification of architectural monuments that resulted drew praise from the admiring Lacan: "It is the monument itself, but isolated, disengaged from all that distracts the eye or the mind."[60]

Lacan's enthusiasm for certain pictures is now hard to fathom. He devoted a great deal of space and lavished much praise on Baldus's pictures of the facade of Saint-Trophîme and the fountain by Pradier and Questal in Nîmes, two pictures that strike the modern viewer as

account, produced three kinds of photographs at each site he visited: for the architect, a general view with "the aspect and precision of a geometric elevation"; for the sculptor, close-up views of the most interesting details; and for the painter, a picturesque view that cap-

among the dullest of Baldus's productions. Mixed with a sincere admiration for Baldus's artistry were his enthusiasm for the subjects (Lacan's discussion of *Fountain, Nîmes* is more about Pradier and the rivers of France than about Baldus) and his thrill at the medium's capacity, in the hands of a skilled practitioner, to faithfully record the world. To judge by the quantity of extant prints, however, Lacan was not alone; *Church of Saint-Gilles*; *Maison Carrée, Nîmes* (fig. 13); and *Church of Saint-Trophîme, Arles* (fig. 14) survive in great number, and Baldus returned to Saint-Trophîme and photographed it in nearly identical fashion at least two more times.

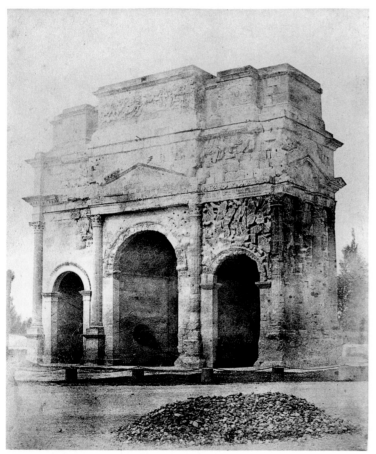

Fig. 15. Wilhelm von Herford (1814–1866). *Roman Arch, Orange*, 1853. Salted paper print from paper negative, 33.4 × 27.3 cm (13¹/₈ × 10³/₄ in.). Agfa Foto-Historama, Cologne. Photo: Rheinisches Bildarchiv

Baldus's tendency in 1853 to present his subject with unmediated directness is most successful in *Tour Magne, Nîmes* (pl. 15). The ancient Roman tomb fills the frame; no context beyond the pebble-strewn foreground is provided. Instead, the photograph's aesthetic and human interest lies in the contrast between the monument's geometric structure and the irregularity of its ruined silhouette; in the modulation of highlights, middle tones, and deep shadows; in the variety of texture found on the deteriorating masonry; and in the battle between the builder's desire for an imperishable memorial, the modern restorer's efforts to preserve the past, and the vegetation sprouting inexorably from its high walls.

Two companions accompanied Baldus on this trip to the Midi—his student Wilhelm von Herford and another, perhaps an assistant.[61] Herford photographed with the direct guidance of Baldus, in some cases—such as at Orange—setting up his camera just alongside his teacher's (fig. 15).[62] Traveling from late September to late October 1853, the team moved from Orange to Avignon, the Pont du Gard, Nîmes, Saint-Gilles, and Arles, making exposures of the region's most important monuments. "Both my traveling companions," wrote Herford, "less accustomed to the south than I, are suffering from insomnia and lack of appetite, for the hottest midday hours are the most favorable for photography, and to spend hours in the open air in this heat is always difficult."[63] Despite the rigors of the campaign, the results were enormously successful. The negatives that Baldus made in the Midi not only formed the next five installments of *Villes de France* but also remained among his most striking and widely distributed images during the next decade, finding a place even in the album he composed in the early 1860s, *Chemins de Fer de Paris à Lyon et à la Méditerranée.*[64]

First widely seen in the exhibition of the Photographic Society of London, which opened January 3, 1854, Baldus's views of the monuments of the Midi captivated the public's attention, "just as they attracted that of the queen and Prince Albert during their visit to the exhibition," according to Charles Gaudin, writing from the British capital for *La Lumière.*[65] Gaudin's readers would already have read

praise of these pictures, for Lacan had written extensively about them in mid-December, describing Baldus's overall plan and purpose in a statement more complete than any from the artist himself: "M. Baldus has sketched a vast plan, the realization of which will render a great service to the arts. He wishes to assemble in his portfolio views of monuments that represent the diverse architectural styles of France. He will thus be able, when his work is completed, to offer the architect, the painter, and the archaeologist a collection of all the types of buildings, from the heavy structures that the Roman colonies left in our ancient cities to the hybrid constructions of the last century. Each will have its place in this gallery, which is at once historical and artistic."[66] Remarking that Baldus had for a long time shown himself to be among the first rank of photographers by virtue of the perfection of his technique, his deeply artistic sentiment, and the clarity and enormous size of his prints, Lacan confirmed the artist's earlier prediction almost word for word: "The views that M. Baldus has brought back this year from his trip to the Midi surpass everything he has done previously."[67]

Photographic Reproductions of Painting and Sculpture, 1853–54

The historical and artistic gallery that Lacan spoke of included more than architecture; masterpieces of painting and sculpture were also part of Baldus's photographic portfolio, and the sensitive reproduction of these art forms was considered no less a challenge than that of depicting architectural monuments.

From the first announcements of the invention of photography, one of its recognized functions was the faithful reproduction of works of art. As early as January 1839 Talbot proposed employing his process for the purpose of "multiplying at small expense copies of . . . rare or unique engravings,"[68] and in Paris Jules Janin wrote shortly after Arago's first presentation of Daguerre's invention that photography "is destined to popularize for us, at very little cost, the most beautiful works of art, for which we have only costly and

Fig. 16. *David d'Angers*, 1853. Salted paper print from paper negative, 18.7 × 15.2 cm (7 3/8 × 6 in.). Bibliothèque Nationale, Paris

unfaithful copies." Before long, he predicted, "one will send one's child to the museum and say to him: 'I need you to bring me a painting by Murillo or by Raphael within three hours.'"[69]

In the first half of the nineteenth century reproductive engravings, etchings, and lithographs far outnumbered original images by *peintre-graveurs*. The reproductive printmaker was thought to exert a creative effect in "translating" the original work, and, far from being considered mere mechanical reproduction, such prints were exhibit-

34

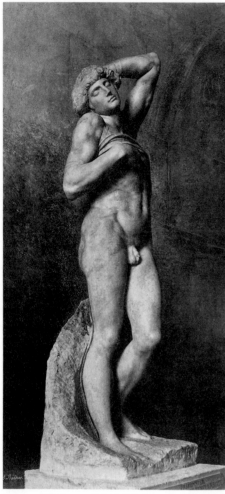

Fig. 17. *"Prisoner," by Michelangelo*, 1854. Salted paper print from paper negative, 40.2 × 19.3 cm (15⅞ × 7⅝ in.). Collection of the J. Paul Getty Museum, Malibu, California

ed in the Salon and reviewed according to criteria beyond precise adherence to the original. One writer early in the century described the graphic artist's interpretive role: "Since the idiom of engraving has fewer resources than that of painting, and inasmuch as the language of the latter is greatly enriched by the variety of colors, the skilled engraver, though obliged to conform strictly to the contours of the original, especially when they are correct . . . is sometimes obliged to make changes in the harmony of the painting he is trans-

lating in order to get closer to the general effect, making one object stand out from another by a different tone where they are separated in the painting only by varying colors that produce tones of the same value."[70] Thus, objectively precise reproduction of paintings was not expected; photography provided a more accurate rendering than the traditional graphic mediums, but it was a fidelity that also required sensitive interpretation.

In the same article in which Lacan praised the views of Notre-Dame and the Tour Saint-Jacques, he devoted vastly more space to Baldus's photographic reproductions of gravures and paintings. Of special note was an album of eleven photographs reproducing Auguste Galimard's recent designs for the windows of the Church of Sainte-Clotilde in Paris.[71] Seemingly unremarkable to modern eyes accustomed to high-quality photographic reproduction of art, *Vitraux de Sainte-Clotilde* was thought by Lacan to be a great achievement. Charles Desolme, editor of *Europe Artiste*, likewise praised it, bemoaning the "unfaithful engraver's burin" and "ignorant lithographic crayon" that had so poorly reproduced the great masterpieces of the past, and heralding Baldus's accomplishment: "By opposing ignorance and fantasy with pure and simple truth, photography has proven that it can reproduce everything, and that it alone is inimitable. The beautiful collection photographed by M. Baldus . . . is a new demonstration of the superiority of this art of reproduction. Never has photography gone so far in its fidelity to light and shade and in its precision of detail; it is truly a miracle."[72]

Along with the *Vitraux de Sainte-Clotilde* and his views of the Midi, Baldus showed two other examples of art reproduction to his fellow photographers gathered at the home of Ernest Lacan on Saturday evening, March 11, 1854. First was a facsimile of the richly illuminated book of hours of Anne de Bretagne, which Baldus had photographed in the autumn of 1853.[73] "All those who have been able to see these naïve vignettes, so heavily painted in brilliant colors and gilding, will understand how much difficulty their reproduction presented,"[74] wrote Charles Gaudin with a mixture of amazement and admiration.

Second, and ultimately more important to the course of his career, Baldus showed his first photogravure reproductions, facsimiles after Jean Lepautre (1618–1682). Lepautre's nearly fifteen hundred etchings and engravings of architectural decorations—friezes, ceilings, vases, mantelpieces, and ornamentation of all kinds—formed a veritable catalogue of the Louis XIV style. Out of favor during the period of French neoclassicism, Lepautre's designs were again highly admired during the Second Empire and looked to for inspiration by new enthusiasts of elaborate architectural decoration. In September 1853, Baldus fulfilled a "very urgent" request from the government for twenty negatives of Lepautre's ornamental designs.[75] Six months later he offered the Office of Fine Arts photogravure plates rather than negatives.[76] After examining Baldus's photogravure facsimiles alongside the original engravings by Lepautre, Gaudin declared that, had the paper been the same, it would have been impossible to distinguish between the two.[77]

There were still other projects that occupied Baldus in the months just before and after his trip to the Midi. He was one of a number of photographers to contribute to Théophile Silvestre's *Histoire des artistes vivants*, a series of short biographies of artists, accompanied by portraits and reproductions, issued in installments beginning July 1853.[78] Nine of Baldus's twelve photographs for Silvestre's book are reproductions of paintings by Delacroix, Ingres, Corot, and Courbet, but three are penetrating portraits of the artists Jeanron, Chenavard, and David d'Angers. Baldus—master of the objectified monument, the long exposure, the pieced paper negative, and the retouched print—tackled with great success a genre of photography that required altogether different talents. These three photographs, especially that of David d'Angers (fig. 16), show Baldus to have been highly sensitive to the particularities of portrait composition, telling detail, lighting, and timing. The bright triangle of white revealed by David d'Angers's unbuttoned jacket, the shallow depth of field, the dramatic side-lighting, and the piercing gaze of the sculptor combine for dramatic effect. Baldus never operated a portrait studio as did so many other photographers of the 1850s, and

only a few other portraits by him are known. One, a self-portrait (fig. 1), was perhaps destined for Silvestre's book, in which the author intended to include photographers as well as painters and sculptors.[79]

In 1854, after the discontinuation of Silvestre's publication, Baldus began two series of his own, one reproducing the work of contemporary painters[80] and the second depicting masterpieces of antique and Renaissance sculpture (fig. 17).[81] Neither now survives as a discrete publication. "In sum," wrote Lacan, "M. Baldus has undertaken a huge task, the scope of which is immense. By bringing together in reproductions of this quality the great works bequeathed to us by the past and those produced in our own day, he is writing, by means of photography, a history of art throughout time and in its three great forms: architecture, sculpture, and painting."[82]

Still defining his professional identity, Baldus apparently welcomed the seemingly limitless possibilities of the medium, which, day by day, found new applications in the realms of art, science, and history. Already an acknowledged master of architectural photogra-

Fig. 18. *Pont de la Sainte*, 1854. Salted paper print from paper negative, 34.1 × 44.4 cm (13³⁄₈ × 17¹⁄₂ in.). Agfa Foto-Historama, Cologne. Photo: Rheinisches Bildarchiv

phy, he explored the medium's capacity to record sculpture and to render the subtle effects of painting, he tested his abilities as a portraitist, and he applied photography to the domain of natural history and commerce. In June 1854 Baldus photographed the prizewinning animals at the Exhibition of the Products of French Agriculture on the Champ de Mars. Commissioned by the Ministry of Agriculture Baldus produced, in the space of a few hours, thirty-two wet-collodion glass-plate negatives of cattle, sheep, and pigs.[83] If he planned to produce a photogravure album from the positive prints, as reported by Lacan, his plans were never realized. No images from this series have been identified with certainty, but one beautiful salted paper print of a bull is likely to have been a part of it. The sculptural presence of the animal, its beautifully rendered contours, and its graded tones are not far from the feel of Baldus's photographs of sculpture or his views of historic monuments.[84]

"The grandiose sites of the Auvergne"
In the summer of 1854 Baldus traveled through the fertile lowlands and rugged mountains of the Auvergne, in central France, a region little changed in appearance and custom by the modern forces that were so radically transforming Paris and much of the rest of the country (fig. 18). On that year's trip Baldus traveled with Fortuné-Joseph Petiot-Groffier, a sixty-six-year-old sugar-beet refiner, inventor, entrepreneur, and politician from Chalon-sur-Saône who had recently renewed his early interest in photography and had become a founding member of the Société Française de Photographie.[85] Together, the young teacher and his elderly pupil coursed the dirt roads of the countryside by horse-drawn cart, moving from ruined castle to thatched hut, from pilgrimage church to paper mill, from town square to wooded chasm. Unlike the previous year, when Baldus and his student Herford had set up their cameras and each had made his own exposures, Baldus and Petiot-Groffier apparently worked in close collaboration. Although they carried Petiot-Groffier's "grand photographe," a handsome camera built by Vin-

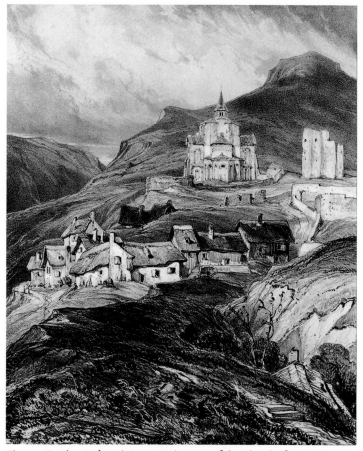

Fig. 19. Eugène Isabey (1803–1886). *Apse of the Church of Saint-Nectaire, Auvergne*, 1831. Lithograph. The Metropolitan Museum of Art, Gift of William M. Ivins Jr. 1922 22.85.8

cent Chevalier in 1846 and able to accommodate negatives of 27 × 36 cm (10⅝ × 14⅛ in.),[86] nearly all their pictures were made with the still-larger camera that Baldus had used the previous year in the Midi. The two men must have worked together in choosing each motif, the best point of view and exact framing, and the most felicitously lit minutes in which to remove the lens cap and expose their negatives.

Baldus, though twenty-five years younger than Petiot-Groffier, was clearly the superior technician and artist; the flawless mastery of large-scale paper negatives and the sophistication of pictorial com-

position that characterize the Auvergne photographs are both in perfect keeping with the work of Baldus and are nowhere so in evidence in the photographs attributable to Petiot-Groffier alone — views of his home, the distillery of Les Alouettes, and the quays of Chalon, as well as of the house of the more famous photographer from Chalon, Nicéphore Niépce. Nonetheless, Petiot-Groffier must have contributed to the collaboration, for numerous images exist in virtually identical prints — one signed by Baldus, another by Petiot-Groffier — and in one case a single print is signed by both.[87] Petiot-Groffier died less than a year later, and the obituary in the

Bulletin of the Société described him as a "friend of the eminent photographer M. Baldus, who counted him among the best of his students."[88]

Whether owing to some aspect of Petiot-Groffier's influence, to the physical character of the region, or to the development of Baldus's aesthetic approach to the medium, or perhaps all three, much of the work produced in the Auvergne represented a shift from Baldus's pictures of the previous year. No longer filling his frame exclusively with historic monuments, Baldus focused on the dramatic landscape of the region and the way in which towns and individual

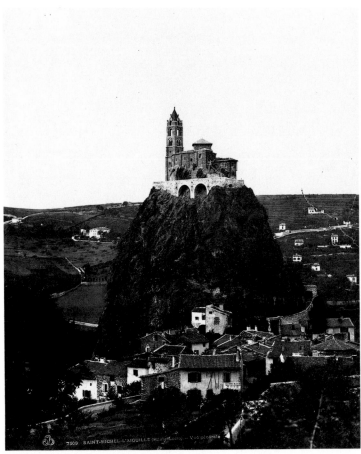

Fig. 20. O. Mestral (active 1850s). *Chapel of Saint-Michel, Le Puy*, 1851. Modern gelatin silver print from original paper negative, 37.5 × 31.1 cm (14³/₄ × 12¹/₄ in.). Musée d'Orsay, Paris

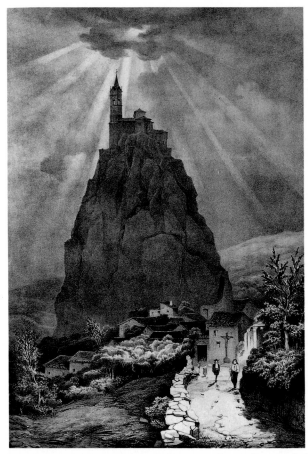

Fig. 21. Jean-Marie-Oscar Gué (1809–1877) or Julien-Michel Gué (1789–1843). *Rock of Saint-Michel, Le Puy*, ca. 1831. Lithograph. New York Public Library

monuments fit into that landscape. In 1853 he had isolated the Provençal monuments from their surroundings to achieve graphic power and documentary value; in 1854, through very different means, he was able to serve those same ends with a poetic force that marks the Auvergne photographs as masterpieces of early landscape photography.

In *Saint-Nectaire* (pl. 16), for example, Baldus stood on a hill some distance from the town and tilted his enormous camera downward until the sky barely showed on the ground glass and until the twelfth-century church was wedged into the corner of the frame. In composing a picture so radically different from both the topographic and picturesque norm (witness Eugène Isabey's lithograph of the same site from the *Voyages pittoresques*, fig. 19) and from his own rigorous minimalism of the previous year, Baldus emphasized the church's commanding site above the sloping roofs, terraced plots, and stepped sluices of the town. The concentrated central focus of the earlier images could not describe the character of this place, and instead gave way to a broad field of paths for the inquiring eye.

At Le Puy, the small chapel of Saint-Michel perched atop a needle of rock (pl. 21) might seem so bizarre that credit for the power of Baldus's photograph should go to its late-eleventh-century builders and the sculptor of landscapes rather than to the photographer. But, in fact, the arresting quality of the image is the result of Baldus's calculated choice of viewpoint and framing and his dramatic use of silhouette, which are fundamentally different from the way Mestral had depicted the same site in 1851 as part of his *mission héliographique* (fig. 20). Mestral's church sits on the horizon; Baldus's reaches for the heavens, barely contained within the frame of his picture. At the same time, Baldus's picture has a sober, classic quality when compared to the full-blown theatricality of Gué's lithograph of Saint-Michel in the *Voyages pittoresques* (fig. 21).

More than in any of his previous photographic campaigns, Baldus embraced a remarkable range of subject and spirit in his pictures of the Auvergne. To be sure, there were pictures consistent with the style of architectural photography he had developed in the years just

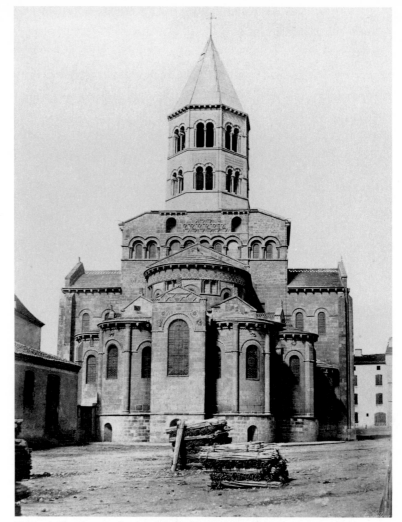

Fig. 22. *Church at Issoire*, 1854. Salted paper print from paper negative, 44.2 × 33.5 cm (17³/₈ × 13¹/₄ in.). Musée d'Orsay, Paris

prior: monumental views of the apses of churches in Brioude and Issoire (fig. 22), for example. But other pictures, such as *Saint-Nectaire* and *Chapel of Saint-Michel, Le Puy* (pls. 16 and 21), focus as much on the site as on the monument itself; the ruined château of Espailly (pl. 17)—its "misshapen and blackened stones merging with the somber rock that supports them"[89]—is barely seen atop the spectacular cliffs and rushing torrent that fill the frame.

Still more of a departure for Baldus was his attention to vernacular architecture and unpopulated landscape. In Paris he had never focused on the narrow streets, picturesque corners, old houses, or commercial shop fronts of the city, but rather on the capital's principal landmarks. Among his subjects in the Auvergne, however, are

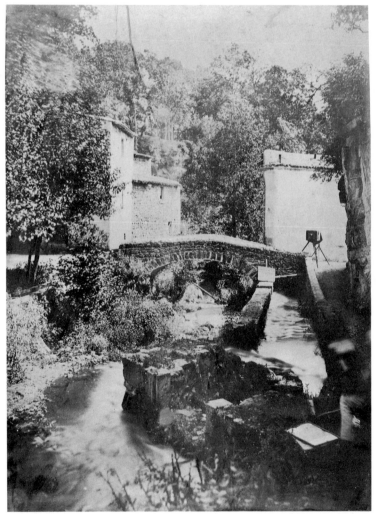

Fig. 23. *Millstream in the Auvergne, with Camera*, 1854. Salted paper print from paper negative, 44.1 × 33.7 cm (17³/₈ × 13¹/₄ in.). Collection of the J. Paul Getty Museum, Malibu, California

numerous views of stone houses and mills nestled between mountain streams and steep wooded slopes (figs. 23 and 24), and other corners of the countryside—a small wooden bridge in Thiers, a thatched house along a woodland path (fig. 25), the rooftops and church of Royat, seen beyond fields and haystacks. In the best of these vernacular scenes Baldus captured the sensate experience of the Auvergne. Climbing the path toward the Château de Murols, Baldus stopped. Here, on the uneven rock-strewn ground, in the dry heat of summer, and fixed in the territorial glare of a neighborhood dog (pictured in a variant image, fig. 26), Baldus and Petiot-Groffier photographed the chaotic array of primitive thatched huts, the rock outcroppings, and the small shrine at the crest of the hill (pl. 18). "See how the grass that covers the path is dry and short, like that hut huddling under its thick thatched roof, lest the wind of these high regions sweep it away with a single breath," wrote Lacan. "Here the noise of the world disappears, vegetation ceases, life stops."[90]

The same two modes of representation found in Baldus's architectural photographs—the picturesque and the rigorously objective—are evident in his landscapes of the Auvergne. If the views of thatched huts and rural tracks lie at one extreme, an arresting pure landscape lies at the other (pl. 20). This surprisingly modern view confronts the features of the land—the face of the cliff, the conical rock outcroppings, the receding stream, the straight-edge horizon—with the same directness Baldus had applied the previous year to architecture in the Midi. From them Baldus created a new kind of landscape—spare, precisely composed, intensely tactile, highly sensitive to the play of texture and tone, volume and silhouette, on the two-dimensional page.

The changed character of Baldus's pictures and the breadth of their content was evident, and Ernest Lacan waxed poetic in his extended praise of these new pictures: "If you are a poet, if you love the grandeur of nature, the sound of torrents on extinct volcanoes, the silence of alpine solitude; if you listen with religious emotion to the eternal hymn that the earth sings to God; then follow M. Baldus to the grandiose sites of the Auvergne. He is a painter, and he knows

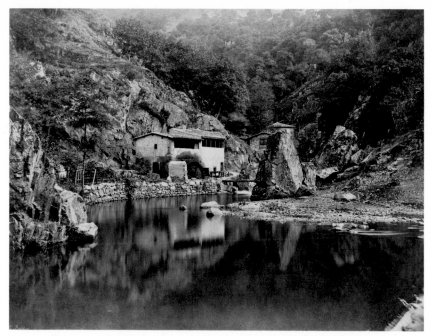

Fig. 24. *"Le Creux d'Enfer," Thiers*, 1854. Salted paper print from paper negative, 33.9 × 44.5 cm (13³/₈ × 17¹/₂ in.). Canadian Centre for Architecture, Montreal

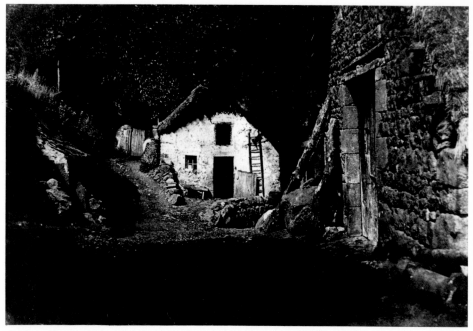

Fig. 25. *Thatched Houses in the Auvergne*, 1854. Modern salted paper print from paper negative, 28.8 × 43.7 cm (11³/₈ × 17¹/₄ in.). Agfa Foto-Historama, Cologne. Photo: Rheinisches Bildarchiv

how to choose his point of view and to direct your admiration. Each of his prints is a poem, sometimes wild, imposing, and fantastic, like a page from Ossian; sometimes calm, melancholic, and harmonious, like a meditation by Lamartine."[91] Before such pictures, Lacan continued, "the poet dreams and the painter is in wonder."

Already enjoying a reputation for prints of enormous dimension, and challenged by subjects too large for his lens, Baldus again turned to the technique of joining several negatives to form a single image, combining the power of scale and the seductiveness of detail. Such pictures, though cumbersome—even inappropriate—for inclusion in an album, had a commanding presence on exhibition. At the 1855 Exposition Universelle, visitors to the rooms devoted to French photography were transfixed by a mountain landscape more than four feet wide. As if "transported to the site itself," Lacan was enraptured by Baldus's *Lake Chambon*, a vast panorama made from

three negatives so skillfully aligned that its joins were undetectable: "Imagine a lake several leagues in circumference hollowed out in the lava, in the midst of volcanoes extinct for centuries. . . . On the deep, calm waters, a few islands look like oases . . . in the distance, the luminous peaks of Mont-Dore, like huge, motionless clouds on the horizon."[92] Unfortunately, neither the prints nor the negatives of Baldus's picture have survived.

The Exposition Universelle of 1855, in Paris, was inspired by the Great Exhibition of the Works of Industry of All Nations, held four years earlier at the Crystal Palace in London. All the world had gone to London in 1851: more than 6 million visitors saw 17,000 exhibits from 77 countries. So impressive a display of Great Britain's imperial might and industrial prowess naturally prompted Napoléon III to begin plans for a world's fair that would rival that of 1851 and that would showcase the art, technology, and commerce of France. Pho-

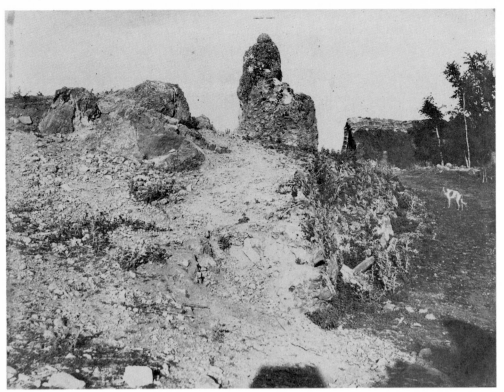

Fig. 26. Édouard Baldus or Fortuné-Joseph Petiot-Groffier (1788–1855). *Village of Murols*, 1854. Salted paper print from paper negative, 24.2 × 31.8 cm (9¹⁄₂ × 12¹⁄₂ in.). Collection of the J. Paul Getty Museum, Malibu, California

tography was but a minor component of the Exposition Universelle, but with more than 4 million people passing through the doors of the Palais de l'Industrie during the summer of 1855, it had never before enjoyed so large an audience in France.

In addition to *Lake Chambon*, Baldus exhibited other photographs from the Auvergne (*Water Mill* and *Pont de la Sainte*), an interior view of the Roman amphitheater at Arles and a two-part panorama of the amphitheater at Nîmes, both probably made in 1853, and several large-format views of Paris, including *Arc de Triomphe, Paris* and a new version of the *Pavillon de l'Horloge, Louvre, Paris*. The Exposition jury awarded Baldus a first-class medal.[93]

One of the most prestigious visitors to the Palais de l'Industrie found her time too limited to take everything in, never making it to the second floor and casting only a glance over the displays of machinery; she lingered in the main court, admiring the crown jewels ("truly superb, and most beautifully set"), items of Sèvres porcelain, and a table service made for the emperor ("of the most splendid and tasteful design"[94]). With other things planned for the afternoon of Wednesday, August 22, she never made it to the photography section, where Baldus's work hung so prominently. But she would have an opportunity later to enjoy his photographs, for even as she made her hurried visits to the sights of Paris—the Louvre, Notre-Dame, the Hôtel de Ville, the Arc de Triomphe, and the Invalides—a lavish album of Baldus's photographs was being prepared as a gift for her. Adorned with a beautiful title page and maps, and bound in sumptuous red leather, this album was indeed fit for a queen.

Still a part of the royal collection housed at Windsor Castle, the photographic album presented to Queen Victoria during her visit to Paris is among the most beautiful ever produced. In it are some of the greatest pictures made during the 1850s, a decade we look upon as a golden age for French photography, when accomplished artists employed a fully mature medium to pioneer a new way of seeing and representing the world. The album, *Visite de sa majesté la reine Victoria et de son altesse royale le Prince Albert 18–27 août 1855: Itinéraire et vues du Chemin de Fer du Nord (Visit of Her Majesty Queen Victoria and of His Royal Highness Prince Albert August 18–27, 1855: Itinerary and Views of the Northern Railway)*, is one of the chief monuments in the history of photography.[95]

The Queen's Visit to France

Queen Victoria's visit to France was an event of historic importance and an occasion for great ceremony. From the moment of her arrival in Boulogne-sur-Mer on August 18, aboard the steam-powered royal yacht *Victoria and Albert*, she was everywhere escorted by Emperor Napoléon III, saluted by military honor guards, and wildly cheered

by crowds of ordinary citizens shouting, "Vive la Reine d'Angle-
terre! Vive l'Empereur!"[96] In Boulogne, forty thousand troops
lined the high cliffs as far as one could see and fired musketry salutes
as the royal yacht approached; on landing, the queen was greeted by
the emperor, addressed by the British residents of Boulogne, and
presented by Baron James de Rothschild with "a magnificent bou-
quet of flowers, with ornamental accompaniments of great value."[97]
Napoléon III, on horseback, escorted the royal party's landau on the
short route from the quay to the railroad station, through the dense-
ly crowded and decorated streets lined with soldiers. Passing under a
gold trelliswork arch seventy-five feet high, topped with a statue of
the Genius of Civilization, and decorated with flags and flowers, the
queen entered a forecourt that had been transformed, in ten days'
time, from a barren lot into a garden of flowers and lush green turf.
The station interior was a breathtakingly rich display of crimson
velvet and gold, and a special boudoir for the queen was decorated in
white and gold with Gobelins draperies and carpet.[98] Victoria quick-
ly boarded the imperial train.

The queen's speedy rail journey to the capital was cause for both
national and corporate pride. The Chemin de Fer du Nord (North-
ern Railway), linking Paris with the Channel, was the most
advanced railroad line in France. Averaging thirty-two miles per
hour (faster than any other French line), express trains traversed the
distance in just five and a half hours—less than one third the time
required by the fastest diligence in the late 1840s, just before the
arrival of rail service.[99] The rapid conveyance of the imperial train
to Paris belied the fact that France lagged years behind Great Britain
in the development of its railroad network.

Napoléon III was surely pleased by the train trip to Paris, for he
was an avid believer in progress through technology and industry,
and had, on coming to power, taken special interest in revitalizing a
railroad industry still unstable after the economic slump of 1847 and
the political crisis of the 1848 revolution. In 1852, as president, he
restructured the plethora of small and fiscally unstable railroad com-
panies into six major lines, or grands réseaux (of which the Nord was

one), and eight secondary lines; he extended all concessions to
ninety-nine years, making investment in the railroads potentially
more lucrative; and he instituted a uniform schedule of tariffs.[100]
With confidence in the railroads restored, two billion francs was
spent on construction between 1852 and 1857, doubling the length of
operating track to more than 5,300 miles with an almost equal
amount conceded but not yet built.[101]

Baron James de Rothschild, president of and principal investor in
the Chemin de Fer du Nord, and other members of the company's
Administrative Council were part of the official welcoming party for
the queen in Boulogne, and were among the passengers on the impe-
rial train to Paris.[102] The railroad company itself was responsible for
much of the fanfare that occurred in Boulogne, Paris, and along the
route, undertaken at considerable expense.[103] "The preparations that
were made at Boulogne and at the other stations of your line, both
for the arrival and the departure, the speed of the journey, and the
orderliness of all of the measures that you took for this grand occa-
sion truly impressed His Majesty," wrote the minister of public
works on behalf of the emperor.[104]

The Album
It was natural that Baron James would have wished to present the
queen with a more lasting souvenir of her railroad journey, and that
he would have thought to commission an album. Many other royal
or imperial progresses had been commemorated in albums or fête
books, and the elaborate iconography and orchestrated beauty of
festival decorations were often better appreciated later, in the quiet
study of engraved pictures of the event, than during the jubilant fes-
tivities themselves. At the conclusion of Victoria's earlier trip to
France, in 1843, King Louis-Philippe had presented her with an
album of watercolor views of the Château d'Eu and of the principal
episodes of her visit (a volume that she reopened and contemplated
before her trip in 1855).[105] The significant events of the French king's
state visit to England three years later were recorded by the lithogra-
pher Théophile Pingret (fig. 27).[106] That Rothschild should have

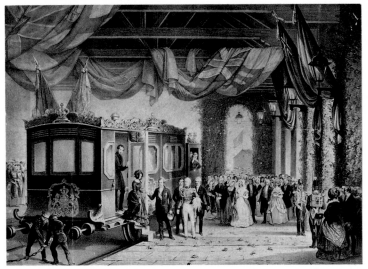

Fig. 27. Théophile Pingret (1788–1875). *Arrival of the Queen of England,* from *Voyage de S. M. Louis Philippe I^{er} roi des français au château de Windsor,* 1846. Lithograph. Musée de la Voiture et du Tourisme, Compiègne

chosen photography for his commemorative album was also natural; he himself was among those who frequented the luxurious studio-boutique of the Bisson Frères at about this time,[107] and he would also have known that the royal couple, and Albert in particular, were photograph enthusiasts. The queen had even brought photographs to France (though Rothschild could not have known that): stereographs for Napoléon III recording his visit to the Crystal Palace in Sydenham some months earlier, as well as photographs from the Crimean War.[108] Perhaps most important in choosing photography for this project was that the medium's technological modernity was akin to that of the railroad itself.

Imagining the album, however, was easier than producing it, as Lacan explained in a short notice in the September 1, 1855, issue of *La Lumière*:

> During the visit to Paris of Her Majesty Queen Victoria, several of our most skilled photographers were sent along the route which the gracious sovereign traveled, with the mission of reproducing the most noteworthy monuments and views between Paris and Boulogne-sur-Mer. The work was not without difficulties since, the prints being destined to compose an album which was to be offered to Her Majesty before her departure, it was necessary in two or three days to make the trip, take the views, and produce the prints. We don't know whether the other artists obtained good results, but we can affirm that M. Baldus brought back from his commissioned trip prints to rival his most beautiful productions. Thanks to his industry and talent, the album could thus be given as a gift to the queen. It is of too much interest for us not to be obliged to describe it in our next issue.[109]

No archival record or account of the royal visit includes any mention of the album's being given to the queen, but Lacan's comments, appearing only five days after her departure, indicate that the goal was achieved. One can well imagine Baron James presenting the album just before the queen's departure from the Paris station en route to Boulogne, so that she might pass part of the time during her actual journey by traveling through its pages.[110] Despite the brief time allotted for its production, the album is magnificent. It is fully bound in red leather with high relief panels, decorated in gilt on both front and back with the royal coat of arms on a field of lions rampant, and bordered by the intertwined initials *V* and *A* and shields bearing the names of the cities and towns traversed by the rail line (fig. 28). Lifting the heavy cover and turning the watered silk endpapers, Victoria would have seen a watercolor-and-silver-leaf depiction of the triumphal arch erected in her honor at Boulogne, here an elaborate decorative setting for the album's title (fig. 29). She could measure the progress of the imperial train on two maps, each drawn with cartographic precision and ornamented with a care and beauty normally reserved for sacred manuscripts (figs. 30 and 31); at the bottom of each map, a photograph by Baldus was set into an elaborate cartouche—*Railroad Station, Paris* on the first, *Railroad Station, Boulogne* on the second.[111] And then, in the parlor car of the imperial train or at home in her library, the queen could begin a pictorial journey from Paris to Boulogne through fifty rich salted paper prints (see appendix 6).

On these pages, train stations alternate with the principal sights along the rail route. The Gare de Strasbourg (now the Gare de l'Est),[112] the Sainte-Chapelle, and the Tuileries Palace establish Paris as the departure point. Leaving the capital, one moves north: first to the Abbey of Saint-Denis, burial place of the French kings, then to the fashionable resort of Enghien, noted for the charm of the half-timbered chalets surrounding the lake, and known during the Second Empire as the site of artistic and literary salons at the summer residence of Princess Mathilde, cousin of the emperor. Boarding again at the small Enghien station, one speeds along the smooth tracks into the distance, to the station at Pontoise, and to the church at Auvers; one passes the château at Boran and the towns of Isle-Adam, Saint-Leu d'Esserent, Montataire, and Creil; and then, beyond the stations at Clermont and Longueau and the ruins of the eleventh-century Château de Boves, one arrives at Amiens. Here, after a view of the gaping arches of the cavernous Amiens station, Baldus presented an extended essay on the city and its magnificent thirteenth-century cathedral—a dramatic view from the top of the belfry and details of the cathedral's sculpted portals, rose windows, and soaring architecture. The photographic journey continues: past the small towns of Ailly, Picquigny, and Long-sur-Somme; glimpsing the Abbaye du Gard from the tracks; stopping to explore the churches of Abbeville and Saint-Riquier and the port of Saint-Valéry; and finally, traversing the viaduct at Étaples and arriving at the railroad terminus at Boulogne and the decorative arch erected for the queen. The final pages of the album show Boulogne's port in a progression that glides past the boats moored along the quay, surveys the buildings on the shore, and slips between the gently curved jetties out to the Channel waters.

Perhaps Lacan exaggerated in saying that the entire photographic campaign was accomplished in the span of two to three days, but he was surely correct that the limitation of time was a great pressure. The queen's port of arrival was determined only about ten days in advance.[113] Plans for the album must have started immediately, if not

Fig. 28. Cover of the album *Visite de sa majesté la reine Victoria et de son altesse royale le prince Albert*, 1855. The Royal Archive © Her Majesty Queen Elizabeth II

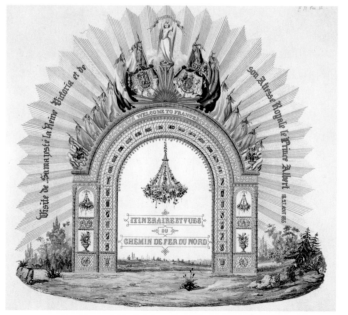

Fig. 29. A. Mille (?). Title page of the album *Visite de sa majesté la reine Victoria et de son altesse royale le prince Albert*, 1855. Watercolor and silver leaf. The Royal Archive © Her Majesty Queen Elizabeth II

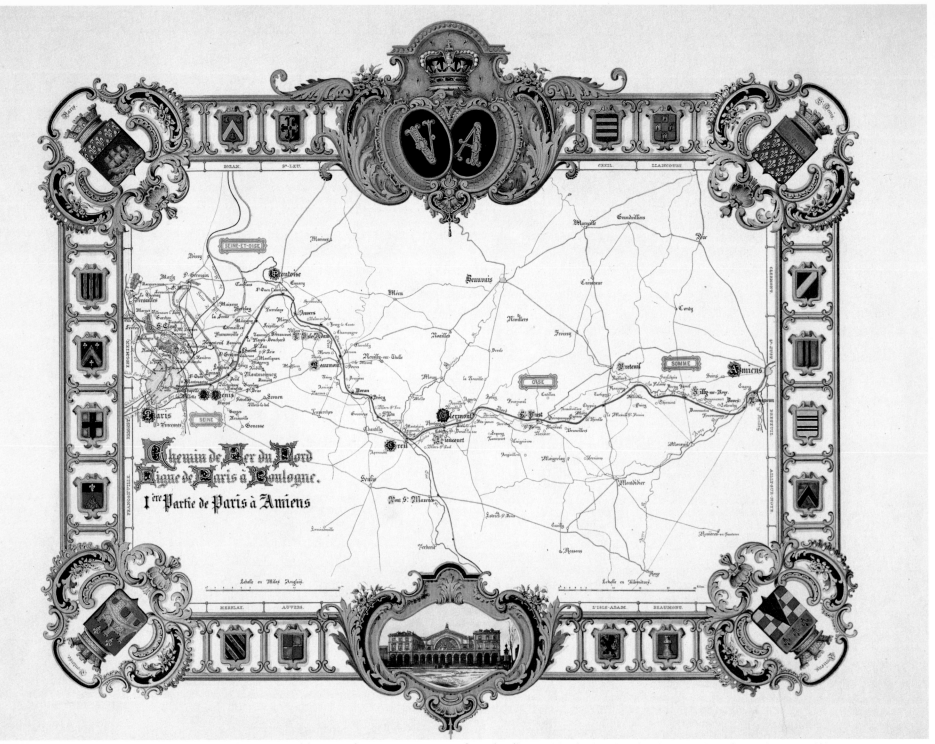

Fig. 30. E. Langlumé. Map of the route from Paris to Amiens, from the album *Visite de sa majesté la reine Victoria et de son altesse royale le prince Albert*, 1855. Inset: Édouard Baldus. *Railroad Station, Paris*, 1855. Salted paper print from paper negative. The Royal Archive

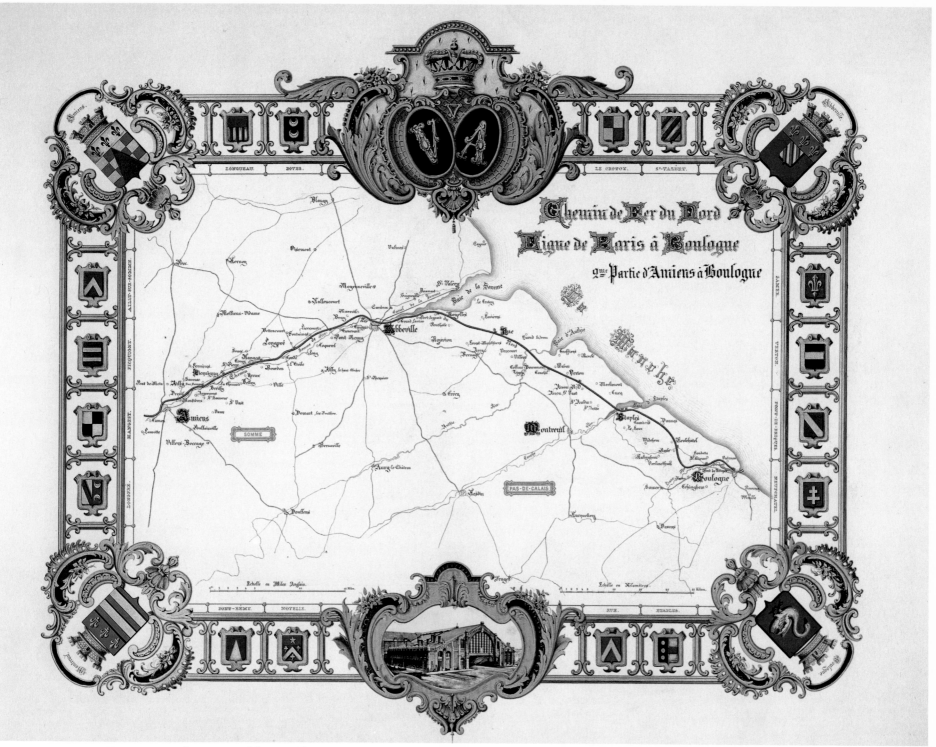

Fig. 31. E. Langlumé. Map of the route from Amiens to Boulogne, from the album *Visite de sa majesté la reine Victoria et de son altesse royale le prince Albert*, 1855. Inset: Édouard Baldus. *Railroad Station, Boulogne*, 1855. Salted paper print from paper negative. The Royal Archive © Her Majesty Queen Elizabeth II

47

Fig. 32. Attributed to Édouard Baldus. *Decorations, Boulogne*, 1855. Carbon print copy, 1890, of a salted paper print from paper negative, 23.7 × 39.6 cm (9³⁄₈ × 15⁵⁄₈ in.). The Royal Archive © Her Majesty Queen Elizabeth II

Fig. 33. Unknown artist. *Entrance of the Queen of England to the Railroad Station, Boulogne*, 1855. Wood engraving from *L'Illustration, Journal Universel*, August 25, 1855. General Collections, Princeton University Libraries

before the queen's itinerary was finalized, for the binding alone could not have been accomplished on only a few days' notice. In selecting Baldus to carry out this task, Rothschild certainly took into account his fine reputation, and he may have known that Victoria and Albert had taken special notice of Baldus's contributions to the 1854 exhibition of the Photographic Society of London.[114] But it may also be that Baldus was simply the best equipped to accomplish the task because of his experience and his existing stock of pictures. Many of the images in the queen's album are precisely the type of architectural and town views that Baldus had been producing for the *Villes de France photographiées* and for his stock since the beginning of his photographic career.[115] We can guess, but cannot confirm, that Baldus printed recently made negatives of Saint-Denis, Enghien, Amiens, Abbeville, and Saint-Riquier (and perhaps Boran, Montataire, Creil, and Saint-Valéry) for inclusion in the queen's album. Note, for example, that *Château of Princess Mathilde, Enghien* (pl. 24) shows the house shuttered for the winter months and the trees leafless, suggesting that the photograph had been made during the previous autumn, winter, or early spring. Only a single photograph in the album *must* have been taken during the royal visit, *Decorations, Boulogne* (fig. 32), shown also in a wood engraving from *L'Illustration* (fig. 33). Nonetheless, it is likely that at least those that show trains, tracks, and stations were also made especially for Rothschild's commission.[116] It is probably true as well that Baldus used the trip made for the queen's album as an opportunity to build up his collection of architectural and landscape negatives; several views that were probably made specifically for the queen's album, such as *Saint-Leu d'Esserent* (pl. 28) with tracks in the foreground, appear on his later stock list.

Precedent would have suggested a different type of subject for this kind of commemorative volume. In his lithograph from 1846, *Arrival of the Queen of England* (fig. 27), for example, Pingret showed the details of the royal car and the decorations erected in the station for the occasion, as well as the participants in the event—the two sovereigns and their entourages, military guards, and, in the left

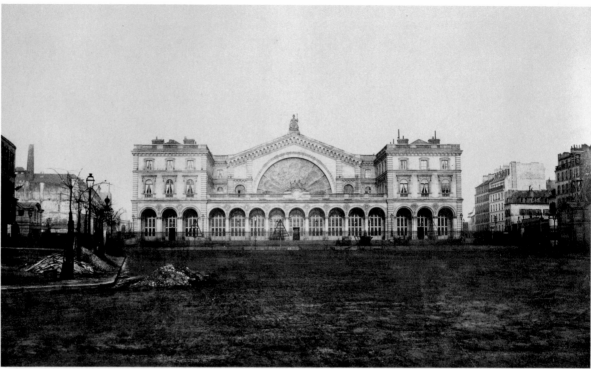

Fig. 34. Attributed to A. A. E. Disdéri (1819–1889). *Gare de Strasbourg, on the Occasion of the Departure of Queen Victoria, August 27, 1855*. Albumen silver print from glass negative, 29 × 21.8 cm (11³/8 × 8⁵/8 in.). Musée de l'Armée, Paris

Fig. 35. *Railroad Station, Paris* (Gare de Strasbourg, now Gare de l'Est), 1855. Salted paper print from paper negative, 27 × 44.5 cm (10⁵/8 × 17¹/2 in.). The Royal Archive © Her Majesty Queen Elizabeth II

foreground, railroad workmen attending to the train. Pingret recorded the details of a historical event in a way that the camera was, at that time, unable to. Although the medium was capable of capturing such scenes by 1855, Baldus chose not to do so, for his album was not intended as a record of the queen's progress through France. It records neither the principal events of her visit nor even the highlights of her journey from Boulogne to Paris. Aside from the one photograph of the Boulogne arch—and even that looking rather barren without its flags and banners—there are no photographs to remind the queen of the lavish decorations and carefully orchestrated ceremonies arranged for her arrival and departure. Compare a photograph of the Gare de Strasbourg attributed to Disdéri (fig. 34), for example, with Baldus's photograph of the same

station in the album (fig. 35).[117] Baldus's photograph of the station is as timeless, quiet, and unpopulated as his scenes of ancient ruins. Disdéri's is filled with dignitaries and military guard standing at attention in the midday sun, waiting to salute the queen; the station is a stage set of bunting, flags, trophies, and garlands.

The photograph *Locomotive of the Royal Train* (one of three pictures of rolling stock, probably by another photographer) could hardly remind the queen of how the engine was "gaily decked out with flags" and "decorated with imperial eagles with outstretched wings."[118] Nor do Baldus's *Railroad Station, Amiens*; *Railroad Station, Picquigny* (pls. 30 and 34); and *Railroad Station, Clermont* (fig. 36) recall the scenes recorded and described extensively in the illustrated weeklies *L'Illustration* and *Illustrated London News*. At

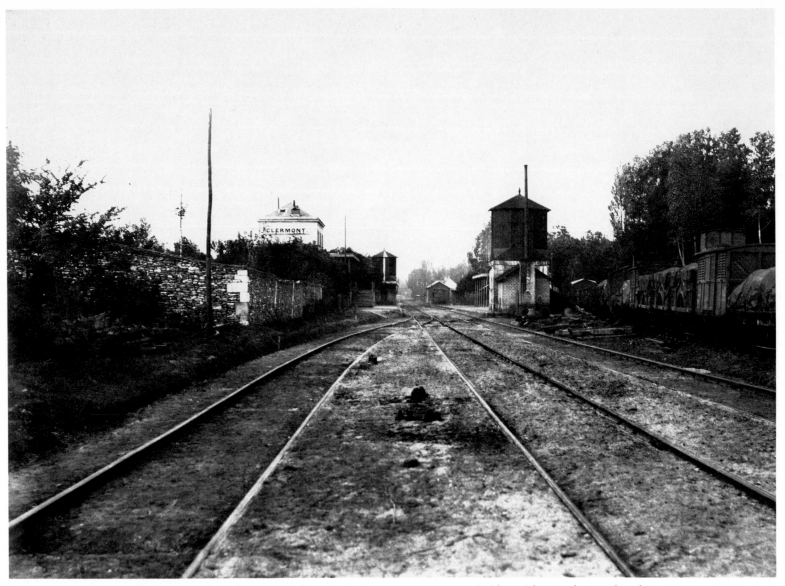

Fig. 36. *Railroad Station, Clermont*, 1855. Salted paper print from paper negative, 30.2 × 44.1 cm (11⁷⁄₈ × 17³⁄₈ in.). The Royal Archive
© Her Majesty Queen Elizabeth II

Clermont, "the National Guard lined the station amid a profusion of evergreens and flags and trophies, while the presence of several hundred ladies in elegant attire seated beneath tastefully draped awning of crimson velvet with rich gold fringe imparted grace and beauty to the decorations . . . and companies of Sappeurs-Pompiers, Gendarmerie, and National Guards lined the approaches to the station."[119] Where one might expect a photograph full of excitement and festivity like the one made two years later at the inauguration of the Toulouse-Bordeaux railroad by Le Gray (fig. 37),[120] one finds instead the functional structures of a small town train station, freight

cars at the side, the smooth rails gliding toward the distant vanishing point. Nowhere in Baldus's photographs would the queen have been reminded of how the royal couple's passage on the line "gave a new aspect to every mile of the road; peopling the dusty lanes with labourers and their wives and children in holiday gear; covering the few bridges with heads; and inspiring villagers, turned awhile from their labour, to line an embankment, to raise a lusty cheer."[121]

Nor, conversely, would the queen have enjoyed more than a distant glimpse of the major monuments that filled so many pages of her album—the churches, cathedrals, and châteaux that Baldus had photographed with such calculation and consideration—since her train stopped only to take on water or to allow for the briefest of speeches and ceremonies. Apart from the crowds on this particular occasion, the view from the rail line was not known for its scenic beauty. "The Paris visitor who has travelled by the Boulogne route," wrote the correspondent for the *Illustrated London News*, "will have remarked the wearisome flatness, the terrible monotony of the landscapes which lie between the capital and the Boulogne railway station."[122]

If not an actual record of the queen's journey, was the album meant as a documentation and celebration of engineering feats? Such a characterization would certainly be true for many other French photographic railway albums made during the two decades that followed—albums by Collard, Masse, Duclos, Berthaud, and others that focus almost exclusively on the locomotives and rolling stock, stations and guardhouses, bridges and viaducts, tunnels and earthworks undertaken during the construction of various lines.[123] But in the queen's album rail images account for less than a third of the total, and only one picture, *Railroad Station, Étaples* (fig. 38), shows an example of impressive engineering, for few such structures were required along this line. The "wearisome flatness" of the landscape could not have been better suited for the railroad.

Nor, finally, was the album merely promotional, a vehicle for encouraging increased travel on the line. Later in the century photographs would be published and exhibited at World's Fairs in order to tantalize a broad public with the array of sights accessible by rail or to illustrate the convenience of rail travel. But the queen's album was unique, sumptuous, and costly, and it is doubtful that many beyond the royal couple and their immediate entourage ever saw it.

Yet, the album presented to Queen Victoria is more than a collection of beautiful photographs; it speaks to issues and aspirations of the epoch. Victoria and Albert's visit to Paris in August 1855 was of great symbolic importance, a visible demonstration of the warm personal friendship that the royal and imperial couples had kindled during the visit of Napoléon and Eugénie to Windsor Castle earlier the same year and of the new Anglo-French military alliance in the Crimea.[124] For Victoria, a torchlight visit to the tomb of Napoléon I at the Invalides, with "God Save the Queen" playing on the organ, was touching proof that old enmities and rivalries had been replaced by friendship. "There I stood," she wrote in her diary, "at the arm of Napoleon III, his nephew, before the coffin of England's bitterest

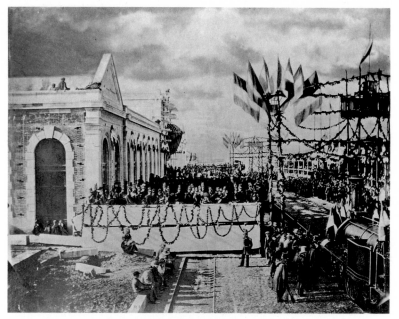

Fig. 37. Gustave Le Gray (1820–1882). *Inauguration of the Chemin de Fer du Midi*, 1857. Albumen silver print from glass negative, 28.1 × 36 cm (11 1/8 × 14 1/8 in.). Bibliothèque Nationale, Paris

51

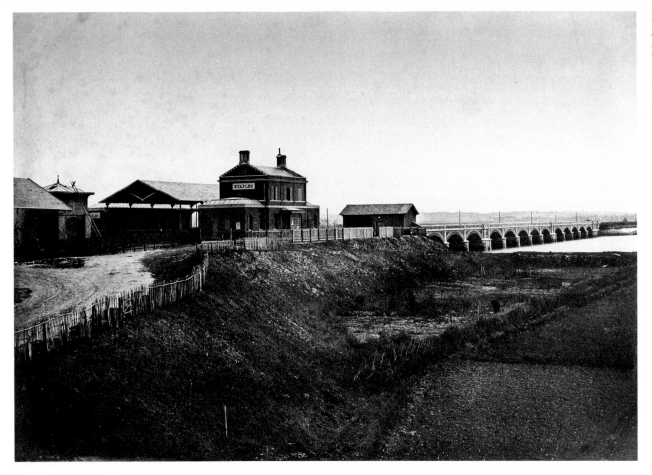

Fig. 38. *Railroad Station, Étaples*, 1855. Salted paper print from paper negative, 30.6 × 44 cm (12 × 17⅜ in.). Galerie Michèle Chomette, Paris. Photo: Sylvain Pelly

foe; I, the granddaughter of that King who hated him most and who most vigorously opposed him, and this very nephew, who bears his name, being my nearest and dearest ally!"[125] Not since 1431, when Henry VI was crowned king of France in Notre-Dame, had a reigning sovereign of Britain crossed the fortifications of Paris, and the warmth and enthusiasm of Victoria's popular reception impressed all: "She has been long accustomed to the roar of applause, to the exuberant expression of loyalty, and to the happy faces of delighted and grateful crowds," wrote the *Illustrated London News*, "but in no previous progress . . . has she been received with so much enthusiasm. . . . Perhaps her life . . . will never afford her such another ovation."[126] Victoria was surprised, too, by the depth of the affection she developed for France, its people, and its emperor. On the day she returned to England from her trip to Paris, she wrote to her uncle the king of Belgium:

Here we are again, after the *pleasantest* and *most interesting* and triumphant ten days that I think I ever passed. So complete a success, so very hearty and kind a reception with and from so *difficile* a people as the French is indeed most gratifying and *most* promising for the future. . . . In short, the *complete* Union of the two countries is stamped and sealed in the most satisfactory and solid manner, for it is not *only* a Union of the two Governments—the two Sovereigns—it is that of the *two Nations!* . . . I have formed a *great* affection for the Emperor, and I believe it is very reciprocal.[127]

Never in modern history had the prospects for economic cooperation and trade between the two nations been as great as they were in 1855. The Chemin de Fer du Nord line from Paris to Boulogne was the essential link, not only for travel and tourism but also for trade. From the very first calls for a nationally directed program of railroad development in the 1830s, it was envisioned that the prime axis of the French rail system would extend from the Mediterranean port of Marseilles through Paris and on to the Channel. One early pamphlet, *Moyen de donner du travail aux ouvriers et la paix à tout le monde—chemin de fer du Havre à Marseille* (*Means of Giving Jobs to the Working Class and Peace to All . . .*), of 1832, for example, declared that a railroad line to the Channel would be "an eloquent proclamation of the desire of the French to create a close and lasting alliance with England."[128]

The railroad's role as economic link between Britain and France is evident in the series of views of Boulogne that conclude the queen's album. All were taken within a few hundred yards of the railroad station. Rather than photograph the towering cathedral, massive belfry, Hôtel de Ville, Palais de Justice, medieval château, or well-preserved ramparts—the kind of subject Baldus most often chose to photograph, but all in the *haute ville* some distance from the railroad—Baldus focused on the port and its contiguity with the station. The scenes are not only beautiful; they have an underlying message of economics, trade, and transport.

In general, however, the album emphasizes the cultural and scenic aspects of the cities along the Paris–Boulogne route, giving a secondary role to the railroad itself. In so doing, it presents the railroad as a natural and unobtrusive means of linking England with the cultural, historic, and economic richness of France. The album as a whole conveys this message, as do individual prints. The foreground tracks of *Saint-Leu d'Esserent* (pl. 28) masquerade as an incidental element in a photograph nominally devoted to the town and church; in fact, however, they form a visual foundation for the cultivated plots, stone houses, and towering church, all of which denote civilization. By presenting the railroad in an understated way, Baldus

(and Rothschild) avoided the appearance of blatant self-promotion, evident elsewhere at the welcoming festivities for the queen, as noted by the *Illustrated London News*: "Some of these words of welcome appeared to have been sagaciously contrived to wear at once an air of patriotism and business. Thus, 'The Directors of the Defender Assurance Company to Her Majesty Queen Victoria' looked too much like a puff. 'Low premiums' underneath would have completed it."[129]

The queen's album was clearly meant to be valued as a work of modern art, one whose sumptuous presentation and artistic quality would place it among the prized pieces of the royal photographic collection. It is also clear from the title of the album, the decorated title page, and the photograph of the Boulogne arch that the album was meant to be tied to the memory of her visit, to have value as a reminder of the "*pleasantest* and *most interesting* and triumphant ten days" Victoria had ever spent.

In fact, the album may have been meant to supplant memory. Like older fête books that were studied with greater care than the actual decorations they depicted and that ultimately outlasted memory of the real event, the queen's album was an artificial reconstruction of her railroad journey. It substituted unseen monuments and quayside town views for what Victoria recorded in her journal as a wearisome journey: "The heat & dust, in the train, were very great,—really dreadful, & I never felt hotter. We passed through uninteresting flat country, intersected with rows of poplars. Stopped at Abbeville, a large town, with fortifications, where a very fat Préfet gave me an Address."[130] Only by functioning in the double role as a valued work of art and as a fabricated evocation of the trip could the queen's album fulfill Rothschild's aim.

Lacking any record of the instructions given to Baldus, we can only presume that Rothschild's motivation for the commission was the same as that which lay behind the various other efforts undertaken by the railroad company during the royal visit—to give visible demonstration (to Napoléon III and to the public, as well as to Victoria) of the company's goodwill, good taste, and efficiency, and to

show the Chemin de Fer du Nord as the physical embodiment of the theme that underlay the entire state visit—the linking of the two nations.

The Photographs

The photographs included in the queen's album are among Baldus's finest. This is his mature style: a classic, objectified vision softened by lessons learned in the landscapes of the Auvergne and an equilibrium of documentation and artistry, of descriptive directness and picturesqueness, of presenting the scene to the viewer and inviting the viewer into the scene.

In these photographs Baldus nearly always places his subject in the middle distance. He steps back from the close-up, frame-filling viewpoint of such 1853 pictures as *Tour Magne, Nîmes* (pl. 15), *Maison Carrée, Nîmes* (fig. 13), *Church of Saint-Gilles*, and *Church of Saint-Trophîme, Arles* (fig. 14), creating a broad, empty foreground in the lower zone of the picture. That slight detachment, an easing of the assertiveness that characterizes his earlier architectural views, imparts a quiet, contemplative air to many of the pictures. The foreground, however, is rarely without interest or without subtle means of luring the viewer into the picture and leading to the principal motif. In *Railroad Station, Pontoise* (pl. 27), a gently sloping hillside of grass leads the eye to a wooden fence, to the piles of construction materials, and to the quiet train station in the middle distance. In Baldus's photographs of the railroad stations of Enghien, Amiens, Picquigny (pls. 23, 30, and 34), and Clermont (fig. 36), the foreground is a broad receding plain of earth and pebbles, slightly out of focus (like the grassy hill of Pontoise, a play of texture between the material of the site and the material of the paper negative); thin, smooth rails converge in the distance, past the station and below the semicircular overpass at Enghien, through the covered shed of Picquigny, and into the dark, cavernous arches of the Amiens station. In each case, instead of isolating the architectural subject—pulling it out of space and setting it on the surface of the picture plane—as he might

have done in 1853, Baldus pulls the observer into the scene over easy ground; by the time we reach the subject, we are engulfed in pictorial space. The subject of these photographs is not the railway stations per se, but rather the way in which buildings are set in the landscape—the same subject treated in his 1854 photograph *Saint-Nectaire*, except that the very nature of a railroad dictates a relationship to the land different from that of a medieval church to its village.

The strategy is not applied only to railroad subjects; compare, for example, Baldus's *Abbey of Saint-Denis* (pl. 22), where the church facade is seen across a deeply shadowed square, to his facade view of Saint-Trophîme (fig. 14), where the architecture nearly fills the frame; the slight retreat and intervening shadows add a dimension of time and expectation that is lacking in the earlier work. The cathedral of Amiens (pl. 32) rises from a dazzlingly detailed plain of rooftops through which a street, like a dark canyon, leads the viewer to his goal. (The extent of detail visible in the roofs, signs, chimneys, and individual bricks that form the allover pattern of the foreground prompted Lacan to call this photograph "one of the marvels of photography . . . the most complete print we have ever seen."[131]) The ruins of Boves (pl. 29) rest on a sparsely treed hill that fills half the picture. In each case one arrives by degrees, experiencing the site rather than merely comprehending it. This foreground plane was so essential a component in Baldus's method of constructing a picture in 1855 that he again resorted to the painter's art when necessary. In *Creil* (fig. 39) he added a triangular patch of sponged-on texture at the bottom of the picture to simulate a riverbank, lest the town appear to float on the far side of the river with nothing to mediate the viewer's visual passage.

In *Château of Princess Mathilde, Enghien* (pl. 24), the photographer has stepped back so that the building is seen across an open lawn and framed by leafless trees; it is a distilled vision of the idea of architecture in landscape, a square block of a house, its windows a grid of black shutters set within an irregular, organic, and softly muffled network of branches. But the mood of the picture, the sense

54

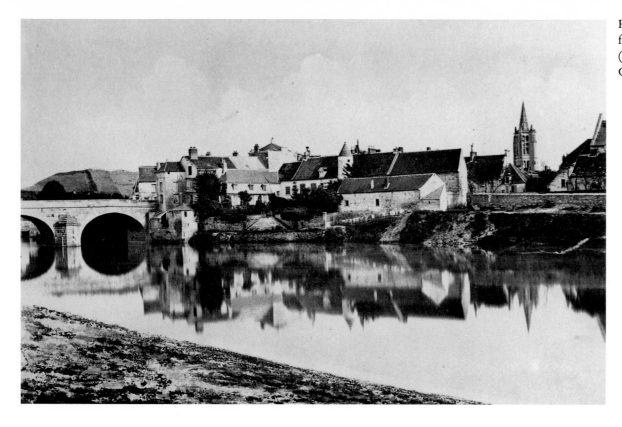

Fig. 39. *Creil*, 1855. Salted paper print from paper negative, 32.1 × 44.3 cm (12⁵/₈ × 17¹/₂ in.). Galerie Michèle Chomette, Paris. Photo: Sylvain Pelly

of mystery that gives it poetic life, comes from the tantalizing combination of Baldus's powerful graphic sensibility with a coloristic impression of light and atmosphere, enhanced by the slight sfumato effect of the paper negative and salted paper print.

At Long-sur-Somme, Saint-Valéry, and at the small chalet at Enghien (pls. 33, 35, and 25), the foreground plane incorporates the reflective surface of water, a subject beautifully rendered by the soft, slightly fibrous texture of the paper negative. So, too, at Boulogne harbor. *Boats at Low Tide, Boulogne* (pl. 36) incorporates Baldus's full understanding of the painting tradition; with its picturesque sailing ships clustered at left, its survey of the buildings that line the quay, and its artificial clouds (printed from a second, painted negative), this beautiful salted paper print could be a seventeenth-century Dutch seascape or a painting by Eugène Isabey. Indeed, Lacan reported showing it to an English photographer "who submitted in

the presence of several artists that it was a reproduction of a painting and not from nature."[132]

If this photograph partook fully of the conventions of the painted marine, a second photograph, made at the same time only a short distance away, pioneered new ground and presaged the concerns of impressionist painters a decade later. Nowhere does Baldus more seductively interpret the combination of water, light, and atmosphere than in *Entrance to the Port, Boulogne* (pl. 37), where elegantly engineered jetties guide ships past the scruffy shoreline into the town's protective harbor and out again to the Channel waters. Bathing cabins have been wheeled out to line the distant beach; a boat rocks gently in the water, registering as a ghostlike blur during the long exposure; ships dot the Channel, fainter and smaller as they approach the horizon. The humid seaside atmosphere is palpable. This matte-surface salted paper print, richly colorful in tones rang-

Fig. 40. Plan of the Louvre and Tuileries Palaces before construction of the New Louvre, in *Réunion des Tuileries au Louvre*, 1857. Salted paper print from glass negative, 18 × 28.7 cm (7¹⁄₈ × 11¹⁄₄ in.). Collection of the J. Paul Getty Museum, Malibu, California

Fig. 41. Plan of the Louvre and Tuileries Palaces after construction of the New Louvre, in *Réunion des Tuileries au Louvre*, 1857. Salted paper print from glass negative, 18.2 × 28.8 cm (7¹⁄₈ × 11³⁄₈ in.). Collection of the J. Paul Getty Museum, Malibu, California

ing from deep eggplant to light peach, demonstrates the degree to which the content and aesthetic character of Baldus's photographs depend on his extraordinary skill in printing his negatives, as well as the degree to which they have survived unchanged.[133] While the color, modulation, and mood of Baldus's photographs almost always contribute to their allure and meaning, seldom are the pictures as exclusively constructed as this one on the perfect coalescence of these intangible but essential values.

The New Louvre, 1855–57

In one of the opening photographs of the queen's album, the Tuileries Palace stretches across the page in a rhythmic pattern of windows, columns, and niches, the stately Pavillon de l'Horloge rising at the center (pl. 38); in front of it the Arc de Triomphe du Carrousel, flanked by small guardhouses, serves as the entrance gateway to the fenced-off courtyard of the palace. But closer to the camera, on our side of the fence, the foreground is filled with blocks of stone,

piles of lumber, carts and wheelbarrows. This was the immense worksite of the grandest construction project of the Second Empire, the building of the New Louvre.

This vast building program had as its aim the construction of wings linking the Louvre and the Tuileries Palace and the clearing of existing buildings in what would become the huge courtyard of the imperial palaces (figs. 40 and 41). For decades various architects and sovereigns had proposed designs for linking the two palaces and for regularizing their myriad architectural styles and divergent axes. The plans that Napoléon III brought to fruition were begun during the Second Republic by the architect Louis Visconti in 1848 and were continued and executed after Visconti's death in December 1853 by Hector Lefuel. With its vast proportions and highly ornamented neo-Renaissance style, the project provided work not only for masons, carpenters, and other construction workers, both skilled and unskilled, but also for artists and artisans of all sorts—sculptors, mural painters, metalworkers, and specialists in decorative plas-

terwork, among others. At the height of construction, in 1854, thirty-five hundred people were employed at the worksite.[134]

As work began to transform the face of the Louvre, Lefuel ordered a few photographs to be taken, almost as an afterthought, to complement the work of the architectural draftsmen. "In accordance with your verbal instructions," he wrote to Achille Fould, the minister of state, on October 14, 1854, "I had perspective views made, for presentation to His Majesty, of the facades of the new buildings and of the restored facades of the Old Louvre on the place Napoléon and the place du Carrousel. . . . I thought it would be useful, too, to record the present facades of the Old Louvre by the process of photography."[135] Little over a year later, on November 5, 1855, Lefuel again wrote to Fould, seeking approval of funds for the photographic reproduction of the architectural statuary and ornament, and requesting authorization to assign the work to Baldus, "who agrees to undertake it, asking only the sum of 15 francs for each negative and 75 centimes for each print."[136] The project that began so modestly eventually comprised more than two thousand photographs and cost more than 60,000 francs; this "stone by stone"[137] documentation of the New Louvre was the largest and most lucrative commission Baldus ever received, and it constituted the most widely known aspect of his oeuvre. No other photographer had yet received so large a commission.

Eventually, Baldus photographed every piece of statuary and a sample of every pattern of decorative stonework. The bulk of these photographs originally served as a means of keeping track of the hundreds of sculptural and ornamental works being executed; the photographs of plaster models and finished works were kept in each sculptor's dossier, along with correspondence and contracts related to their work.[138] But by 1856 Baldus's photographs were understood to serve a grander purpose. Fould reported to the emperor, "In the interest of art and in order to preserve for history the models, numbering more than eight hundred, which were executed by the sculptors of the New Louvre, I charged the architect with making reproductions of them by means of *photography*. These drawings,

properly classified and aided by the measured drawings executed by the Technical Services [Bureaux des Études], will make it possible at some later date to produce a full account of the construction of the Louvre, which will be of the highest interest for the history of art."[139]

By the time of Fould's report, Baldus had already made more than twelve hundred photographs of the Louvre and its sculptural ornamentation. The majority were small paper-negative photographs of sculpture and sculptural detail, ranging in size from half an inch square to 7 × 9 inches (figs. 86 and 89). Although generally straightforward and documentary, the small photographs occasionally have a surprising sculptural presence or graphic appeal (fig. 42). But it was in his large-format (35 × 45 cm; 13¾ × 17¾ in.) glass-negative photographs of each of the pavilions of the New Louvre, shown in full or in large details, that Baldus expanded the boundaries of his artistic achievement.

Fig. 42. *Decorative Moldings for the New Louvre*, 1857. Albumen silver print from glass negative, 7.6 × 7.9 cm (3 × 3⅛ in.). Collection Joachim Bonnemaison, Paris

These large-format photographs of the Louvre, beyond admirably fulfilling their documentary function, are among Baldus's most carefully crafted and clearly articulated demonstrations of photography's unparalleled capacity to represent architecture. They fully exploit the medium's ability to render the spatial play of light and volume and to accurately record the most intricate details, unmediated by picturesque convention or personal style of draftsmanship. These large prints, contact printed from glass negatives of the same size, are far sharper and smoother than a similarly scaled enlargement from a modern 35mm film negative, and their extreme clarity, surprising in Baldus's day, still impresses us today.

For the most part, Baldus's photographs are not construction views per se, like many of Louis-Émile Durandelle's views of the construction of the Paris Opera a decade later, for most of the demolition and structural building were completed before Baldus began his full-scale documentation. Instead, he photographed the Louvre pavilions as they neared and reached completion. Some views show the final stages of building, such as *Pavillon Richelieu* (pl. 39; fig. 48), where the entrance arch of the newly constructed facade is still braced by wooden scaffolding and the activity of the worksite is still apparent. Every detail of freshly carved stone is rendered with extraordinary crispness, and the slate roof glistens in the sun. The ensemble is monumental. In other views, such as *Pavillon Sully* (pl. 43), the completed edifice, here animated by the gently blowing trees in the foreground, testifies to the grandeur of the Second Empire and the taste of Napoléon III. Large detail views of the New Louvre show the rich ornamentation of planar surfaces (pl. 41) and the sculptural presence of individual architectural elements (pl. 42).

The crystalline clarity of these pictures stems in part from Baldus's choice of a new kind of negative, glass coated with a photosensitized emulsion of collodion (guncotton dissolved in ether). Though cumbersome and complex (the glass negatives had to be coated, exposed, and developed before the collodion dried), the extraordinarily precise glass negative was already winning favor over the slightly textured paper negative by the mid-1850s. Baldus had used glass negatives for his pictures of the animals at the 1854 agricultural fair, where a short exposure was required, but for large-format architectural studies—and particularly on expeditions away from Paris—he continued to favor paper negatives because of their relative ease of preparation and portability. Here, the length of the project and an on-site darkroom ("a small shed on the terrace alongside the water"[140]) made the Louvre documentation an ideal occasion to master this time-consuming and physically demanding process.

The idea of assembling the thousands of photographs into presentation albums was first broached by Lefuel in anticipation of the inauguration of the New Louvre in August 1857. Lefuel wrote to Fould on May 9, 1857:

> Your Excellency has not forgotten that since the beginning of work at the Louvre, and especially since the sculptures were begun, I took care to reproduce by Photography all of the sculptural motifs, both statuary and ornamental, which decorate the new constructions.
>
> You previously . . . authorized the expenditures necessary for this type of photography, and the results we have obtained are certainly far from causing one to regret that cost. As a result we now have a collection that, simply by virtue of its breadth, has become extremely worthwhile from all points of view.
>
> It was your thought . . . that we might be able to make a certain number of copies from the negatives in hand, which, classified and bound in volumes, would form a body of work of enough interest and value that it could be offered as a gift by H. M. the Emperor at the time of the inauguration ceremony that you have planned for this coming August 14. . . .
>
> If, in principle, you approve the project I have had the honor of proposing to you, I could give immediate orders, to ensure that they will be ready by the aforementioned date.[141]

In fact, the production of the albums could not be completed on such short notice, and it was not until the end of the year that twenty-five sets, each containing more than two thousand photographs in four

volumes, could be distributed to the imperial household, high government officials, and the reigning monarchs of Europe.[142] An additional eleven copies of the albums were produced for the libraries of certain important cities and several imperial palaces.[143]

In his thousands of photographs of the New Louvre, arranged in albums by the office of the architect, Baldus constructed a second Louvre, pavilion by pavilion, from chimney to plinth and from general view to minute sculptural detail.[144] As individual records these photographs served a practical function on the bustling worksite; but as a collected whole they formed a new means of comprehending and communicating a complex subject, bit by bit, to be reconstituted by the mind. Only photography—precise, omnivorous, prolific, and rapid, and then only in the hands of an artist both sensitive and rigorous—could produce an archive as a new form of art.

Although the New Louvre was inaugurated in August 1857, construction work on various portions of the new and old sections of the Louvre continued up to and beyond the burning of the Tuileries Palace during the 1871 Commune, and Baldus remained an occasional photographer of the Louvre at least until the mid-1860s, producing negatives both for the government and for his personal business (pl. 40).[145]

At the same time that he was producing the Louvre negatives for a very specific purpose and client, Baldus also sold a series of Louvre prints to the Office of Fine Arts as part of his ongoing series of architectural monuments,[146] and exhibited this body of work widely, both in France and abroad (see appendix 9). Views of the Louvre were among the photographs that he exhibited at the Exposition Photographique in Brussels in 1856. Lacan, in a refrain that had become practically habitual, declared that they "surpass all that this distinguished photographer has exhibited until now. It is impossible for photography to go further: it is perfection." He continued, justifying his superlatives by describing the merits of these photographs more specifically: "If one studies, for example, the section of the Pavillon Richelieu which he has titled *Large Detail of the New Louvre*, one finds all the qualities, all the riches of photography at the

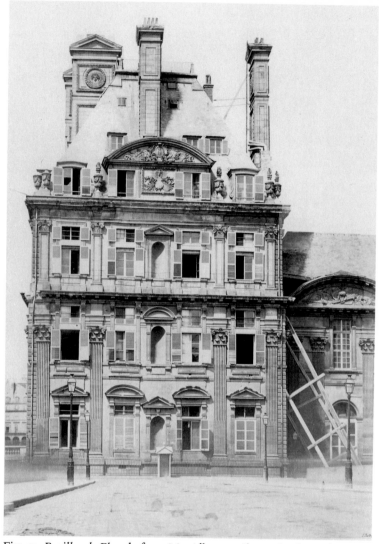

Fig. 43. *Pavillon de Flore*, before 1861. Albumen silver print from glass negative, 78.5 × 57 cm (30⅞ × 22½ in.). Musée Carnavalet, Paris

same time: exquisitely fine detail, atmospheric transparency in the shadows, perfect modeling in the figures, richness, fullness, power in the effects of light and of relief. In a word, all those things that suffice individually to call attention to a print are brought together in this splendid picture."[147]

A photograph of the entrance to the Louvre—a single block of Baldus's own monument—was his sole submission to the third exhi-

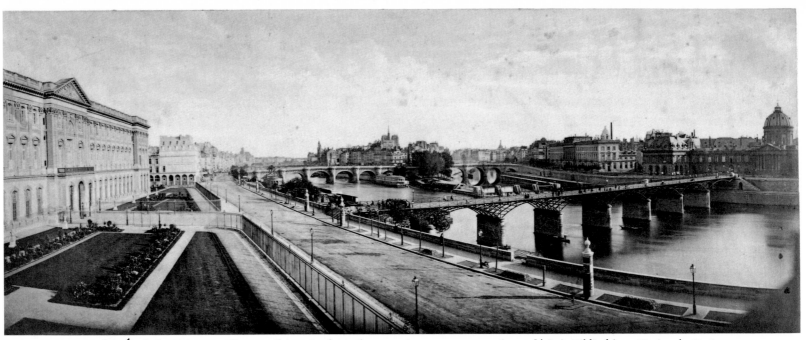

Fig. 44. *Panorama of the Île-de-la-Cité*, 1858. Albumen silver print from glass negative, 22.7 × 57.3 cm (9 × 22½ in.). Bibliothèque Nationale, Paris

bition of the Société Française de Photographie in 1859, an event of particular importance as the first occasion on which photography was shown under the same roof as, albeit separated from, the Salon of painting and sculpture in the Palais de l'Industrie. "It is no doubt with a certain coyness that the masterful M. Baldus has sent only one photograph to the exhibition," wrote Louis Figuier. Quantity had become so inextricable a part of the conception of the Louvre documentation that a single photograph no longer sufficed except to point to the larger whole. Only for those who, like Figuier, already knew Baldus's project could a single picture stand for or summarize the fuller accomplishment. "It is true that that photograph sums up all the qualities of this eminent artist. In his *Door to the Library of the Old Louvre* [possibly pl. 41] one finds that power of touch, that vigor, that perfection of detail, that overall harmony which distinguishes the works of M. Baldus."[148]

The physical conditions of the Louvre assignment not only provided Baldus with a convenient opportunity to use glass negatives, they also allowed him to fulfill his continuing desire to make very large prints, here by working with larger equipment rather than by building an image from multiple negatives. Among the most spectacular of all Baldus photographs are the views of the worksite (fig. 76), the finished Richelieu, Sully, and Turgot pavilions of the Louvre, and the Pavillon de Flore in *format grand-monde* (fig. 43). By their sheer size—80 × 60 cm (31½ × 25⅝ in.)—and by their clarity of tone and detail, these prints powerfully convey the monumental grandeur of the building project.

At the Louvre, Baldus also explored the panorama. Time and again, beginning in 1851, he sought to widen the scope of his lens by forming a single image from several negatives. In 1857, from the upper stories of the Louvre, Baldus first made a series of seamless

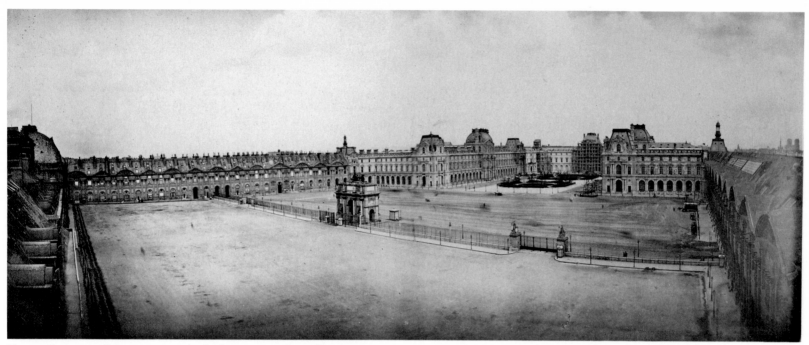

Fig. 45. *Panorama of the Louvre*, 1857. Salted paper print from glass negative, 14 × 30.5 cm (5¹/₂ × 12 in.). Collection Joachim Bonnemaison, Paris

panoramic views. Made on wet-collodion glass-plate negatives with a camera designed by Felix-Napoléon Garilla,[149] the views encompassed a visual sweep of one hundred degrees. One such photograph, *Panorama of the Île-de-la-Cité* (fig. 44), taken from the window of the Galerie d'Apollon, stretched from the exterior of the Cour Carré at left, past the Île-de-la-Cité, to the dome of the Institut at right. Marc-Antoine Gaudin saw this panorama at a weekly meeting of the Cercle de la Presse Scientifique and wrote about it in *La Lumière*, noting its "perfect clarity" and the multitude of people animating the scene—the boatmen on the river and "the curious in every attitude" adorning the Pont des Arts.[150] Baldus's stock list records other large-format panoramic views, 60 cm (23⅝ in.) wide, showing the Louvre and the garden side of the Tuileries Palace. In addition, he produced similar views in a smaller format at this same time.[151]

Impressive as their scale and scope may have been, the photographs Baldus made with a panoramic camera do not measure up to his most accomplished work, a shortcoming the photographer himself must have sensed. *Panorama of the Louvre* (fig. 45) is a perfect demonstration. Looking out a window of an upper story of the Pavillon de Flore, Baldus used a panoramic camera to survey the entire palace complex, from the roof of the Tuileries Palace at the left to the courtyard facade of the Grande Galerie at the right; the entire New Louvre and Cour Napoléon are visible in the background, even the distant Pavillon Sully, still shrouded in scaffolding. The picture is filled with information, but it is oddly unsatisfying. The strong compositional structure—the consummate resolution of the picture within its frame—that is the hallmark of Baldus's photographs made with the large-format still camera is missing here, for the panoramic camera simply did not allow Baldus to view the entire

image on the ground glass and to calculate and adjust that image to form the perfect picture. More disturbing still is the disorienting depiction of space that results from the pivoting lens of a panoramic camera, a complete departure from the clear articulation of space normally found in Baldus's work. The Tuileries Palace and the Grande Galerie, at right angles to each other in reality, appear parallel on the photograph. The straight lines of the far arm of the Louvre and of the fence that bisects the courtyard seem to curve as they move across the page. The majestic solidity of the Louvre, expressed so beautifully and so forcefully in Baldus's large-format photographs, is nowhere to be found here.

Even after having tried his hand at Garilla's camera, Baldus nearly always opted to construct his panoramas out of discrete units—his standard 35 × 45 cm negatives. Despite the slight disjunctions where negatives joined, the rendering of space within each section remained true, in contrast to the perspectival distortions produced by the panoramic camera. Most important, building a panorama block by block allowed Baldus to compose each section on the ground glass with careful thought and to create a picture possessing the measured cadence and solid structure so basic to his art.

"Everyone knows MM. Baldus, Le Gray, and Bisson Frères"

Although Baldus was commissioned to fully document the construction of the New Louvre, he was not the only one to photograph the unfinished or completed edifice; Gustave Le Gray and the Bisson Frères also produced impressive photographs of the Louvre pavilions (figs. 46, 47, and 49). In a genre of photography where documentation was often a more obvious concern than personal artistic expression, what does it mean to speak of an artist's personal style? When the primary viewpoint is often either self-evident or constrained by physical aspects of the site, what, other than technical skill, distinguishes the work of one photographer from that of another? Do the barely discernible differences between certain photographs by the Bisson Frères, Le Gray, and Baldus—slight variations in the direction of light or small discrepancies in cropping—carry meaning, or are they accidental, and therefore insignificant in the face of overwhelming similarities of content, style, and technique?

Answering such questions is complicated by our lack of knowledge concerning the interaction between the artists. We know, for example, that both Baldus and the Bisson Frères worked on the Louvre construction site simultaneously, but we do not know whether they shared their expertise, facilities, cameras, or, perhaps, even negatives. Conversely, it is unclear whether their rivalry prompted one to imitate the work of the other, hoping to obtain a share of the market and critical acclaim.

The photographs of Baldus and the Bisson Frères were often spoken of in the same breath by critics reviewing exhibitions in the 1850s: "The monumental reproductions by MM. Bisson and Baldus are extremely noteworthy and have already earned their authors well-deserved reputations."[152] "The eye is stopped right away by some frames of phenomenal size: those of MM. Baldus and Bisson Frères."[153] "The reproduction of monuments . . . has today attained the limits of what is possible . . . [and work in this genre was] represented at the exhibition of 1859 by the submissions of artists long known to the public; everyone knows MM. Baldus, Le Gray, and Bisson Frères."[154] Louis Figuier, in describing the work of these photographers, chose different words, but he drew more or less the same picture of each, speaking of the "perfection of detail" in Baldus's work and the "fineness of detail" in that of the Bissons, of the "transparency of shadows" in the Bissons' work and the "subtlety of the shadows" in Le Gray's.[155]

Only rarely were the prints compared in a way that articulated real differences, and even then it was mostly a matter of taste or personal allegiance, not of insightful interpretation. Paul Périer, reviewing the photography section of the Exposition Universelle of 1855, remarked on the easy comparison between the Bisson Frères and Baldus, whom he referred to as "the one photographer who could as yet be considered to rival [the Bissons'] preeminence in the

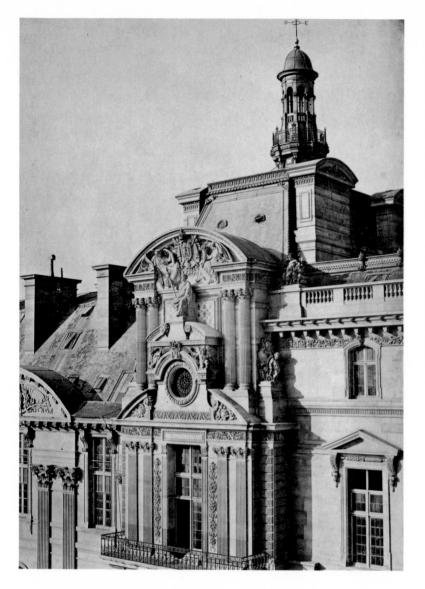

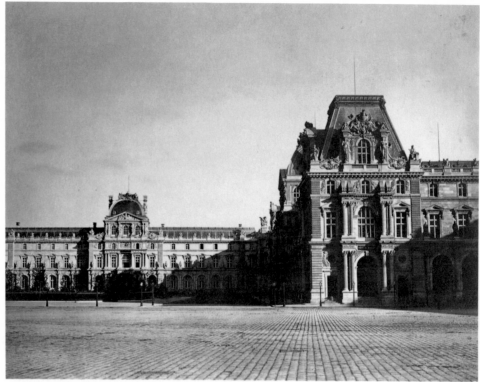

Fig. 47. Gustave Le Gray (1820–1882). *Pavillon Mollien, Louvre*, 1857–59. Albumen silver print from glass negative, 37.3 × 47.9 cm (14³/₄ × 18⁷/₈ in.). Courtesy of the Board of Trustees of the Victoria and Albert Museum, London

Fig. 46. Gustave Le Gray (1820–1882). *Pavillon Rohan, Louvre*, 1857–59. Albumen silver print from glass negative, 50 × 36.2 cm (19³/₄ × 14¹/₄ in.). Collection Jay H. McDonald, Santa Monica

reproduction of monuments," but protested against the equal appreciation given the work of each.[156] Périer criticized the prints sent by Baldus, saying, "It is strange that, for such a grand occasion, M. Baldus did not make a more judicious choice in his positive prints. . . . These proofs are pushed too far in printing, or removed too early from the fixing bath, whence result shadows of an intensity completely outside the range of normal tones and which offer nothing

more than black spots, dull and lifeless, impenetrable to both eye and mind, and which allow nothing to be seen in their darkness."[157] Périer wrote, "It is enough to look at the interior vaults of the *Arc de l'Étoile*, the surrounding houses, the arcade below the *Pavillon de l'Horloge*, etc., to prove that we are not exaggerating in the slightest and that, in the language of the studio, between the *contrasts* that we are criticizing and our criticism itself, it is only the former which are

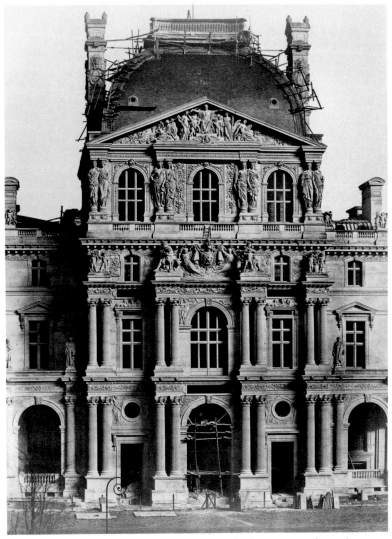

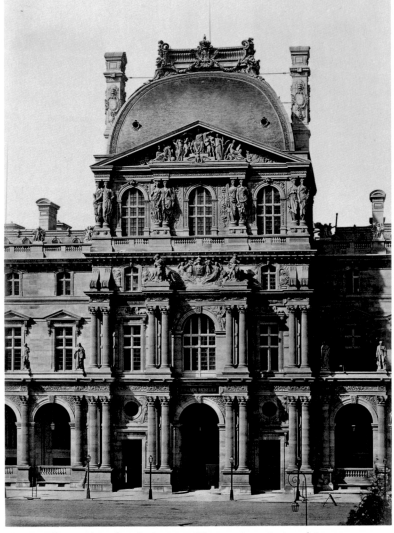

Fig. 48. *Pavillon Richelieu, Louvre*, 1855–56. Salted paper print from glass negative, 51.7 × 37.7 cm (20³/8 × 14⁷/8 in.). École Nationale Supérieure des Beaux-Arts, Paris

Fig. 49. Bisson Frères (Louis-Auguste Bisson, 1814–1876; and Auguste-Rosalie Bisson, 1826–1900). *Pavillon Richelieu, Louvre*, 1858. Albumen silver print from glass negative, 45.5 × 34.2 cm (17⁷/8 × 13¹/2 in.). Bibliothèque Nationale, Paris

violent."[158] In the photographs of the Bisson Frères he found all the qualities felt to be lacking in these particular Baldus prints. Ernest Lacan, by contrast, found in the same Baldus photograph of the Arc de Triomphe "a delicacy of detail and a transparency in the shadows" and admired the forcefulness of tone and clarity of contour that characterized the *Pavillon de l'Horloge*.[159] Where Lacan saw in Baldus's view of the Louvre "a sober light, a solemn aspect, and an austere tone that admirably suit this old and magnificent masterpiece of the Renaissance," he thought the Bissons' photograph of the same subject "too coy, too adorned," and too yellow in tone.[160]

Although it is refreshing to read specific criticisms after Lacan's consistently superlative praise, politics was surely a factor in the varying evaluations of Baldus's work. Périer, vice president of the Société Française de Photographie, was writing in the society's *Bulletin*, and while the Bisson Frères were founding members of the Société, Baldus had yet to join. Conversely, both Baldus and Lacan had been active in the Société Héliographique, an organization that the Bisson Frères had never joined.

In considering the similarity of vision in these photographs, one ought not forget that the appearance of art in any medium is determined not only by the eye and hand of the artist but also by the visual habits of the society, the expectations of patron and public, the technical state of the medium, and the shared aesthetic notions of a particular culture. Despite the greater visibility of personal style in painting than in photography, many battles have been waged over the attribution of painted works, and the distinction between the work of one Italian Renaissance painter and that of another has frequently been argued over the shape of an ear. That two artists' painted output might be difficult or impossible to distinguish does not mean that they lacked personal artistic depth — only that, in each case, the artists' aims and means were largely influenced by outside factors: the demands of iconography, the accepted technical practices for the medium, the culture's generally held notions of beauty, and pictorial conventions for the display of various emotions.

The same might be said of these photographs of the Louvre. The marvel of the Louvre pavilions resided in their grand scale, fine proportions, and abundant sculptural ornamentation; the marvel of photography in the mid-1850s lay in its ability to register reality with minute exactitude. Naturally, each photographer sought to reveal all this in his work, and each was a master of technique, able to exploit the latest photographic processes flawlessly. Each chose the process (glass negatives, often printed on albumen paper), perspective, and lighting conditions that would show the subject to best advantage, free of perspectival distortion and in all its amazing

detail. These external constraints left but a small space for expressive content.

Ultimately, however, the work of each artist generally reveals its maker. In examining the many hundreds of photographs made by Baldus during the construction of the New Louvre, it becomes clear that he was indeed recording the building, in Lacan's words, "stone by stone," not merely in the vast extent of his endeavor, with every decorative element recorded by the camera, but in the physicality of the representation. His views of the Louvre, particularly his "grands détails," such as the *Imperial Library of the Louvre*, *Pavillon Rohan*, and *Pavillon Denon* (pls. 41, 42, and 44), show the crispness of freshly carved stone, the solidity and three-dimensionality of every column and capital and caryatid, every figural group and bas-relief, every egg and dart and dentil. Baldus's customary masking of the sky serves here, as in his earlier work, to isolate the architecture, to present it as an exquisitely crafted object. "It is the monument itself."

Le Gray's photographs of the Louvre are different. To be sure, the same architectural and sculptural elements are present, detail for detail. But there is a different relationship between the physical and the ethereal. In Baldus's *Pavillon Rohan* (pl. 42), for example, light and shadow pick out and describe the stonework like a giant piece of sculpture. In Le Gray's view of the same motif (fig. 46) the stone of the building reflects and radiates light. The slightly higher framing encompasses the pale but present sky, so that sunlit atmosphere and bright new stonework are tied together. With his shorter lens and higher framing Le Gray also encompassed more of the building. Where Baldus's photograph is about the material presence of a single monumental architectural element, Le Gray's is about the relationship of that element to the roof and lantern above and to the different styles of architecture left and right. In Le Gray's most dramatic photograph of the Louvre (fig. 47) the physicality of the buildings, so central to Baldus's treatment of the site, is replaced by a bold articulation of the space defined by those buildings.

Similarly, subtle differences in framing, angle of view, and choice of lighting conditions distinguish the work of Baldus and the Bisson

Frères. In Baldus's view of the Pavillon Richelieu, still under construction (fig. 48), the enormous building fills the picture plane, barely contained within the frame. Baldus positioned the camera slightly below the midpoint to render the facade like an architectural elevation while simultaneously conveying the effect of a towering edifice. A diffused morning light reveals the three-dimensionality and surface detail of the architectural features.

In a similar photograph by the Bisson Frères (fig. 49), the completed pavilion, despite its grand scale, appears diminished and distant, the result of a slightly higher vantage point and of the broader compass of a shorter lens. The harsher light of the high, early afternoon sun in the Bisson view obscures, rather than clarifies, many of the smaller sculptural and architectural elements. The columns of the first and second stories, for example, so clearly defined and easily read in the Baldus, are lost in the pattern of strong shadows and bright stonework of the Bisson view. Similarly, the sculptures of the pediment, especially the central figure of France, are more fully visible in Baldus's version. Even in Baldus's later view of the same structure as it nears completion (pl. 39), made in the full glare of a midday sun, monumentality and legibility prevail.

THE FLOODS OF 1856

In June 1856, in the midst of his work at the Louvre, Baldus set out on a brief assignment, equally without precedent in photography, that was in many ways its opposite. From a world of magnificent man-made construction, he set out for territory devastated by natural disaster. From the task of recreating the whole of a building in a catalogue of its thousand parts, Baldus turned to the challenge of evoking a thousand individual stories in a handful of transcendent images. From a documentary mission that narrowly confined personal expression, he embarked on a reportage assignment over which he had free artistic reign.

Torrential rains in mid- and late May 1856 caused rivers to swell and low-lying areas to flood throughout France. Nowhere was the devastation greater than in the Saône and Rhone Valleys, where the rivers crested at nearly twenty-six feet, destroying entire sections of Lyons, Avignon, Tarascon, and many smaller towns along the entire length of the rivers' course (fig. 50). A dispatch from Lyons on the evening of Saturday, May 31, reported a break in the dikes that protected the neighborhoods of the left bank: "The Charpennes, the Brotteaux, and the Guillotière [sections of Lyons] are invaded by water. Houses constructed of pisé [a kind of clay] are crumbling in great numbers from moment to moment. . . . The level of the Rhone has surpassed that of 1840, the highest ever seen until now."[161] The following day, after the river had finally begun to recede, the newspaper *Salut Public* reported:

> Half the city was submerged, and the crowd walked about in a stupor along the edges of the muddy lagoons, which had, at certain points, nearly the rage of the river itself. But as awful as the situation was in the city proper, it pales beside the terrible calamity of the left bank. . . . The entire length of the town is nothing but ruins. . . . The Charpennes no longer exists. . . . One can hardly imagine the quantity of wood, materials, furniture, and things of every sort carried, not so much by the river, now flowing again within its banks, but by the vast floodwaters that cover so large an area. Horses, cattle, and other animals have died.[162]

In the area around the Church of Saint-Pothin (fig. 51) clouds of dust, like the smoke of artillery fire, erupted as houses collapsed one after another. Across the city thirty thousand people were left homeless.[163]

In a chilling personal account of the floods in Tarascon, J.-B. Laurens, whose lithographs of the Chemin de Fer de Lyon à la Méditerranée are discussed below, described the events of the evening of May 31, 1856. By six o'clock the Rhone had risen to twenty-six feet and so violently battered the roadway of the suspension bridge that officials considered cutting its cables lest they pull down the quay to which they were attached and thereby cause a breach through which the Rhone would flood the entire town; at the same time, they feared that the wreckage of the suspension bridge

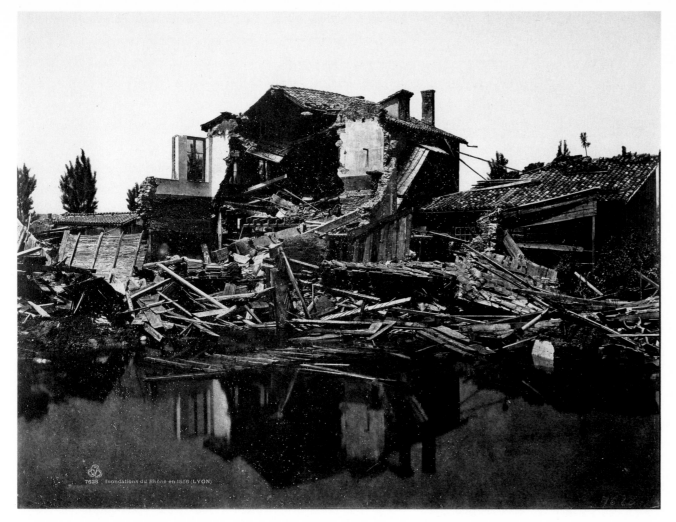

Fig. 50. *The Floods of 1856, Brotteaux Quarter of Lyons*, 1856. Salted paper print, 1994, from the original paper negative, 30.2 × 46.6 cm (11⁷/₈ × 18³/₈ in.). Musée d'Orsay, Paris

might, in turn, destroy the railroad viaduct just downstream. By eight o'clock the river level was receding and all seemed secure, but in fact the drop was due to a break in the riverbank five miles upstream and the flooding of the surrounding plain. The alarm was sounded, and residents moved belongings and animals to the relative safety of the embankment. "Before eight-thirty one could observe only insignificant puddles of water produced by seeping from the Rhone, the pressure of which must have been very strong," wrote Laurens, "but a moment later a muffled and sinister sound, like that of the wind before a storm, announced the arrival of the Rhone

waters. I saw them rushing with unimaginable violence through the streets of the town, and was all but swept away, rolling and tumbling on the first wave as I tried to enter a house, where, in the space of a quarter hour, I saw the water rise to a height of ten feet. . . . The plain surrounding Tarascon is nothing but a vast sea."[164]

So great was the destruction that Napoléon III departed Paris in the middle of preparations for the baptism of the prince imperial in order to visit the scene in person. Accompanied by the minister of agriculture, commerce, and public works, the director general of civil engineering, and a number of other government officials, the

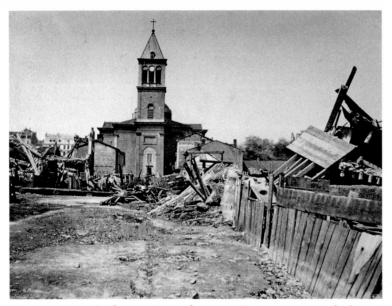

Fig. 51. *The Floods of 1856, Church of Saint-Pothin, Lyons,* 1856. Salted paper print from paper negative, 32.5 × 43.5 cm (12³/₄ × 17¹/₈ in.). Collection Robert Hershkowitz, London, and Alain Paviot, Paris

emperor toured the most heavily damaged sections of Lyons on June 3. He departed the following day for Vienne, Avignon, Orange, Tarascon, and Arles. The high waters made it necessary for the imperial party to enter Avignon by boat and to survey the surrounding countryside from the place du Rocher, next to the cathedral. South of Avignon the rail line was cut, so the emperor traveled by boat through three miles of flooded plain to Tarascon, where he traversed the city streets by boat and distributed aid to the town's inhabitants still trapped in the upper stories of their houses.[165] Napoléon's tour of the flood-ravaged region and his demonstration of compassion for its populace were widely admired and later immortalized in two history paintings of grand ambition: William Bouguereau's *Napoléon III Visits the Victims of the Floods, Tarascon, June 1856* and Hippolyte Lazerges's *The Emperor at the Cours Morand, Lyons, Visiting the Victims of the Floods* (figs. 52 and 53).

Only four days behind the emperor, on June 7, Baldus arrived in Lyons, dispatched to the scene by the French government to record the catastrophic effects of the floods. Aided by an assistant, he spent eight days fulfilling his mission under extremely difficult conditions; he returned with twenty-five large-format negatives of Lyons, Avignon, and Tarascon.[166]

By the time Baldus arrived in the Rhone Valley the river had largely subsided, leaving the photographer to record not the torrent itself but rather the ruinous shells of buildings in Lyons and the eerily serene landscape around Avignon. In striking contrast to Lazerges (in whose painting the emperor, on horseback, comforts the inhabitants of the fallen houses of the Brotteaux), Baldus remained true to his preferred subjects of landscape and architecture and to his established aesthetic vision, creating a moving record of this natural disaster without explicitly depicting the human suffering left in its wake. The "poor people, tears in their eyes, scavenging to find the objects most indispensable to their daily needs,"[167] are all but absent from the photographs, as if the destruction had been of biblical proportion, leaving behind only remnants of a destroyed civilization; in only a single scene is the ghostly presence of the flood victims detected (pl. 47).

Like Roger Fenton in the Crimea only a year before, or the corps of American Civil War photographers the following decade, Baldus faced the challenge of describing destruction, death, and chaos in symbolic, rather than literal, terms. To be sure, the nature of his record of the flood was partly conditioned by the limitations of the medium. He was simply not on hand for the most dramatic moments of the deluge, the widely reported incidents of local heroism, or the emperor's visit, and the several-minute exposures of his paper negatives made them ill-suited to capturing the activities of the inhabitants as they went about cleaning up the wreckage. But the character of his pictures is more a product of a conscious decision; had he sought a more instantaneous record of events, he could have chosen to photograph with glass negatives in a smaller format (the smaller the camera, the faster the exposure). Claude-Marie Ferrier, for example, was sent by the government at the same moment to record

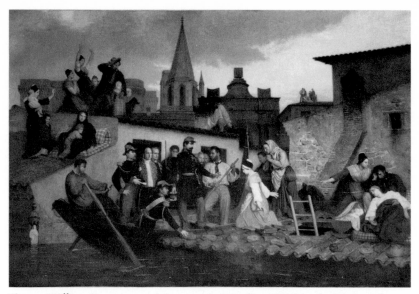

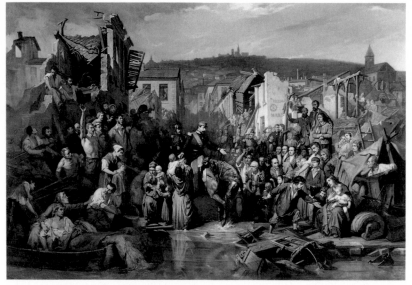

Fig. 52. William Bouguereau (1825–1905). *Napoléon III Visits the Victims of the Floods, Tarascon, June 1856*, 1857. Oil on canvas. Hôtel de Ville, Tarascon

Fig. 53. Hippolyte Lazerges (1817–1887). *The Emperor at the Cours Morand, Lyons, Visiting the Victims of the Floods*, 1857. Oil on canvas. Musée National du Château de Compiègne

the effects of the flooding in the Loire Valley and returned to Paris with a series of stereoscopic views that created the illusion of actually being at the scenes of destruction.[168]

Baldus, by contrast, created monumental pictures showing the effects of nature's force. Even the close-up views of ruined buildings in the Brotteaux and the Charpennes, which speak most vividly of the destructive power of the flood, reveal Baldus's habitual compositional devices and his predisposition for order and stasis. As in his photographs of the monuments of the Midi and Paris, or those made along the Chemin de Fer du Nord, one finds the diagonal foreground plane leading directly to one corner (pl. 47), the frontal view and central placement of architectural subjects (fig. 51), and the clear delineation of perspective (pls. 48 and 52). Even in his photograph of a house left half standing in the fetid floodwaters, amid the confused wreckage of timber, tiles, and fallen walls, Baldus framed his subject like a monumental palace mirrored in a reflecting pool (pl. 45; fig. 50).

Nowhere are disorderly composition, skewed perspective, or disequilibrium used to emphasize the chaotic consequences of the flood. Such visual strategies were simply not part of Baldus's vocabulary or, for that matter, yet seen anywhere in the still-young medium of photography.

The large panorama of Avignon, in particular, possesses a seductive beauty which shows that Baldus was as concerned with the pictorial aspects of his photograph as with its documentary role. Already known for the remarkable scale of his work, Baldus aimed to encompass the entire river valley in a single image. Standing on the cathedral terrace from which Napoléon III had surveyed the territory a few days earlier, Baldus pivoted his camera to compose a sweeping panorama of six negatives joined together for a total length of more than seven and a half feet (fig. 54).[169] That he signed and numbered some of these negatives individually indicates that he considered them successful single sheets as well (pls. 49–51). From

69

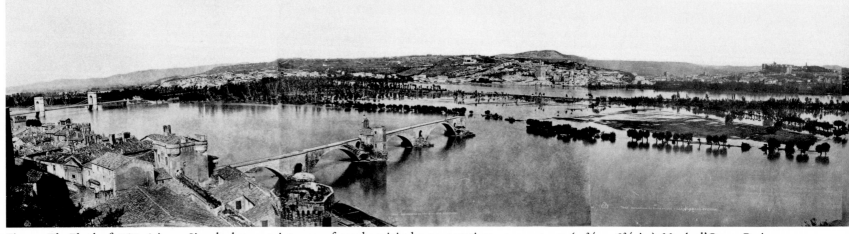

Fig. 54. *The Floods of 1856, Avignon.* Six salted paper prints, 1994, from the original paper negatives, 32.4 × 250 cm (12³/₄ × 98³/₈ in.). Musée d'Orsay, Paris

the great height of the cathedral terrace one can see the flooded island of Barthelasse, the town of Villeneuve-les-Avignon, and the river, slowly returning to the confines of its banks; mulberry and willow trees dot the watery landscape, showing the contours of previously dry land. The long band of the Rhone Valley, beyond the crenellated walls of Avignon itself and below the dark cliffs and fortifications of Villeneuve, has a fairy-tale softness. Trees, boats, houses, and hills float on the water's surface, sitting not as if on a hard, reflective sheet of glass but rather as if on a cushion of pale heather velvet. There is no hint of the violent torrent.

Lacan, while expressing unreserved praise for this "most beautiful print,"[170] sensed the dual nature of Baldus's flood photographs as gripping historical documents and as art, praising and lamenting them in the same breath: "It is with profound sorrow that one examines these views . . . which represent, with a painfully eloquent fidelity, the streets turned to torrents, houses upended, walls destroyed, fields ravaged and transformed into swamps. They are very sad pictures, but beautiful too in their sadness!"[171]

The broad role of Baldus's mission was better understood than any specific function his photographs might serve. He was certainly not charged with cataloguing damage to bridges, dikes, or other major public structures that would be in need of repair. Nor were his photographs displayed, printed, or published by the government to show details of the disaster to a broad citizenry or to enlist support for the many public subscriptions to aid flood victims. In fact, with no specific purpose for them in mind, it took the government two years to ask for the negatives that they had paid for. In the interim Baldus treated the flood negatives as part of his stock and even delivered additional prints made from them to the government in January 1858, in what had, since the *Villes de France* began in 1853, become an annual sale of photographs to the Office of Fine Arts.[172]

Baldus was commissioned to record the calamitous consequences of the flood out of a more general understanding that photography could play a role in documenting the principal events of history in a way that was fundamentally different from the heroic fictions of history painters. Photography "records in turn the memorable events of our collective life on its magic slate, and each day it enriches the archives of history with some precious document," wrote Lacan.[173]

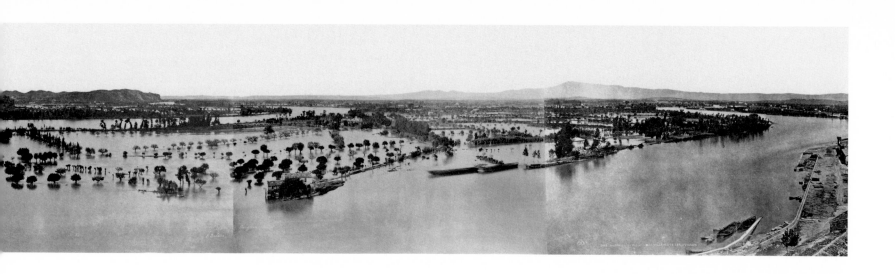

The Late 1850s: Continued Travels and Success

Château de la Faloise, 1857

By 1856 Baldus was at the height of his career. More successfully than any other French photographer, he could sum up an architectural monument in a single, fully resolved image; he had developed an art of deconstruction and reconstruction in his archive of Louvre photographs; and he had mastered a new kind of photographic documentation that evoked, and stood for, an event that could not itself be represented. His photographs had won the praise of critics and colleagues, and he had received commissions from captains of industry and government ministers; his work was sold by a dozen merchants in Paris and by print and book dealers in Nîmes, Hamburg, Florence, Venice, Turin, Milan, Vienna, and London,[174] and he employed a dozen assistants.[175]

Although Baldus enjoyed both private and corporate patronage, his high professional stature was due primarily to the substantial and sustained support of the government; the *mission héliographique*, the *Villes de France photographiées*, the Louvre documentation, and the

pictures of the flooded Rhône were all made possible by official patronage. In obtaining these commissions and subscriptions Baldus may well have found an ally in Frédéric Bourgeois de Mercey. Landscape painter, art critic, novelist, and travel writer, de Mercey knew Baldus from the start of his photographic career, for both were founding members of the Société Héliographique in 1851. Moreover, de Mercey had served on the subcommittee of the Historic Monuments Commission that selected the photographers—including Baldus—who were awarded *missions héliographiques*. First in the Ministry of the Interior, beginning in 1841, and later in the Ministry of State, beginning in 1853, de Mercey headed the Office of Fine Arts; he played a central role in the Exposition Universelle of 1855, serving on the Fine Arts jury and overseeing, with Chennevières, the construction of the Palais des Beaux-Arts. Baldus could hardly have had a better-placed friend as he sought government support for his various projects.[176]

A series of five photographs by Baldus attests to the ties of friendship between the two men, for they were made on the grounds of the Château de la Faloise, the country house of de Mercey.[177] The series may have been made in 1857, for although the images are undated,

Fig. 55. *Group at the Château de la Faloise*, 1857. Salted paper print from glass negative, 31.4 × 43 cm (12³/₈ × 16⁷/₈ in.). Canadian Centre for Architecture, Montreal

one was shown at the second exhibition of the Société Française de Photographie in that year.

The photographs in this series, however, do not focus on the château. Instead, the photographer's visit to de Mercey's estate was the occasion for a rare foray into the depiction of plein-air leisure, a subject that would become a mainstay of impressionist painting a decade later. One view shows family members and guests posed alongside a stream, with the château on a hill in the background (pl. 54); in a calculated visual game that Baldus would have seen clearly in the upside-down image on his ground glass, the artist positioned some of the figures on a small wooden bridge where their forms—seated, standing, and reclining—would be more strongly visible in silhouetted reflection than in reality. In another photograph Baldus looked down the hill from the château, carefully placing figures along the path to direct the eye toward the stream and bridge (fig. 55).

Even when photographing de Mercey and his family in an intimate and seemingly informal garden scene (pl. 53), Baldus arranged the bench and chairs with nearly architectonic symmetry and posed the figures with great deliberateness. Just how formal Baldus's picture is can readily be seen if one compares it with a parallel subject in painting a decade later, Claude Monet's *Le déjeuner sur l'herbe*, of 1866 (fig. 56). The painter's models lounge on the forest floor, clustered in conversation, linked in one another's gaze. Deliberately

posed by the painter in casual attitudes, turned frontward and backward, the models seem unaware of the artist. The informality of Monet's scene is one that would only later be associated with the photographic snapshot.

Despite those elements in Baldus's photograph that are most akin to the formal devices employed by the impressionists—the flat white shapes of parasol and dress, for example—the figures are stiff, each in his own physical and mental space. Might that stiffness be a reflection of de Mercey's slight uneasiness before the camera? While acknowledging that photography was indispensable to the traveler who wished to reproduce "the special physiognomy of a region, its monuments, and the details of its architecture," de Mercey thought the results less satisfying when applied to landscape composition and portraiture. "It is a tracing of nature, and what tracing, no matter

how exact it is, has ever approached the copy made with intelligence by a talented artist?"[178] Or might this image record an element of tension in the friendship between artist and patron, an awkward placement of the photographer in the midst of de Mercey's family? The standing, top-hatted gentleman whose face is blurred appears in none of the images where the camera is more distant; perhaps this is Baldus, nodding a signal to his assistant after setting up the scene and taking his position?

At home, too, Baldus was an exemplar of the successful Second Empire bourgeois. By coincidence, on the day that he set out from Paris for Lyons, June 6, 1856, the Council of State approved his application for French citizenship, based on prefectural and ministerial reports of his moral and political rectitude, his financial security, and his success in fulfilling government commissions.[179] In 1856 or 1857 the family moved from an apartment on the rue du Bac to a larger and more comfortable apartment on the third floor of 16, rue Saint-Dominique-Saint-Germain, in the seventh arrondissement of Paris.[180] Although not extravagant, the apartment was comfortable, comprising a small kitchen with running water, a dining room and adjoining antechamber, a salon hung with paintings[181] and abundantly furnished, a master bedroom, a children's bedroom, and areas occupied by Baldus's mother-in-law.

Baldus rented working space in the same building.[182] In a fourth-floor studio he stored his stock of more than a thousand prints and 175 negatives, as well as his photographic equipment. On the fifth floor he kept a worktable and easel (perhaps still used for painting) and a press, no doubt for his experiments in photogravure. And finally, in a small studio on the sixth floor, most likely with access to the roof or balcony, he stored printing frames of various sizes.

In late 1857 Baldus purchased a still larger residence, the house of the recently deceased sculptor Charles Simart at 25, rue d'Assas.[183] As the family prepared to move, Elisabeth, Baldus's wife of more than a dozen years, fell sick. She died on March 13, 1858, at the age of thirty-four.[184] Her death left him alone to care for his children,

Fig. 56. Claude Monet (1840–1926). *Le déjeuner sur l'herbe*, 1866. Oil on canvas. Musée d'Orsay, Paris

Fig. 57. *Cherbourg*, 1858.
Salted paper print from glass
negative, 23.6 × 43.5 cm
(9¼ × 17⅛ in.). École
Nationale Supérieure des
Beaux-Arts, Paris

aged nine, ten, and eleven. By May, Baldus moved into the house on the rue d'Assas with his three children and his mother-in-law,[185] and he lived there until 1886. He never remarried.

Baldus's photographic activity changed little with his wife's death, perhaps because Mme Étienne helped care for the children. During the next five years he was often away from home, on photographic excursions to Brittany and Normandy, several times to the Côte d'Azur, Provence, and the Dauphiné, to Bayonne, Périgueux, and Poitiers. In Paris he continued to work at the Louvre and to produce a series of views of the city.

The Imperial Visit to Normandy, 1858

In August 1858 Emperor Napoléon III and Empress Eugénie traveled through Normandy on a trip that culminated in Cherbourg on August 5–7 with joint naval maneuvers of the French and British fleets, the inauguration of the new Bassin Napoléon (an impressive work of naval engineering that greatly expanded the port facilities of Cherbourg), and the launching of the ship *Ville de Nantes*. The historic importance of the events was heightened by the presence of Queen Victoria and Prince Albert at Cherbourg aboard the royal yacht.

According to the *Moniteur Universel*, more than sixty photographers battled the wind and tide to take away in their portfolios what their fellow spectators could preserve only in memory, but it was Baldus who was officially charged with recording the event.[186] In many ways the choice was an odd one because Baldus had proved himself a photographer of places and things rather than of events (something evident even in his pictures of the floods), and Le Gray's marines were the most popular photographs in all of Europe, making him the more obvious choice for an event that focused on the sea. Perhaps it was Baldus, rather than the administration, who proposed the project, relying on his official contacts and his record of

successful government assignments to secure the commission. Other photographers, more accustomed to recording animated scenes, left Cherbourg with views of the town, its fortifications, the decorations erected for the imperial visit, the new docks before and after immersion, the *Ville de Nantes*, the troop encampment, and the fleets.[187] The illustrated weeklies published numerous wood engravings of the significant moments of the visit.[188]

Baldus made a series of rather tame views showing the French and British fleets at Cherbourg (fig. 57),[189] which his friend Lacan praised. But his most successful photographs from the trip to Normandy were intended to enrich his expanding series of views of French monuments rather than to fulfill the expectations of the commission, which spoke of "the principal episodes of Their Majesties' trip."

"In passing by the good town of Caen," where the imperial couple stopped the day before going to Cherbourg, wrote Lacan, "this able artist could not resist the desire to add the two magnificent churches that the old Norman city possesses to his collection of reproductions of monuments,"[190] the churches of Saint-Pierre and of Saint-Étienne, the latter also called the Abbaye aux Hommes. Not since his *mission héliographique* photographs had Baldus posed figures in a prominent position before a historic monument; at the Church of Saint-Étienne (pl. 59), however, he did just that, but in a new way. The figures in this photograph act neither as indicators of scale nor as stand-ins for the armchair traveler. Instead, they explain the architecture almost anthropomorphically. The two tall towers of the west facade, capped by ornate thirteenth-century octagonal spires with turrets and lancets, and the simpler lantern tower and four-sided spires of the east-end towers find their exact parallels in the two gentlemen in top hats and the two more sturdily built but less elegantly attired workmen at their side. At Saint-Pierre, Baldus photographed the impressively tall tower, built in 1308, and the bulging sixteenth-century chapels of the east end (pls. 60 and 61). Again incorporating figures, this time in a manner far more reminiscent of his *mission* work or of the *Voyages pittoresques*, Baldus took

up a position much favored by watercolorists, according to the writer Théophile Gautier, from which the gracefully ornamented crossing tower can be seen rising behind cracked and sagging old houses.[191]

Eager to build his collection of photographs of French monuments, Baldus probably stopped at Rouen on the same trip, although the city was not on the imperial itinerary; a half-dozen views of the Palais de Justice, the cathedral, and other notable landmarks date from the late 1850s, most likely from this trip. Baldus's elevated, angled view of the cathedral facade (pl. 62) is a dappled field of light

Fig. 58. Claude Monet (1840–1926). *Rouen Cathedral*, 1894. Oil on canvas. The Metropolitan Museum of Art, Theodore M. Davis Collection, Bequest of Theodore M. Davis, 1915 30.95.250

Fig. 59. *Périgueux*, 1860. Albumen silver print from paper negative, 33.2 × 43 cm (13 1/8 × 16 7/8 in.). Bibliothèque Municipale de Périgueux

playing on Gothic tracery and ornament, inevitably calling to the twentieth-century viewer's mind Monet's extended series of paintings of the same scene made in 1894 (fig. 58).[192]

Less than two years later, Baldus again took advantage of a specific commission to travel outside Paris and to expand his stock of images. Called to Périgueux in May 1860 to record the Tournepiche bridge, Saint-Front mill, and Renaissance-style houses along the Isle River before their imminent destruction during the rebuilding of the quays, he made thirteen negatives to fulfill the commission and added at least one view of the Cathedral of Saint-Front to his inventory of negatives (possibly fig. 59).[193] Revealing only the first traces of the extensive reconstruction carried out by Paul Abadie, the cathedral crowns the picturesque rooftops and

zigzagging bridge of Périgueux in a composition similar to his views of Saint-Nectaire and Auvers (pls. 16 and 26) earlier in the decade.

Despite Baldus's continued activity and commercial success, many photographs from the late 1850s suggest that he lacked for the moment a strong aesthetic direction. Accomplished but most often uninspired, the photographs are pastiches of his own previous work, recalling but not fully evoking the picturesque scenes of 1851, the severe work in the Midi of 1853, the poetic images in the queen's album of 1855, or the brilliant views of the Louvre in 1855–57. It would take something new and dramatically different before the lens—first the mountainous landscape of eastern France and later the heroic work of railroad engineers—to again spark discovery and invention.

The Dauphiné, Savoy, and the Côte d'Azur, about 1860

About 1860, Baldus traveled to the Dauphiné, Savoy, and Nice, and photographed the impressive features of the land—glaciers, rocky chasms, alpine peaks, seaside rock formations, and provincial towns. Whether these pictures were the product of Baldus's search for new and inspiring subject matter or allied to political events is difficult to know, for the trip cannot be dated precisely. Nonetheless, by the time he exhibited his photographs of the region (and quite possibly by the time they were made) Savoy and Nice were the newly won fruit of Second Empire military power. By a prearranged agreement between Napoléon III and the renowned Italian statesman Cavour, France obtained these French-speaking territories from the Kingdom of Sardinia in exchange for military support in the 1859 war against the Austrians and for Italian unification. The Treaty of Villafranca formalized the annexation on March 24, 1860.

At the fourth exhibition of the Société Française de Photographie, in 1861, Baldus exhibited landscape photographs of the Dauphiné and Savoy, including *"Le Bout du Monde," Allevard*; *Waterfall at Sassenage*; *Landscape near Allevard*; *Landscape at Voreppe*; *Chamonix*; and *"Mer de Glace," Chamonix*; others from the

same campaign include *Valley of Grésivaudan* (pl. 67), *Valley of Chamonix*, and *Source of the Aveyron River* (pl. 66). Baldus's continued use of paper negatives in the 1860s, when collodion on glass was almost universally the process of choice even for travel photography (where ease of preparation and portability made paper a more logical choice), might appear surprising. But his mastery of the process had reached such a level of perfection that the clarity of detail makes it all but impossible to recognize these photographs as the product of paper negatives. Nonetheless, Baldus's technique drew much comment in 1861. Marc-Antoine Gaudin, editor of *La Lumière* after the departure of Lacan in 1860, remarked that the pioneering Baldus had been surpassed by his followers, and regretted the photographer's continued use of the antiquated paper negative, declaring that, while very good for landscape, it could not compete with albumen and collodion for detail and transparency.[194] Gaudin's brother Charles lashed out at Baldus in the following issue of *La Lumière*, finding Baldus's work heavy and harsh. His most barbed attack was directed at Baldus's habitual retouching of the negative, including the addition of painted clouds to the sky. "M. Baldus goes further still," he wrote. "He has taken it upon himself to wipe out a mountain chain to produce what he considers a more artistic effect; he has even added grotesque and gigantic trees smack in the middle of glaciers, a monument to inappropriateness." Gaudin argued that exhibitors should be required to present only unretouched prints, thereby excluding "these monstrosities in which art pretends to correct nature."[195] Although Gaudin's tirade may seem out of proportion, it is true that the painterly devices which blended harmoniously with Baldus's more traditional subjects and style (the clouds, for example, in *Boats at Low Tide, Boulogne*, pl. 36) appear inappropriate in the harder, rougher landscapes of eastern France (pl. 67).

It will come as no surprise that Ernest Lacan, writing in the *Moniteur de la photographie*, took a different point of view concerning Baldus's use of the medium. "Baldus has remained faithful to his dry paper [negative] process, and one cannot but congratulate him for it," he wrote, declaring that these photographs held their own against those that had made the photographer's reputation. Lacan wrote of *"Le Bout du Monde,"* *Allevard* as vividly evoking "a certain forgotten corner in the mountains of the Dauphiné . . . a gorge, squeezed between two walls of vegetation that separate to allow one to see the first summits of the Alps on the horizon. A stream, crossed in the middle ground by a narrow and perilous bridge, animates the solitude."[196]

Some of the "forgotten corners" that Baldus sought out were not forgotten; the Bout du Monde had been the subject of a lithograph by James Duffield Harding that appeared in the *Voyages pittoresques* in 1854. The cliff-bound town of Pont en Royans, which Baldus photographed on this campaign or, perhaps, a few years earlier, was also a well-known stop on the picturesque tour and had been drawn by Léon Sabatier for a lithograph in the same volume of the *Voyages pittoresques* (fig. 60). What was striking was not the finding but rather the recording of the site. Baldus dared to push the town's bridge and cantilevered houses to the very top of the picture and to banish the horizon altogether, focusing with a brute realism on the rough rock surfaces of the ravine (pl. 65).

This surprising physicality, seen too in the ice and rock of *"Mer de Glace,"* *Chamonix* and *Source of the Aveyron River* (pl. 66), is surely a response to the overwhelming force of the region's natural landscape. The gentler topography of the northwest, by contrast, had lent itself more to the rendering of ethereal effects, as in *Entrance to the Port, Boulogne* (pl. 37), or to a celebration of all that man had built upon the land. Even in the Auvergne, where Baldus had earlier focused on the landscape, man was master: chapels capped the most inaccessible peaks, castle ruins crowned remote cliffs, and stone houses and mills nestled securely in the mountain hollows. But here, in Haute Savoie, Baldus instead emphasized the tenuousness of man's hold over nature. The houses of *Pont en Royans*, small testimony of man's inventiveness, cling to the cliffs in improvised fashion. The town of Chamonix is dwarfed by alpine peaks and glaciers. The massive industrial gear in *Allevard* (pl. 64) seems cast aside by the powerful torrent. The work of the stonecutters seems trivial

Fig. 60. Léon-Jean-Baptiste Sabatier (d. 1887). *Pont en Royans*, 1854. Lithograph. New York Public Library

Development of the Railroad

Much of Baldus's work is an expression of Second Empire values and aspirations. His *mission héliographique* and *Villes de France photographiées* were a part of the nation's resurgent interest in its medieval and antique past; in the Chemin de Fer du Nord album he addressed the political and economic alliance of France and Britain; he proudly presented the magnificence of Napoléon III's reign in his documentation of the New Louvre; photographing the 1856 floods, Baldus retraced the steps of the emperor, calling to mind his noble compassion; and in the alpine landscapes he explored the territory ceded to France in the Italian war against Austria. But in the second of his railway albums, the *Chemins de Fer de Paris à Lyon et à la Méditerranée*, Baldus drew from a decade's work to speak most forcefully and eloquently about Second Empire France. In the album's photographs and in related images of engineering projects elsewhere in France, he celebrated a powerful vehicle of political, economic, and cultural unification and used the railroad to define French nationhood geographically and historically.

By 1861, when he was commissioned to produce an album of views along the railroad from Lyons to the Mediterranean, Baldus had traveled through the region a half-dozen times, and he understood well the way in which the railroad could transform a traveler's experience of time and distance, of the landscape, and of local custom and culture en route. On his first trip south—perhaps in 1849, before one could take a train from Paris to the Mediterranean—Baldus would have traveled by carriage. The Compagnie des Messageries dispatched three hundred horse-drawn diligences a day from Paris to the major cities of France,[197] and road improvements enabled them to travel three times faster than they had a half-century earlier. Nevertheless, such coaches were still painfully slow, averaging less than six miles per hour.[198] The trip from Paris to Lyons by diligence took a minimum of fifty-five hours.[199] "You

before the block of granite mountain on the far side of the valley of Grésivaudan (pl. 67). In each case, Baldus places the human presence at the periphery and gives Nature center stage. In these corners of the empire, Civilization had yet to make deep inroads.

arrive [in Lyons] after three nights of insomnia, four days of famine, four centuries of torment!"[200] Freight moved even more slowly, requiring twelve days for the Paris to Lyons trip and a month for the full course from Paris to Marseilles.[201]

Balzac described, in *Un debut dans la vie*, published in 1842, the diligence service of the 1820s between Paris and L'Isle-Adam, a distance of twenty-seven miles which the writer's fictional coachman Pierrotin proudly traversed in a mere five and a half hours. Within a few years of Balzac's writing, the route could be traveled by train in just over an hour. Balzac recounted in detail how Pierrotin carried fifteen passengers on his small two-wheel coach: eight tightly packed inside a carriage meant for six; three, dubbed "rabbits," perched on the driver's bench (four if Pierrotin sat on the footrest); and three in the "hen-roost," or luggage compartment.[202] "There are villages less populous than a diligence," remarked one writer of the 1850s.[203]

Only a few seats were available in the faster *malle-poste*, or mail coach. This alternative to the diligence was notoriously uncomfortable.[204] Victor Hugo described this torturous means of travel in *Le Rhin* (1839): "At the moment of departure, all is well. The driver cracks his whip. . . . One feels in a strange and pleasant situation; the movement of the coach brings gaiety to the spirit. . . . [As night falls and sleep beckons, the road] is no longer a road; it is a chain of mountains. . . . Two contrary movements take hold of the carriage, shake it with rage like two enormous hands: a movement from front to back and back to front, and a movement from left to right and right to left, pitching and rolling. From that moment on, one is no longer in a carriage, but in a whirlwind. Tumbling, dancing, bouncing, one is thrown against one's neighbor. From there, a nightmare without parallel."[205]

The earliest calls for a national blueprint for and massive government role in railroad construction came from the followers of the social philosopher Claude-Henri, comte de Saint-Simon (1760–1825).[206] Saint-Simon's writings, which articulated a theory of social organization for the new industrial age, had their greatest influence after the philosopher's death; they were the foundation for Auguste Comte's positivism, for French socialism before and after the revolution of 1830, and, increasingly in the 1830s, 1840s, and 1850s, for the advocacy of industrialization.

Although the steam railroad appeared too late to figure in the writings of Saint-Simon himself, the beneficent view of technological progress that he had outlined prompted his followers, including Michel Chevalier, Barthélemy-Prosper Enfantin, Émile and Isaac Péreire, and Paulin Talabot, to embrace the railroad enthusiastically and to see it as a catalyst for social and political progress. Chevalier described the railroad as "the most perfect symbol of universal association" and proposed a "Système de la Méditerranée," a network of trains and steamboats linking France with the entire Mediterranean basin.[207] He envisioned a shrinking world in which Rouen and Le Havre would be as accessible to Paris as the suburbs then were, and in which travel to Saint Petersburg would require half the time it currently took to journey from Paris to Marseilles. "When a traveler leaving Le Havre in the early morning will be able to lunch in Paris, dine in Lyons, and hook up the same evening in Toulon with the steamboat for Algiers or Alexandria . . . an immense change will arise in the composition of the world; from that day, what is now a vast nation will be a medium-size province."[208] Despite its utopian aura, Chevalier's plan led directly to the construction of the French railroads and the Suez Canal.[209]

French passengers rode the rails for the first time along a section of the Saint-Étienne–Lyons line in May 1831—standing in coal cars—but it was only in 1837, with the opening of an eleven-mile line linking Paris and Saint-Germain, that railroads captured the public imagination in France.[210] Jules Janin likened the experience to one of sheer magic: "Seated on this carpet, you simply think of where you want to go, and you are there."[211]

Application was made that same year for a concession to build a rail line between Lyons and Marseilles—the first between two major cities. From antiquity, the valleys of the Rhone and Saône Rivers had been the principal route by which Mediterranean peoples gained

access to Gaul and the lands of northern Europe. Because navigation on the Rhone, France's most powerful river, was difficult, land routes along its banks were favored.[212] It was therefore natural that the route from the Mediterranean to Lyons and Paris was considered an axis of primary importance in planning a national railroad network.

Stendhal wrote in 1837 of the heavy traffic along the road linking Lyons and Vienne: "The number of horses that perish along the route, and whose sad remains one sees, is quite considerable. . . . All the soaps, all the oils, all the dried fruits that the South supplies to Paris and the North, travel this route. . . . It is therefore at this point in France that one ought to begin the railroads."[213]

Only after five years of debating the proper roles of government and private industry in so costly and important an enterprise did the government establish a general plan for a network of major lines, or *grands réseaux*, linking Paris with other major French cities. Legislation passed in 1842 placed the government in charge of the infrastructure and assigned the superstructure to private initiative. It also established the path of the PLM (Paris–Lyon–Méditerranée) line and provided the necessary financial impetus for construction to begin. The first section to be granted a concession, under the directorship of Paulin Talabot,[214] was the line from Avignon to Marseilles, a route that would include some of the most significant engineering feats yet attempted in the French railroads' brief history: a viaduct crossing the Durance River, a viaduct crossing the Rhone at Tarascon to link up with the Beaucaire line, and the three-mile tunnel at La Nerthe, near Marseilles.[215]

By the time Baldus traveled south for his 1851 *mission héliographique*, significant sections of the journey from Paris to Marseilles could be made by train.[216] On his 1853 trip he indeed traveled by rail as far as Lyons, before continuing by river and road.[217]

In 1838 the Compagnie des Messageries had at its disposal 1,400 posthouses, 500 drivers, and 20,000 horses, but by 1854 their imminent demise in the face of railroad expansion was already evident: "Wherever the steam engine hurls along the railway, the carriages of the *ancien régime* pull back in shame and rush to other places where steam is unknown. But steam, that conquering queen of modern societies, gains ground each day step by step, and, in that daily retreat of the Messageries, one can already fix the day and time when they will be dead in France."[218]

In the early days of railroad development it had seemed prudent to encourage small companies to undertake the construction of short sections of railroad, since the industry was as yet too unproven to attract the vast capital required for achieving the long lines planned. By the dawn of the Second Empire, however, the opposite was true: construction was under way on all sections of the *grands réseaux*, and the plethora of small companies impeded the efficient coordination of schedules, tariffs, matériel, and construction. Thus, by legislation in 1852, the Compagnie du Chemin de Fer de Lyon à la Méditerranée was formed by the fusion of numerous smaller companies.[219] The new company received a ninety-nine-year concession on all its lines, and Paulin Talabot was named director.[220] Five years later the Paris–Lyon and the Lyon–Méditerranée companies were joined. The two companies worked together cooperatively from that date, but it was not until 1862 that the two administrative councils were merged and Talabot took the helm of the united PLM company as director general.[221]

The Album

In July 1861 the Administrative Council of the Southern Region approved a proposal to commission a photographic album: "The director placed before the Council a proposal, prepared by the engineer in chief for construction, for the execution by M. Baldus of a collection of photographic views of the various structures and environs of the line from Lyons to Marseilles and Toulon. After having heard the explanations of the director, the Council approved the proposal and authorized for its execution the opening of a primary credit of 20,000 francs."[222]

Unfortunately, neither the report of the engineer in chief nor the explanations of the director remain in the PLM archives.[223] The

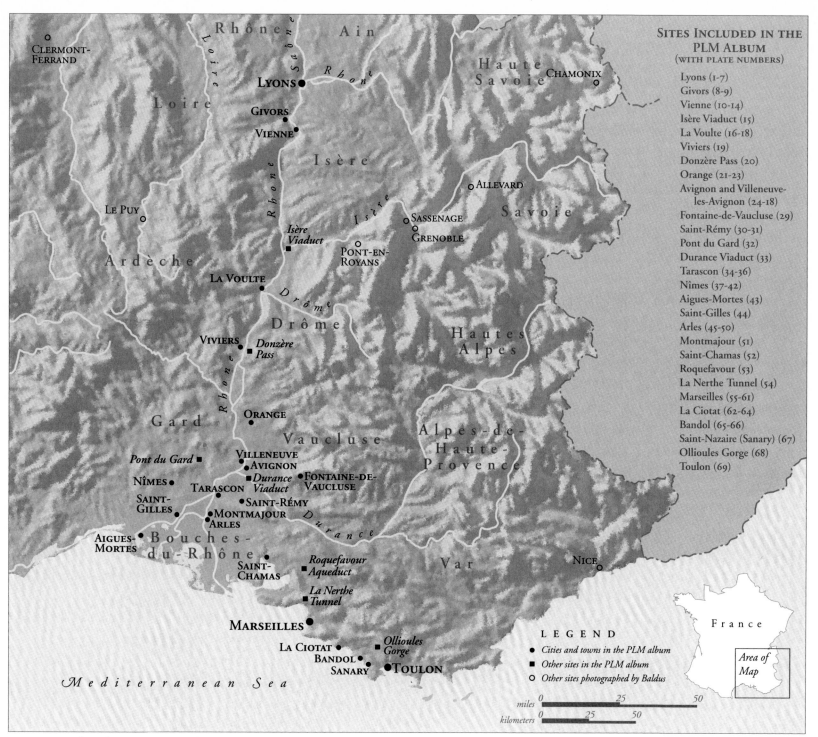

Fig. 61. Map of southeastern France, showing sites included in the PLM album

SITES INCLUDED IN THE
PLM ALBUM
(WITH PLATE NUMBERS)

Lyons (1-7)
Givors (8-9)
Vienne (10-14)
Isère Viaduct (15)
La Voulte (16-18)
Viviers (19)
Donzère Pass (20)
Orange (21-23)
Avignon and Villeneuve-
les-Avignon (24-18)
Fontaine-de-Vaucluse (29)
Saint-Rémy (30-31)
Pont du Gard (32)
Durance Viaduct (33)
Tarascon (34-36)
Nîmes (37-42)
Aigues-Mortes (43)
Saint-Gilles (44)
Arles (45-50)
Montmajour (51)
Saint-Chamas (52)
Roquefavour (53)
La Nerthe Tunnel (54)
Marseilles (55-61)
La Ciotat (62-64)
Bandol (65-66)
Saint-Nazaire (Sanary) (67)
Ollioules Gorge (68)
Toulon (69)

LEGEND
● Cities and towns in the PLM album
■ Other sites in the PLM album
○ Other sites photographed by Baldus

France

Area of Map

miles 0 25 50
kilometers 0 25 50

archives are also silent concerning any prior connection between Baldus and the engineer in chief, Molard,[224] and on other questions concerning the commission—why the albums were made, how many were produced, and to whom they were presented.[225] Despite its title, the album that Baldus produced, *Chemins de Fer de Paris à Lyon et à la Méditerranée*, shows sites only along the route south of Lyons (fig. 61), suggesting that the Administrative Council of the Southern Region wished to record its individual identity in photographs before being subsumed in the larger PLM company.

The PLM album includes work spanning Baldus's most active period, from the early large-format paper-negative photographs of 1853 through the small-format glass-negative photographs of the early 1860s. It also contains some of the finest work in each of the major genres of his output—architecture, civil engineering, and landscape.

The album is a masterfully composed sequence of sixty-nine photographs (see appendix 8).[226] The first group of images, covering the territory from Lyons to the Donzère Pass, focuses on the railroad itself; fifteen of the first twenty images depict viaducts, stations, tunnels, and track. Then, as if leaving the train far behind, the album explores the historic towns of Provence, with their magnificent antiquities and medieval fortifications, châteaux, and churches; only three of thirty-one images in this section concern the railroad (views of the viaducts across the Durance and at Tarascon). The theme of engineering reemerges in the third group of photographs, as the album moves from the Saint-Chamas viaduct, through the tunnel at La Nerthe, and to the vast rail yards and ports of Marseilles. In the final suite of images Baldus focuses on the small coastal towns and natural beauty of the Côte d'Azur, concluding with a view of the station at Toulon.

Although some photographs were made specially for the album and others were drawn from existing stock, each picture gains in complexity by being part of a larger framework. For example, Baldus placed two photographs in sequence to draw attention to the role of Marseilles as the crucial link in an interlocking transportation network. The first image shows the vast rail yards of the Marseilles train station, with freight cars of all sorts stretched along the sidings as far as the eye can see (fig. 62). In the second image the port of Marseilles bristles with the masts and rigging of densely packed sailing ships (fig. 63). Together, these two images attest to the commercial importance of the city, as if illustrating Chevalier's "Système de la Méditeranée" and explaining why the PLM railroad was so vital to the nation.

Elsewhere in the album Baldus linked vastly different subjects, removed from one another geographically (and therefore separated from one another in the sequence of pictures), by using similar pictorial structures. At the Vienne station, for example, he framed the scene so that every element of the picture directs the eye straight back, down the tracks and into the black arch of the tunnel (pl. 73). One hundred thirty miles to the south, in Arles, and more than thirty pages later in the album, Baldus employed the same approach in the cloister of Saint-Trophîme (pl. 80). The modern tunnel and the barrel vault of the medieval cloister gallery are equated visually. Despite the historical and functional differences of their subjects, the discrepancy of interior and exterior space, and the fact that in one the black arch represents the beginning of the vaulted space of a tunnel and in the other a solid end wall, the two constructions are parallel in perspective, shape, tone, and rhythm. By the same means, the compositional structure of *Cloister of Saint-Trophîme, Arles* is echoed in the receding arcades of *Amphitheater, Arles* (pl. 77) and *Aqueduct at Roquefavour*, on the following pages of the album.

This visual linking of disparate subjects can also be seen in the nearly identical way in which Baldus represented the modern La Mulatière Bridge in Lyons (fig. 64) and the Saint-Bénézet Bridge in Avignon (fig. 65), among the most important engineering works of medieval France as one of only four bridges crossing the Rhone south of Lyons. The elevated perspective (just below the level of the bridge roadway), the angled view of the receding arches, the left-foreground wedge of riverbank, and the moored barges unite the two pictures despite the seven centuries of history that separate their

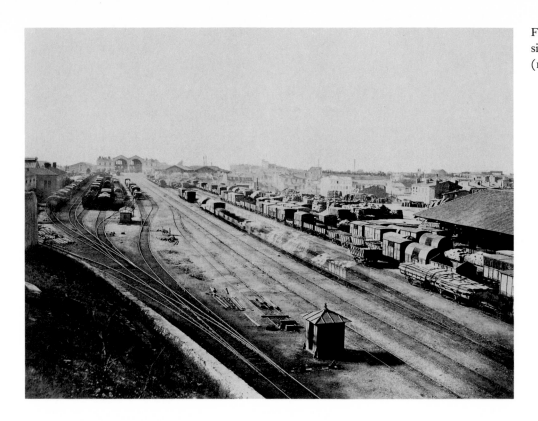

Fig. 62. *Railroad Station, Marseilles*, late 1850s. Albumen silver print from paper negative, 30 × 42.5 cm (11³/₄ × 16³/₄ in.). Gilman Paper Company Collection

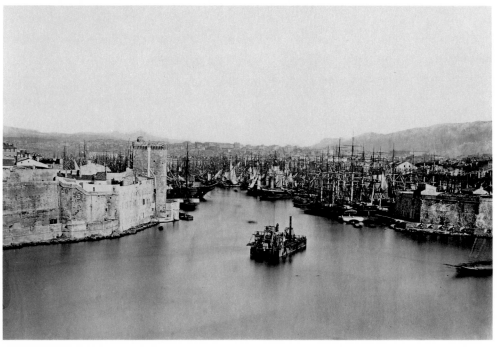

Fig. 63. *Port of Marseilles*, ca. 1860. Albumen silver print from glass negative, 27.5 × 42.5 cm (10⁷/₈ × 16³/₄ in.). Gilman Paper Company Collection

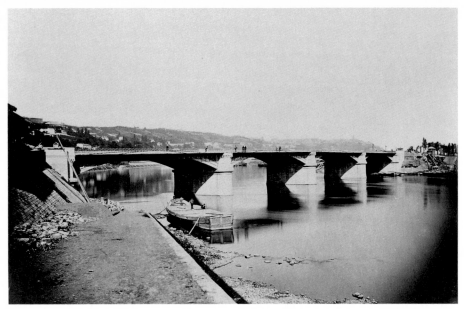

Fig. 64. *La Mulatière Bridge, Lyons*, ca. 1861. Albumen silver print from glass negative, 28 × 44.4 cm (11 × 17½ in.). Gilman Paper Company Collection

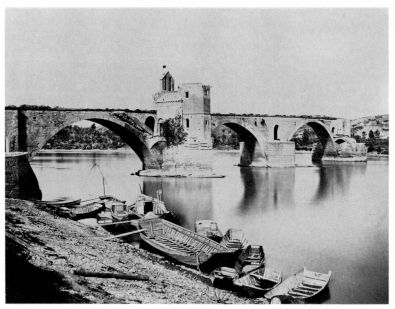

Fig. 65. *Saint-Bénéɀet Bridge, Avignon*, early 1860s. Albumen silver print from glass negative, 20.9 × 28.5 cm (8¼ × 11¼ in.). Gilman Paper Company Collection

subjects. In this equation lies the essential meaning of the PLM album: that a historical continuum embraces antiquities, medieval monuments, and modern structures, and that the products of Second Empire technology and engineering are the natural descendants of France's architectural past.

This bringing together of past and present is nowhere more eloquently articulated than at the middle of the PLM album. The first section of the album, as described earlier, focuses primarily on the railroad. Then the focus shifts to the monuments of Provence: the triumphal arch and Roman theater at Orange; the profile of Avignon and views of its Papal Palace, Saint-Bénézet Bridge, and Tour Philippe-le-Bel; the dizzying view from high on the hills surrounding the town of Fontaine de Vaucluse and its powerful spring; and the Roman arch and mausoleum at Saint-Rémy. Examining these pages, the viewer forgets the railroad and becomes immersed in the world of France's Roman and medieval past. The final image in this

series of antiquities is the Pont du Gard (fig. 66), the magnificent first-century B.C. aqueduct that provided water to the Roman town of Nîmes—perhaps the best known and most impressive of all French antiquities. The aqueduct's solid construction and beautiful design have made it a model of the Roman builder's superb melding of engineering and architecture. Having reached this historical crescendo, one turns the page to find a photograph of the masonry viaduct across the Durance, just south of Avignon, built by the engineers Talabot and Borel in 1846–49 (pl. 76; only the right half of this panorama appears in the album). The low, sleek form and compound curves of its arches contrast markedly with the form of the Pont du Gard and signal distinctly modern principles of aesthetics and engineering. The next two plates, too, show a modern viaduct, at Tarascon, each of its iron arches spanning more than two hundred feet.

It is no accident that Baldus placed these pioneering examples of modern engineering directly after the ancient Pont du Gard. The

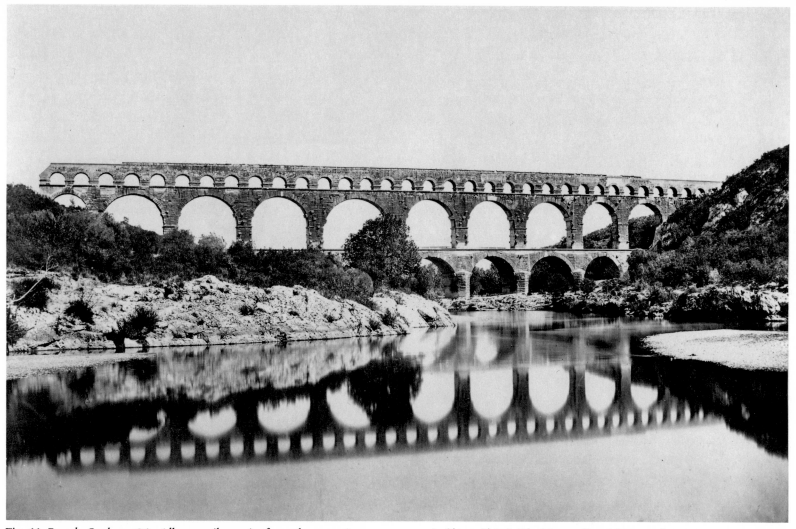

Fig. 66. *Pont du Gard*, ca. 1861. Albumen silver print from glass negative, 27 × 43.4 cm (10⅝ × 17⅛ in.). The Metropolitan Museum of Art, The Elisha Whittelsey Collection, The Elisha Whittelsey Fund, 1962 62.600.52

sequence even required a bit of creative shuffling, for the resulting route—Avignon, Vaucluse, Saint-Rémy, the Pont du Gard, the Durance, Tarascon, Nîmes—is not particularly logical from a geographic standpoint (see fig. 61). The juxtaposition was important, however, because Baldus intended not only to show the historic sites accessible by railroad but also to place side by side the noble vestiges of Roman imperial civilization and the new manifestations of Second Empire genius.

The same comparison appears at the opening of a long and detailed article on railroads in Pierre Larousse's *Grand dictionnaire universel du XIX^e siècle*, perhaps the most comprehensive and inspired account of this subject published in the period.[227] The author presents Jean-Jacques Rousseau's impressions of "one of the great works that the engineers of antiquity seem to have bequeathed to modern civilization as a model." Rousseau wrote, "I went to see the Pont du Gard: it was the first structure of the Romans I had seen.

85

. . . The object surpassed my every expectation. . . . Only the Romans could produce such an effect. The appearance of this simple and noble structure impressed me all the more because it is in the middle of a desert where silence and solitude make it more striking and intensify one's admiration. . . . One wonders what strength carried these enormous stones so far from any quarry and brought together the labor of so many thousands of men in a place where not a single one of them lived." The author of the article then asks: "What would the great philosopher have said if he had been given the chance to contemplate the immense bridge at Nogent-sur-Marne with its four round arches, each fifty meters wide, built to allow passage of the line from Paris to Mulhouse? What would he have said, too, at the sight of the iron bridges on the Rhine at Kehl, on the Garonne at Bordeaux, and finally at the sight of the Alpine tunnel? If there was, for more than a thousand years, a period of dormancy for great structures, we have been striving since the beginning of this century to regain lost time."[228]

To celebrate the railroad meant even more than connecting past and present; the railroad promised to link the capital and the provinces in a unified nation as never before. Speaking in support of a highly developed, nationally planned rail network in 1837, Baptiste Legrand, director of civil engineering, explained with visionary zeal that "the roads are the highways of agriculture; the canals and rivers are the highways of commerce; the railroads are the highways of power, of enlightenment, and of civilization."[229] If early writings appear in retrospect naively utopian in their belief that improved communication of products, people, and ideas would bring about a universal and harmonious society, the debate was argued with more particularity (but still with bitter disagreement) in the 1850s and 1860s, when the railroad's influence on society was no longer a theoretical matter.

Eugène Flachat, writing in 1863 about "the relative influence of the railroads in France and England on the public wealth, morals, and life-force of the nation," argued that the rails had indeed brought greater economic equality and political unity to the nation.

"Once, one was Breton, Gascon, Normand, Picard, Lorrain, Alsacien, Provençal," he wrote, "but it was only in the top professions, in the big cities, in the army or the navy that one understood and loved France."[230] According to Flachat the difficulty of moving people and goods by road, river, and canal had fostered the continuing use of *patois*, or regional dialects, had prevented contact with other parts of the nation, and had led to vast differences in prices for basic commodities in different regions of France. "The railroads," he said, "have everywhere spread a more equal political life. In the provinces hope is springing up on all sides for the institutions and establishments needed to speed the march of civilization."[231]

Others argued that the railroads had had precisely the opposite effect. Until the weave of the railroad network was much finer, wrote Gustave Poujard'hieu in 1859 in a volume advocating a more extensive rail system, it would only heighten the economic disparity between rich and poor regions.[232] Because the interests of urban capital determined rail routes, he insisted, they traversed only the richest and most populous regions and served the needs of industries built in the previous half century. The poorest districts, essentially agricultural, had yet to see the railroad.[233]

Adolphe Meyer wrote in the same year of the effect that the new line from Marseilles to Toulon was having on the region. Like Flachat and Poujard'hieu, Meyer spoke of the economic changes brought by the railroad, but he also expressed concerns beyond the economic. As a native of Aix-en-Provence with a sensitivity to the traditions of his region, Meyer did not welcome the homogeneity that the railroad was bringing to the nation. Unlike Parisians, who saw the railway as a civilizing force and the conduit by which the cultural and political unification sought by the Revolution and Napoléon I might finally be achieved, and who regretted the persistence of *patois*, of local weights, measures, and currencies, and of pagan superstitions,[234] Meyer saw cultural richness in peril: "It is to be supposed that the deeply original character of the inhabitants of this part of our land will soon be changed as a result of building the railroad. The calm, the poetry, and the happiness that the rural pop-

ulation finds in the secluded life will no doubt disappear along with the old customs, the prejudices—if you prefer—and the ancestral traditions."[235]

Baldus's presentation of the railroad—in an album commissioned by the rail company itself—clearly aimed to put forward the side of Industry, Empire, and Civilization. In celebrating the railroad and placing it in a historical context, Baldus confirmed the current definition of French nationhood. In another age the Roman roads, arenas, aqueducts, and other public works united the populace, provided the structure and resources that made life possible, and tied distant settlements of the empire to the imperial capital, both physically and culturally. Later, the Gothic cathedrals linked diverse people in common beliefs and values, and provided a physical center for the life of the community and a moral center for the life of the individual. In Baldus's day it was the railroad that brought about nationhood. First, by facilitating the communication of goods, people, and ideas between the capital and the provinces and between France and the world, it unified the nation physically. Second, by requiring the standardization of time, currency, measure, and language, the railroad reinforced the economic and cultural unity of the nation. And finally, by linking the work of modern engineers with a glorious past, Baldus showed the railroad to be part of a national history that stretched back to antiquity and gave legitimacy to the Second Empire.

The Photographs

What of the photographs themselves? To sustain creativity—to recognize that what was once new and untested has become the tried and proven path, and to abandon it for something once again uncertain—is perhaps the greatest challenge for any artist. By the time Baldus received the PLM commission in 1861, he had long since developed successful formulas for composing pictures and for conveying ideas about architecture and the vestiges of history. Returning to the facade of Saint-Trophîme, to the Pradier and Questal fountain, and to the amphitheater in Nîmes with glass negatives in hand, he set up his camera in precisely the same positions he had selected in 1853. His new photographs had the greater clarity of glass and recorded the changes brought about by restoration, but they were not new *pictures*. The artist had not rethought the processes of represention and communication. Though proof of Baldus's mastery of the genre, the large-format views of historic monuments in the PLM album, drawn from his earlier work or newly made, no longer represented an artistic advance. Those views made on smaller glass negatives (e.g., *Saint-Rémy*; *Château, Tarascon*; *Montmajour*; *Temple of Diana, Nîmes*; and *Gate of Augustus, Nîmes*) rely, to an even greater extent, on habit rather than on careful consideration.

When he began work on the PLM album Baldus was most creatively exploring landscape rather than historic architecture, and it is likely that he had just completed in the preceding year or eighteen months the majestic landscape photographs of La Ciotat that figure near the end of the album (pls. 81, 82, and 84). Here, Baldus tempered the impression of nature's overwhelming scale and raw power that was so present in the alpine scenes. Focusing on the features of the landscape as though they, too, were monuments, these photographs possess a classic balance which parallels that of Baldus's architectural views of 1855: a human scale, despite the grandeur of the scene; a softness of surface, whether rock, vegetation, or water; a perfect gradation of tone; and subtle effects of light and shadow. These are civilized landscapes.

But throughout the PLM album the moments of greatest invention come in Baldus's depiction of the railroad. In the queen's album of 1855, Baldus had suggested a relationship between the railroad and the town of Saint-Leu d'Esserent by including the railroad tracks in the lower zone of the picture to form a visual foundation for the houses and church (pl. 28). In 1861 or 1862 he articulated the same idea at La Voulte with a more heroic gesture (pl. 75). In the later image, of Industry Triumphant, the iron arch—more than sixty yards wide—of the recently completed viaduct spans the entire town, the château, and the Romanesque-style church.[236] The

Fig. 67. Jean-Joseph-Bonaventure Laurens (1801–1890). *Southern Entrance to La Nerthe Tunnel*, 1857. Lithograph. Musée de la Voiture et du Tourisme, Compiègne

boldness of *Viaduct at La Voulte* in comparison with *Saint-Leu d'Esserent* may be Baldus's response to the far greater presence of advanced works of civil engineering on the PLM line than on the Paris–Boulogne route, but it is surely also his fulfillment of the PLM album's more overtly intended role as a celebration of the railroad's transformation of the land and culture of France.

As in the best of his earlier architectural photographs, the aesthetic innovation of this picture is perfectly married to its documentary function. Baldus framed the bridge at a slight angle, yielding a nearly frontal view of the masonry pier and iron voussoirs at the right while showing a three-quarter view of the pier at the left. In so doing he made evident the width of the bridge and revealed the underside of the metal construction; the structure, shown unobstructed, remains clearly defined throughout. Combined with the strong frontal lighting, the angled view records the airy network of iron both as light against dark shadow and as dark silhouette against white sky.

Just how novel Baldus's depiction of the railroad was can be seen by comparing his photographs with the contemporaneous lithographs that Jean-Joseph-Bonaventure Laurens (1801–1890) made of the same subjects.[237] Laurens also enjoyed the official patronage of the PLM company, receiving a subsidy for a series of lithographs entitled *Album des Chemins de Fer de Lyon à la Méditerranée*.[238] These prints, most made between 1857 and 1863, include views of historic monuments and landscapes as well as scenes directly related to the railroad.

Often, at first glance, it would seem that photographer and lithographer had stood side by side, so close are their compositions, but in every case the works of the two artists diverge in form and meaning. Near the entrance of the tunnel at La Nerthe, Laurens stood with paper and pencil close to the spot where Baldus would soon set up his camera (fig. 67). Positioned at the side of the roadbed, Laurens drew the tracks parallel to the picture plane. He downplayed the feat of the engineer, placing the tunnel to the side and obscuring its distinctly man-made geometry as if it were analogous to the natural cleft in the rocks at the right. Its function is made clear in a narrative way: a locomotive steams through the tunnel arch, a convention Laurens repeated elsewhere—as did nearly every other artist who drew a railroad tunnel. He added figures at the right (resting workmen or weekend picnickers?) and provided a verdant setting.

Baldus took a different course. His *La Nerthe Tunnel, near Marseilles* (pl. 79) presents an opposition between the immovable mountain, which seems to engulf the tunnel's architectural entrance, and the black arch at the center of the picture. The space of the tunnel—a void without visible end, carved out by brute force—is unlike the bravado of viaducts and other constructions pictured in the PLM album, such as the soaring, lacy web of the *Aqueduct at Roquefavour*, the image that precedes this one in the album. Only by accentuating the barrenness of the setting (going so far as to mask out the few trees that topped the rock), the seeming impenetrability of the stone, and the limitless blackness within, could Baldus hint at the scope of what was, in fact, the most difficult engineering work on the entire Lyons–Marseilles line and the longest tunnel yet seen in France.[239]

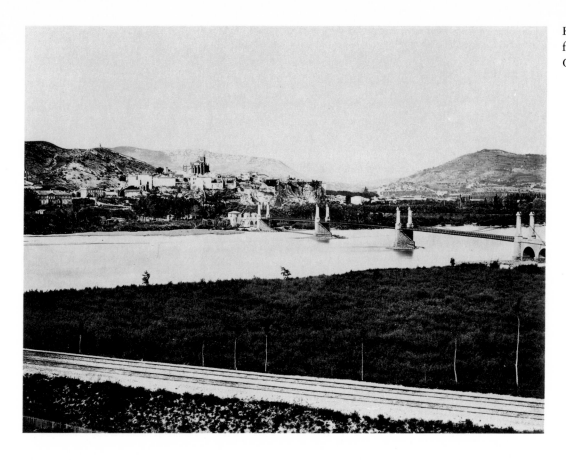

Fig. 68. *Viviers*, ca. 1861. Albumen silver print from glass negative, 33.4 × 43.1 cm (13 1/8 × 17 in.). Gilman Paper Company Collection

Framing the scene so that the tracks lead in a gentle curve directly to the stone cliff and the tunnel opening, Baldus emphasized the confrontation between the requirements of the railroad and the features of the terrain—indeed, between Second Empire man and the constraints of nature.

In comparing the photographs of Baldus with the lithographs of Laurens, one also has a different sense of the artist's place within the scene. Laurens positioned himself—and, by extension, the viewer—off to the side, an unobtrusive bystander examining the motif out of the corner of his eye; to this end, his compositions are balanced but asymmetrical, scattered in their focus. By contrast, Baldus employed the same approach as in his earlier photographic work—a direct confrontation between camera and subject, an uncontested focal point, and, in those where figures pose, an awareness of the presence of the photographer. By applying an old strategy to a new subject, Baldus achieved a radically new result.

A pair of consecutive plates in the PLM album shows another instance in which the relationship of railroad and landscape inspired Baldus to invent a new way of seeing. Poised halfway up a rocky slope at the Donzère Pass, the northern entrance to Provence, Baldus pointed his lens toward Viviers on the opposite bank of the Rhone (fig. 68). Like earlier views (pl. 27), the picture is a succession of light and dark bands that move into the distance step by step: the rocky foreground, the straight tracks, the verdant riverbank, the flowing Rhone, the far bank, the hilltop town and church, the distant mountains, and the sky. This is the work of a proven photographer performing his well-practiced art.

In the following plate, however, *Entrance to the Donzère Pass*

89

(pl. 78), Baldus made a visual discovery and produced a picture unlike any he had yet made. It was, perhaps, while carrying his equipment to or from his hillside perch that Baldus paused along the very stretch of track pictured at the bottom of *Viviers* and saw the landscape as never before. Rather than an orderly succession of planes, *Entrance to the Donzère Pass* is a vortex. Everything moves toward the distant point where the tracks round the bend, pivoting around a telegraph pole. The cliff wall, the tracks, the embankment, the river, and the distant mountains rush from the corners and edges of the photograph. By animating the landscape itself with a sense of speed, Baldus departed from painterly tradition and from his own pictorial habits as radically here in 1861 as he had in 1854 with *Saint-Nectaire* (pl. 16) and *Rocks in the Auvergne* (pl. 20). It is not a narrative depiction of the railroad's transformation of the landscape that Baldus gives here, but rather a visceral expression of space and time in a new age.

The final pair of images restates the album's central theme and climactically demonstrates the boldness of Baldus's artistic invention. Here, wilderness and civilization—Nature and Man—are juxtaposed. *Ollioules Gorge, near Toulon* (pl. 85), probably made on the same campaign as the photographs of Savoy and the Dauphiné, is barren and untamed. The picture, like the gorge itself, is walled in by cliffs at left and right, an effect emphasized still further by the blackness that edges the sides and bottom of the print. The retaining wall at the left (serving what purpose is unclear), the vestiges of a ruined château on the farthest hill, and the few scattered trees barely relieve the desolation of the rocky landscape. Turn the page and one is in a different world. In *Toulon* (pl. 86) there is a Cartesian order to the arrangement of space and structures. The materials are iron and glass, dressed stone and brick. Everything is crisp, industrial, modern. Most dramatically, the tracks, that "great demarcation line between past and present,"[240] race straight back through the station, as if pointing toward Nice and the Italian frontier (lines already viewed as the next logical extension of the PLM network)—and toward the future.[241]

Although more than half Baldus's professional life still lay ahead, his greatest achievements had already been realized by the early 1860s. During the next two decades Baldus increasingly shifted his energies from the production of great photographs to the commercial and industrial applications of the medium.

In part, this shift can be explained by personal factors. In the years following the death of his wife in March 1858, her mother, Mme Étienne, probably helped care for the children.[242] After Mme Étienne's death in April 1862, the responsibilities of fatherhood may have kept Baldus closer to home and to his three teenage children, and prompted him to focus on Parisian views and on the publication of his work in gravure form. By 1869, when his daughters were married and his son had reached majority, Baldus was approaching sixty, and the labor and hardship that characterized the extended photographic excursions of his younger days may have seemed less appealing, less necessary, or less possible.[243]

But there were also external reasons for the change in Baldus's photographic activity. Throughout the 1850s and 1860s, the course of the medium itself increasingly shifted away from the large, richly printed photographs that Baldus produced and that were so admired and collected within the photographic community. Instead, social and economic forces pushed photography toward ever-cheaper and more widely distributed images. In the early 1850s few outside scientific, artistic, and aristocratic circles collected photographs, but by 1860 the carte-de-visite portrait and the stereo card, produced by the thousands and available at extemely low cost, had brought photography into the homes of a much broader public. It was surely in an attempt to market his work to souvenir-seeking tourists and to the public, rather than to the photographic connoisseur, that Baldus produced a series of small-format views of Paris and even tried his hand at stereographic photography (fig. 69).[244]

Civil Engineering Projects

The Chemin de Fer du Nord and PLM albums were not Baldus's only photographic forays into the industrial world. Civil engineers found photographs to be a useful tool for both education and documentation and in the late 1850s brought photography into the library and curriculum of the École des Ponts et Chaussées, where the nation's engineering corps was trained.[245] In the log of photographs given to the school, the first entries record gifts from the Bissons (photographs of the aqueduct at Roquefavour) and Baldus (views of the viaducts at Tarascon and across the Durance) given prior to the first dated entries, which record gifts in March 1859. With these large photographs and their variants, showing the full spans of the Durance (pl. 76) and Tarascon viaducts in two-part panoramas, each more than forty inches wide, was a picture of still grander scale. Baldus's largest extant photograph is a panorama of the canal bridge across the Garonne at Agen, formed of six negatives, printed on three sheets of paper, and measuring roughly 30 × 100 in. (fig. 70). Although in a sad state of disrepair, this remarkable photograph still impresses one with its scale and the sweep of its vision.

Only a few photographs of French railroads are known from the early 1850s, and Baldus's 1855 album for Queen Victoria was without

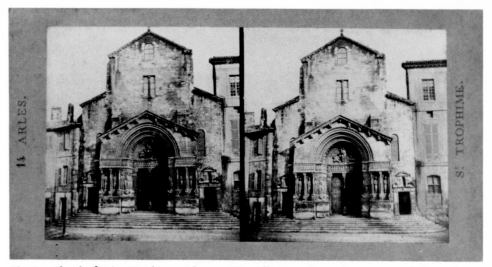

Fig. 69. *Church of Saint-Trophîme, Arles*, ca. 1864. Albumen silver print stereograph from glass negative, 7 × 14.2 cm (2³/₄ × 5⁵/₈ in.). Collection Pierre-Marc Richard, Paris

precedent in the medium of photography. But by the late 1850s, during the period of rapid rail expansion and the early transformation of photography into a commercial industry, railroad works and other major engineering projects were routinely photographed. In April 1858 the director of the École des Ponts et Chaussées observed

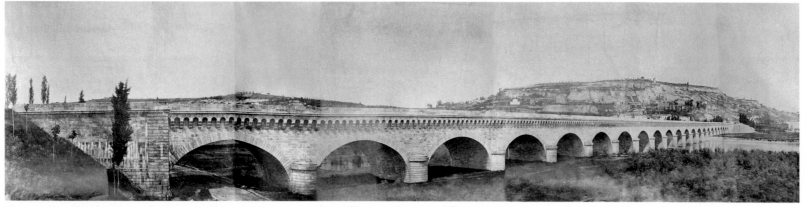

Fig. 70. *Canal Bridge Across the Garonne River, Agen*, ca. 1855. Three albumen silver prints from six negatives, 73 × 249 cm (28³/₄ × 98 in.).
École Nationale des Ponts et Chaussées, Paris

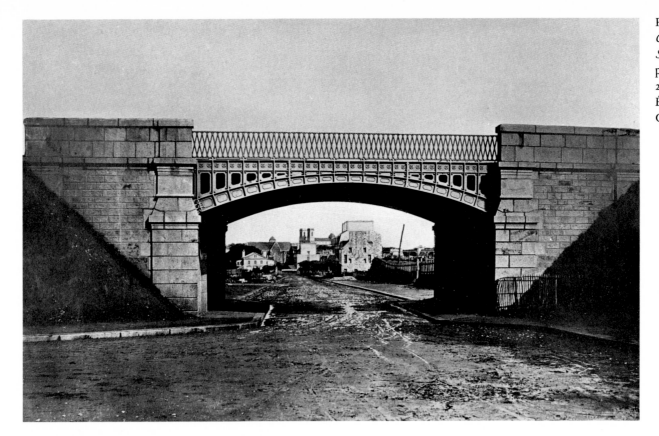

Fig. 71. *Cast-Iron Overpass, Chemin de Fer de Rennes à Brest, Saint-Brieuc*, 1863. Albumen silver print from glass negative, 28.2 × 43.9 cm (11 1/8 × 17 1/4 in.). École Nationale des Ponts et Chaussées, Paris

that photography "is by now employed on many worksites, not only to record the details but even to see the state of progress of the construction."[246]

Baldus's contemporary Hippolyte-Auguste Collard (who promoted himself as the official photographer of civil engineering), for example, was commissioned to document the numerous bridges built across the Seine in Paris in the late 1850s and 1860s.[247] Collard's portfolios show successive stages of construction and amply document the activity of the worksite—workmen performing various tasks, scaffolding and machinery scattered about, and piles of timber, stone, and gravel at the ready. Collard also produced railroad albums at the same time that Baldus was working on the PLM album,[248] but he focused on bridges, viaducts, stations, and other railroad installations rather than on historic monuments or towns along the route.

The same is true of A. J. Russell's photographs of the American railroads, Charles Clifford's of the Spanish railroads, and those of a host of local photographers in other regions of France.

Only rarely did Baldus photograph an industrial construction site. He was, in general, more interested in celebrating the heroic accomplishments of the engineers than in detailing the practical means by which they achieved their results. One exception is the series of five photographs Baldus made along the Toulouse–Bayonne line in July 1861, which shows the Hastingues, Bidouze, and Aran bridges under construction (pl. 68).[249] Although no archival documents survive to indicate the origin of these photographs, their presentation makes it clear that they were made at the request and for the use of the railroad company and its engineers: each bears a printed series title at the top, a precise title and date

below, and a legend at the bottom giving technical details of the construction shown.

Twice more, civil engineers called upon Baldus to document their projects. In a set of five photographs made in 1863 along the railroad line from Rennes to Brest, in Brittany, Baldus presented the bridges and viaducts in a straightforward and highly distilled style (fig. 71).[250] These photographs seem generic rather than specific, brought back from the edge of dullness and formula only by the incidental details of the scene—the muddy road and distant houses in one view, the railroad ties piled at the side in another.

Finally, in 1864, Baldus recorded the construction of the Al-Kantara bridge in Constantine, his only known work from Algeria.[251] He made six photographs of the construction high above the ancient Roman bridge and the black depth of the Rummel Ravine.[252] In the most dramatic of these (pl. 69) the half-built bridge, at the top edge of the page, looms above the rocky chasm.[253] A decade after most French photographers had abandoned the paper-negative process in favor of wet collodion on glass, Baldus continued to use the process he had mastered more than a dozen years earlier. The relative ease of working with paper, which required no on-site darkroom, surely governed his choice of negative material for a mission that took him far from home and into uncertain work conditions.

Small-Format Views

Most of Baldus's work after the PLM album, however, was closer to home. In the early 1860s he produced a series of ninety-five small-

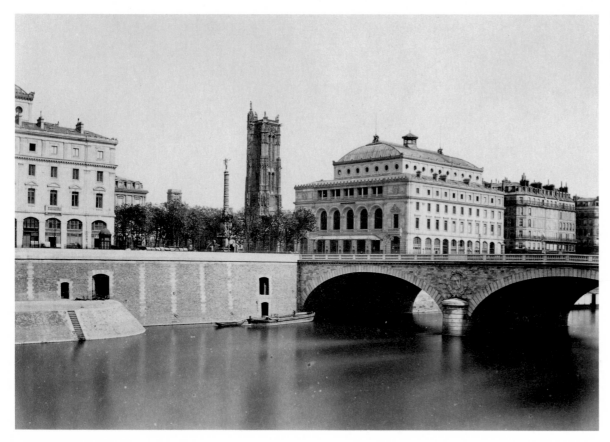

Fig. 72. *Theaters of the Place du Chatelet, Paris*, ca. 1864. Albumen silver print from glass negative, 19.2 × 28 cm (7$\frac{1}{2}$ × 11 in.). The Metropolitan Museum of Art, David Hunter McAlpin Fund, 1944 44.55.15

format views of Paris (fig. 72), albumen prints from glass negatives approximately 22 × 29 cm (8⅝ × 11⅜ in.).[254] These small-format photographs often duplicate the subject and viewpoint of Baldus's earlier large-format paper or glass negatives and in some cases are mere copy photographs of the earlier work. Nonetheless, they pale in comparison to their antecedents. In the later work Baldus was less concerned about perspectival distortions and distracting elements in the negative, and less attentive to the tonal balance, color, and surface quality of his prints. Equally important, for an artist known during the previous decade for the enormous size of his prints, the diminished power is simply a matter of scale.

Surely intended for the tourist and the broad public, these small-format views of Paris are the forerunner of the photographic postcard, often collected as an aide-mémoire and assembled by the purchaser in volumes with such titles as *Vues de Paris*, *Souvenir de Paris*, and *Paris en photographie*. While interesting from the standpoint of the social and commercial history of photography, these small-format views remain of decidedly secondary importance for those seeking the pinnacles of Baldus's accomplishment.

Photogravure Publications

Beginning in the mid-1860s and lasting until the early 1880s—in other words, for more than half his career as a photographer—Baldus's primary commercial activity centered on the production of photogravures, a process that he had first explored in 1854. Photogravures are printed with ink on paper and are thus inherently more stable than photographic prints produced by light and chemistry; rather than being etched or engraved manually, the metal printing plate is produced photographically from a negative. Baldus's photogravure process (or *héliogravure*, as he called it) triumphed equally as a photographic method of producing facsimile gravures (fig. 73) and as a gravure method of printing photographic images (figs. 74 and 75).

Baldus exhibited photogravure facsimiles of old master prints as early as 1855 (see appendix 9), receiving high praise.[255] His first

major publications in gravure form, issued from 1866 to 1869, reproduced the ornamental engravings of past masters. One volume reproduced the work of fifteenth- to eighteenth-century artists including Aldegrever, Dürer, and Holbein,[256] another the work of the sixteenth-century Italian engraver Marcantonio Raimondi,[257] and still other volumes more than four hundred designs for furniture, fireplaces, cups, vases, trophies, finials, balustrades, decorative ironwork, cartouches, and arabesques by Jacques Androuet Ducerceau (fig. 73).[258]

Although these apparently met with some success (one volume, at least, having been issued in a second edition), Baldus's facsimile publications had nothing to do with promoting artistic photography or his own photographic work. Instead, they were an industrial applica-

Fig. 73. Plate 25 from the *Meubles* series, *Oeuvre de Jacques Androuet dit Du Cerceau*, 1869. Photogravure, 18.2 × 13.7 cm (7¼ × 5⅜ in.). The Metropolitan Museum of Art, Rogers Fund, transferred from the Library 1994.123.25

Fig. 74. *Tuileries, South Wing, Quay Facade*, from *Palais du Louvre et des Tuileries*, 1869–71. Photogravure, 8 × 29 cm (3¹/₈ × 11³/₈ in.). The Metropolitan Museum of Art, Gift of George L. Morse, transferred from the Library 1994.128.1.10

tion of photography that brought credit and financial gain to Baldus as an inventor and entrepreneur rather than as an artist.

Baldus first published his own photographs in photogravure form in a publication on the architecture and ornamentation of the Louvre and the Tuileries Palaces issued in installments beginning in 1869 (fig. 74).[259] His process yielded richly inked, velvety textured prints with an extraordinary clarity and fineness of detail, which he heightened occasionally with etched lines added by hand.[260] The three volumes of *Palais du Louvre et des Tuileries*, each with one hundred plates, parallel the photographic albums made earlier for the minister of state in presenting sculptural and ornamental details as well as a few larger architectural views. The publication must have seemed ironically timely, for while it was still being issued the Tuileries Palace and parts of the Louvre were burned down during the 1871 Commune. Unlike the score of photographers who documented the dramatic wreckage of the Franco-Prussian War and the Commune, Baldus appears not to have photographed the ruined shells of the Second Empire.[261] Perhaps ill at ease depicting the destruction left in the wake of war between his native country and his adopted home, Baldus chose instead to publish the photographs

that had earlier earned him his reputation—clear and glorious representations of the civic and ecclesiastic buildings of historic and modern France.

Encouraged by the success of his volumes on the Louvre, he published a portfolio of one hundred photogravures reproducing elements of interior and exterior decoration of the Château de Versailles and of the Grand and Petit Trianons—garden vases, statuary, fountains, paneling, moldings, consoles, tables, and so forth, as well as six exterior architectural views.[262] Like his facsimiles of older engravings, his publications on the Louvre and Versailles formed pattern books for students, designers, and architects to use as models of good taste.

With his photogravure publication *Les principaux monuments de la France* of the early 1870s Baldus came full circle, issuing in gravure form a series of his architectural photographs much like his *Villes de France photographiées* of the early 1850s.[263] In a few cases he even used the same negatives that he had made decades earlier (e.g., *Church of Saint-Gilles* and *Church at Issoire*).

Baldus's last known photographic activity was a publication much in the same vein as his Louvre and Versailles volumes—a collection

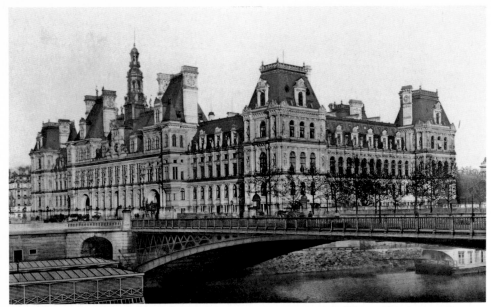

Fig. 75. *Hôtel de Ville, Paris*, 1884. Photogravure, 27.7 × 41.3 cm (10⁷/₈ × 16¼ in.). Canadian Centre for Architecture, Montreal

of one hundred photogravures of the architecture and sculptural decoration of the new Hôtel de Ville of Paris, built from 1882 to 1884 to replace the building burned down by the Communards a decade earlier (figs. 75 and 91).[264] Although similar in content and style to his earlier work at the Louvre, more photographs of the architecture per se are included. No documents have been found to indicate whether Baldus was officially charged with the documentation of the reconstruction, as he had been at the New Louvre, but the photographs themselves show that he must have had access to the construction site and darkroom facilities close at hand. Typically, Baldus avoided any overt political comment: There are no views of the old Hôtel de Ville or of its burned-out shell, nor is there any accompanying text concerning the history of the building. In the final exterior view Baldus showed the reconstructed Hôtel de Ville from the opposite bank of the Seine (fig. 75), much as he had shown its predecessor in a succession of views beginning a full thirty years earlier (pl. 10). Baldus's aesthetic approach to the representation of

architecture and the construction of a photographic composition had changed little in three decades.

From all his publishing activity, Baldus would appear to have been continuing a long-successful career. Such was not the case. Perhaps having overextended himself in the production of *Hôtel de Ville*, or perhaps the victim of other circumstances, Baldus found himself in October 1885 signing over to his son-in-law Charles Waltner as collateral for a loan of 1,500 francs more than seven hundred copper printing plates for the Louvre, Versailles, Hôtel de Ville, and Ducerceau gravure publications, as well as thousands of unsold prints from them.[265] His action was probably a means of protecting from creditors the means of his livelihood as well as items of sentimental value (a piano, furniture, and faience that had been part of his wife's dowry), for he had already found it necessary to sell his rue d'Assas house the year before.[266] Only fifteen months later, in January 1887, Baldus filed for bankruptcy; the records give no indication of the identity of his creditors, nor of the cause or extent of his debt.[267] No further documents relating to the final years of his life have been found.

Édouard Baldus died at one o'clock in the afternoon, December 22, 1889, in his home at Arcueil-Cachan, a suburb south of Paris.[268] He was seventy-six. He was buried alongside his wife and mother-in-law in the local cemetery.[269]

Neither the national nor the photographic press took note of Baldus's death or recorded his life's achievements. So profoundly had the medium of photography changed that few must have remembered his triumphs of the 1850s, and his more recent work must have seemed strikingly anachronistic. Nor could his family long preserve Baldus's legacy: his son died shortly before him without having married, and both his daughters were divorced and had no children.[270] Today, his tombstone lies neglected and in disrepair, in the shadow of the arcade of the Arcueil aqueduct.

Long after Baldus's death, we can perhaps now separate the magnificence of his articulation and celebration of Second Empire

taste, values, and accomplishments from a political judgment of Napoléon III and from the prejudices of our own age—a romantic nostalgia for pre-Haussmann Paris and a preference for the bohemian over the establishment artist (especially since the concept of an avant-garde did not even exist in photography in the 1850s).

In an age utterly saturated by photographic and electronic imagery, when we have become jaded to the inherent magic of photography and more sophisticated in our awareness of the way in which photographic images are mediated (by the halftone screen, for example), we can again see not only the photographic image but also the photographic print. We pause at the surface of the picture before moving from our own world into the photographer's and revel, as did Baldus's contemporaries, in the seductive *matière* of the still-handcrafted medium—the rich, velvety salted paper prints in colors of gray violet, eggplant, cool black, and ruddy brown, or the absolute clarity of a perfectly preserved albumen print, contact printed from a wet-collodion-on-glass negative. And we find that the meaning of Baldus's work lies not only in the photograph as image but also in the photograph as object.

Only with the perspective of time, with a knowledge of impressionism, modernism, and conceptual art, with the ubiquitous presence of photography and photographic reproduction, and with a renewed concern about the relation between technological progress and cultural history, have Baldus's photographs reemerged as beacons from another age. It is now clear, in a way that it could not possibly have been in 1889, that Baldus established in the 1850s the classic mode of representing architecture both in the single photograph—monumental in its presence and exquisitely legible in its detail—and in the photographic archive—exhaustive in scope and minutely focused in its individual components.

A Matter of Time: Architects and Photographers in Second Empire France

BARRY BERGDOLL

We are certain that architects, for whom the daguerreotype seems to have been
expressly invented, will properly appreciate its rare quality of execution and
will find in these pictures, in which nature herself has taken up the brush, useful
information on the monuments of antiquity and invaluable material for study.

—*Encyclopédie d'architecture* (1852)[1]

From his earliest photographs, Baldus focused his lens princi-
pally on monumental architecture and grand works of engi-
neering. Recording both structures under construction and
ancient and medieval buildings recently elevated to the newly coined
category of protected *monuments historiques*, he developed an austere
and monumental style of framing, composition, and lighting which
memorialized the monuments of France's past and of its emerging
present. For exhibition he carefully pruned his images, rarely show-
ing more than a handful of prints, attentive that his fellow photogra-
phers and critics contemplate only his most perfected images. But his
working day was often spent on construction and restoration sites,
surrounded by architects, site foremen, and ornamental sculptors
(fig. 76). For them he prepared hundreds of photographs which
gradually became part of their own working documentation. Al-
though the history of photography has been principally concerned
with the milieu of amateurs and the selected images Baldus exhibit-
ed, this essay seeks to resituate Baldus in relation to the professional

milieu of architects, who were among his most important clients, and
to place his exhibition prints in relation to the voluminous documen-
tary photographs that paid his bills.

At his death in 1880 Hector Lefuel, architect of the New Louvre,
the grandest new monument and symbol of the Second Empire, left
his successor a working office filled with official documents—
copious handwritten registers, reams of ministerial correspondence,
architectural sketches, precisely rendered construction drawings,
and thousands of paper photographs, the vast majority of them bear-
ing Baldus's signature stamp.[2] By then Baldus had moved on, work-
ing in the early 1880s on the reconstruction of the Hôtel de Ville
under Théodore Ballu. Lefuel and Ballu were not alone in having an
official photographer record aspects of the work; the most important
French public buildings from the late 1850s on had one, if not sev-
eral, photographers at hand.

By the end of the Second Empire Baldus's photographs were
everywhere, from the architectural office to the architectural class-
room and library. Yet the modern architectural historian searches in
vain for an appreciation, even a mention, of Baldus's name by a
nineteenth-century architect. The collections of the Société Centrale

Fig. 76. *Worksite of the New Louvre*, ca. 1855. Salted paper print from glass
negative, 58.5 × 78.9 cm (23 × 31⅛ in.). Musée Carnavalet, Paris

des Architectes, founded in 1841, were formed by donations of its architect members. Beginning in the 1850s photographs of completed buildings, of their construction, and of the plaster models used to study that rich sculptural decoration which became de rigueur for important public buildings during the Second Empire were deposited along with the architect's own renderings. But when signed, these photographs are more likely to bear the name of the architect than that of the photographer. Many are even dedicated by the architect to a colleague with an *hommage de l'auteur*, much as one might sign a personal portrait or a photographic carte de visite.[3] Both architects and photographers actively sought to strengthen their protection under French copyright law, but it was not until the twentieth century that they were granted the same rights enjoyed by other image makers.[4] In this world of fluid authorship rights the photographer remained for the architect a nameless presence, a presence ever more integral to the architect's work of conception and representation as the century progressed, but one who was considered transparent, no more a creative artist in his own right than the lens he manipulated. Accordingly, just as the master architect of a complex project might sign a drawing done by anyone in his office, so the photograph, or *dessin photographique* as it was often called, could be signed by the author of the building rather than by the author of the representation.[5]

This professional silence was reciprocal. Baldus, for example, wrote only about the technical aspects of his art, never giving more than the slightest clue of his awareness of his professional markets or of his own distinctive aesthetic of architectural representation. Yet even without mutual acknowledgment, Second Empire architecture and Second Empire photography continued to reflect one another, each conditioning the other in ways that can now be read from the images and from the evidence of the archives and libraries where photographs came to rest.

Romantic Historicism in Architecture and the Invention of Photography

By the time Arago announced the discovery of photography in January 1839 and laid a daguerreotype of the apse of Notre-Dame before the eyes of the Academy of Sciences, architects had been seeking for over two decades precisely what photography could now offer mechanically: a means of representing architecture with irreproachable precision and objectivity. In the late 1820s and early 1830s, as Niépce and Daguerre experimented with means to capture the image of the camera obscura, a new generation of architects was challenging both the conventions of architectural drawing and the historical philosophy of the French academic establishment. The allegiance of this so-called romantic school to the notion that historical study could be scientific, and could thus provide an objective basis for architectural knowledge, made them especially receptive to the photographer's claims to veracity. This group of architects challenged architectural orthodoxy in the late 1820s and 1830s; they would be among the first to experiment with daguerreotypes in restoration work in the 1840s; and in the 1850s and 1860s they would be involved with professional photographers in new designs.

The painstaking preparation of graphic records of the extant monuments of antiquity was the established bedrock of the academic education of that elite cadre of architects who, having won the Grand Prix for their skills in composition and rendering, were to further their study at the French Academy in Rome. In Italy the pensionnaire of the Academy was to fill his portfolio with drawings after the remains of the antique past, and to send back to Paris each year a detailed restoration study of a key surviving monument, enriching both the library of the École des Beaux-Arts in Paris and the architect's own working portfolios. The study of the monuments of antiquity would thus provide the final set of tools required to conceive the great public monuments in France which were, in large measure, reserved for the laureates of the Prix de Rome.

But in the 1820s a generational conflict emerged that was to acquire overnight the reputation of a sea change in historical atti-

tudes. Spearheaded by a young group of recent laureates—Félix Duban, Henri Labrouste, Louis Duc, and Léon Vaudoyer—the controversy centered on the very raison d'être of archaeological study.[6] Whereas the academicians expected the younger architects to study a roster of the finest models of antique architecture dating from Rome's golden moment, and to derive from them an absolute ideal of beauty, the new generation declared an omnivorous interest in the monuments of all periods from the rise of the Etruscans to the Renaissance. Sustained by the new historiography of Augustin Thierry, François Guizot, and Jules Michelet, they maintained that buildings were often more eloquent testimony to the past than written texts and, for many early civilizations, the only testimony of beliefs, customs, and daily life.

Convinced that materials and constructional technology determined style as much as abstract ideals, the younger generation scrupulously recorded the way buildings were put together, the materials employed, and the effects of contrasting colors that enlivened building surfaces. A new style of precise watercolor rendering (fig. 77) was the result of this attitude, a style in marked contrast to the freer, more personal renderings of their teachers. Sharing their drawings among themselves, they also made precise copies, seeking thus to minimize the role of personal style and vision and to achieve a new standard of historical veracity. Years later Charles Blanc praised the innovations in rendering that Duban had introduced by favorably comparing his Italian drawings to photographs: "If photography could render colors the way it reproduces forms and surfaces, it would be no more precise, of no more appropriate expressiveness, or even of a more striking veracity [than Duban's watercolors]."[7]

In 1826 Antoine-Laurent-Thomas Vaudoyer, secretary of the architectural section of the Academy, wrote to his son Léon in Rome to warn him of the Academy's suspicion that the camera lucida lay behind this new precision. The academicians were alarmed that the pensionnaires were relying on scientific optics rather than on a cultivated artistic intelligence and personal vision. Invented in 1806 by

Fig. 77. Léon Vaudoyer (1803–1872). *Temple du Dieu Redicule, Rome*, 1832. Watercolor, wash, and pencil. Fondation Jacques Doucet, Bibliothèque d'Art et d'Archéologie, Paris

William Hyde Wollaston, the camera lucida—a small prism mounted on a metal rod which permitted the artist to see simultaneously a view of the real world and its projection on his sketchpad—was widely used by traveling artists in Italy, but rarely acknowledged.[8] The younger Vaudoyer defended the honor of the young architects as artists: "The camera lucida . . . would be an entirely useless instrument to anyone who does not know how to draw."[9] But the real issue was the underlying motive for the use of an optical instrument. Architectural monuments were no longer to be the transparent embodiment of abstract ideals of architectural proportion, the repository of standards of classical usage; rather, they would be examined as dense surfaces on which were recorded the social formation of architectural styles through the interaction of cultures, the confrontation of traditional models with technical and material progress, and the impact of changing societal institutions. Henceforth, the

positive truths of history would be the basis of architectural knowledge and design. Arago lamented in 1839 that the artists who had been sent to Egypt with Bonaparte had sketchpads rather than cameras, which would have yielded images of "real hieroglyphics" rather than "fictional hieroglyphics."[10] Likewise for the young generation of Grand Prix winners, most notably Duban, Vaudoyer, and Labrouste, the camera lucida was a valuable guarantee of the accuracy of renderings on which they would rely for years. Photography thus appeared on the scene just as the singular authority of classical architecture was being challenged, broadened to new periods of historical study, and confronted with a quest for scientific truth.[11]

Truth and Restoration: The Historic Monuments Commission

With a commitment to real over ideal history, the younger generation of Grand Prix laureates pursued two parallel activities in Paris in the 1830s and early 1840s as they awaited appointments as head architects of important public buildings. One was the study and restoration of the national architectural heritage for the recently established Historic Monuments Commission, the other the writing of the first comprehensive histories of French architecture. The Historic Monuments Commission, established in 1837 by François Guizot, the historian turned minister of the interior, relied heavily on this new generation in the work of inventorying the national monuments. For the first time the "national patrimony," itself a new coinage, was to be surveyed systematically, submitted to taxonomic organization, and ranked in priority for protection and restoration.[12] The inventory would not only provide field knowledge of the principal phases of national architectural history (still little understood and often maligned); it would also identify buildings most urgently in need of conservation. Most important, it removed historic buildings from local control and established standards and priorities of restoration on a national level; everything was to be controlled by architects from Paris trained in the new historical principles and new restoration techniques. The Commission's most pressing need was

accurate images of the buildings, which would make it possible to make decisions hundreds of miles from the site.

Under the direction of Prosper Mérimée, appointed inspector general in 1834 and first director three years later, the Historic Monuments Commission became a rallying point for a group of architects impassioned by the French Middle Ages, most particularly Mérimée's young protégé, Eugène-Emmanuel Viollet-le-Duc. Félix Duban and the slightly older Auguste Caristie were the two original architect members alongside the historians, antiquarians, and administrators. Labrouste and Vaudoyer undertook frequent missions in the 1840s and joined the central committee after 1848, when it was expanded to include more architects. Mérimée was the great champion of the Middle Ages, and Duban and Vaudoyer promoted the study of the French Renaissance, which represented for them the vital and experimental synthesis of antique forms and harmonies with the constructive genius and curiosity of the French medieval tradition. With these overlapping historical views, the Historic Monuments Commission became a crucible for forging a new alliance between historical study and modern architectural creation.

The value of photography to the historical and architectural work of the Commission was recognized only gradually. As early as March 1839, Baron Isidore Taylor, best known for his monumental *Voyages pittoresques et romantiques dans l'ancienne France*, a recording of the Roman and medieval architectural history of France in picturesque lithographs, proposed that daguerreotypes be used to supplement the Commission's collection of measured drawings.[13] But it was not until the advent of paper and glass negatives, and an increase in the scope of the Commission, that the experiment of the *missions héliographiques*—a systematic photographic survey of major monuments and Baldus's first governmental patronage—was launched in 1851.[14] By then, several of the younger architects had become interested in working with a photographer, most notably on the two showcase restorations of the 1840s, the Château de Blois and the Cathedral of Notre-Dame de Paris.

In August 1843 Duban, a veteran of the controversy over the

camera lucida, commissioned Hippolyte Bayard to make daguerreo-
types of the château at Blois, which he had been asked to study by
the Commission six weeks earlier. Mérimée, who never concealed
his distaste for the daguerreotype, noted Duban's enthusiasm in a
letter two months later to a friend, Albert Staufer:

> You have a great rival in making daguerreotypes. Duban, whom we
> have appointed to study the restoration of the Château de Blois, has had
> some fifty views made. Architecture is always preferable to landscape,
> but until you have found a way to substitute paper for your metal plates,
> you will always have a cold tint which doesn't move me.[15]

Mérimée went on to lament that the duc de Luynes's efforts to pro-
mote experiments in printing from daguerreotypes had, so far, not
yielded satisfying results. Duban's enthusiasm for photography may
well have been fostered by the duc de Luynes, for whom he had been
at work for several years restoring and remodeling the château at
Dampierre.[16] With his hope that the photographic image might
freeze, at least for memory, the effects of time and that it could serve
as the historical conscience of the work ahead, he was probably
drawn to the permanence of the daguerreotype over the paper pho-
tographs which Bayard was pioneering in France at the same time.

As Duban set about planning the restoration of the Château de
Blois, the most complicated of all the restorations undertaken in the
1840s, the daguerreotypes provided vital evidence. No list of views
requested has come to light, so it is impossible to know if Duban
exploited the jewel-like precision of the daguerreotype to record the
decorative details of the château's exterior architecture and to help
him prepare the extraordinarily precise large-scale drawings he
submitted for review in 1844.[17] One of Bayard's three surviving
daguerreotypes from this pioneering campaign reveals that nearly all
the rich ornamentation of the balustrades and pinnacles of the exte-
rior stair of the François Ier wing had been lost or mutilated; all were
recreated by Duban between 1844 and 1848 (fig. 78). Once restora-
tion was under way, the architect turned to an even more direct
means of recording the current state of the structure, taking plaster

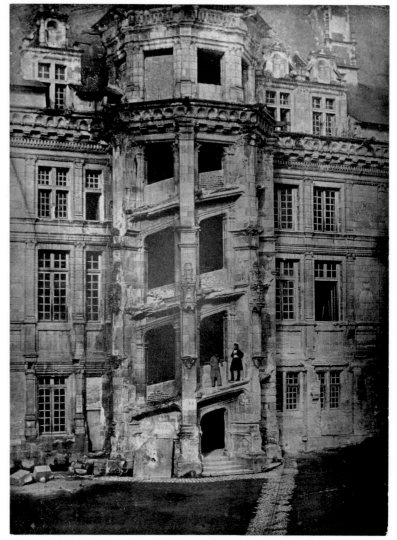

Fig. 78. Hippolyte Bayard (1801–1887). *View of the Staircase of the François I^er
Wing of the Château de Blois*, 1843. Daguerreotype. Société Française de
Photographie, Paris

casts of the principal moldings and ornamental sculpture of each
wing to serve both as historical records and as models for the stone
carvers. Here Duban worked in the spirit of Mérimée's vision of
restoration, though he was more willing to embrace the new tools of
photography than was the pioneer of French architectural restora-

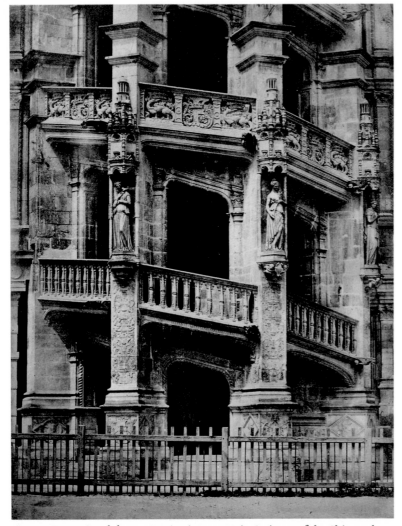

Fig. 79. François-Alphonse Fortier (1825–1882). *Stairway of the Château de Blois*, in *Revue Générale de l'Architecture et des Travaux Publics*, 1856. Salted paper print from paper negative, 24.8 × 18.8 cm (9¾ × 7⅜ in.). The Metropolitan Museum of Art, Library Fund, 1950, transferred from the Library 1990.1101.1

historical moment; the result would be a complex in which the evolution of French architecture was narrated with a clarity accessible even to the layman.

Of course, the daguerreotypes had limitations, which probably accounts for the fact that Duban does not seem to have used photography again for at least another decade. Unlike drawings, which were regularly copied to ensure communication between Paris and Blois—Duban worked only periodically at the site and all his work was submitted for governmental review—the daguerreotype yielded only a single image. And despite its sharp detail, it was tiny. It thus offered much too reductive a scale for design work and could serve only as a complement to measured drawings, often at full scale for ornamental details. As Duban's interest in polychromy extended to his projects for both the interiors and the exteriors of the château, photography's limitations were further underscored. One use, however, was clear: photography could be the historical conscience of restoration. In 1856, for the first time, an architectural journal, the *Revue Générale de l'Architecture*, included photography within its pages, an experiment that would not be repeated for several decades. That year's issue included a tipped-in print of the newly restored staircase at Blois (fig. 79). The reviewer, entranced by the seamless relation between the restored monument and its graphic representation, marveled at the accuracy of the details: "The delicate arabesques which climb playfully up the face of the buttresses can be read [on the photograph] as easily as the joints of the stonework," he noted. "If one pays attention and looks with a magnifying glass one can even differentiate, by the tonality of the stones and the sharpness of the moldings, the parts that date from the original construction from those which have been restored."[19]

Viollet-le-Duc, Lassus, and the Consecration of Photography in Restoration

The two great proponents of the Gothic Revival—Viollet-le-Duc and Lassus, who had begun their collaboration as restorers under

tion. "Prohibiting the imagination is the archaeologist's first duty," Mérimée explained. "Divining must be replaced by scientific analysis, which should allow the historical sciences to make the same kind of progress as the natural sciences."[18] Duban was determined that each wing of the château should be restored to the purity of its own

Duban at the Sainte-Chapelle—were early converts to photography. Indeed, Viollet-le-Duc's transition from the practice of lithography for Taylor's *Voyages pittoresques* to a fascination with photography paralleled his shift from a romantic to a scientific appreciation of Gothic architecture. In 1843, during the competition to restore Notre-Dame, Viollet-le-Duc commissioned daguerreotypes from the optical engineers Lerebours and Kruines, who had a shop at the other end of the Île-de-la-Cité.[20] Lassus celebrated "this marvelous discovery of our era, this admirable technique that obliges light itself to reproduce the image of objects and to fix them on a metal plate, on glass or on paper,"[21] and he relied on it increasingly as an oracle of truth in the extensive historical research he undertook in the archives and on the fabric of each building before allowing restoration work to begin. For Lassus the photograph was both an irrefutable historical record and a powerful instrument in the Sisyphean battle against the ravages of time on these monuments which so many saw as repositories of historical memory. "I have seen important parts disappear—fragments of drapery, of hands, and even a whole head," he wrote in 1849 of the Royal Portal at Chartres, where the stones were crumbling when he began his restoration. "I have daguerreotypes made at different times which give an idea of the rapidity of the problem."[22] Ironically, these daguerreotypes have not themselves survived.

Over the course of his career Viollet-le-Duc assembled a large collection of photographic views of French cathedrals, an essential part of teaching architects' portfolios of prints and drawings. To his son he confided in a letter that the photograph, now the reproducible paper image, was likely to spell the end of the work of countless draftsmen hitherto called upon in restoration projects.[23] By 1851, the year the *missions héliographiques* were organized, Mérimée, having seen a highly convincing view of an interior at the Palais Royal, observed that photography had overcome one more obstacle as a useful instrument for architects: "Viollet no longer carries pencils," he noted, with his flair for exaggeration.[24] Three years earlier the two men had drawn up official guidelines for the restoration of

cathedrals for the Office of Diocesan Buildings (Service des Edifices Diocésains), the division of the Ministry of Education and Religion that was responsible for overseeing restoration work in the French cathedrals. Their requirements included detailed drawings, a full historical text, and an itemized budget. "It would even be appropriate to supply, whenever possible, daguerreotypes of the principal views of the building to be repaired," they suggested, proposing for the first time the systematic use of photography in restoration, three years before the *missions héliographiques*.[25] "It is no longer admissible in our day to draw up a restoration project for a building without having a photograph before your eyes," concluded the *Encyclopédie d'architecture* in 1852.[26]

By the 1860s, the photograph was established without question as a necessary adjunct of restoration work and Viollet-le-Duc's lessons were given a broad distribution by his inclusion of photography among the techniques praised in the 1866 entry "Restoration" in his *Dictionnaire raisonné de l'architecture*, the first theoretical exposition of what he called the modern science of restoration. With the heightened historical consciousness of the nineteenth century, Viollet-le-Duc explained, restoration could now extract a building from the flow of time and render it "in a perfect historical state that may never have existed [at any given moment in the past]." In this rupture in the flow of time, photography played a key role. Whereas drawings, even those made with the aid of the camera lucida, could frequently entail human error, photography

> . . . has the advantage of making possible an exact and irrefutable presentation of a building in any given state; it provides documentation that can continually be referred back to, even after the work of restoration has covered over some of the damage that came about as a building was falling into ruin. Photography has also motivated architects to be even more scrupulous in the respect they must accord to the smallest remaining fragment of an ancient disposition; it has enabled them to come to a more exact appreciation of the structure of a building; and it has provided them with a permanent justification for the restoration work they carry out. It is impossible to make too great a use of photography in

restoration; very often one discovers on a photographic proof some feature that went unnoticed on the building itself.[27]

Just as drawing was for Viollet-le-Duc a higher mode of seeing, so photography was meant to surpass the capriciousness of the eye, to provide a document fixed and immutable that one could return to again and again for information, that one could collate and juxtapose with other images to trace the evolution of style, to constitute a regional style, or to understand the trace of the architect or stonemason.

In the published historical record of the restoration of the Cathedral of Notre-Dame — the *Monographie de Notre-Dame de Paris* (ca. 1860) — photography is fully integrated in the range of two-dimensional representations that communicate the building's complex three-dimensional reality.[28] Plans, sections, and elevations — the traditional trio of architectural representation — are given in fine line engravings, carefully scaled and measured. The stained glass is recorded in chromolithographs. But the only synthetic views of this "ensemble filled with variety like nature herself" are provided by photographs.[29] They alone render the overall presence and reality of the building. The twelve photographs, some signed by the Bisson Frères, date from various moments in the long restoration, leaving a record of the cathedral at different stages in its recent history. If the drawings could disassemble the building into its component parts, conveying their physical relation to one another and revealing what was not readily available to the naked eye, only the photographs could convey the sense of the passage of time, increasingly the preoccupation of historicist architects.

Baldus and the Lessons of the Mission Héliographique

Although historians have often been puzzled by the fact that the *mission héliographique* of 1851 did not spawn a systematic and sustained use of photography by the state's young agency for monumental restoration, it was to have enormous consequence for Baldus, for it inaugurated direct contact with architects.[30] The photographic missions, granted to Hippolyte Bayard, Henri Le Secq, Gustave Le Gray, and O. Mestral, in addition to Baldus, had been drawn up by a subcommittee that included Léon de Laborde and Charles Lenormant, both founding members of the Société Héliographique, Henri de Cormont, Mérimée, and a single architect, Léon Vaudoyer. Mérimée, along with Vaudoyer, who was just completing a serialized history of French architecture for the popular magazine *Le Magasin Pittoresque*, probably had the greatest hand in drawing up the list of monuments and views to be included, judging from the fact that the regions chosen corresponded to the principal schools of French Gothic architecture. Monuments in two categories were emphasized: those important in the history of French architecture and those currently being restored or considered for future restoration. Despite the wealth of monuments in many places visited, only one or two buildings had been selected for each site.

For the architects it may have seemed that one photographer was interchangeable with another; it was the objectivity of the image that mattered. But styles quickly emerged. If Le Secq would increasingly concentrate on the poetry of architecture, on the play of shadows over sculpted figures and modeled architectural surfaces, Baldus pursued a different understanding of architecture. By the time he completed his *mission* he had absorbed the aesthetic preferences and historical ethos of the Commission. The ideal of the individual monument, freed from the distractions of urban fabric and, when possible, even from later "parasitic" additions, would henceforth be his as well. Monuments were to stand apart, their profiles and details speaking clearly for a whole phase of French civilization. As Baldus retraced his steps in the Midi in the following years, returning to many of the same subjects for his sales lists and for his most important subscriber, the Ministry of the Interior, he honed a personal style much indebted to contemporary architectural beliefs. Over and over again his subject dominates the frame. He isolated the monument visually from its immediate surroundings, and he favored a horizon line that minimized distortion of the principal lines of the architecture. When possible he chose an elevated viewpoint, such as

in his views of the Temple of Augustus and Livia at Vienne and of Notre-Dame at Beaune (pl. 6). This not only permitted him to fill his frame with the monument; it created an undistorted elevation approximating that of an architectural rendering.[31] In addition he generally chose light conditions that allowed a sufficient amount of detail to be seen without sacrificing the overall silhouette, which conveyed the building's characteristic physiognomy. He allowed himself an oblique perspective only when it would underscore the volumes of the building. And he fully subscribed to the notion of architectural legibility dominant in mid-nineteenth-century architectural theory; architects could read the vital facts of a building's structure, style, and details in Baldus's prints, just as the general public could read French history through a direct confrontation with monuments they had never visited.

Baldus's subjects, as well as his style, show a keen awareness of contemporary architectural priorities. As Ernest Lacan noted in 1853 of the photographer's first independent campaign, *Villes de France photographiées*, "[Baldus] wishes to assemble in his portfolio views of monuments that represent the diverse architectural styles of France. He will thus be able, when his work is completed, to offer the architect, the painter, and the archaeologist a collection of all the types of buildings, from the heavy structures that the Roman colonies left in our ancient cities to the hybrid constructions of the last century. Each will have its place in this gallery, which is at once historical and artistic."[32] This gallery, however, was not original; it drew directly on the new canon of French architectural history defined by the generation of romantic architects and the advocates of the Gothic Revival.

Beginning with a series of articles supplied by Albert Lenoir and Léon Vaudoyer to the *Magasin Pittoresque* and published serially from 1839 to 1852, a new historiography had emerged in which the evolution of French architecture was recounted as a linked chain of key monuments that simultaneously advanced the progress of style and the progress of civilization. The same notion was reflected in Daniel Ramée's *Manuel de l'histoire générale de l'architecture* (Paris,

1843) and Louis Batisser's *Histoire de l'art monumental dans l'antiquité et au moyen âge* (Paris, 1845). The most richly illustrated of these monumental histories was Jules Gailhabaud's *Monuments anciens et modernes: Collection formant une histoire de l'architecture des différentes peuples à toutes les époques*. The four folio volumes of this much-consulted work were issued in 1850, and included full-page engravings after drawings by scores of architects, including Lenoir, Viollet-le-Duc, Vaudoyer, and Labrouste. It is striking how consistently Baldus chose buildings given prominence in these histories, frequently those included among the engraved illustrations. Baldus was after the consecrated, not the unknown or the novel. Like the editors of the *Annales Archéologiques*, who applauded each new collection offered for sale by the growing number of photographers specializing in architecture,[33] Baldus hoped that photography would create the museum of architecture so often discussed by French architects as a vital resource for teaching and public education. Baldus's genius lay not in his choice of subjects but in his keen sense of composition and the austere discipline of his views, in which he aimed to surpass any of the known views in their drama, immediacy, and embodiment of the monumental. Baldus generally provided only one view of a building, even though the standard architectural representation of a building required, minimally, a plan, a section, and an elevation, frequently complemented by several perspective views. But just as historicist architects were persuaded that a single monument could summarize a phase of history, so Baldus sought the single view of the building that could convey its physiognomy, its meaning, its majesty, and its overwhelming presence as a monument.

Yet given the quest for truth, for Viollet-le-Duc's "exact and irrefutable presentation of a building," what ultimately intrigues anyone who spends time with Baldus's large-format architectural views of the 1850s is his persistent reworking, or editing, of the images. Over and over again one discovers evidence of the painstaking work of painting and cutting-and-pasting on many of the negatives. Skies are almost systematically suppressed, lending the buildings a more salient profile. Distracting incident is eliminated by

the framing. Most striking is the disappearance of parts of neighboring buildings that rival or distract from the majesty of the monument. One of the earliest examples of such reworking is evident if several views of Saint-Trophîme at Arles are juxtaposed (figs. 14 and 69). Baldus had already photographed the Romanesque church in 1851 for the *mission héliographique*, but in 1853 and on several later occasions he returned to take new views. Some were carefully edited, allowing the monument to surge upward with clean rectilinear lines to gain a greater majesty for the church's profile. Although nothing changed at Saint-Trophîme during these years, Baldus took the liberty of removing the upper story of the buildings at either side, one of which served as the bishop's palace! At Nîmes Baldus cleaned up the square around the Maison Carrée (see figs. 12 and 13), taking it upon himself to act on the conclusions reached by Auguste Caristie, whose excavations in the 1820s revealed that in antiquity the temple had stood in the midst of an impressive forum.

Baldus was working in the spirit of many restoration projects of the 1840s and 1850s which sought to "free" monuments from later additions and distracting urban fabric. And he was echoing the philosophy advanced by such architectural theoreticians as Hippolyte Fortoul, Léon Vaudoyer, and César Daly that each epoch in architectural history was characterized by its own particular line and silhouette.[34] The practice of *dégagement* had been conceived theoretically as early as the mid-eighteenth century, when Voltaire declared that for Paris to become a city of magnificent monuments, it would suffice to demolish the parasite structures that hid the city's splendid history from view. But under the Historic Monuments Commission *dégagement* became part of the battery of restoration techniques intended, paradoxically, to underscore the historical purity of monuments by creating a frame of empty space around them. For the armchair traveler or student of architecture, Baldus invented the art of virtual restoration.

Under Baron Haussmann's reign as prefect of the Seine, *dégagement* became the slogan of a comprehensive urban aesthetic. From his appointment in June 1853 the *artiste démolisseur*, as Haussmann's

detractors soon labeled him, formulated the vision of a city of grand avenues culminating in a series of key architectural monuments. But even before the architects and engineers arrived on the scene to carve views through the city, leveling entire streets and districts to "liberate" views and to craft a new hierarchy between foreground monuments and background fabric, Baldus had begun to edit the urban scene in his Parisian views. Quite coincidentally, he delivered the first set of four photographs of the promised *Villes de France photographiées* to the ministry just one week before the famous ceremony in which Napoléon III handed Haussmann a map of the works he wished to see executed in Paris. But Baldus seems to have anticipated the prefect's plans! A second group of eight prints arrived six months later and concentrated on Parisian subjects, notably the sequence of monuments that Haussmann was beginning to align along the east-west axis running from the Arc de Triomphe at the Étoile via the Louvre to the Hôtel de Ville.[35]

Baldus had recorded the work of *dégagement* begun by Haussmann's predecessor Jean-Jacques Berger in his 1852–53 view of the Tour Saint-Jacques newly liberated from surrounding structures (pl. 11) as part of the work on the operation to create a monumental cross axis of the principal north-south and east-west boulevards at this point.[36] The church tower, lost in the densely woven fabric that had overtaken the site of the church demolished during the Revolution, was now to be set alone in a verdant square. It would serve as a great urban marker where the extended rue de Rivoli crossed the future boulevard de Sébastopol. This view of a demolition in process is rare in Baldus's work, and he would soon replace it on his stock list by a photograph of the tower as restored by Ballu, with a monumental neo-Gothic base and a full complement of Gothic-style ornaments to replace the damages of the Revolution and the decay of the ages (fig. 80). Unlike Charles Marville, Baldus would not be the chronicler of the upheaval of Haussmannism but rather the purveyor of monumental images that captured and enhanced the aesthetic of the new Paris. Soon he even anticipated Haussmann's work of transforming historic monuments into urban beacons. The late

Fig. 80. *Tour Saint-Jacques*,
ca. 1858. Albumen silver print from
glass negative, 44.1 × 32.8 cm
(17³⁄₈ × 12⁷⁄₈ in.). Canadian
Centre for Architecture, Montreal

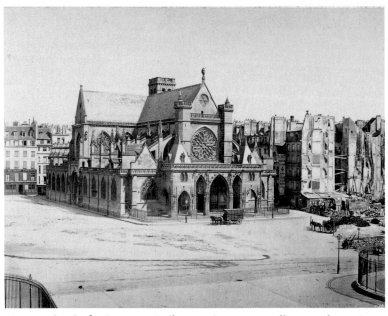

Fig. 81. *Church of Saint-Germain l'Auxerrois*, 1852–53. Salted paper print from paper negative, 33.2 × 44.5 cm (13⅛ × 17½ in.). Musée National des Monuments Français, Paris

Fig. 82. *Church of Saint-Germain l'Auxerrois*, 1854–57. Albumen silver print from glass negative, 32.3 × 44.4 cm (12¾ × 17½ in.). Canadian Centre for Architecture, Montreal

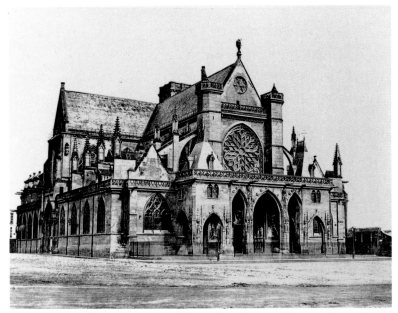

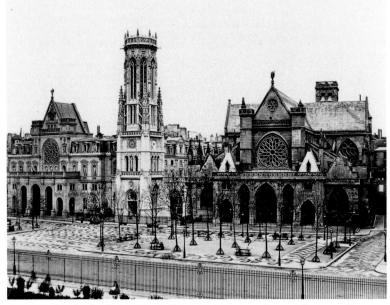

Fig. 83. *Church of Saint-Germain l'Auxerrois*, 1854–57. Albumen silver print from paper negative, 30 × 40.4 cm (11⅞ × 15⅞ in.). Canadian Centre for Architecture, Montreal

Fig. 84. *Church of Saint-Germain l'Auxerrois*, 1861 or later. Albumen silver print from glass negative, 20.6 × 26.7 cm (8⅛ × 10½ in.). Canadian Centre for Architecture, Montreal

medieval Church of Saint-Germain l'Auxerrois, across from the Louvre, was one of the few monuments Baldus photographed repeatedly (figs. 81–84). And when he returned to it he cleared away the surrounding buildings—long before Haussmann had fully formulated the project of creating a great square in front of the church and of linking the church's facade into a larger composition with a pendant facade for Jacques-Ignace Hittorff's town hall of the 1st arrondissement and its new civic clock tower by Ballu, a great piece of urban scenography completed only in the 1860s.

At times Baldus went to even greater lengths than Haussmann, particularly when it came to eighteenth- and early-nineteenth-century monuments that had been conceived as integral parts of larger urban designs. Over the course of the early 1850s, for example, when the architect Simon-Claude Constant-Dufeux was remodeling Soufflot's Pantheon that it might once again become the Church of Sainte-Geneviève, Baldus returned several times to take photographs. He experimented with formats to enhance the building's powerful frontal presence, emphasizing the juxtaposition of portico and dome as the carrier of the monument's message. But with each successive view he began to liberate the monument even from the urban setting Soufflot had designed to frame the temple (fig. 85 and pl. 57). About 1856 Baldus erased the upper stories of Soufflot's École du Droit, to the left of the Pantheon, so that nothing would compete with the lucid silhouette of the portico and dome. Here the photographer seems in tune with Constant-Dufeux's view that Soufflot's building needed to be enhanced so it would more dramatically express its religious purpose and architectural audacity.[37] Like the historicist architects, who sought to render historical truths more apparent to the eye than the accidents of urban development generally permitted, Baldus cultivated a photographic style in which nothing distracted from the essence of the architecture portrayed.

Photography on the New Building Site

Although it went largely unheralded by his contemporaries, Baldus's appointment as photographer on the construction site of the New

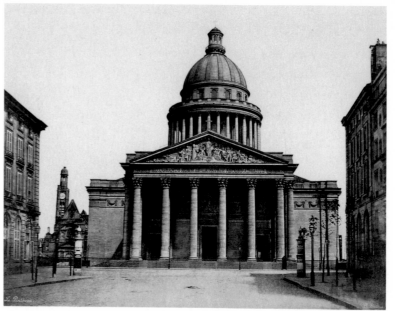

Fig. 85. *Pantheon, Paris*, 1853. Salted paper print from paper negative, 33.5 × 43 cm (13¼ × 16⅞ in.). Canadian Centre for Architecture, Montreal

Louvre was an epochal moment in the history of architectural representation. Not only was photography to become an integral part of the process of imperial image-making that centered on this extravagant undertaking,[38] but as Baldus began to perform his duties between 1855 and the early 1860s a whole range of new uses for photography became apparent to the Louvre's architect, Hector Lefuel. By the time the more than two thousand photographs Baldus had taken in his first years on the site were organized into presentation albums at the end of 1857, having a photographer on a public building site was on its way to becoming an accepted practice.

Baldus's appointment was almost an afterthought.[39] He arrived after the main work of construction was essentially complete, which may, in part, explain the near absence of the drama of construction from his first campaign of photography at the Louvre, with the exception of the panoramic view in which phantom stone layers and carts appear amid the cluttered foreground (fig. 76). With the docu-

mentation of bridge construction for the Administration of Bridges and Roadways (Administration des Ponts et Chaussées) by Collard in the late 1850s and of Charles Garnier's Opera after 1862, the documentation of the stages of construction became one of the prime duties of a building-site photographer.[40] It was about this time that Baldus was recording Lefuel's destruction and reconstruction of the Grande Galerie of the Louvre (pl. 40).

Lefuel had begun agitating for a photographer in October 1854, nine months after he was named to replace Louis Visconti, who had died in December 1853, but it was only late in 1855 that Achille Fould, the minister of state, signed the appointment.[41] Whoever could rightly claim credit for the idea—and both Lefuel and Fould did—architect and state had very different visions of photography. For the state, Baldus's photographs would join the proliferation of other images emanating from this great worksite to serve as continual publicity for the young empire. Both for immediate consumption and for posterity, the photographs would attest to the army of artistic talent that had been deployed at the Louvre and serve to celebrate the patronage and the luxury of the arts under the reign of Napoléon III. Although the project of realizing the centuries-old dream of completing the Louvre as a symmetrical composition united to the Tuileries Palace had in fact been launched by a decree of the Second Republic in 1848, work did not really get under way until the eve of the coup d'état. From 1852 Napoléon III moved quickly to stamp the project with his imperial signature—visible in particular in the proliferation of *N*s in the decorative vocabulary—and to accelerate the work (fig. 86). The Louvre was the linchpin of his architectural politics in Paris, for it would confirm that his regime was fulfilling the desires of the historical monarchies of France to expand the great palace, and that it had the power to orchestrate building industries and artistic talents to achieve in record time what had eluded generations of his royal predecessors, even Napoléon I. Determined that the Louvre-Tuileries complex be complete in time for the Exposition Universelle of 1855—a goal soon forgotten—Napoléon III ordered work to continue around the clock. The New

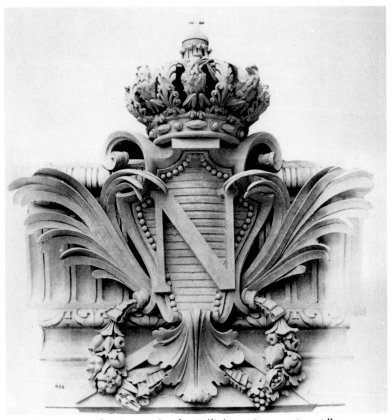

Fig. 86. *Ornamental N*, in *Réunion des Tuileries au Louvre*, 1857. Albumen silver print from paper negative. Bibliothèque Nationale, Paris

Louvre initiated the rhythm of shift work and the armies of workmen that would become commonplace in the public works of the Second Empire.

Over the course of the construction, when the worksite was largely closed to the public, the government helped ensure that images of it were constantly circulating. The illustrated press was well fed by the images, largely engravings of the sort that appeared regularly in such popular journals as *L'Illustration* and *Le Magasin Pittoresque*, which had blossomed in the 1840s. Photography was now to be added to that battery of images. Ernest Lacan was effusive in his

praise of Baldus's first photographs at the Louvre: "It is to be hoped that, as each part of the New Louvre is finished it can be reproduced like this, so that those living in the provinces or in foreign countries can come to know and admire, as we have, the marvelous beauty of this gigantic monument, which will be the collective masterpiece of the leading artists of our time, inspired by the grand and patriotic spirit that presides over the construction."[42]

Baldus's monumental style (pl. 39) served the project brilliantly. As images of imperial France, of its power, luxury, and abundance, his photographs of the pavilions as they emerged from scaffolding with their decorative sculpture spoke every bit as clearly as Napoléon III's flowery discourses on the Louvre's purpose, namely to assume its place as the great characteristic monument of the modern age. "And thus, the completion of the Louvre, for which I salute you for your zealous and talented participation, is not the whim of the moment, but rather the realization of a plan conceived for the glory and upheld by the country's instinct for more than three hundred years,"[43] declared the emperor at the inauguration.

Baldus's photographic albums had been carefully prepared to commemorate that truth, and copies were distributed to the imperial family, foreign heads of state, and government officials.[44] The presentation albums, each custom-made under Fould's direction, offered a highly coherent analysis of the Louvre's architecture, moving clockwise around the Cour Napoléon from the Pavillon Rohan to the Pavillon des Lesdiguières, presenting each of the pavilions with consistent logic from the pediment to the sidewalk. After photographs of the architect's plans and several panoramic views of the Cour Napoléon before and after Lefuel's work, each sequence began with an overall view, labeled "elevation," and then continued with a series of details moving down the facade (in fact the larger photographs sliced into layers), to culminate with individual photographs of the sculptures and moldings of each pavilion. As the pages of the album were turned, the building could be scanned and reassembled. Views from elevated vantage points taken with a long lens gave the impression that the eye was literally freed from the pedestrian perspective to survey architecture as never before.

But these very photographs had found a working vocation in the gritty world of the construction site long before they were assembled and bound with embossed leather bindings carrying the imperial coat of arms.[45] Lefuel quickly discovered that Baldus was no simple intruder, for whom it was necessary to clear vantage points or arrange for permission to photograph on Sundays. The scale and intensity of the Louvre project surpassed everything in the recent history of French public architecture and announced a new administrative scale for the work of official architects. At the height of the construction some thirty-five hundred workmen were employed on the site, yet Lefuel was determined to retain personal control over every detail. In addition to the armies of ornamental sculptors who worked directly on the scaffolds, the Louvre's facades were to play host to an extensive program of figurative sculpture. A pantheon of great Frenchmen from the arts, religion, and politics stands guard over the place Napoléon; military figures fill the niches of the long wing along the rue de Rivoli.[46] The pediments of each pavilion are adorned with allegorical subjects celebrating the new golden age of French civilization. For the Pavillon Richelieu, Duret sculpted "France in Prosperity, surrounded by all her children who have welcomed in their midst Peace and Abundance, calls upon History that she record and celebrate the advantages that the country has received from Napoléon III, and orders the arts to make the memory of these deeds eternal" (fig. 87 and pl. 39). On the Pavillon Denon, Simart sculpted "Napoléon III, strengthened by destiny and by the support of all Frenchmen in appreciation for the good deeds of Napoléon I, brings the era of revolution and vile discord to a close, and rallies France to the execution of the great undertakings that will glorify his reign" (fig. 88 and pl. 44).[47] And smaller groups crown the frontispieces, balustrades, and dormers of each of the principal pavilions. Hundreds of sculptors, including some of the most prominent names of the period (Carpeaux, Préault, Etex, Barye), were given commissions as part of the program. The Louvre, in the emperor's words, was to be a veritable "encyclopaedia of the

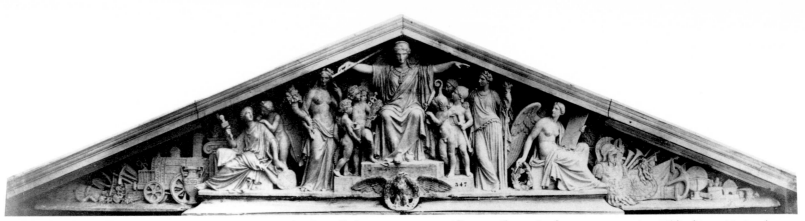

Fig. 87. *Pediment of the Pavillon Richelieu, Louvre*, in *Réunion des Tuileries au Louvre*, 1857. Albumen silver print from paper negative. Bibliothèque Nationale, Paris

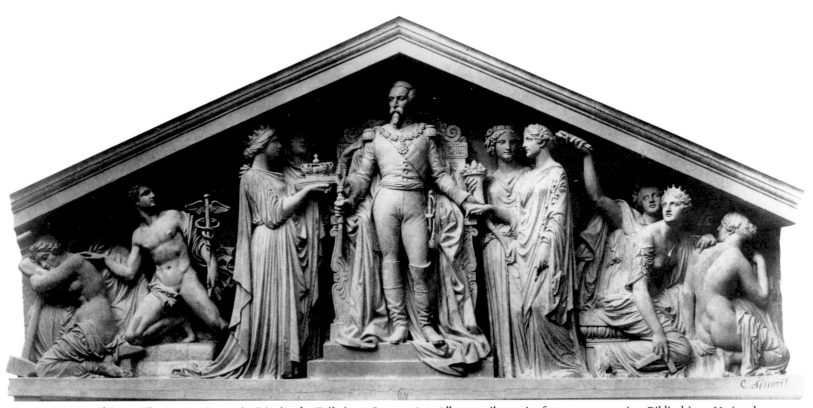

Fig. 88. *Pediment of the Pavillon Denon, Louvre*, in *Réunion des Tuileries au Louvre*, 1857. Albumen silver print from paper negative. Bibliothèque Nationale, Paris

arts," its style a prototype for the new age of prosperity and historically sophisticated taste.

Although the decorative campaigns had already begun when Baldus arrived on the scene in 1855, photography would make reviewing, approving, and keeping track of the work infinitely more efficient. Each of the figurative sculptors was required to submit a small-scale model in clay or plaster; this accepted, the sculptor could proceed to a full-scale plaster model which could be tested in a mock-up of the building before carving was finally approved. Baldus's photograph of each model was kept with the individual sculptor's dossier as a reference once the full-scale plaster model was returned to the sculptor's studio. Lefuel thus had at hand a faithful image of every sculpture. He could continue to fine-tune his design and to review the placement intended for the figures before they were delivered to the site. Photographs were kept of rejected models as well, and these are included in the albums prepared at the end of the project.

Shortly before his death, in 1853, Visconti had penned the stylistic ideology of the New Louvre: "The character of the new architecture will be derived religiously from that of the Old Louvre."[48] Following the example set by Duban in his restoration at Blois, Visconti had all the details of the Cour Carrée's richly sculpted sixteenth-century facades copied in plaster casts (fig. 89) and explained that "the architect will suppress all personal pride in order to preserve the original character of the monument."[49] Photography would endorse this oath of historical truth. Lefuel retained Visconti's plan and the overall organization of his elevations, but embellished the focal points of the architecture to rival the richness of the Cour Carrée. He continually studied the existing buildings to serve as models for the ornamental vocabulary of the new wing, though in fact it would be impossible for any visitor ever to view the two buildings at a single glance.

Baldus's albums contain scores of photographs of these molds taken directly from the surfaces of the Old Louvre before they were in turn restored. Although the photographs were not intended to

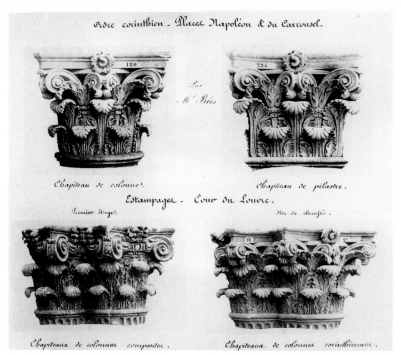

Fig. 89. *Casts from the Cour Carrée and Models for the New Louvre*, in *Réunion des Tuileries au Louvre*, 1857. Four albumen silver prints from paper negatives. Bibliothèque Nationale, Paris

serve as direct models for the ornamental sculptors, who would work from three-dimensional casts, they made it possible to keep track of the movement of the models, which circulated on the site like the books of a lending library. Large registers were kept to record the actual locations of the plaster models of even the most minor decorative detail, and ledgers were established to record the completion of each piece of work and authorize payment to the individual carver.[50] They also enabled careful control of the movement of models and the dispatching of sculptors and their works to the right part of the building, and served as a backup if the fragile molds were damaged. In addition Baldus photographed each plaster model as it was completed and approved, so that gradually the on-site office of the architect had a photograph of every element of carving on this vast structure.

Fig. 90. Account book of ornamental sculpture work for the cathedral of Marseilles, with photographs by an unidentified photographer, 1870s. Archives Nationales, Paris

The practice established at the Louvre was to be a prototype for nearly all the major worksites of the empire. At the Paris Opera, the regime's great symbolic undertaking of the 1860s, construction and decoration were minutely recorded.[51] The same was true of the two new theaters designed by Gabriel Davioud on the place du Châtelet (fig. 72). The account books of the construction of Vaudoyer's cathedral of Marseilles (1852–93), launched as the great political symbol of the Second Empire in the south of France, integrated photography directly into the accounting system to provide a record of precisely how the budget for decorative sculpture was being spent

(fig. 90).[52] In addition, the large-scale plaster model of the cathedral, kept in the on-site office in Marseilles, was photographed for Vaudoyer and the minister of education and religion to consult in Paris.

Architectural Design in the Age of Photomechanical Reproduction

It was in the context of the Louvre commission that a much more extensive function for photographic models was first postulated. And it was the Louvre experience which would help direct Baldus to

the publishing projects that dominated his production after 1865. If the 1850s had been the great decade of commissions from the state and the private railroad companies, in the 1860s Baldus sought increasingly to anticipate the demands of the architectural market for images and to assert his own role as author of those images. At the same time he turned to a smaller format to supply the growing demand for souvenir and study photographs.

Fould made it clear in his report on the work at the Louvre in 1856 that Baldus's photographs were intended to circulate far beyond the construction site. The New Louvre was to serve as a model for public architecture and architectural sculpture throughout the country, notably for the new prefectures and administrative buildings erected in the 1850s through the 1870s. The photographs would not only serve as references for architects and sculptors on these provincial projects, they would also help educate the next generation of artisans. The revived French Renaissance style of Napoléon III's Louvre was to become the new vernacular of public architecture in Fould's vision:

> With the interests of both art and posterity in mind I asked the architect to have the more than eight hundred models made for the sculptural decoration of the New Louvre recorded by photography. . . . These models . . . could be sent to the principal schools of drawing in the departments where the working class is trained; and they will be all the more useful there since most of these models are inspired by the finest and proudest epoch of French architecture.[53]

Upon completion of the albums Lefuel drew up a list of libraries in the provinces that were to receive copies.[54]

With the building boom of the 1860s in Paris, the demand for historically accurate ornament for both the exterior and the interior decoration of new public buildings and for the grand houses that began to line the boulevards of the western arrondissements created an expanded market for architectural model books. Collections of plates proliferated, many of them recording, ironically enough, buildings and interiors menaced by Haussmann's demolitions. Cer-

tain engravers, such as Claude Sauvageot, made a specialty of this new genre, which culminated in the fine steel engravings published by César Daly in 1869.[55]

Like many of his fellow members of the Société Française de Photographie, Baldus subscribed to the notion that the photographic print was merely a transitional medium in the development of photography as a printed form.[56] Photomechanical images would be permanent and allow for greater production and distribution; in addition, as printed material they entitled the photographer to copyright protection that did not necessarily apply to photographic images. Shortly after he produced some of the finest photographs of his career, in the railway album commissioned by the Compagnie du Chemin de Fer de Paris à Lyon et à la Méditerranée, Baldus renewed his interest in photogravure as a means both of enhancing the profitability of his growing stock of images and of launching his career as a publisher of books. Baldus imagined a whole new application for the medium in the production of highly accurate books of models. In 1866 he published a collection of rare ornamental engravings, of the sort much prized by architects as models.[57] This was nothing more than a reprint by photogravure of individual engravings of the ornamental plates that were increasingly used by architects to cater to the growing taste for interiors in the revival styles of the French Renaissance and the various "Louis" styles. Three years later he undertook a more ambitious and coherent project, a series of photomechanical reprints of Jacques Androuet Ducerceau's decorative plates. Baldus wrote an introduction to the third and final volume, his only printed statement of purpose:

> Our epoch has given a great boost to the art of ornamentation, and today's taste is directed with ever greater enthusiasm to the works of the fifteenth, sixteenth, seventeenth, and eighteenth centuries, which produced so many talented engravers and so many great architects. To this we contribute our own research by offering to the scholarly public this set of engravings of furniture and ornaments after original drawings by Jacques Androuet, known as Ducerceau, which we have reproduced by means of photogravure.[58]

Baldus signed his photogravures with the initials "EB," in the style of Ducerceau's own interlaced initials, claiming the rights of authorship granted to traditional engravers but which photographers were still fighting to achieve.

In that same year he conceived the idea of using to more profitable ends some of the many hundreds of photographs he had taken at the Louvre a decade earlier. In this he was probably piqued by the competition of the successful publication of *Le Napoléonum*, a single volume on the Louvre with photographs by the Bisson Frères. Perhaps he was also aware of Charles Nègre's proposal to prepare a major photogravure monograph on the Louvre and its collections.[59] Whereas Baldus's earlier prestige albums created under Fould's direction in the late 1850s had offered a systematic survey of the great project of the imperial Louvre, the photogravure volumes published from 1869 to 1875 were composed of interior and exterior decorative motifs chosen from the larger stock with no apparent ordering principle.[60] All sense of context, of the larger architectural project, has disappeared. The published volumes were intended simply as pattern books for architects, decorative sculptors, and, in particular, initiates in the new trade of interior decoration, whose fortunes had risen with those of Paris's haute bourgeoisie.

Although to the modern scholar these volumes defy all logic, they had a wide circulation in the nineteenth century, to judge by their dispersal in French provincial libraries and by the stamps of ownership in copies in American collections, for the most part those of sculptors and architects rather than book collectors.[61] The École des Beaux-Arts acquired Baldus's albums for its reference library, where increasingly the students had recourse to photographs in the quest for historical models. The École Boule, founded in 1886 to train artisans in the production of luxury decorative arts, formed an important collection of photographs for students to use as models; it included a substantial collection of Baldus's commercial prints and albums.[62] But Baldus's images were not confined to the world of working models. At the Musée de la Sculpture Comparée, a museum of plaster models of French sculpture primarily from the Middle

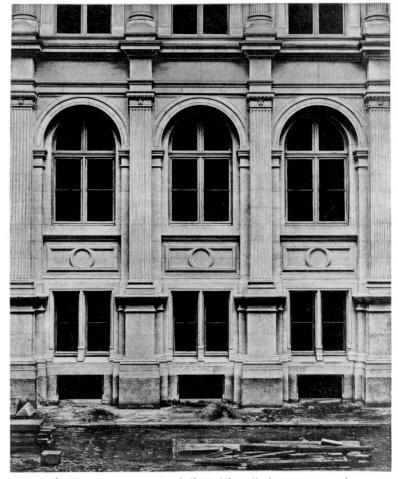

Fig. 91. Plate 39 in *Reconstruction de l'Hôtel de Ville de Paris*, 1884. Photogravure, 28 × 23.2 cm (11 × 9⅛ in.). The Metropolitan Museum of Art, Gift of Mariana Cook and Hans P. Kraus Jr. 1993 1993.484.1.37

Ages organized by followers of Viollet-le-Duc to encourage architects and sculptors to uphold the medieval ethos, photographs by Baldus were organized topographically along with those of other photographers.[63] Here the images could be juxtaposed and placed in new sequences as the narratives of French architectural history were refined. Indeed, by the time Baldus died in obscurity in 1889, his vision of French architecture, so deeply colored by the historicist philosophy of mid-nineteenth-century architectural culture, had, in

turn, permeated the world of architectural training, practice, and memory.

In the opening years of the Third Republic, during the 1870s, the conflictual politics of the Catholic right and the Republican left were spelled out on the skyline of Paris between the construction of Sacré-Coeur and the reconstruction of the Hôtel de Ville. Photography played a vital role in the realization of both buildings. Durandelle photographed every stage of the construction of Sacré-Coeur. His images were even worked over by the architect to communicate with the on-site sculptors, who could follow indications inked directly on photographs of the building's rising framework to verify the placement of inscriptions and relief decorations. Engravers and lithographers relied on these images to prepare their own printed illustrations of the work, many of them published in the press and used in publicity brochures to help raise new funds during the votive church's protracted construction.[64] At the Hôtel de Ville, which had been burned down during the Commune and was being rebuilt in a much-embellished version of the original by Ballu and E. Desperthes, Baldus recorded not only the building as it emerged from the scaffolds but every model and completed sculpture for the great pantheon of famous Parisians that was to adorn the facades (figs. 91 and 75).[65] During this period the first photographic collages appear, in which alternative decorative solutions are tested against an existing background, and increasingly photographs are part of the documentation required for a public building project.[66] By the late 1880s photography had entered the working world of representations by which the architect continued to refine complex public buildings, buildings that were modified as they were erected and which bristled with the decorative embellishments of armies of sculptors, painters, and mosaicists. If architects by their silence had reduced Baldus's work to a documentary medium, a way station, in their production of permanent images, Baldus had asserted the singular capacity of photography to "disengage" the monumental truth of architecture from the fabric of everyday experience.

PLATES

Early Work and the
Mission Héliographique of 1851

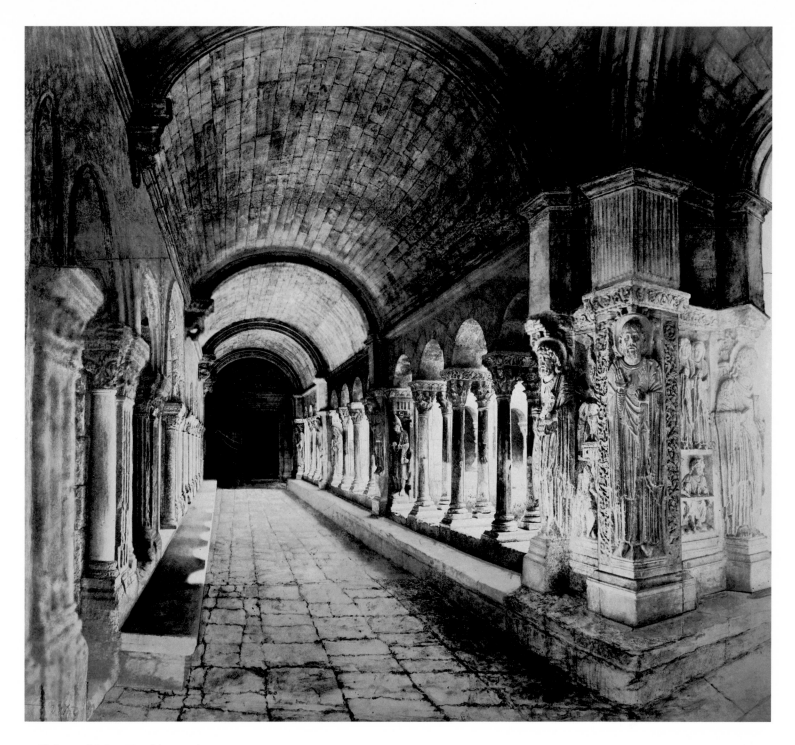

1. Cloister of Saint-Trophîme, Arles, 1851

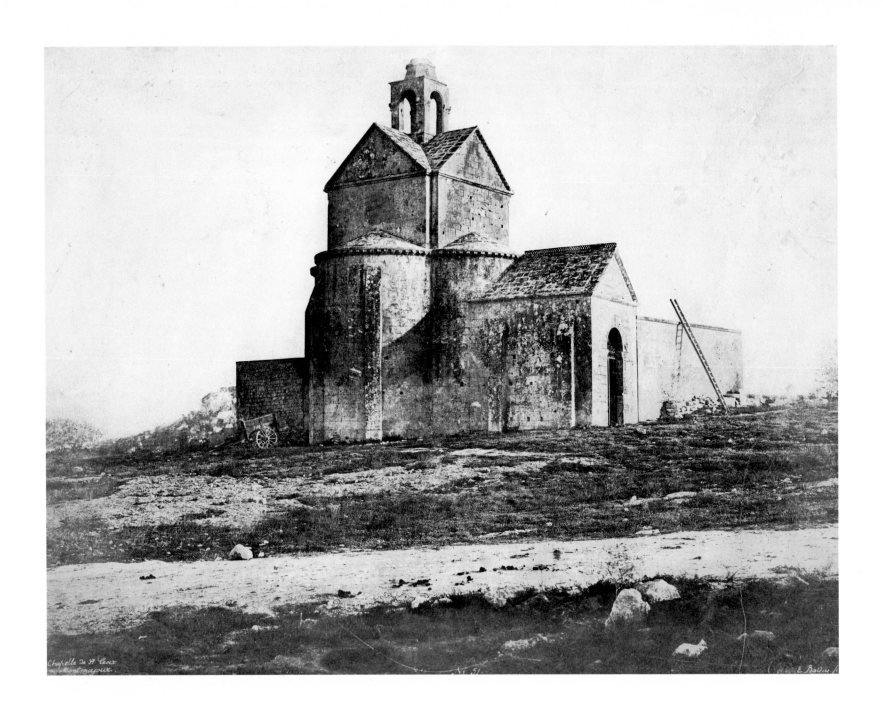

124 2. Chapel of Saint-Croix, Montmajour, 1849?

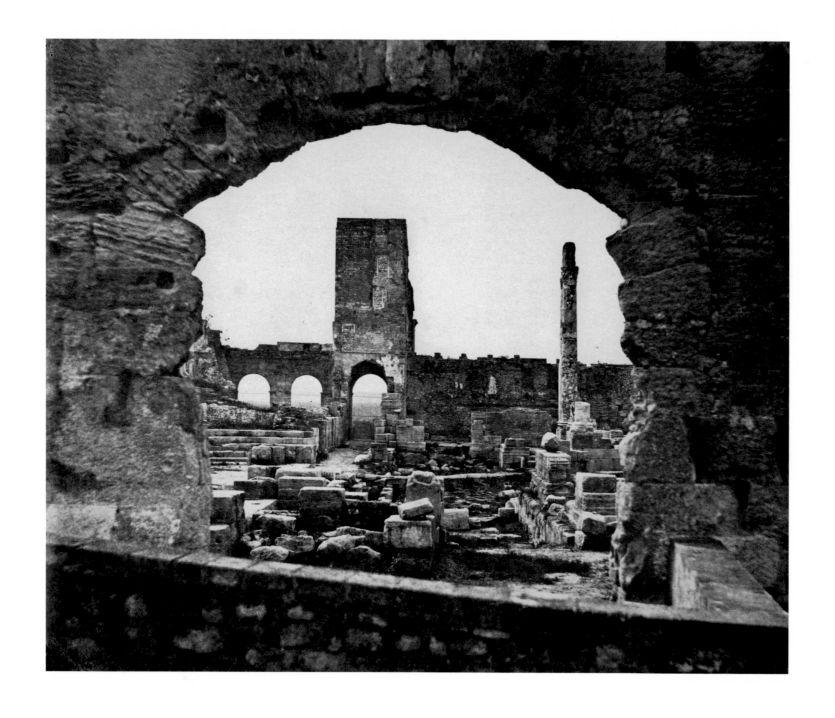

3. Roman Theater, Arles, 1851?

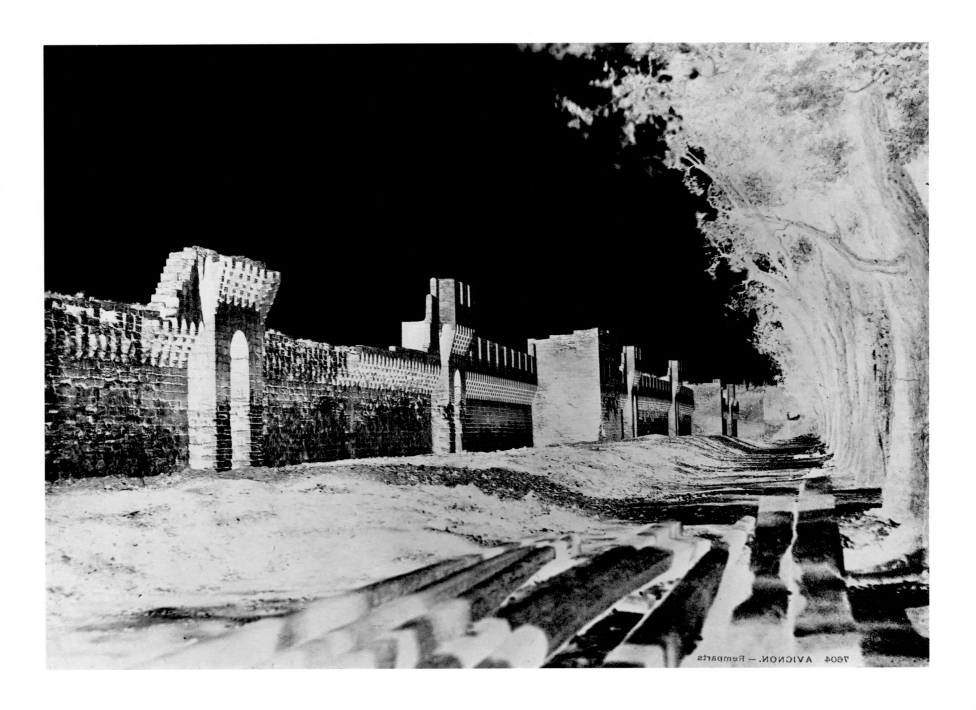

4. Ramparts of Avignon, 1851 (negative)

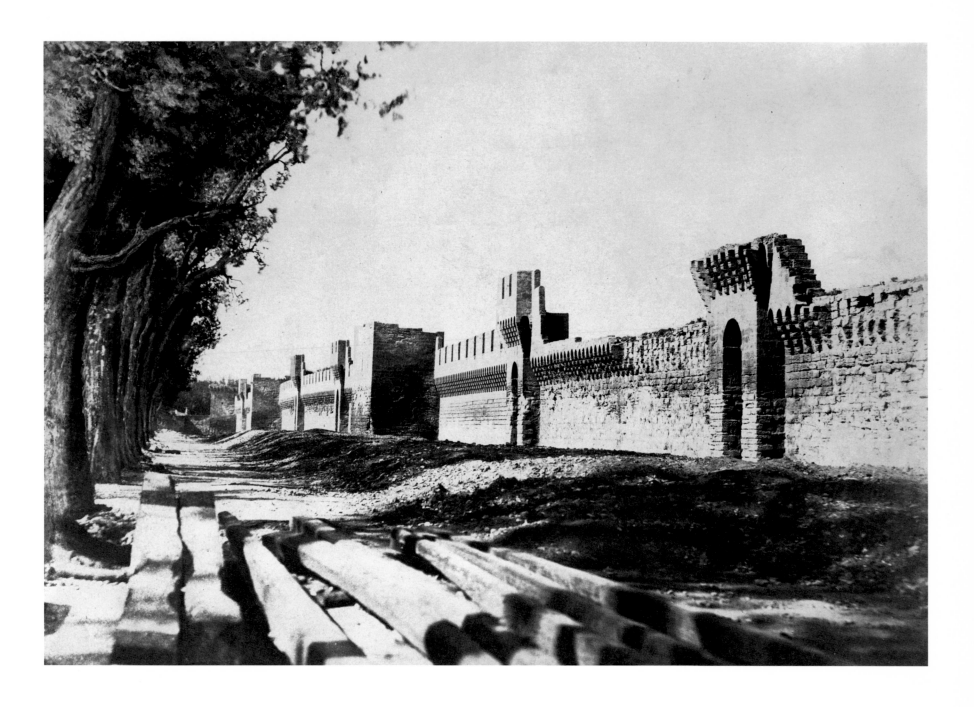

5. Ramparts of Avignon, 1851

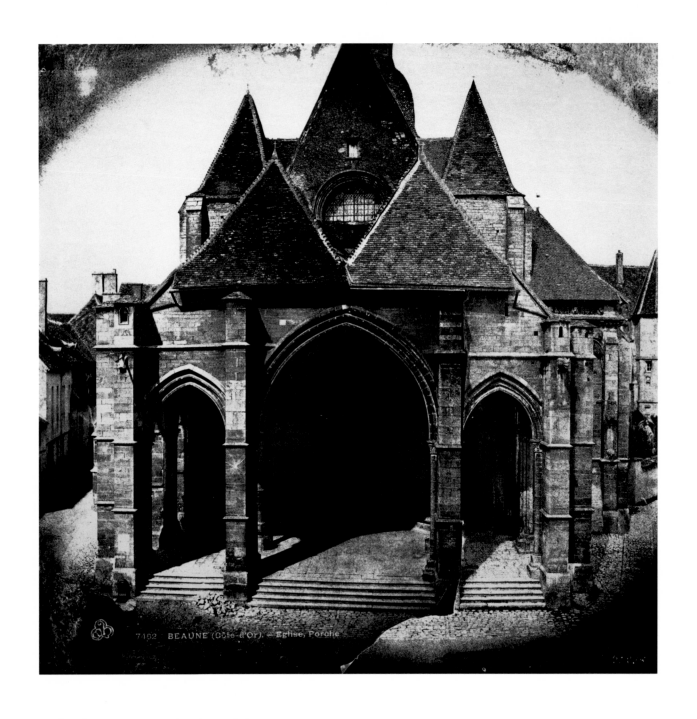

128 6. Church at Beaune, 1851 (modern print)

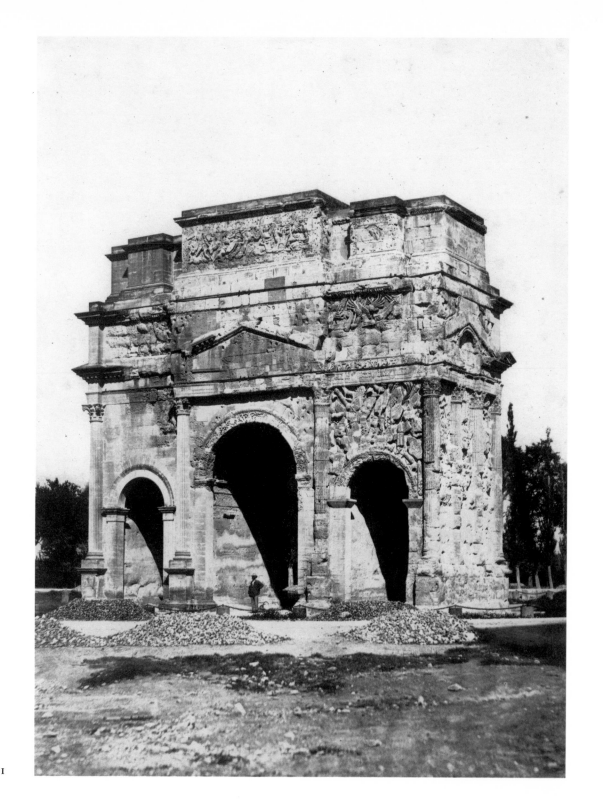

7. Roman Arch, Orange, 1851

Paris, 1852–53

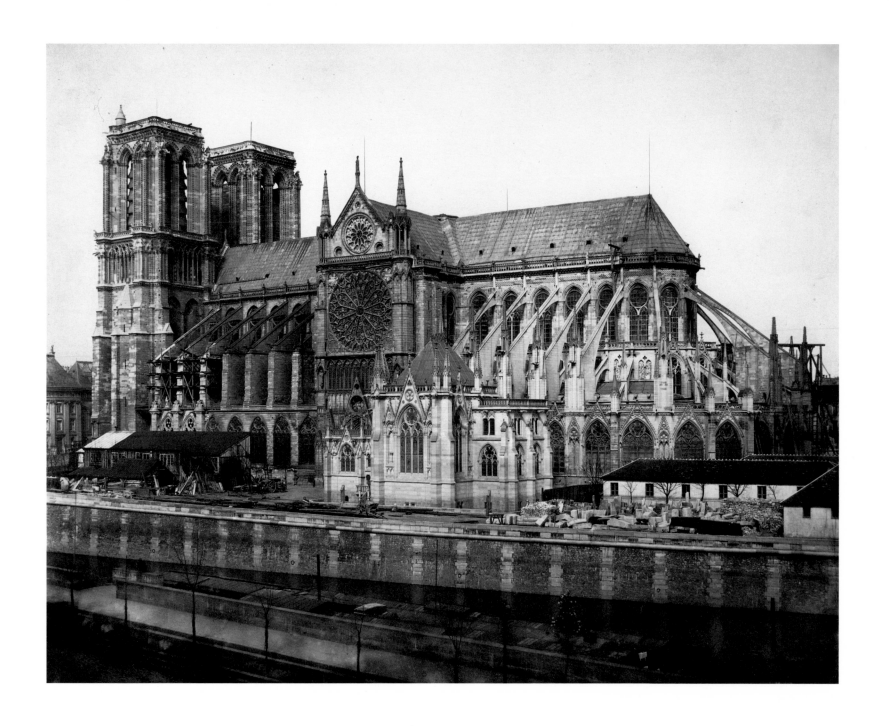

8. Notre-Dame, Paris, 1852–53

131

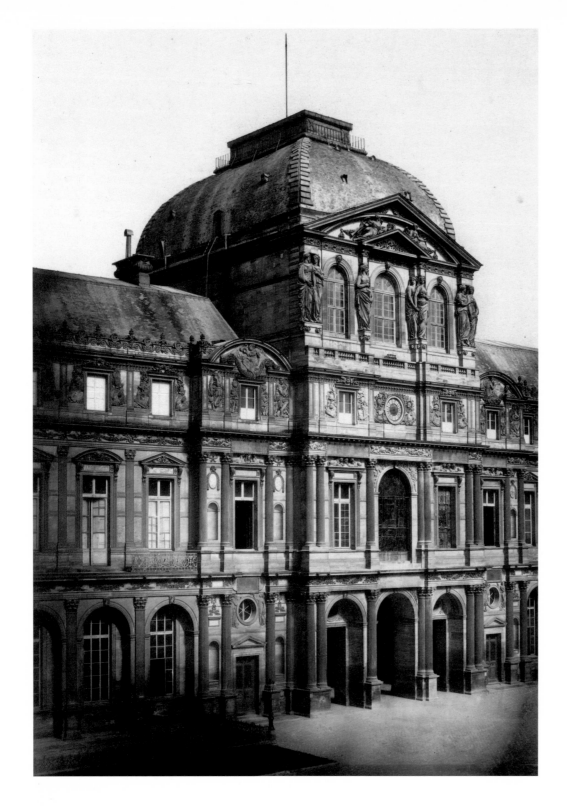

9. Pavillon de l'Horloge, Louvre, Paris, 1852–53

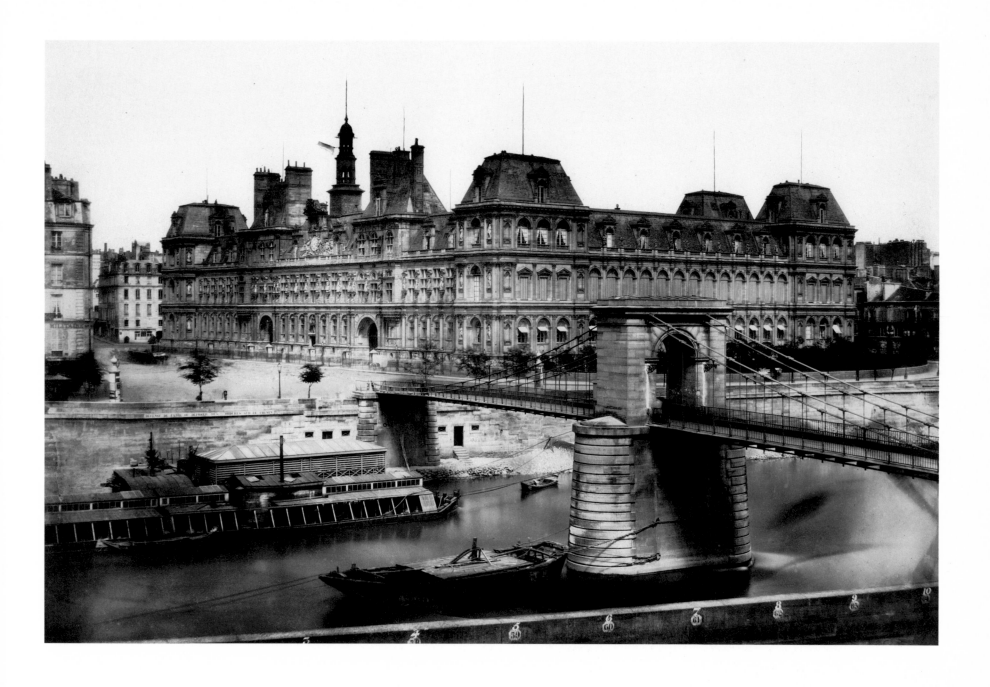

10. Hôtel de Ville, Paris, 1852–53

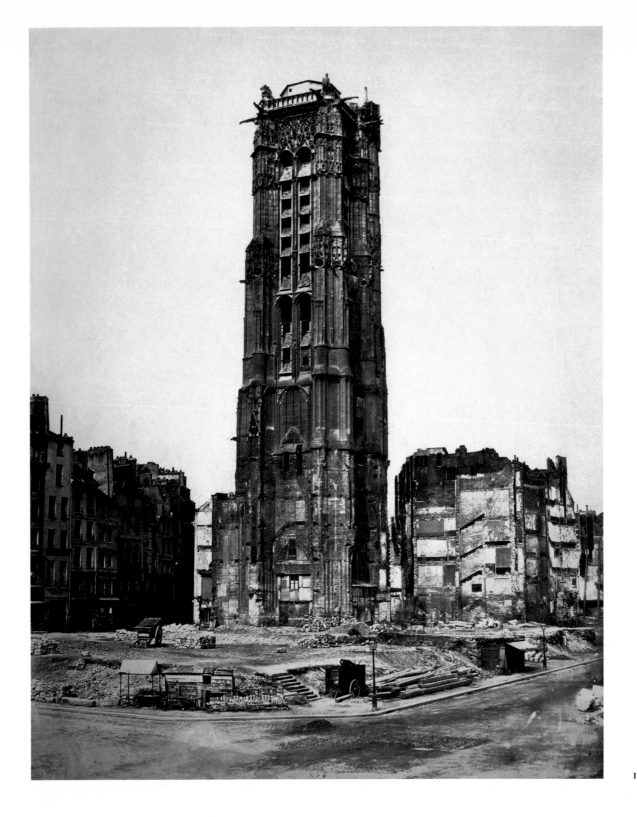

11. Tour Saint-Jacques, Paris, 1852–53

The Midi, 1853

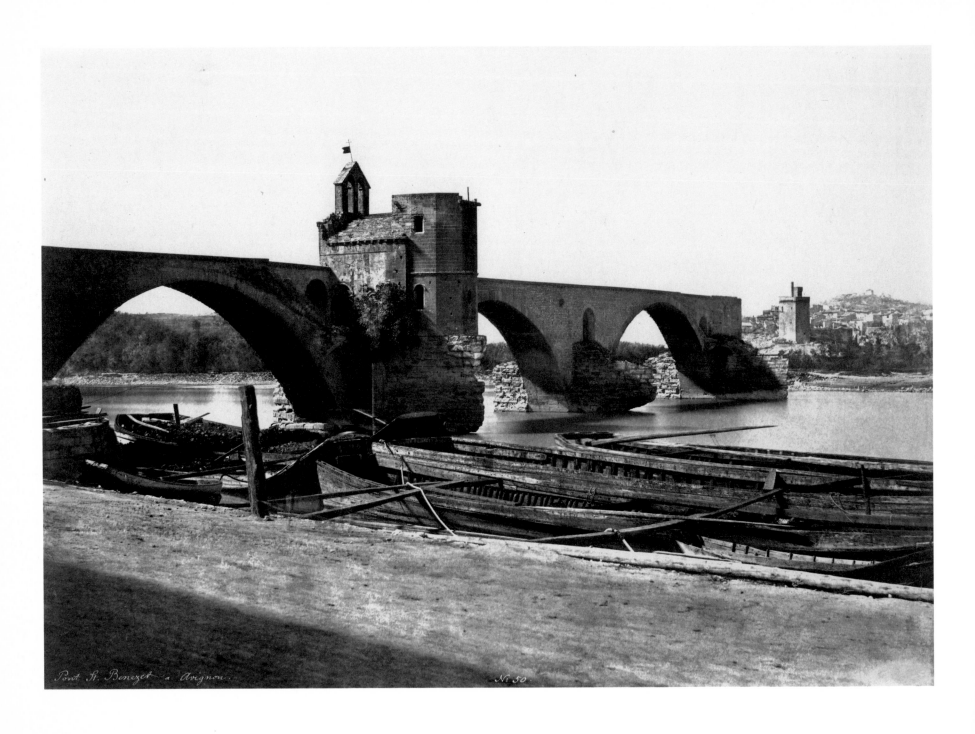

Pont St. Benezet a Avignon. No. 50.

12. Saint-Bénézet Bridge, Avignon, 1853

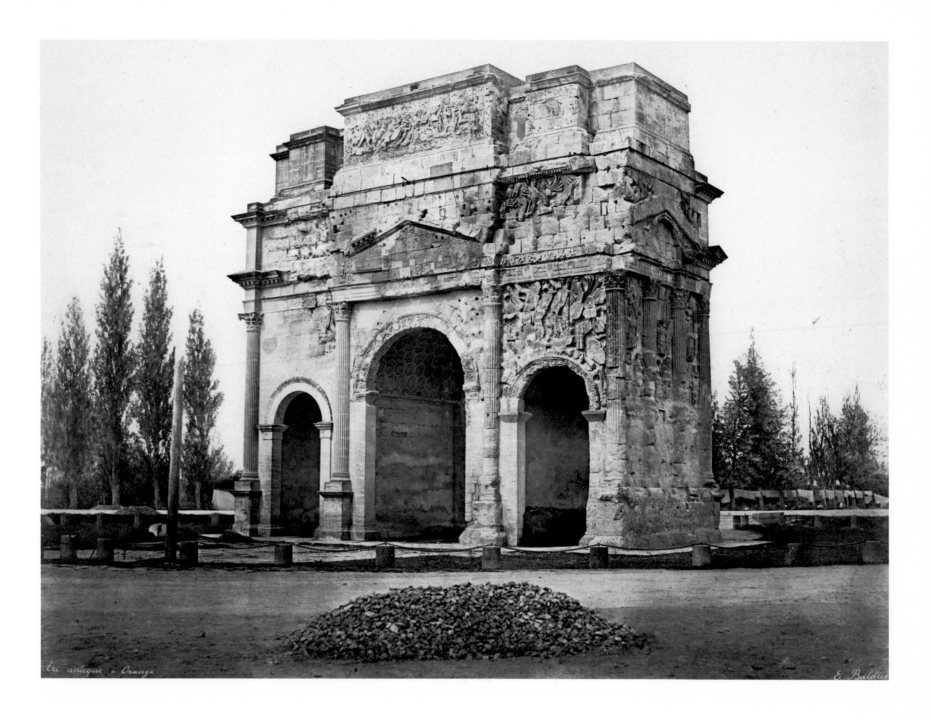

13. Roman Arch, Orange, 1853

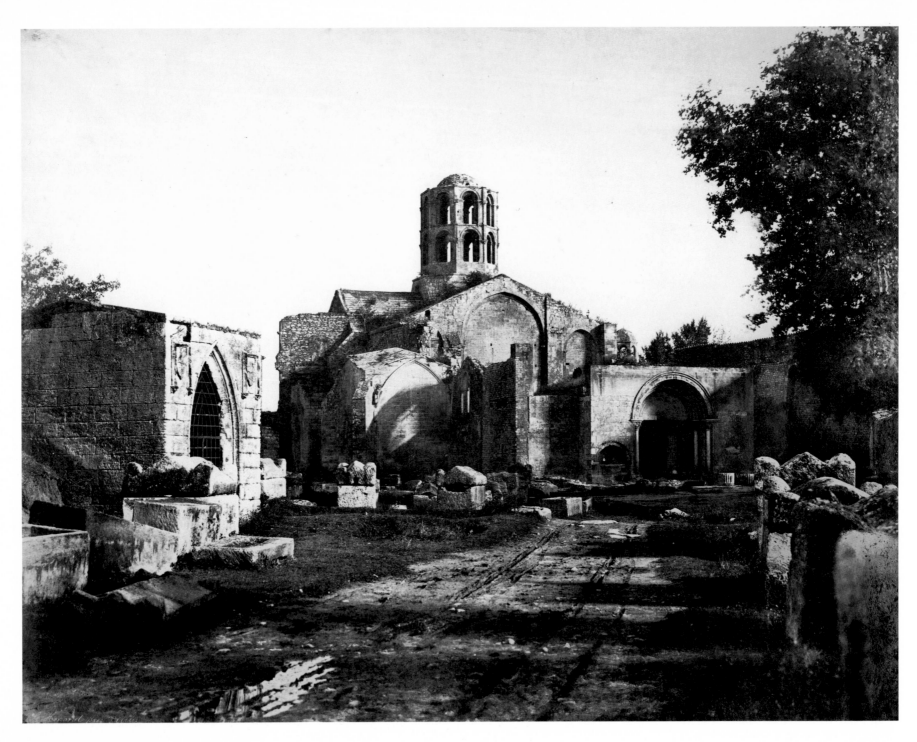

14. Church of Saint-Honorat, near Arles, 1853

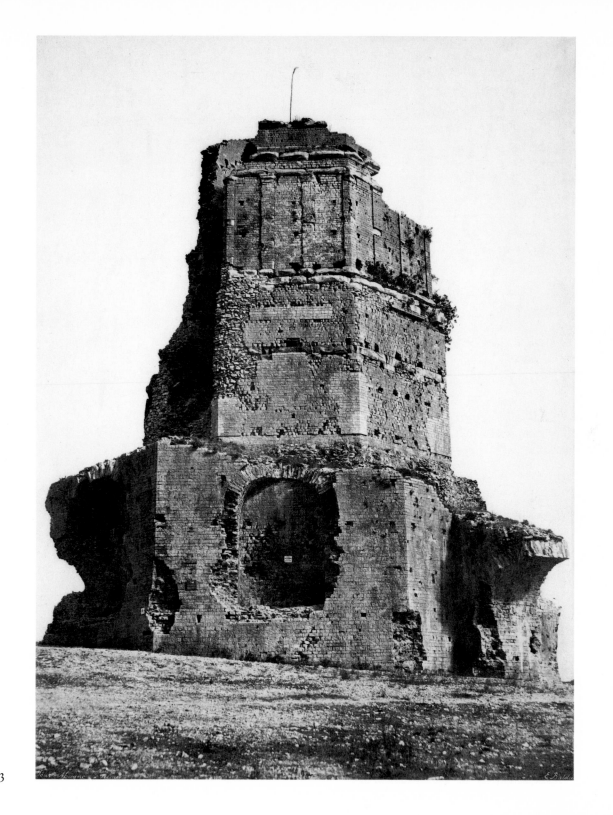

15. Tour Magne, Nîmes, 1853

139

The Auvergne, 1854

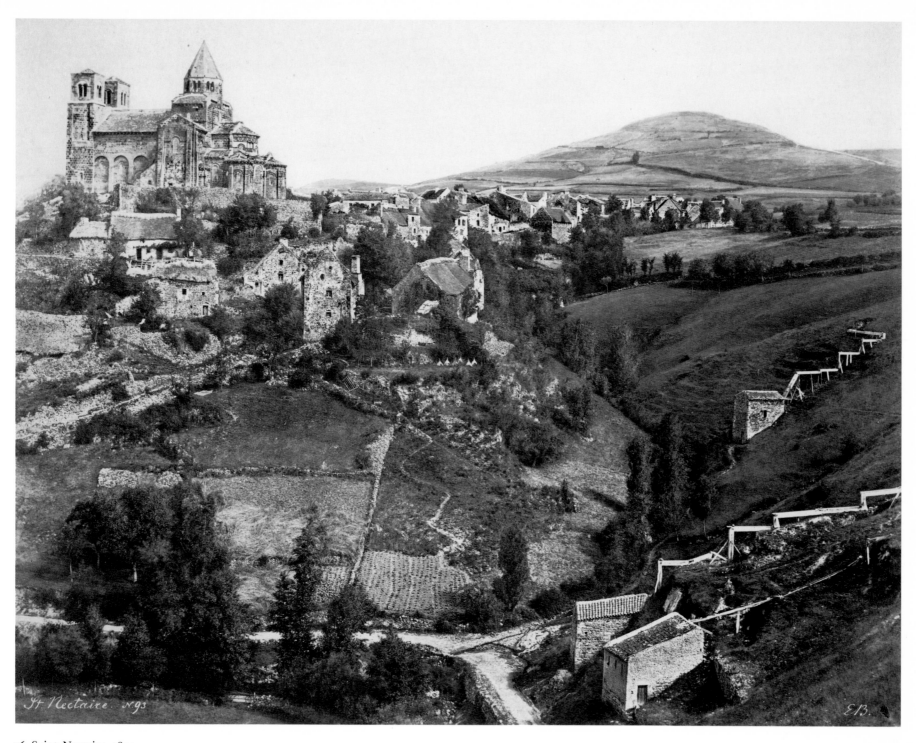

16. Saint-Nectaire, 1854

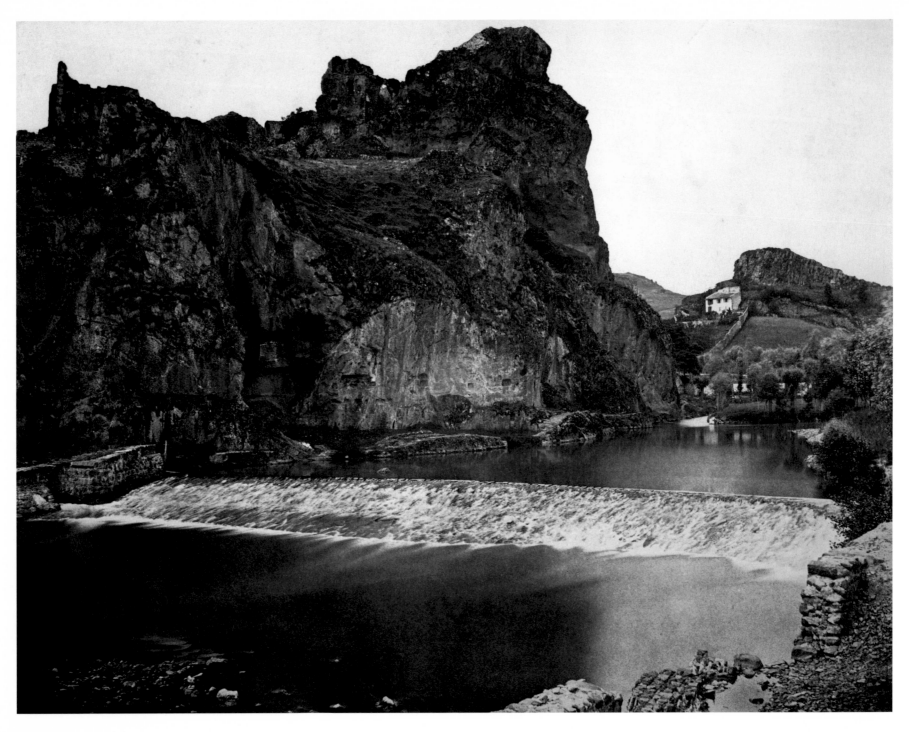

17. Château d'Espailly, 1854

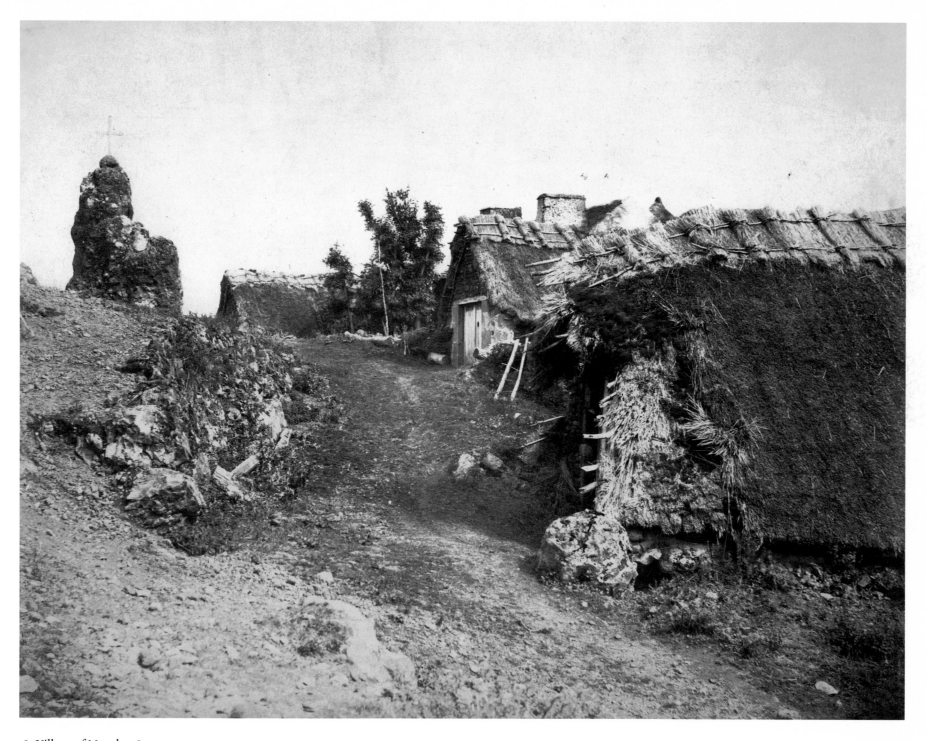

18. Village of Murols, 1854

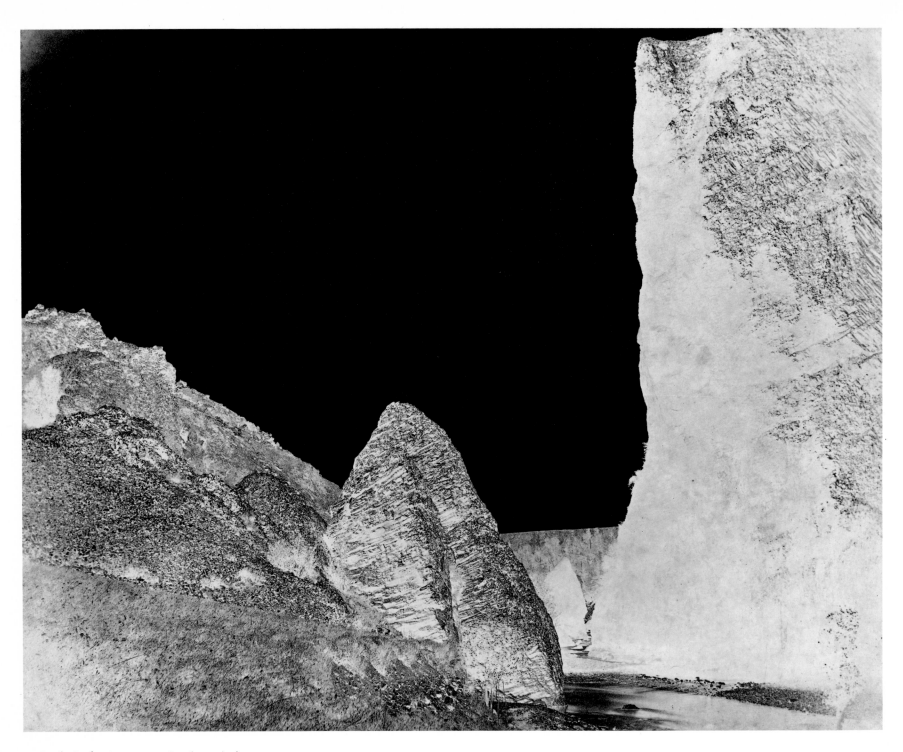

19. Rocks in the Auvergne, 1854 (negative)

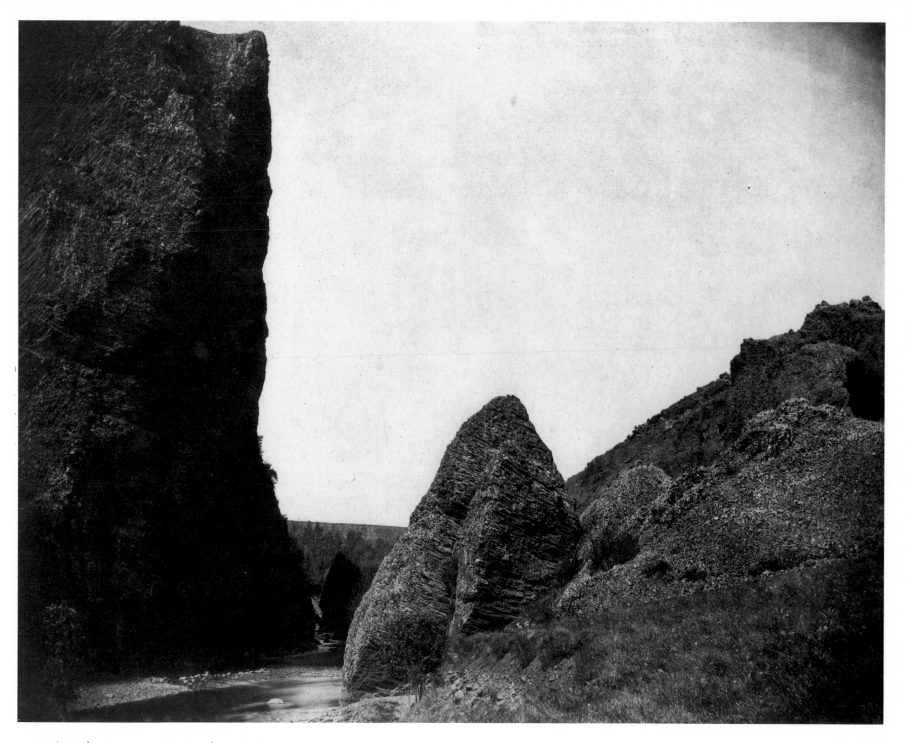

20. Rocks in the Auvergne, 1854 (modern print)

21. Chapel of Saint-Michel, Le Puy, 1854

The Chemin de Fer du Nord Album, 1855

22. Abbey of Saint-Denis, 1855 or earlier

23. Railroad Station, Enghien, 1855

24. Château of Princess Mathilde, Enghien, 1854–55

25. Chalet, Enghien, 1855

Egl. d'Auvers. E. Baldus

26. Church at Auvers, 1855

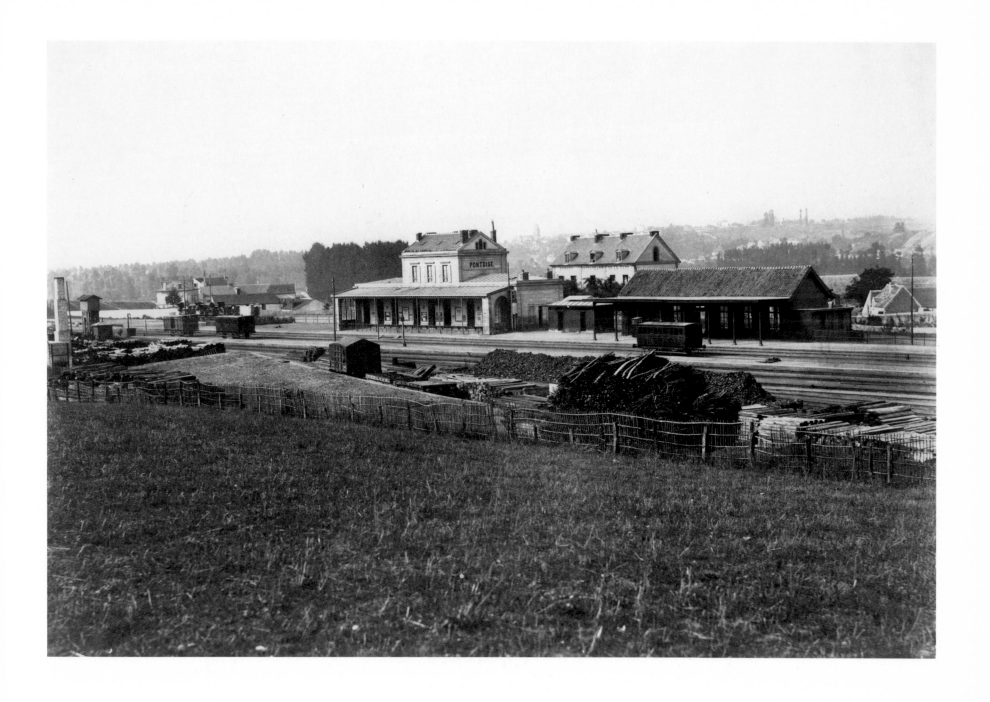

27. Railroad Station, Pontoise, 1855

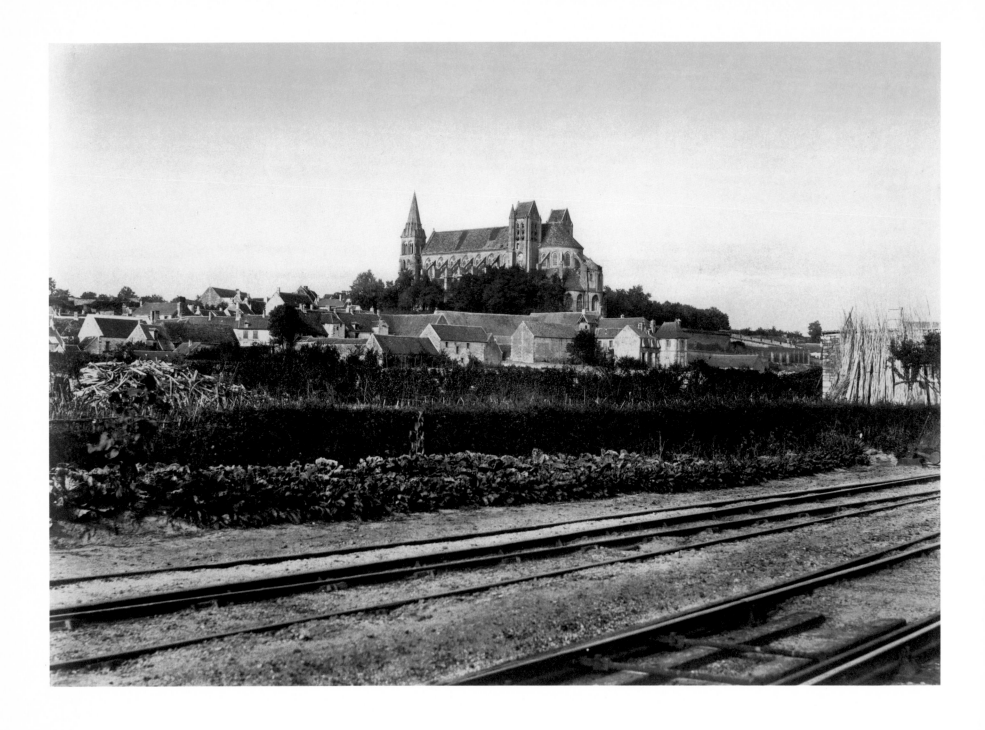

28. Saint-Leu d'Esserent, 1855

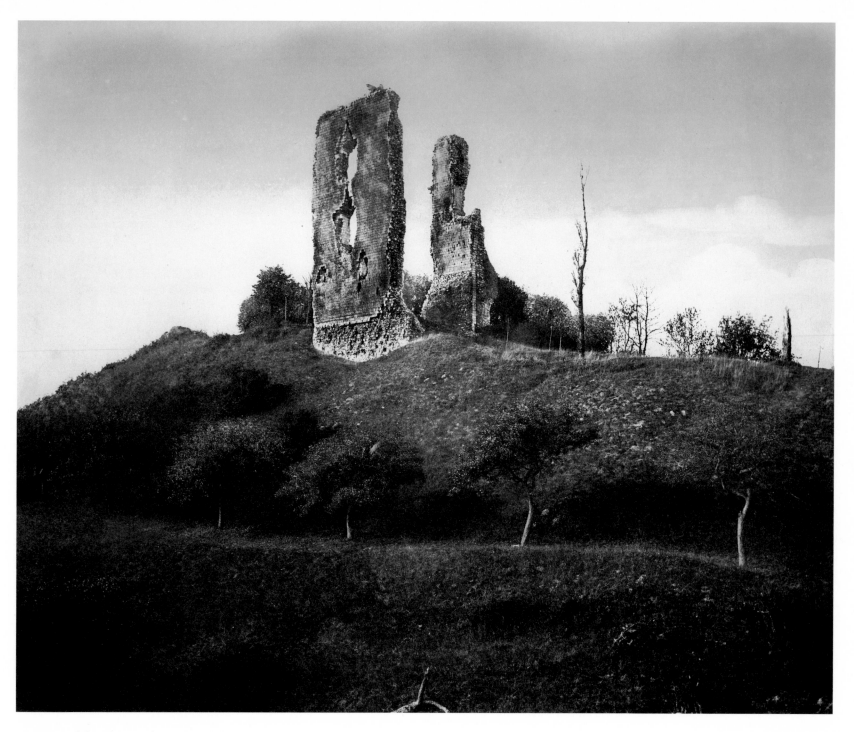

29. Ruins of the Château de Boves, 1855

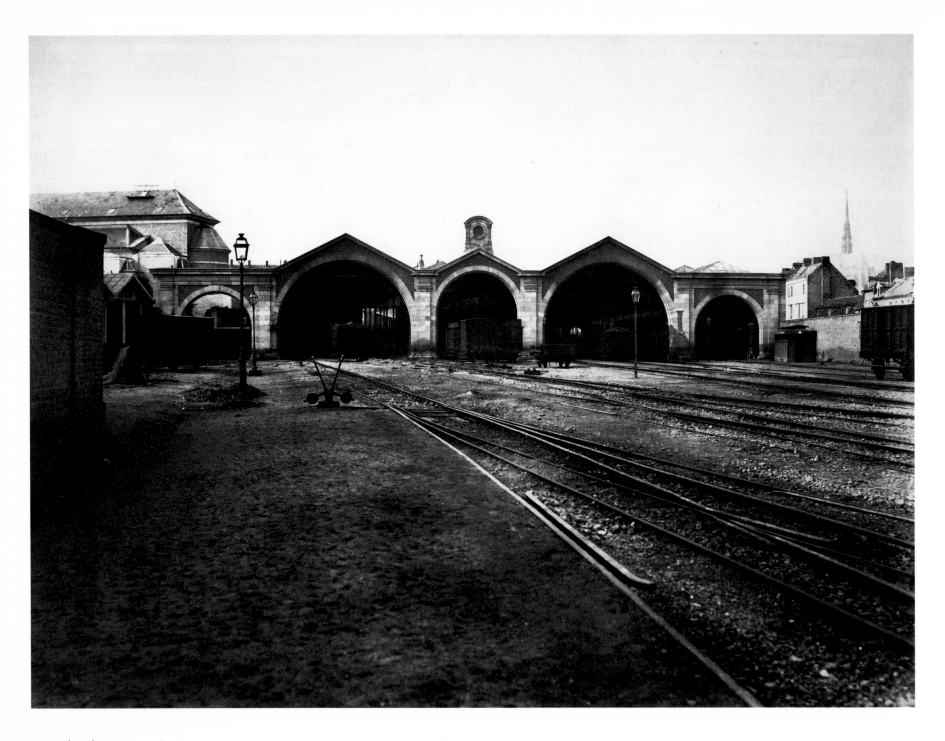

30. Railroad Station, Amiens, 1855

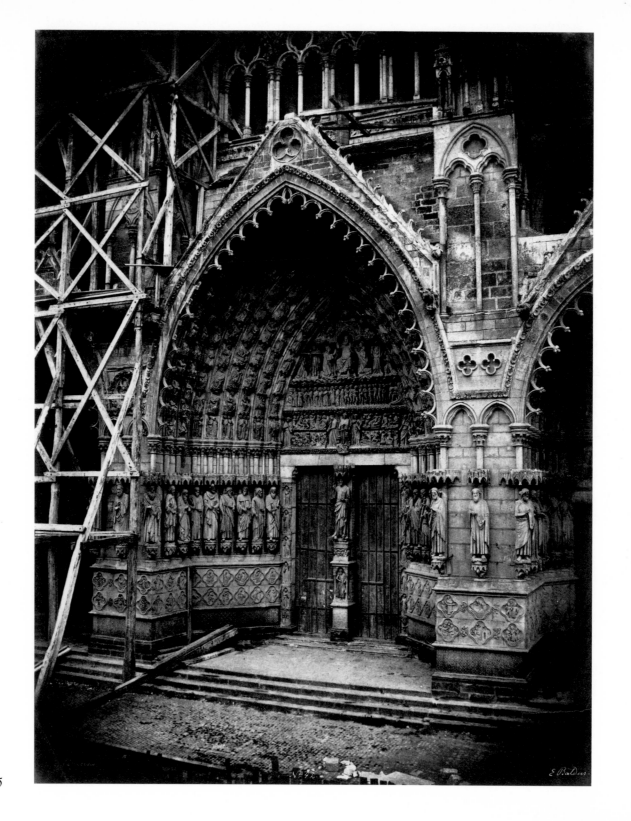

31. Portal, Amiens, 1855

157

32. Amiens, 1855

33. Long-sur-Somme, 1855

34. Railroad Station, Picquigny, 1855

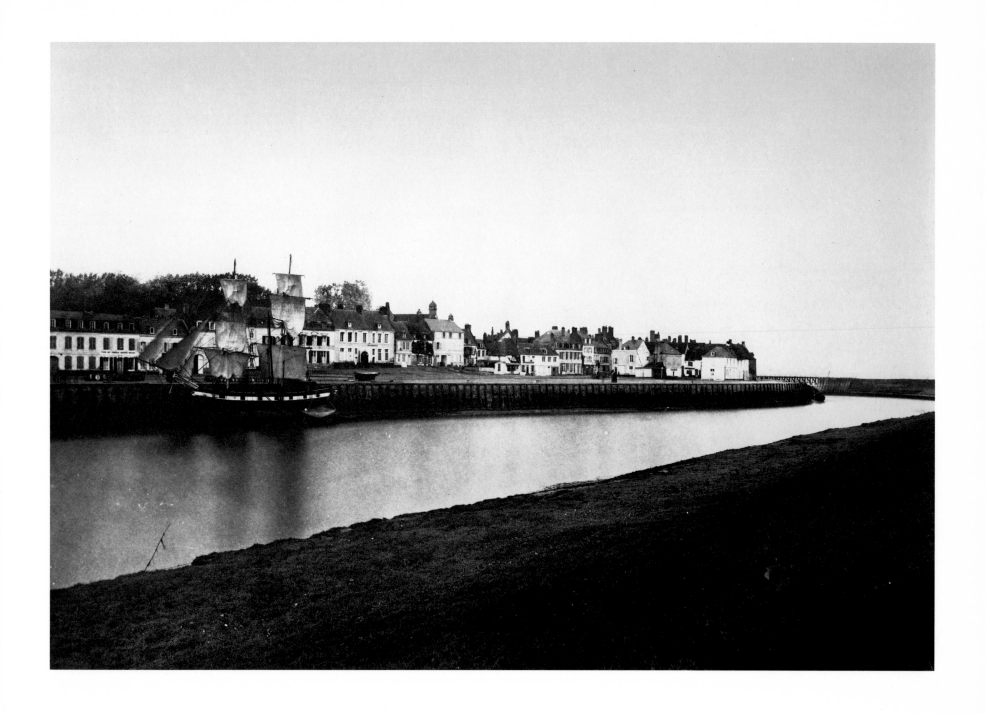

35. Saint-Valéry, 1855

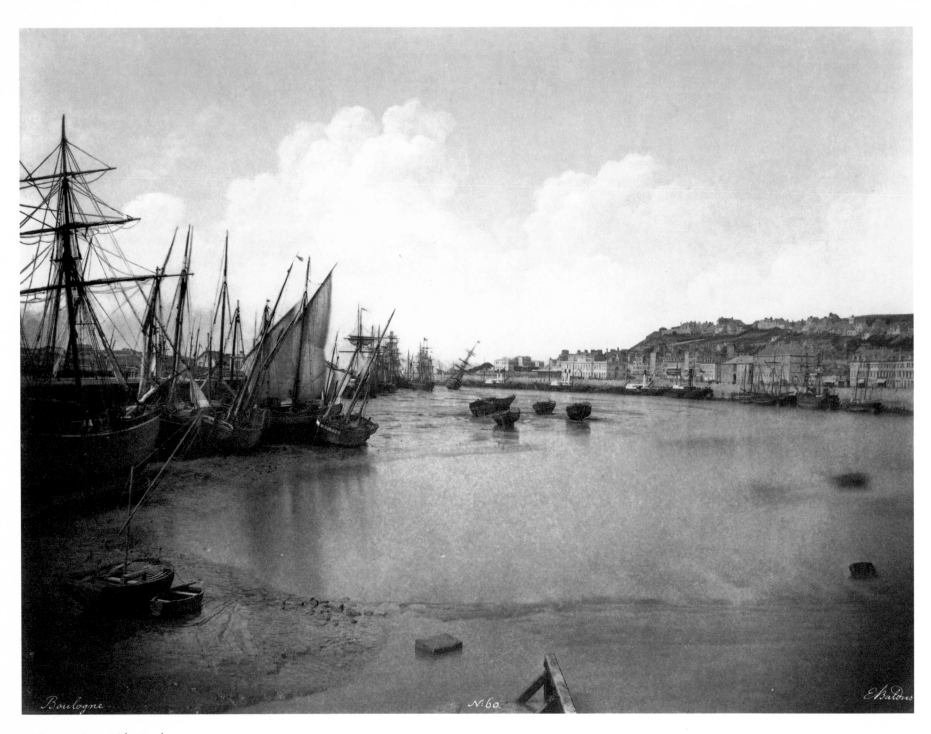

Boulogne N. 60. E Baldus

36. Boats at Low Tide, Boulogne, 1855

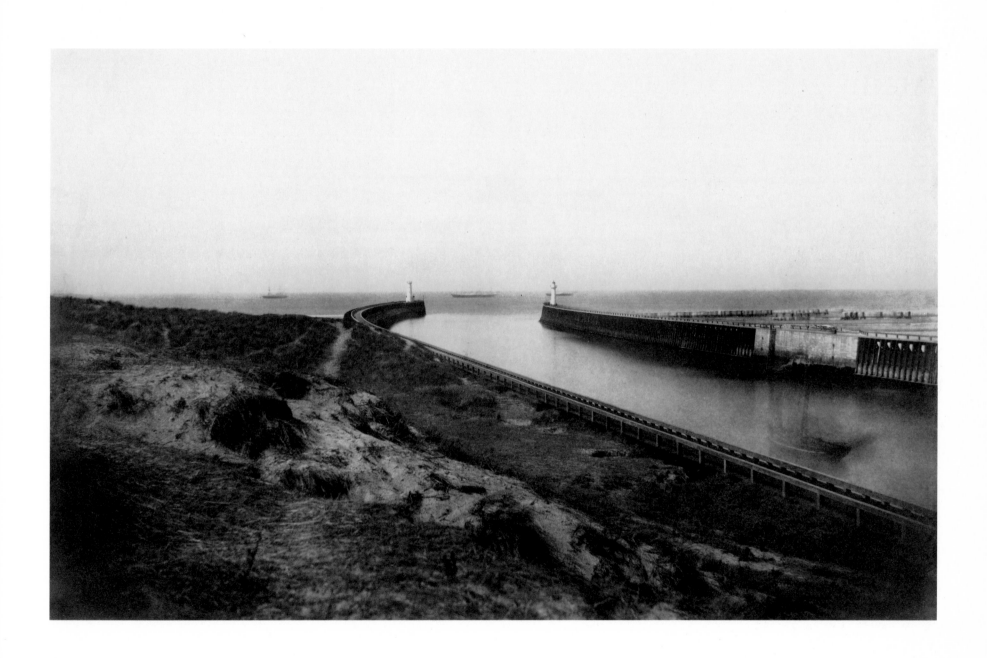

37. Entrance to the Port, Boulogne, 1855

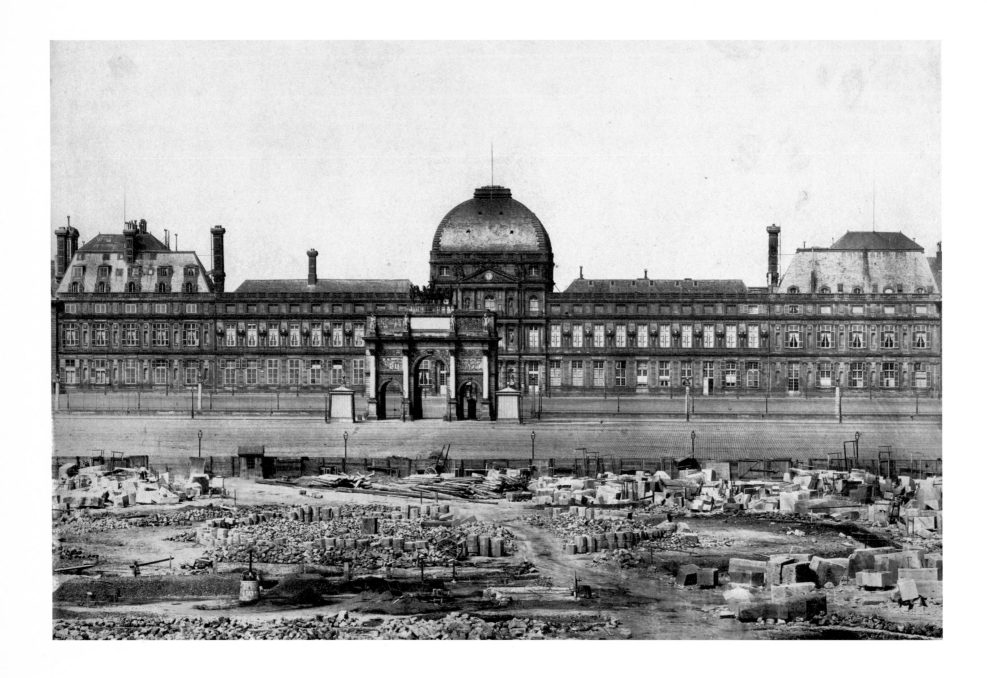

38. Tuileries Palace, Paris, 1855

The New Louvre, 1855–57

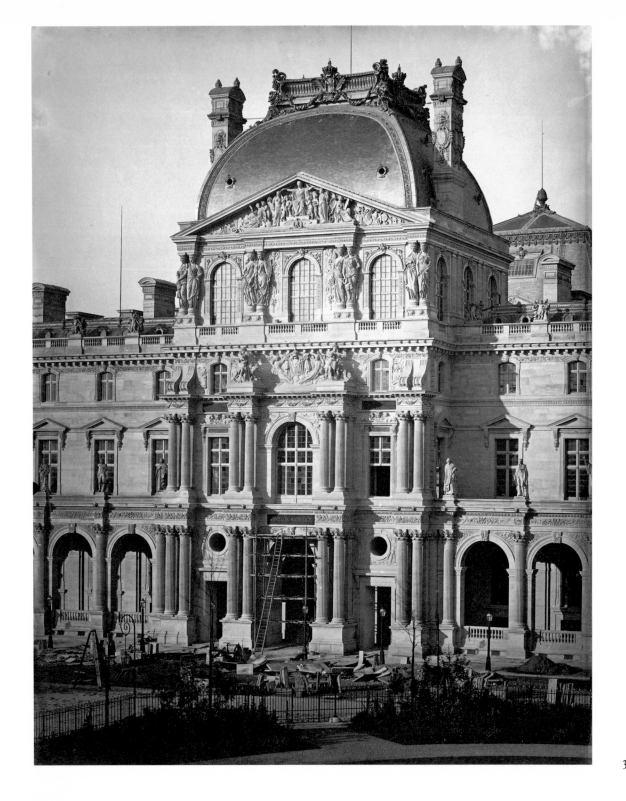

39. Pavillon Richelieu, Louvre, Paris, 1856–57

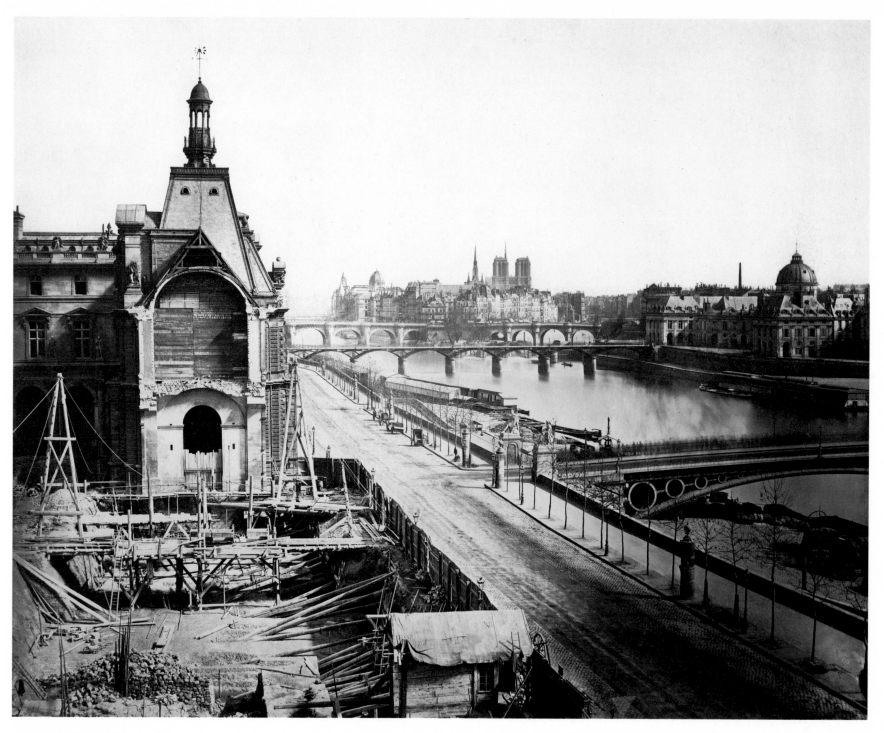

40. Destruction of the Grande Galerie, ca. 1865

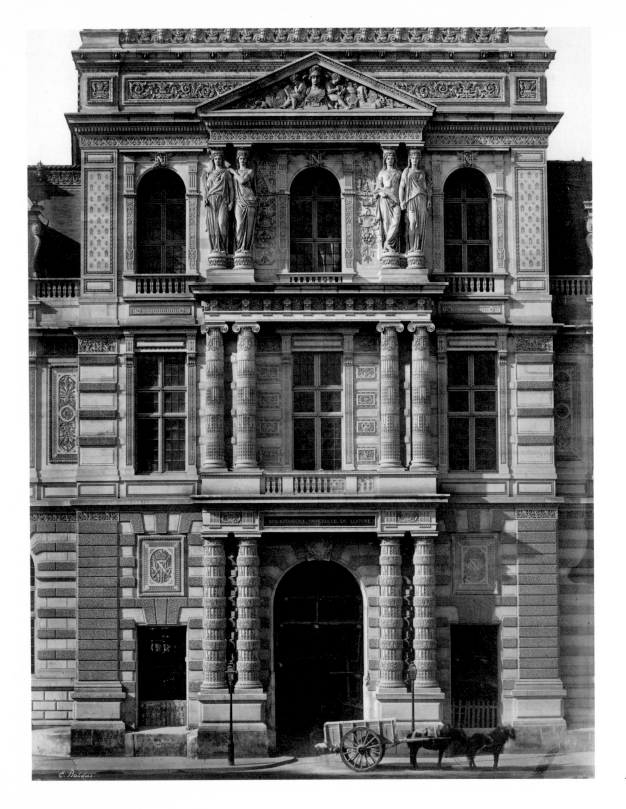

41. Imperial Library of the Louvre, Paris, 1856–57

42. Detail of the Pavillon Rohan, Louvre, Paris, ca. 1857

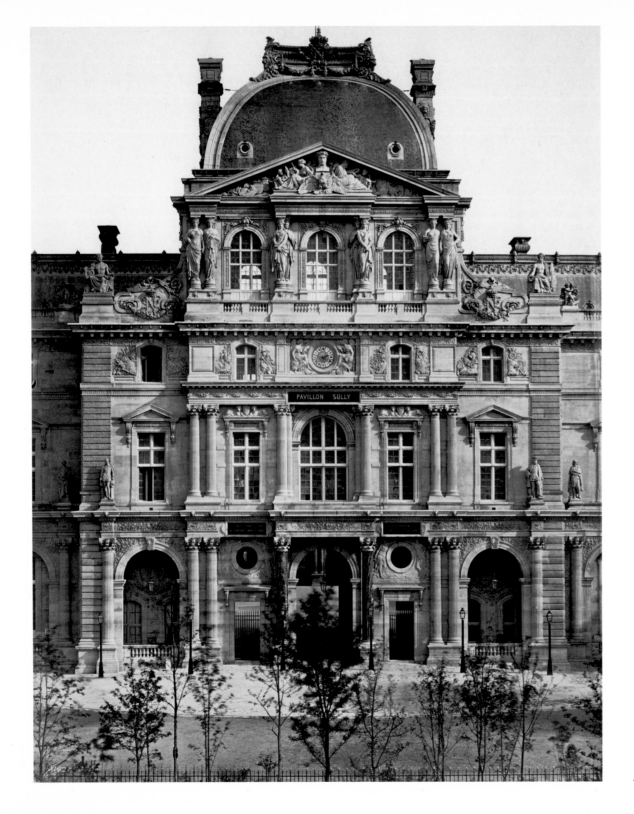

43. Pavillon Sully, Louvre, Paris, ca. 1857

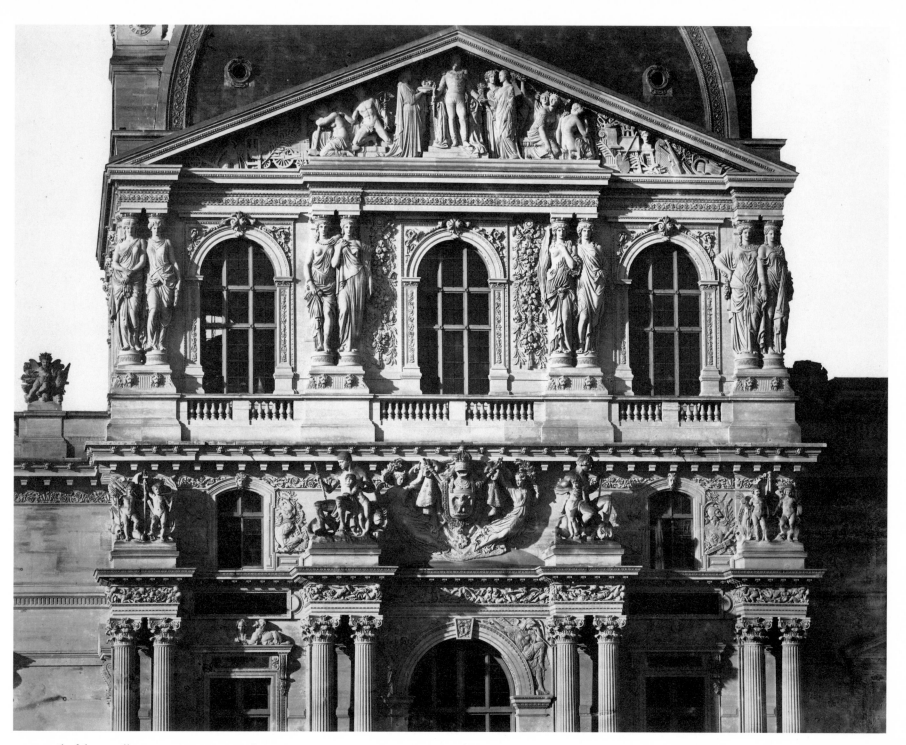

44. Detail of the Pavillon Denon, Louvre, Paris, ca. 1857

The Floods of 1856

45. The Floods of 1856, Brotteaux Quarter of Lyons, 1856 (negative)

46. The Floods of 1856, Brotteaux Quarter of Lyons, 1856

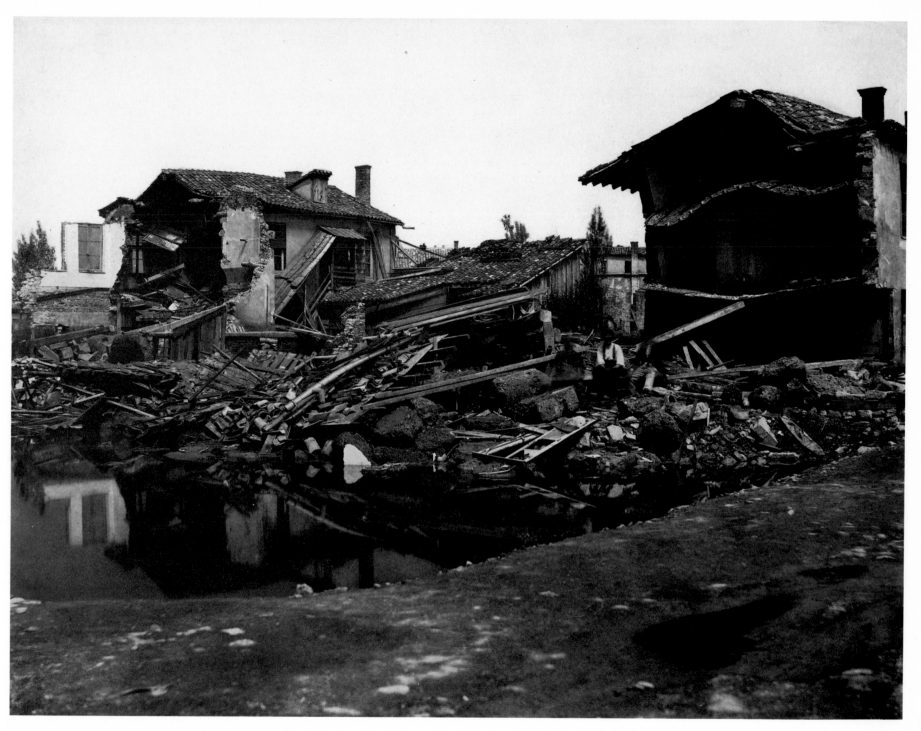

47. The Floods of 1856, Brotteaux Quarter of Lyons, 1856

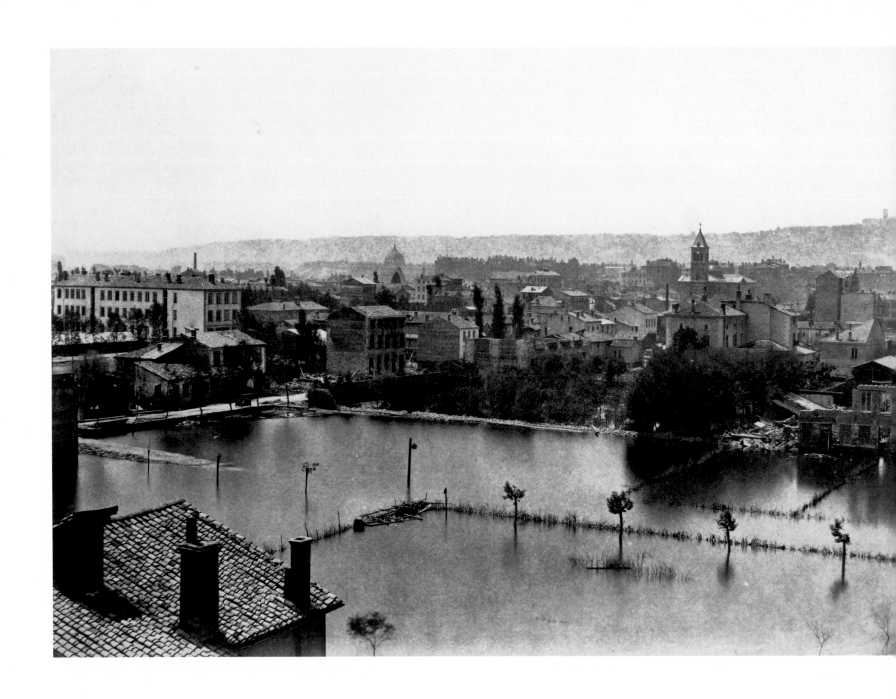

48. The Floods of 1856, Brotteaux Quarter of Lyons, 1856

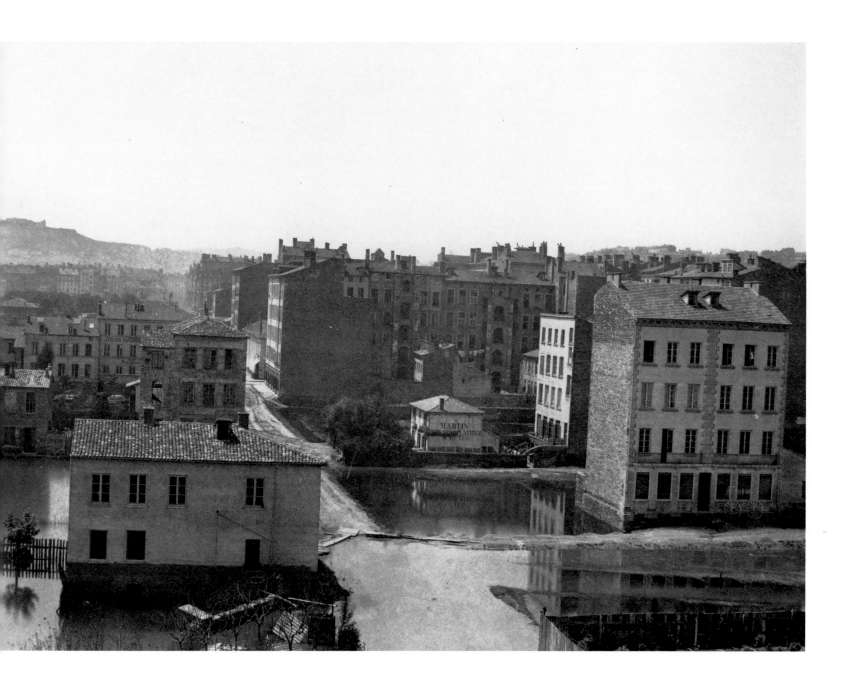

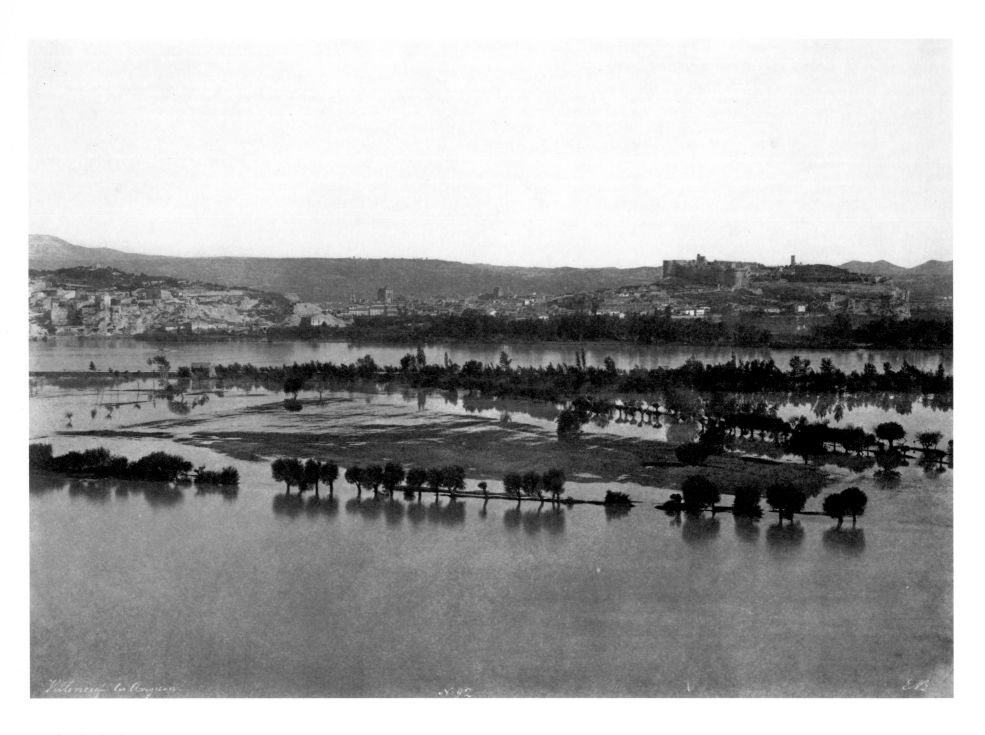

49. The Floods of 1856, Avignon, 1856

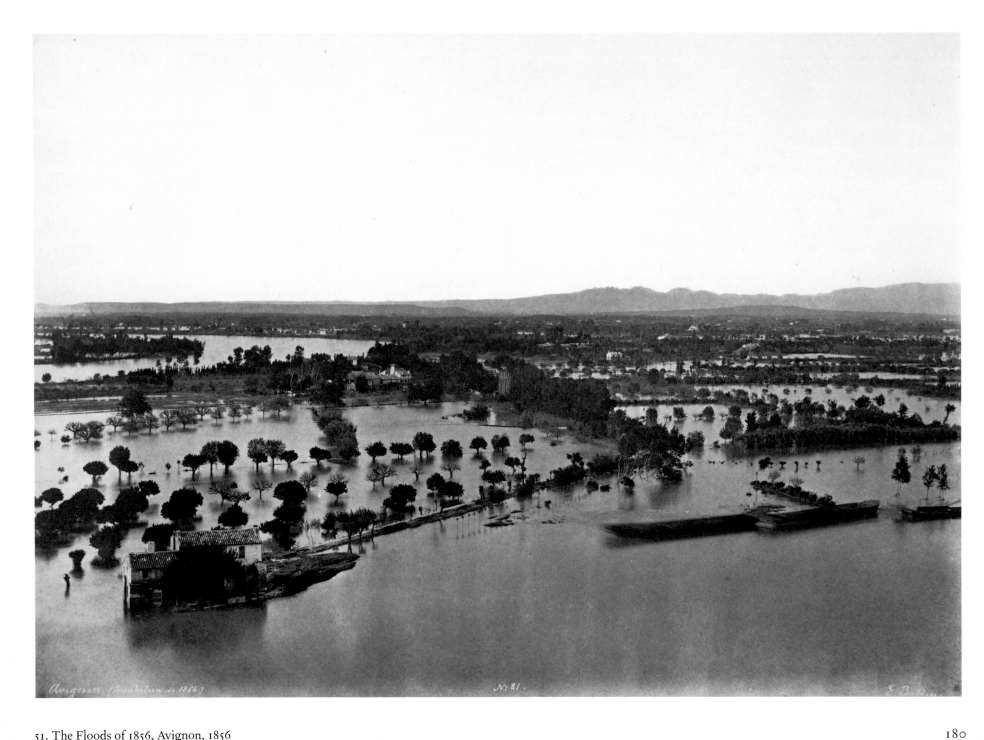

Avignon. (Inondation de 1856.) N: 81. E. B. D.

51. The Floods of 1856, Avignon, 1856

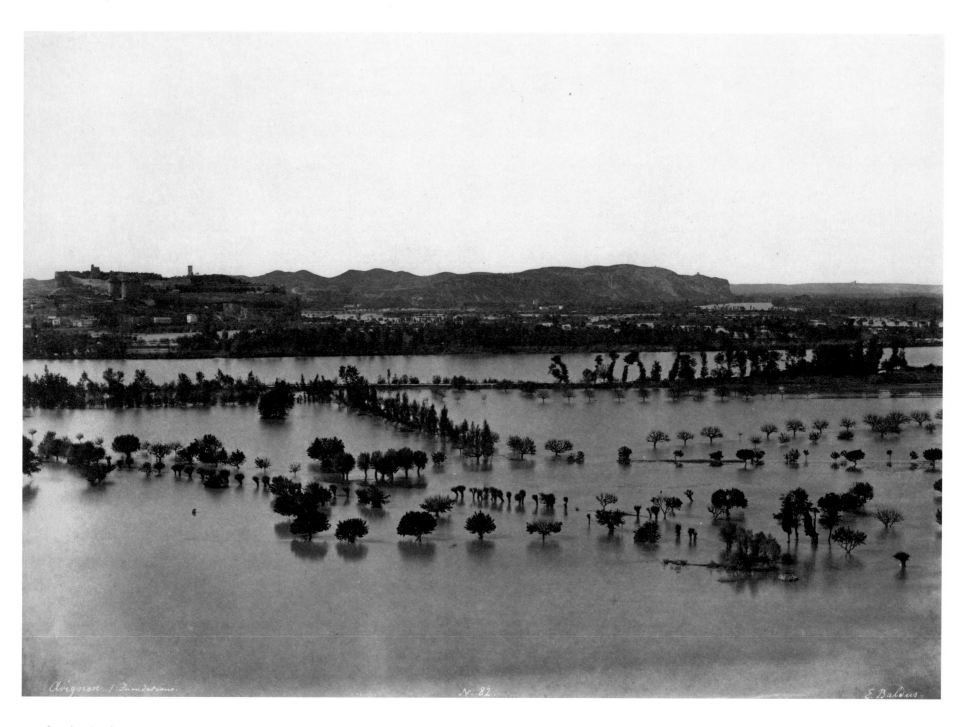

Avignon. / Inondations. N. 82. E. Baldus.

50. The Floods of 1856, Avignon, 1856

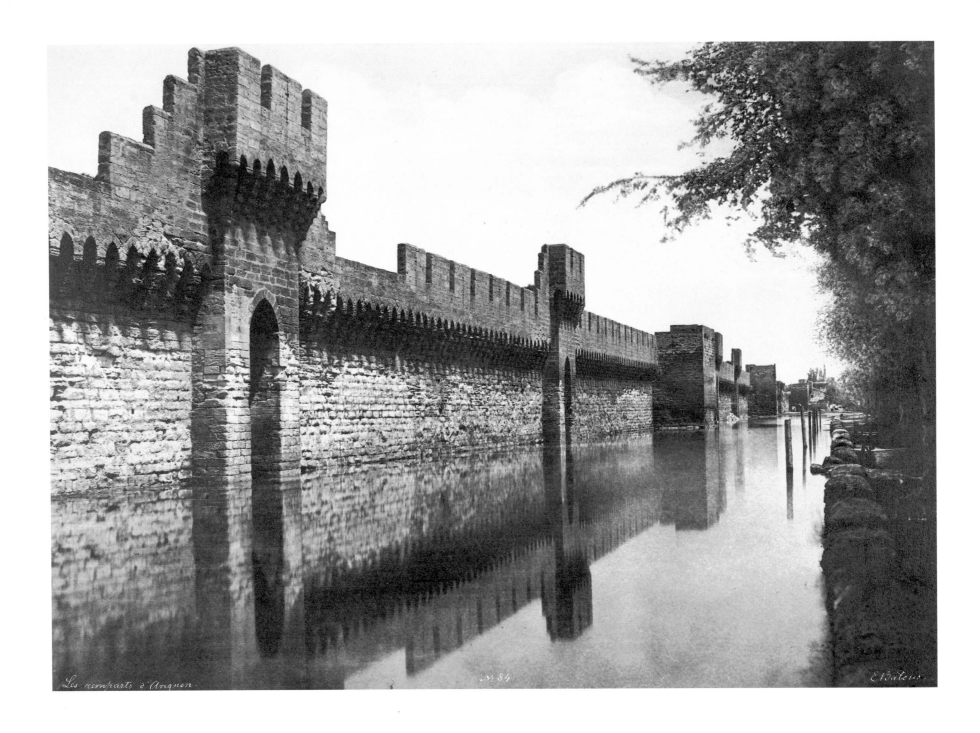

Les remparts d'Avignon.　N° 84.　E. Baldus

52. Ramparts of Avignon, 1856

Château de la Faloise, 1857

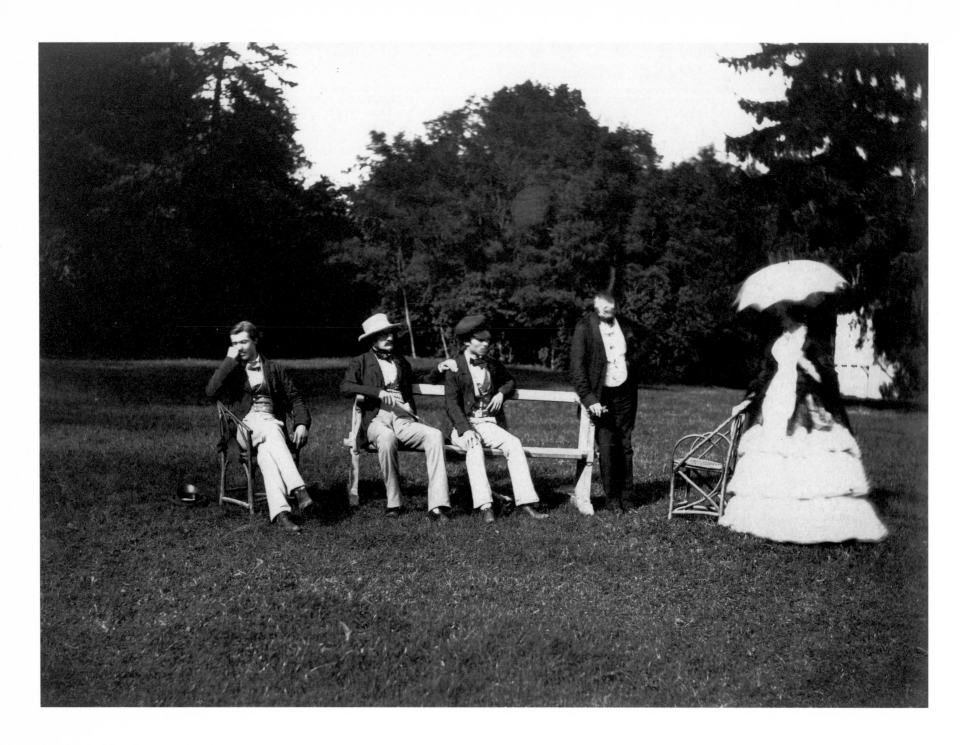

53. Group at the Château de la Faloise, 1857

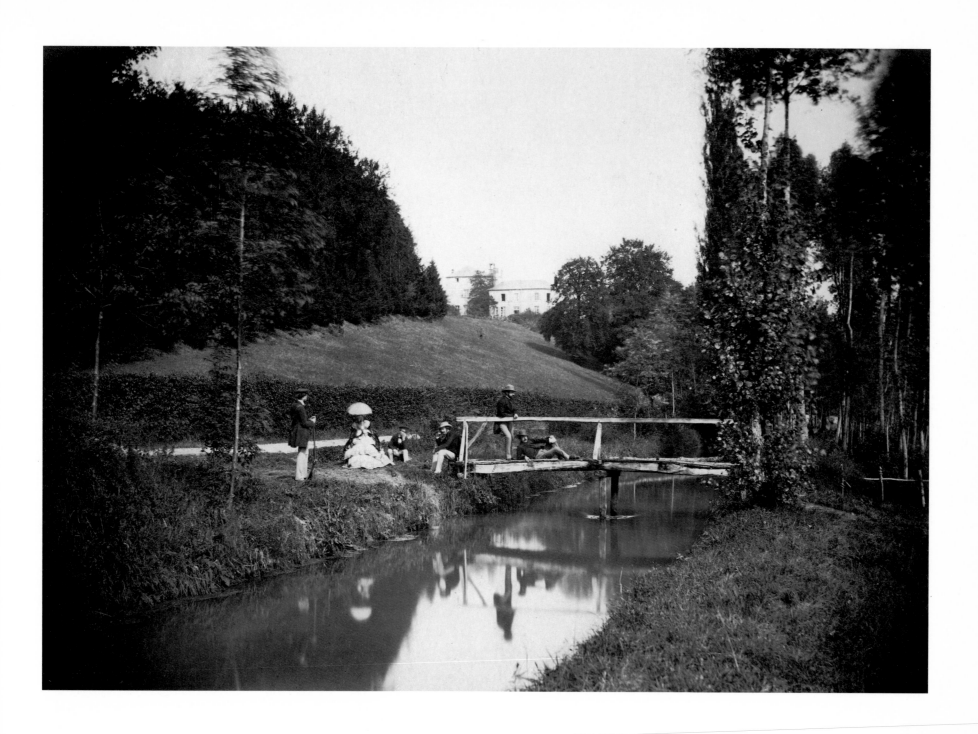

54. Group at the Château de la Faloise, 1857

Monuments, late 1850s

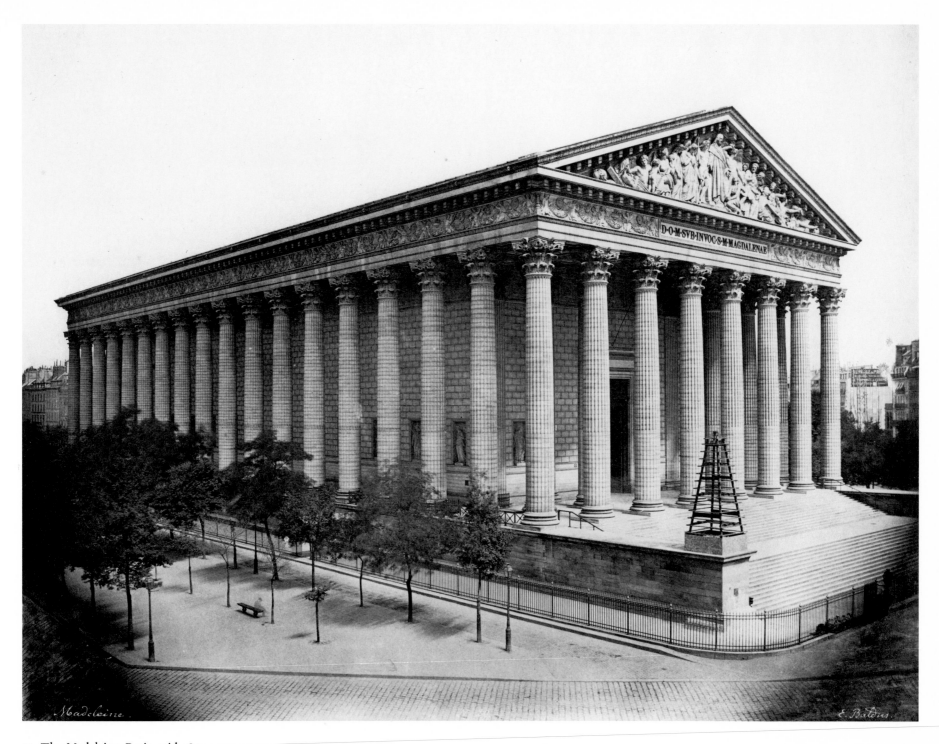

55. The Madeleine, Paris, mid-1850s

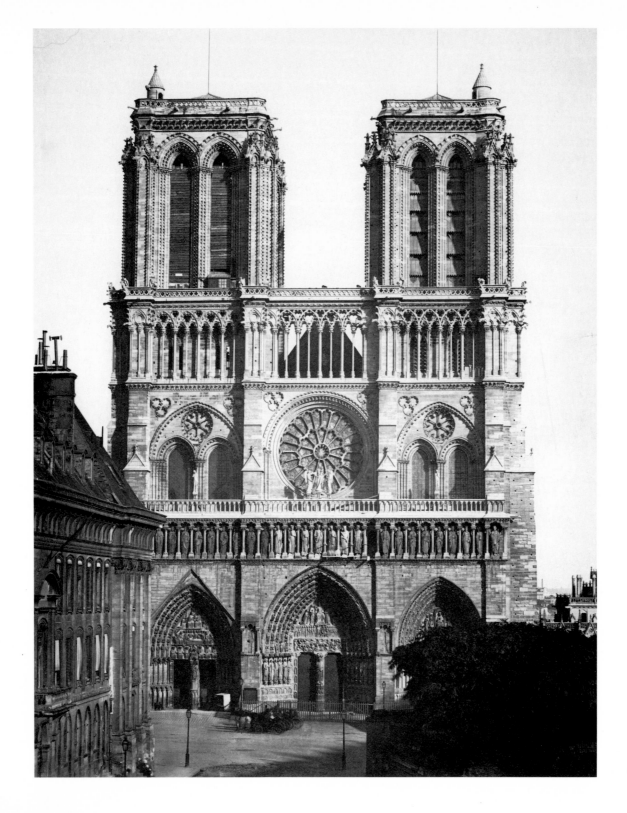

56. Notre-Dame, Paris, ca. 1857

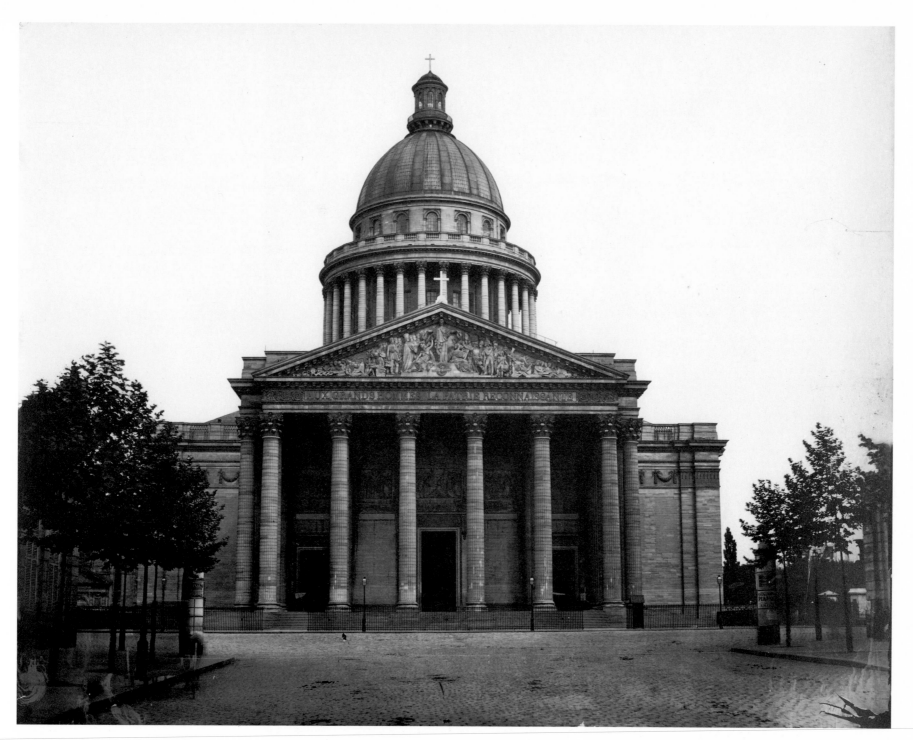

57. The Pantheon, Paris, ca. 1856

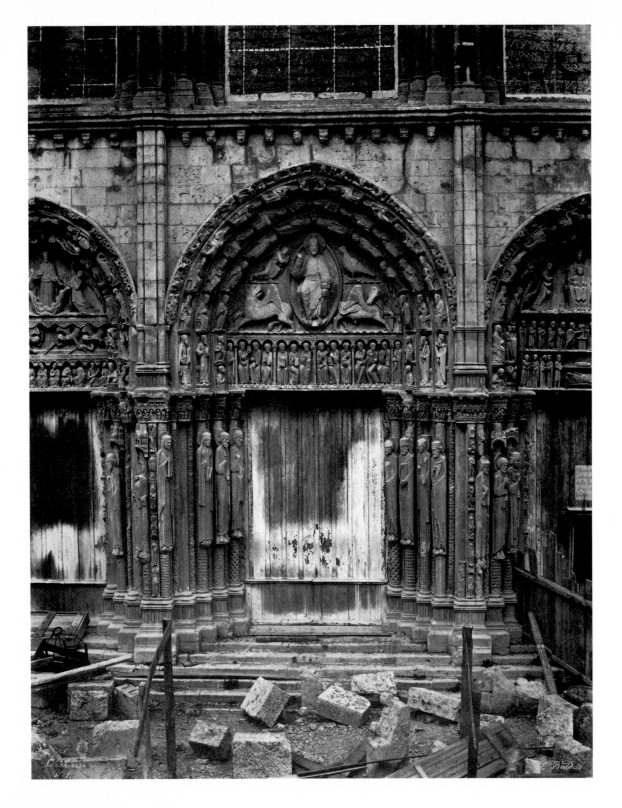

58. Portal, Chartres, ca. 1855

59. Church of Saint-Étienne, Caen, 1858

60. Church of Saint-Pierre, Caen, 1858

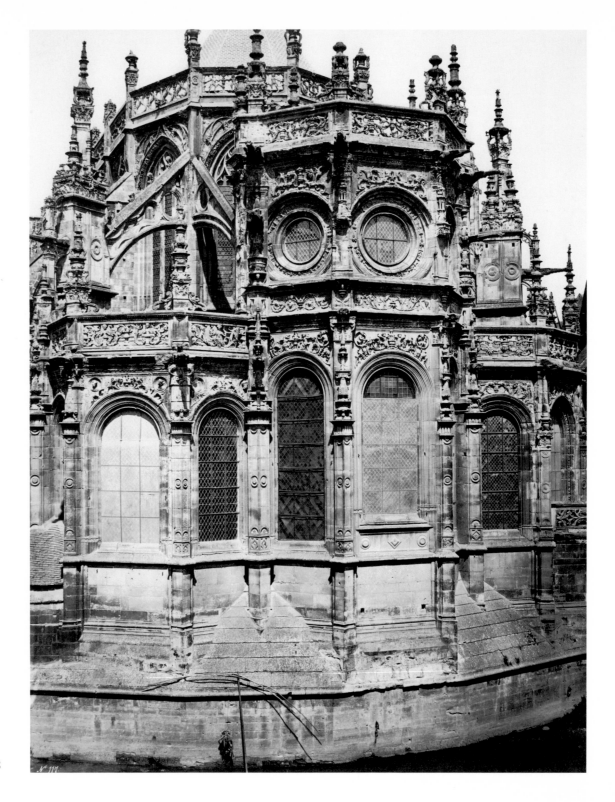

61. Apse of the Church of Saint-Pierre, Caen, 1858

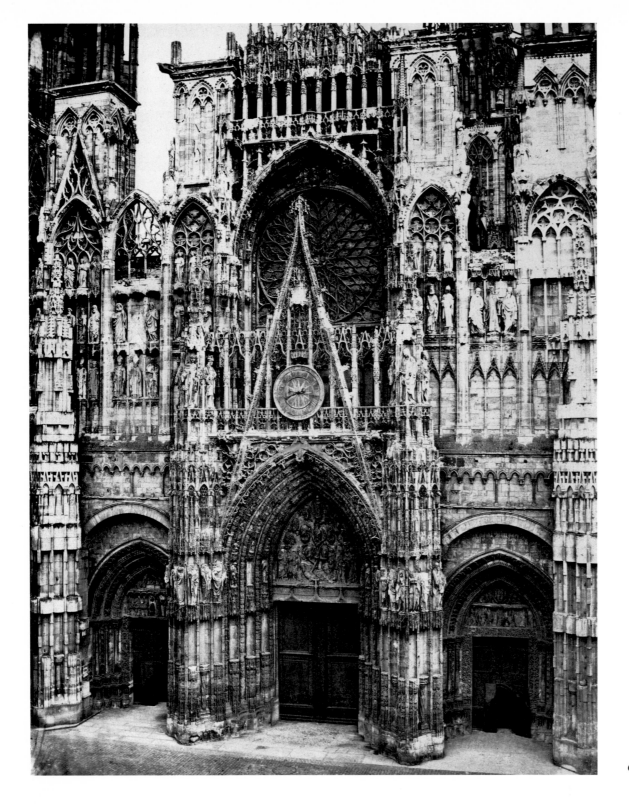

62. Notre-Dame, Rouen, 1858

63. Cathedral of Reims, ca. 1860

Far Corners of France, 1854–64

64. Allevard, ca. 1859

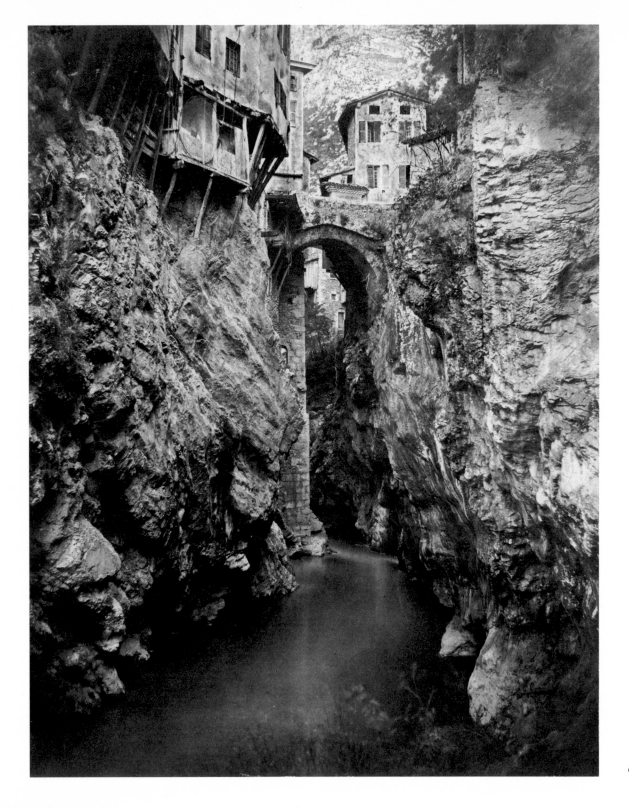

65. Pont en Royans, 1854–59

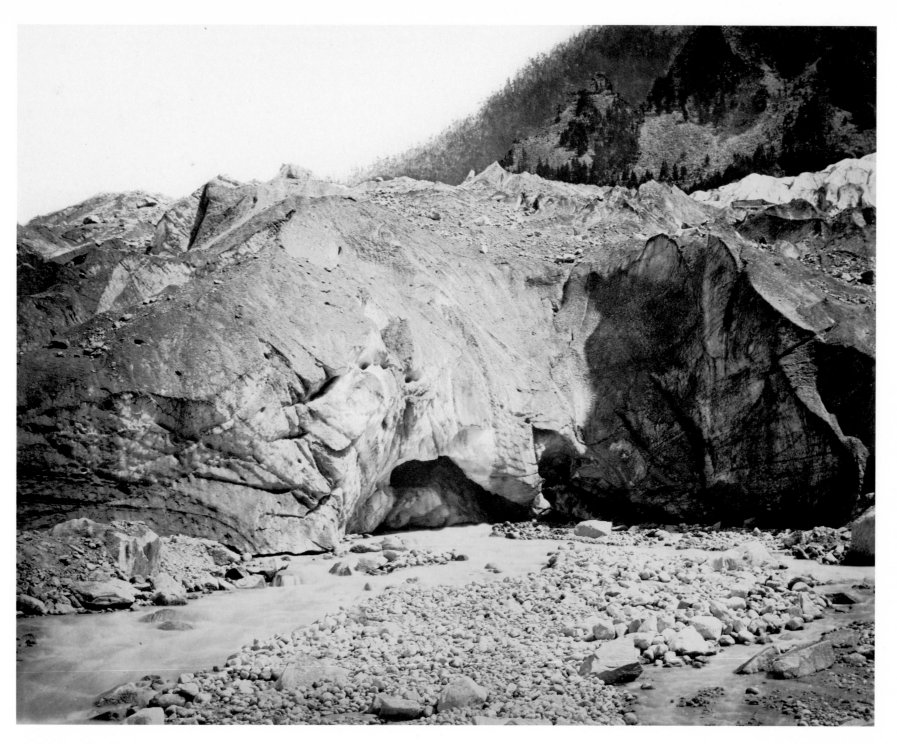

66. Source of the Aveyron River, ca. 1859

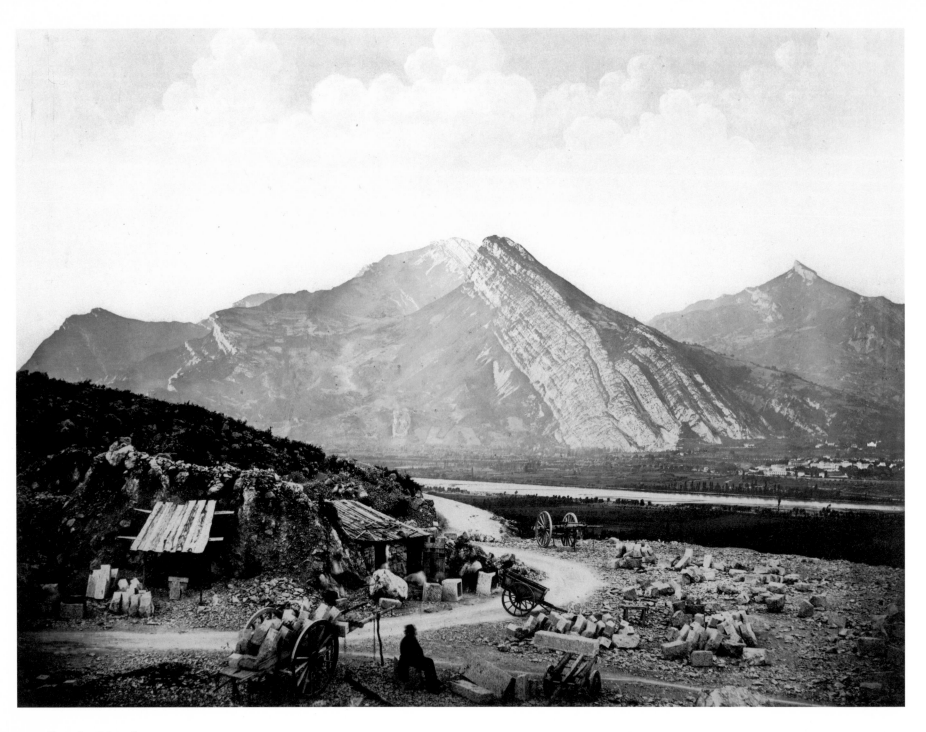

67. Valley of Grésivaudan, ca. 1859

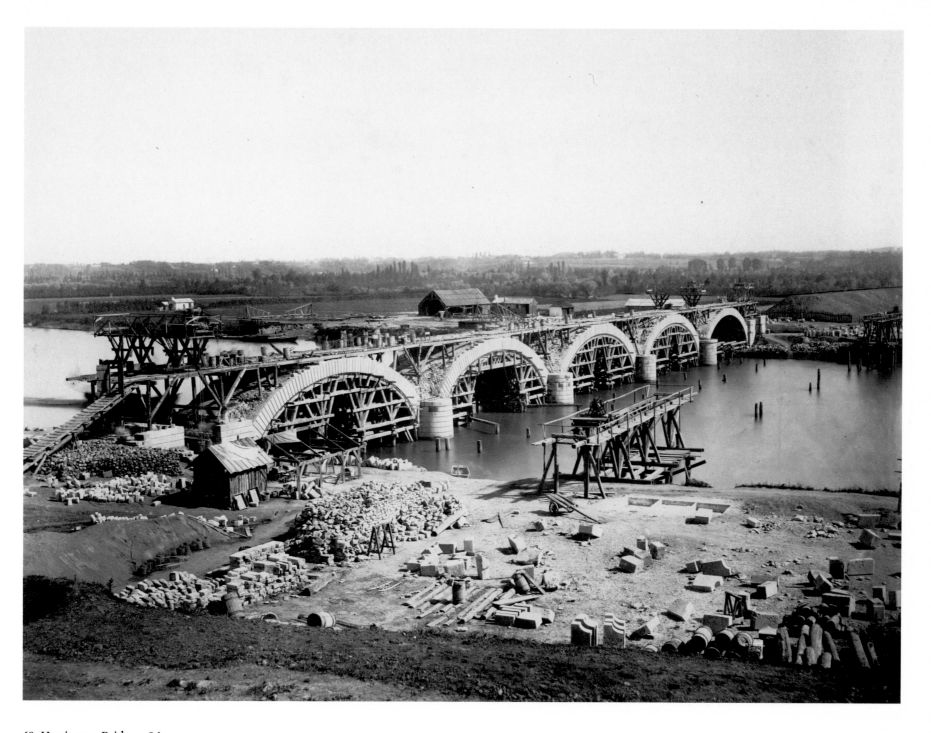

68. Hastingues Bridge, 1861

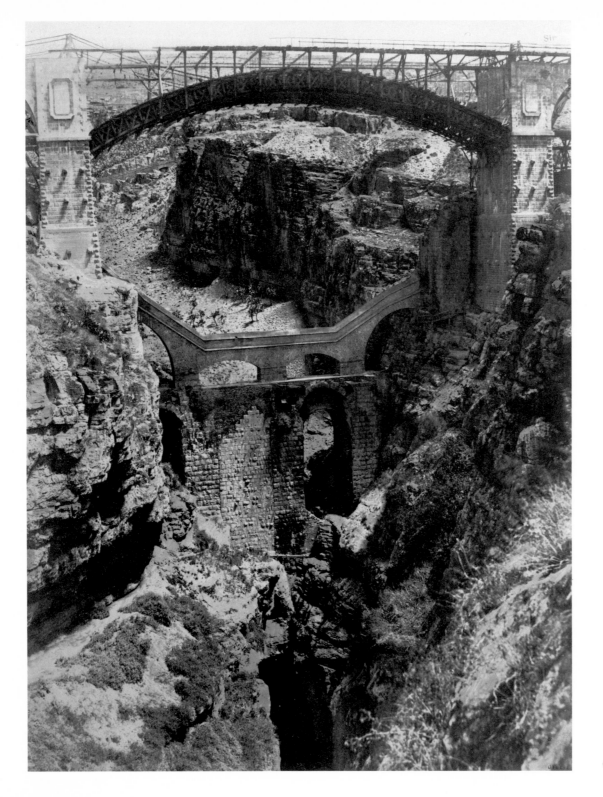

69. Al-Kantara Bridge, Constantine, Algeria, 1864

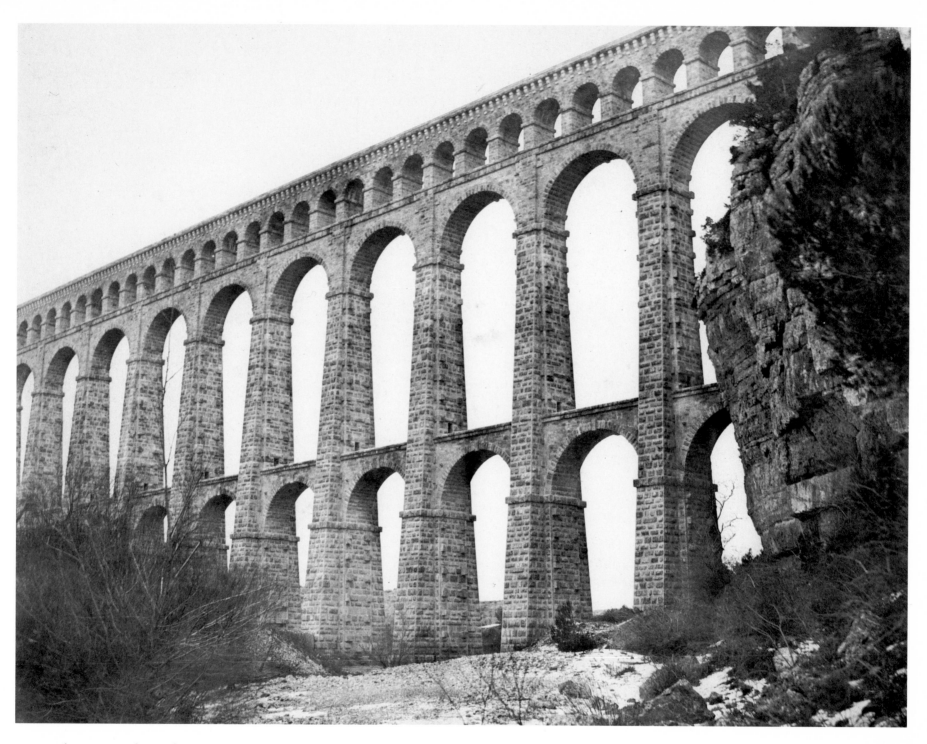

70. Aqueduct at Roquefavour, late 1850s

The Paris–Lyon–Méditerranée Album, 1861

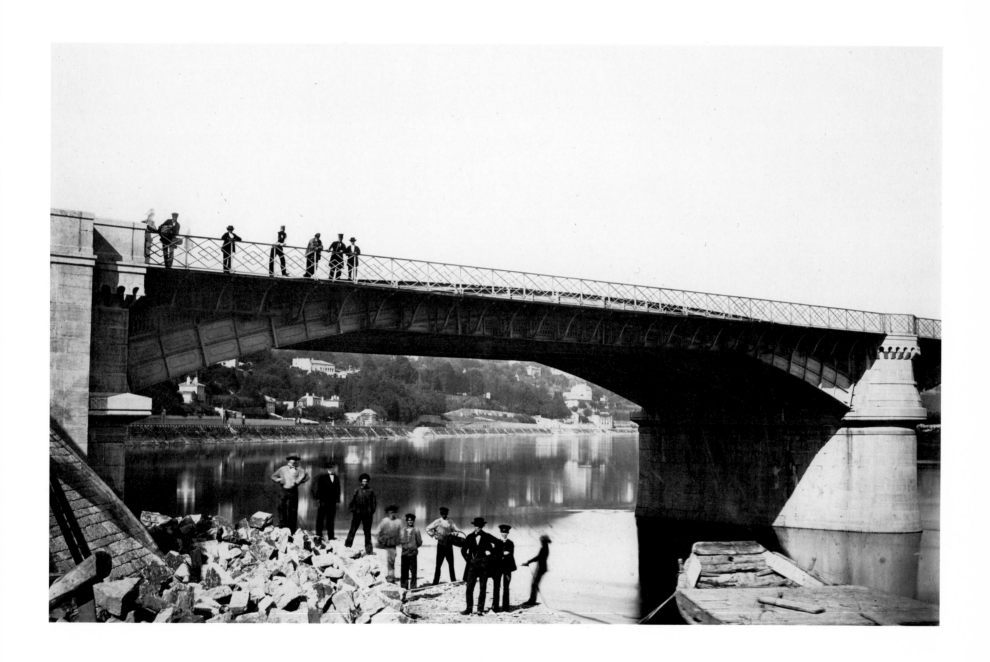

71. La Mulatière Bridge, Lyons, ca. 1861

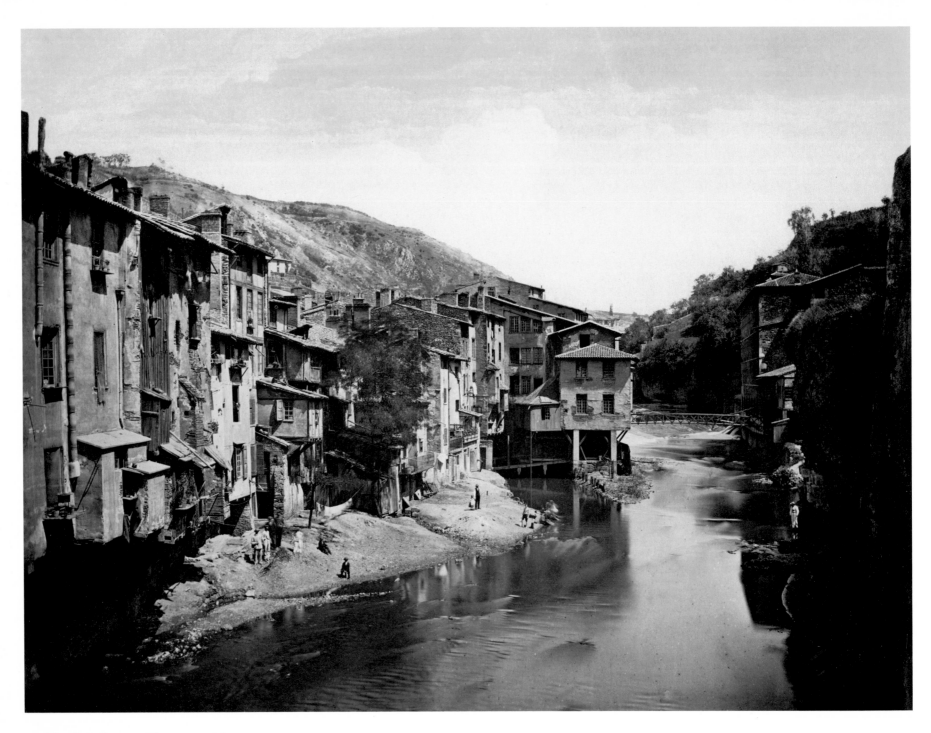

72. Saint-Jean Quarter, Vienne, ca. 1861

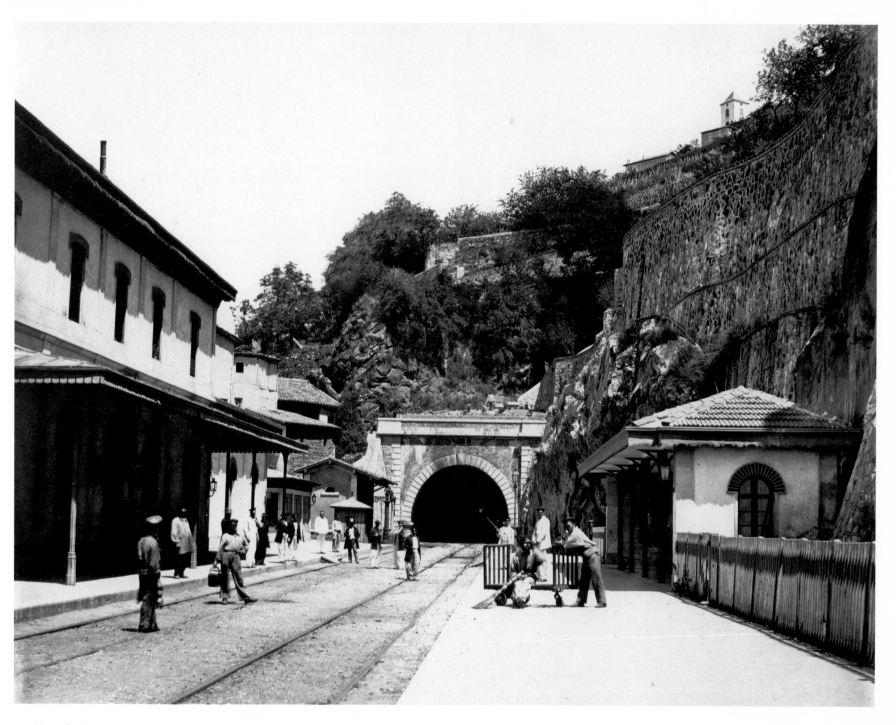

73. Tunnel, Vienne, ca. 1861

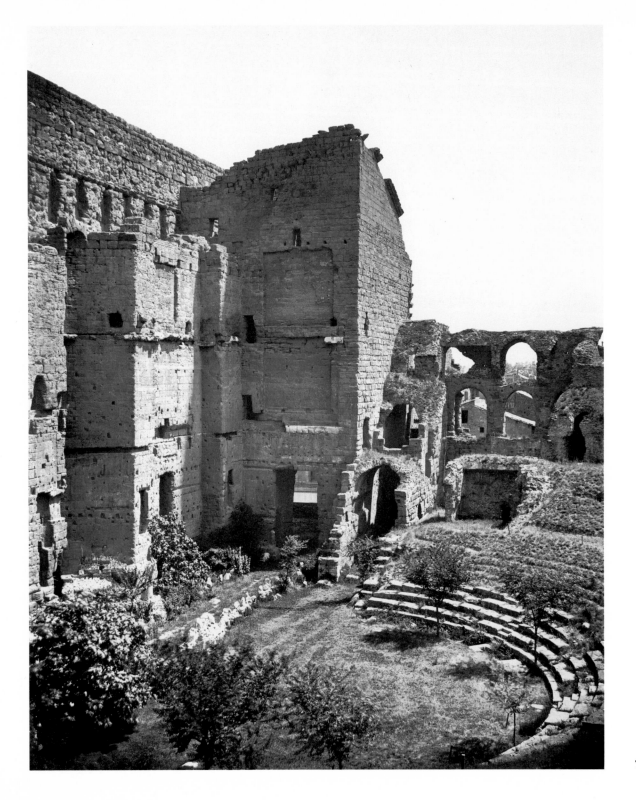

74. Roman Theater, Orange, ca. 1861

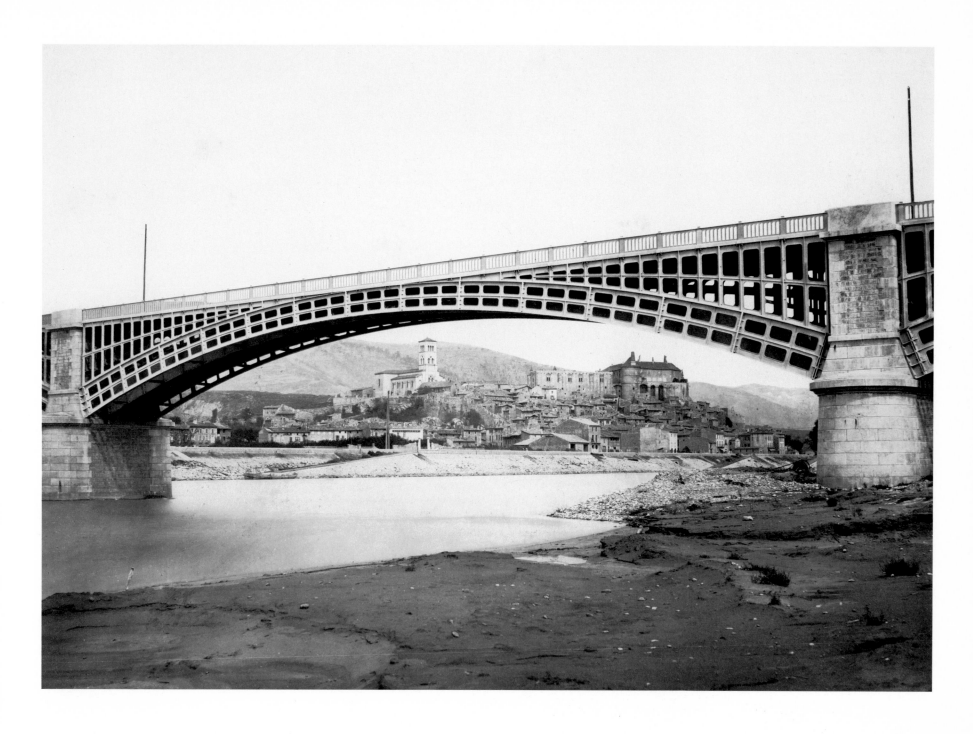

75. Viaduct at La Voulte, 1861 or later

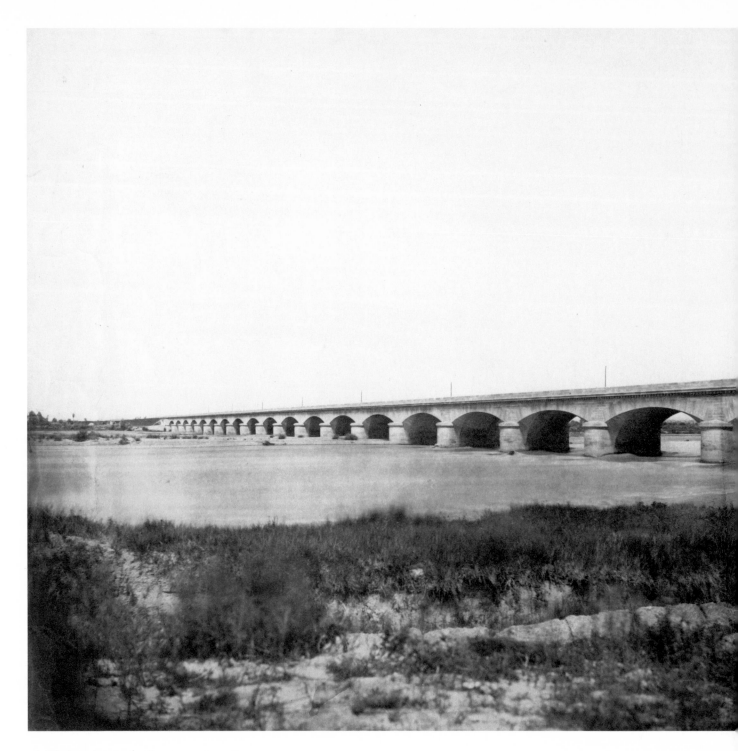

76. Viaduct Across the Durance, 1855–58

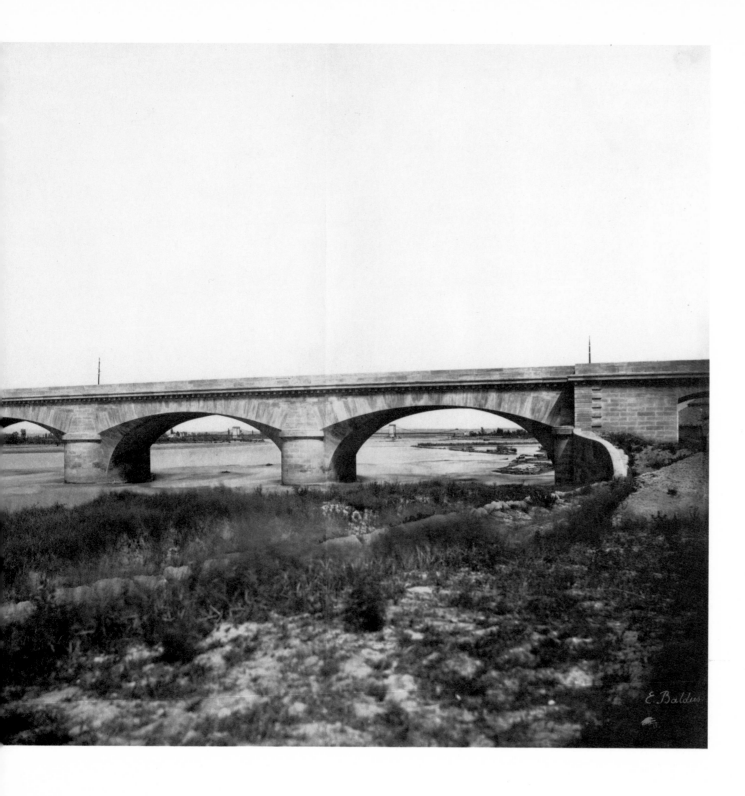

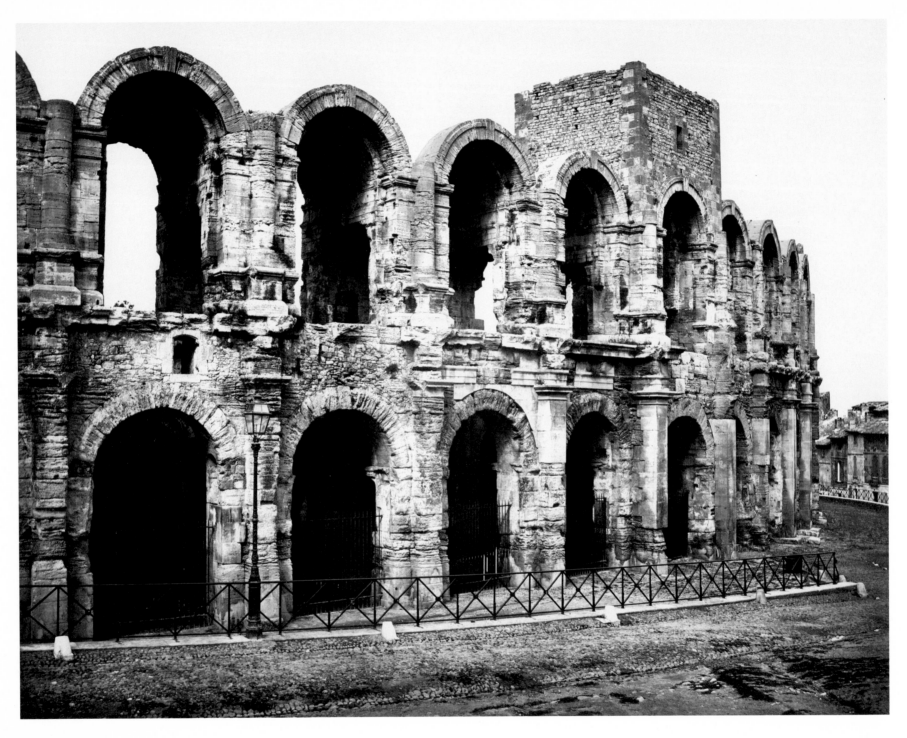

77. Amphitheater, Arles, ca. 1859

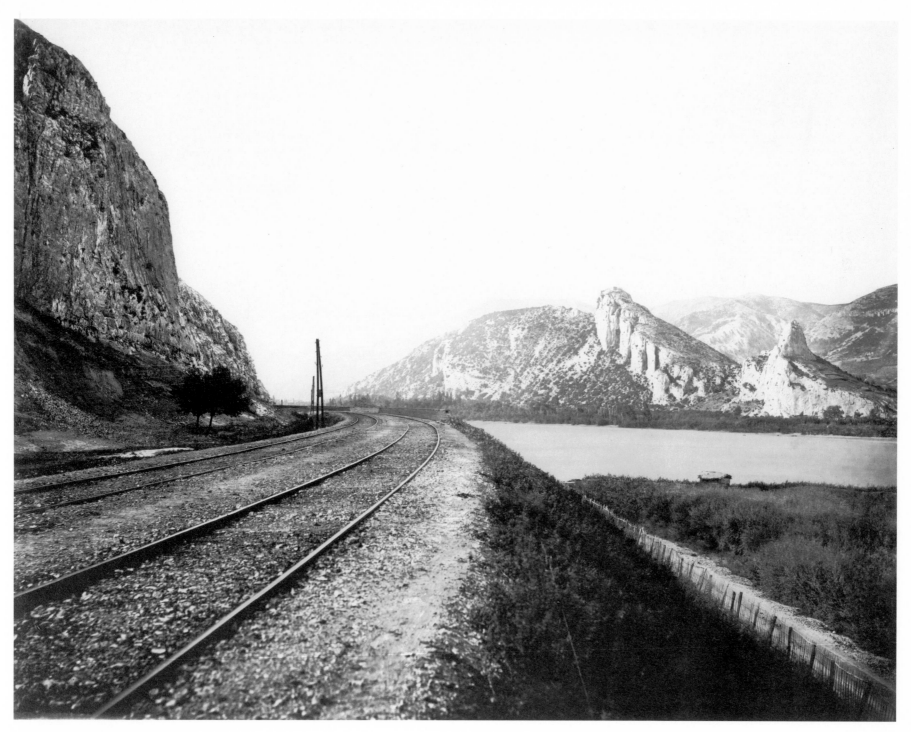

78. Entrance to the Donzère Pass, ca. 1861

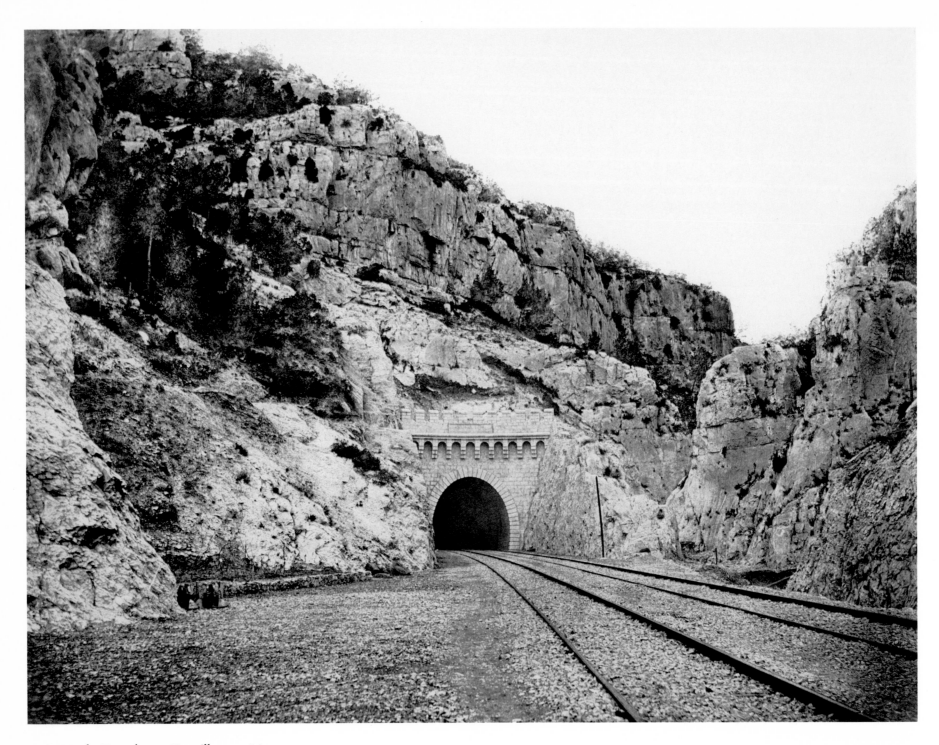

79. La Nerthe Tunnel, near Marseilles, ca. 1861

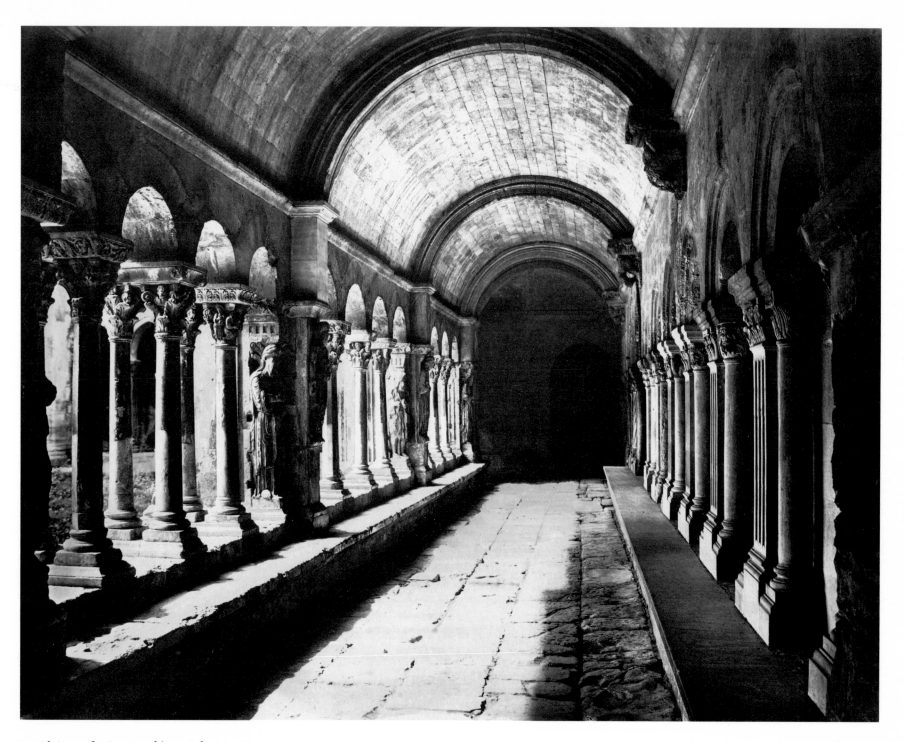

80. Cloister of Saint-Trophîme, Arles, ca. 1861

81. La Ciotat, ca. 1860

82. "The Eagle's Beak," La Ciotat, ca. 1860

83. Bandol, ca. 1860

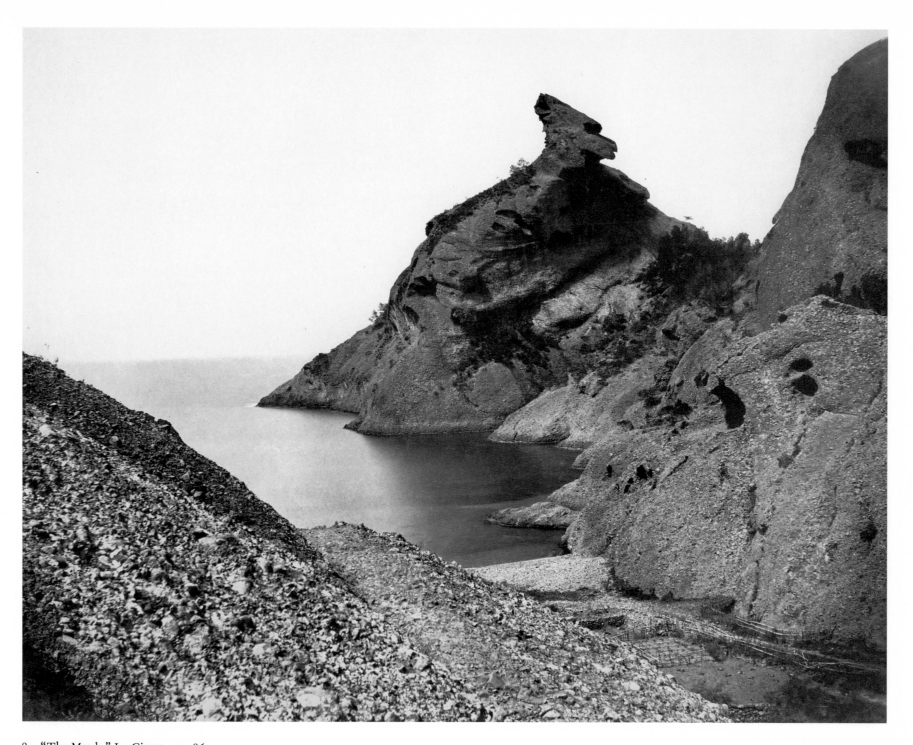

84. "The Monk," La Ciotat, ca. 1860

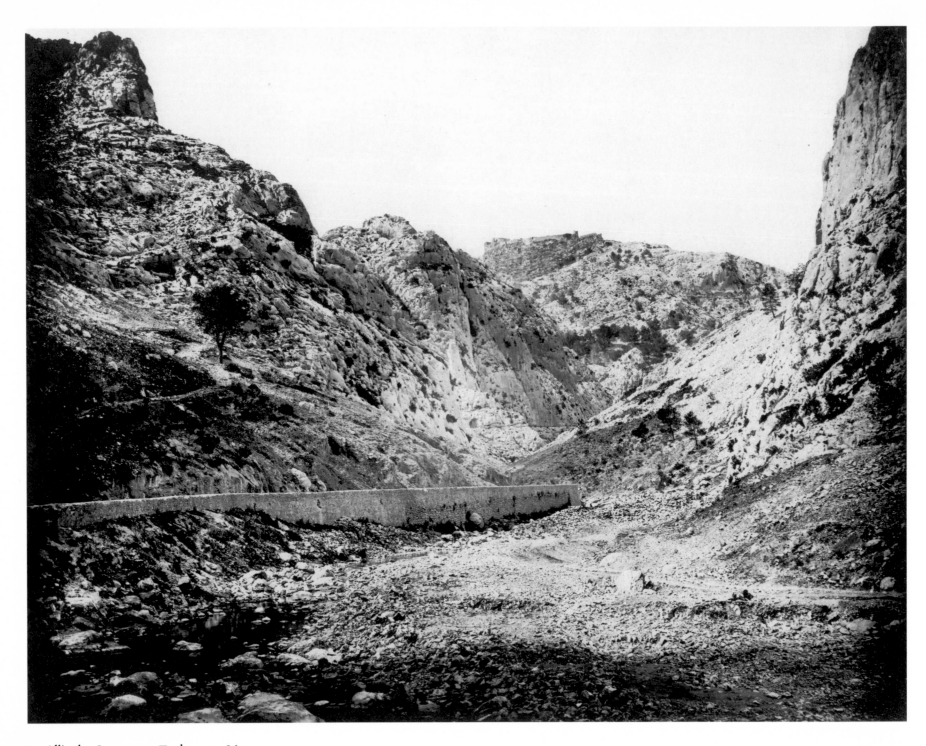

85. Ollioules Gorge, near Toulon, ca. 1860

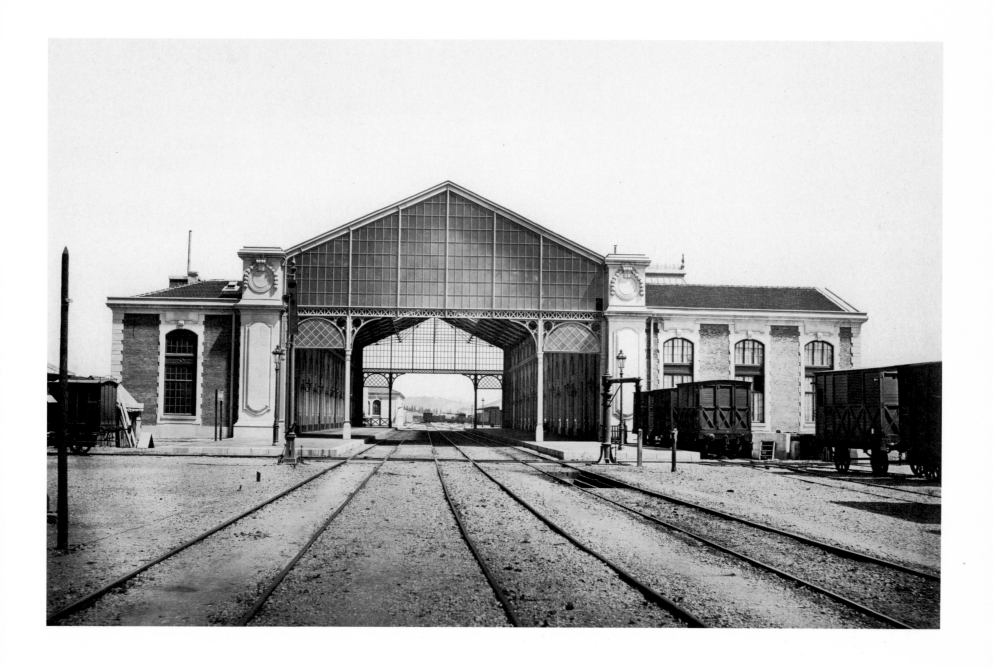

86. Toulon, 1861 or later

Plate List

Titles given below are Baldus's own titles, translated but only minimally standardized in format. Untitled works have been given descriptive titles.

Dimensions refer to the image size, height preceding width.

Inscriptions. Only those inscriptions written or stamped by the artist are given below, with the exception of those imprinted by the Historic Monuments Commission on the three negatives.

Ex collection is given for works with a significant provenance. Several listings deserve a word of explanation:

Léon Bourquelot worked in the Office of the Architect of the Louvre and assembled the albums of Baldus's photographs that were distributed by Napoléon III in early 1858. Clearly he worked closely with Baldus and received for his own collection particularly rich prints of Baldus's photographs from the period 1855 to 1857—photographs of the Chemin de Fer du Nord, the floods of 1856, Paris monuments, and the Louvre. A large group of exceptionally well preserved prints from this collection, many unmounted, was discovered in 1988–89 by Bourquelot's descendants.

"Napoléon III (?)" has been used to designate prints from an album that came to light in 1990–91 and that bears the imperial coat of arms on its cover. Although the album lacked its title page and several plates when found, its contents are nearly identical to those of the queen's album and are exceptional in their print quality. The origin of the album is not known.

The marquis de Rostaing may have been a student of Baldus. A group of very fine prints by Baldus, largely landscapes from the mid-1850s, surfaced in 1991 together with several photographs by the marquis de Rostaing and are presumed to have come from his collection.

1. *Cloister of Saint-Trophîme, Arles*, 1851
Salted paper print from paper negatives
44.8 × 50.2 cm (17⁵/₈ × 19³/₄ in.)
Musée National des Monuments Français, Paris
MMF PH.102.161

2. *Chapel of Saint-Croix, Montmajour*, 1849?
Salted paper print from paper negative
33.4 × 43.2 cm (13¹/₈ × 17 in.)
Inscribed in the negative lower left, "Chapelle de St Croix / à Montmajour"; lower center, "Nº 51."; lower right, "E. Baldus fc / 1849"
Canadian Centre for Architecture, Montreal
PH1978:0002

3. *Roman Theater, Arles*, 1851?
Salted paper print from paper negative
21.3 × 25.9 cm (8³/₈ × 10¹/₄ in.)
Signed in pencil on mount lower right, below photograph, "E Baldus."; lower right corner, "Theatre romain d'Arles"
Musée d'Orsay, Paris, dépôt des Archives de la Bibliothèque de la Manufacture de Sèvres
Do 1983–135

4. *Ramparts of Avignon*, 1851
Paper negative
25 × 35.9 cm (9⁷/₈ × 14¹/₈ in.)
Printed on negative lower left, "mh [in trefoil] 7604 AVIGNON.—Remparts"; inscribed in pencil on negative lower left, "230"

Musée d'Orsay, Paris, dépôt des Archives Photographiques du Patrimoine Do 1982.494

5. *Ramparts of Avignon*, 1851
Salted paper print from paper negative
25 × 35.9 cm (9⁷/₈ × 14¹/₈ in.)
Musée National des Monuments Français, Paris
MMF AMH 230

6. *Church at Beaune*, 1851
Salted paper print, 1994, from the original paper negatives
27.4 × 27.8 cm (10³/₄ × 11 in.)
Musée d'Orsay, Paris MH 7461

7. *Roman Arch, Orange*, 1851
Salted paper print from paper negative
35.3 × 26.2 cm (13⁷/₈ × 10³/₈ in.)
The Metropolitan Museum of Art, Purchase, The Horace W. Goldsmith Foundation Gift and Edward Pearce Casey Fund, 1990 1990.1127

8. *Notre-Dame, Paris*, 1852–53
Salted paper print from paper negative
34.5 × 44.5 cm (14 × 17¹/₂ in.)
Musée d'Orsay, Paris, dépôt des Archives de la Bibliothèque de la Manufacture de Sèvres
Do 1983–135

9. *Pavillon de l'Horloge, Louvre, Paris*, 1852–53
Salted paper print from paper negative
39.5 × 27.7 cm (15¹/₂ × 10⁷/₈ in.)
Signed in pencil on mount lower right, below photograph, "E. Baldus f."
The Metropolitan Museum of Art, Purchase, The Horace W. Goldsmith Foundation Gift, 1991
1991.1042

10. *Hôtel de Ville, Paris*, 1852–53
Salted paper print from paper negative
29 × 44.3 cm (11¹⁄₂ × 17¹⁄₂ in.)
Canadian Centre for Architecture, Montreal
PH1977:0040

11. *Tour Saint-Jacques, Paris*, 1852–53
Salted paper print from paper negative
43.5 × 34.5 cm (17¹⁄₈ × 13⁵⁄₈ in.)
Private collection, Paris

12. *Saint-Bénézet Bridge, Avignon*, 1853
Salted paper print from paper negative
30.1 × 43.3 cm (11⁷⁄₈ × 17 in.)
Inscribed in the negative lower left, "Pont St.
Benezet a Avignon."; lower center, "N⁰ 50"; lower
right, signature effaced; facsimile signature stamp
on mount lower right, below photograph, effaced
Ex coll.: Marquis de Rostaing (?)
Collection Joel and Anne Ehrenkranz

13. *Roman Arch, Orange*, 1853
Salted paper print from paper negative
32.4 × 44.2 cm (12³⁄₄ × 17³⁄₈ in.)
Inscribed in the negative lower left, "Arc Antique à
Orange"; lower right, "E. Baldus."
Canadian Centre for Architecture, Montreal
PH1980:1072

14. *Church of Saint-Honorat, near Arles*, 1853
Salted paper print from paper negative
33.7 × 43.2 cm (13¹⁄₄ × 17 in.)
Inscribed in the negative lower left, "St. Honorat
près d'Arles"
Ex coll.: Charles Nègre
Private collection, Paris

15. *Tour Magne, Nîmes*, 1853
Salted paper print from paper negative
43.5 × 32.5 cm (17¹⁄₈ × 12³⁄₄ in.)
Inscribed in the negative lower left, "Tour Magne
à Nîmes"; lower right, "E Baldus"
Bokelberg Collection

16. *Saint-Nectaire*, 1854
Salted paper print from paper negative
34.5 × 45 cm (13⁵⁄₈ × 17³⁄₄ in.)

Inscribed in the negative lower left, "St. Nectaire.
N⁰ 93"; lower right, "EB."
Bokelberg Collection

17. *Château d'Espailly*, 1854
Salted paper print from paper negative
33.2 × 43.3 cm (13¹⁄₈ × 17 in.)
Inscribed in pencil on mount lower right,
below photograph, "E. Baldus"
Ex coll.: Fortuné-Joseph Petiot-Groffier
Private collection, Paris

18. *Village of Murols*, 1854
Salted paper print from paper negative
34.4 × 44.1 cm (13¹⁄₂ × 17³⁄₈ in.)
Inscribed in pencil on mount lower right,
below photograph, "E Baldus"
Ex coll.: Fortuné-Joseph Petiot-Groffier
Private collection, Paris

19. *Rocks in the Auvergne*, 1854
Paper negative
33.9 × 44.8 cm (13³⁄₈ × 17⁵⁄₈ in.)
Ex coll.: Fortuné-Joseph Petiot-Groffier
Private collection, Paris

20. *Rocks in the Auvergne*, 1854
Salted paper print, 1978, from the original paper
negative
33.9 × 44.8 cm (13³⁄₈ × 17⁵⁄₈ in.)
The Metropolitan Museum of Art, Gift of
Joel Snyder, 1988 1988.1112.1

21. *Chapel of Saint-Michel, Le Puy*, 1854
Salted paper print from paper negative
33.9 × 44.4 cm (13³⁄₈ × 17¹⁄₂ in.)
Inscribed in the negative lower left, "Rocher de
Saint-Michel au Puy N⁰ 65"; lower right,
signature effaced
Ex coll.: Marquis de Rostaing (?)
Courtesy Charles Isaacs Photographs

22. *Abbey of Saint-Denis*, 1855 or earlier
Salted paper print from paper negative
42.7 × 34 cm (16⁷⁄₈ × 13³⁄₈ in.)
Ex coll.: Léon Bourquelot
Collection Michael and Jane Wilson

23. *Railroad Station, Enghien*, 1855
Salted paper print from paper negative
31.3 × 44.3 cm (12³⁄₈ × 17¹⁄₂ in.)
Ex coll.: Napoléon III (?)
The Metropolitan Museum of Art, Louis V. Bell
Fund, 1992 1992.5002

24. *Château of Princess Mathilde, Enghien*, 1854–55
Salted paper print from paper negative
31 × 44.3 cm (12¹⁄₄ × 17¹⁄₂ in.)
Ex coll.: Napoléon III (?)
The Metropolitan Museum of Art, Louis V. Bell
Fund, 1992 1992.5001

25. *Chalet, Enghien*, 1855
Salted paper print from paper negative
26.2 × 36.3 cm (10³⁄₈ × 14¹⁄₄ in.)
Ex coll.: Napoléon III
Musée National de la Voiture et du Tourisme,
Château de Compiègne MV 3930

From the album *Train impérial: Voyage de Paris à
Compiègne*, originally kept in the imperial parlor
car of the Chemin de Fer du Nord

26. *Church at Auvers*, 1855
Salted paper print from paper negative
32.4 × 43.2 cm (12³⁄₄ × 17 in.)
Inscribed in the negative lower left, "Egl.
d'Auvers."; lower right, "E Baldus."
Ex coll.: Léon Bourquelot
The Metropolitan Museum of Art, Purchase,
Rogers Fund, and Joyce and Robert Menschel and
Harriette and Noel Levine Gifts, 1990 1990.1012

27. *Railroad Station, Pontoise*, 1855
Salted paper print from paper negative
29.7 × 43.8 cm (11³⁄₄ × 17¹⁄₄ in.)
Ex coll.: Léon Bourquelot
Collection Michael and Jane Wilson

28. *Saint-Leu d'Esserent*, 1855
Salted paper print from paper negative
30.6 × 43.5 cm (12 × 17¹⁄₈ in.)
Ex coll.: Léon Bourquelot
Simon Lowinsky Gallery, New York

29. *Ruins of the Château de Boves*, 1855
Salted paper print from paper negative
33 × 40.4 cm (13 × 15⁷⁄₈ in.)
Ex coll.: Napoléon III (?)
Musée d'Orsay, Paris, acquis par le Comité
national de la photographie pour le Musée d'Orsay
Pho 1991-10

30. *Railroad Station, Amiens*, 1855
Salted paper print from paper negative
32 × 44 cm (12⁵⁄₈ × 17³⁄₈ in.)
Ex coll.: Léon Bourquelot
Musée d'Orsay, Paris, don de la Société des
Amis d'Orsay Pho 1988-7

31. *Portal, Amiens*, 1855
Salted paper print from paper negative
44 × 33.8 cm (17³⁄₈ × 13¹⁄₄ in.)
Inscribed in the negative lower left, "Amiens";
lower center, "N° 42."; lower right, "E Baldus."
Ex coll.: Léon Bourquelot
Quillan Company (courtesy of Jill Quasha)

32. *Amiens*, 1855
Salted paper print from paper negative
29.6 × 44.3 cm (11⁵⁄₈ × 17¹⁄₂ in.)
Inscribed in the negative lower left, "E. Baldus.";
lower center, "N° 4"; lower right, "Amiens."
Musée d'Orsay, Paris, dépôt des Archives de la Bib-
liothèque de la Manufacture de Sèvres Do 1983-118

33. *Long-sur-Somme*, 1855
Salted paper print from paper negative
32 × 40.2 cm (12⁵⁄₈ × 15⁷⁄₈ in.)
Ex coll.: Napoléon III (?)
Collection Michael and Jane Wilson

34. *Railroad Station, Picquigny*, 1855
Salted paper print from paper negative
32 × 43.1 cm (12⁵⁄₈ × 17 in.)
Ex coll.: Napoléon III (?)
Musée d'Orsay, Paris, acquis par le Comité
national de la photographie par l'intermédiaire de
la Société des Amis d'Orsay Pho 1993-6

35. *Saint-Valéry*, 1855
Salted paper print from paper negative

28.2 × 40.4 cm (11¹⁄₈ × 15⁷⁄₈ in.)
Ex coll.: Léon Bourquelot
Musée d'Orsay, Paris, don de la Société des
Amis d'Orsay Pho 1988-6

36. *Boats at Low Tide, Boulogne*, 1855
Salted paper print from paper negative
30 × 40.2 cm (11⁷⁄₈ × 15⁷⁄₈ in.)
Inscribed in the negative lower left, "Boulogne.";
lower center, "N° 60."; lower right, "E Baldus"
Ex coll.: Léon Bourquelot
Collection Ezra Mack, New York

37. *Entrance to the Port, Boulogne*, 1855
Salted paper print from paper negative
28.8 × 43.5 cm (11³⁄₈ × 17¹⁄₈ in.)
Ex coll.: Napoléon III (?)
The Metropolitan Museum of Art, Louis V. Bell
Fund, 1992 1992.5000

38. *Tuileries Palace, Paris*, 1855
Salted paper print from glass (?) negative
30.5 × 46.5 cm (12 × 18¹⁄₄ in.)
Inscribed in pencil on mount lower right, below
photograph, "E. Baldus"
Courtesy Galerie Michèle Chomette, Paris

This photograph is a cropped version of the image
illustrated as fig. 76.

39. *Pavillon Richelieu, Louvre, Paris*, 1856–57
Salted paper print from glass negative
44.3 × 34.6 cm (17¹⁄₂ × 13⁵⁄₈ in.)
Ex coll.: Léon Bourquelot
Musée d'Orsay, Paris Pho 1988-11-8

40. *Destruction of the Grande Galerie*, ca. 1865
Albumen silver print from glass negative
45 × 39 cm (17³⁄₄ × 15³⁄₈ in.)
Ex coll.: Léon Bourquelot
Musée d'Orsay, Paris Pho 1988-11-3

41. *Imperial Library of the Louvre, Paris*, 1856–57
Salted paper print from glass negative
43.8 × 34.9 cm (17¹⁄₄ × 13³⁄₄ in.)
The Metropolitan Museum of Art, Purchase,
The Horace W. Goldsmith Foundation Gift, 1994
1994.137

42. *Detail of the Pavillon Rohan, Louvre, Paris*,
ca. 1857
Salted paper print from glass negative
43.5 × 34 cm (17¹⁄₈ × 13³⁄₈ in.)
Facsimile signature stamp on mount lower right,
below photograph
École Nationale Supérieure des Beaux-Arts, Paris
PH 3782

43. *Pavillon Sully, Louvre, Paris*, ca. 1857
Albumen silver print from glass negative
44.8 × 34.8 cm (17⁵⁄₈ × 13³⁄₄ in.)
Inscribed in the negative lower left, "N° 92"
Canadian Centre for Architecture, Montreal
PH1978:0023:003

44. *Detail of the Pavillon Denon, Louvre, Paris*,
ca. 1857
Salted paper print from glass negative
33.7 × 42.8 cm (13¹⁄₄ × 16⁷⁄₈ in.)
Facsimile signature stamp on mount lower right,
below photograph
École Nationale Supérieure des Beaux-Arts, Paris
PH1424

45. *The Floods of 1856, Brotteaux Quarter of Lyons*,
1856
Paper negative
34 × 45.5 cm (13³⁄₈ × 17⁷⁄₈ in.)
Printed on negative lower left, "mh [in trefoil] 7628
Inondation du Rhône en 1856 (LYON)"; inscribed in
pencil on negative lower right, "7628"
Musée d'Orsay, Paris, dépôt des Archives
Photographiques du Patrimoine Do 1982.507

46. *The Floods of 1856, Brotteaux Quarter of Lyons*,
1856
Salted paper print from paper negative
30.3 × 43.6 cm (11⁷⁄₈ × 17¹⁄₈ in.)
Ex coll.: Léon Bourquelot
Musée d'Orsay, Paris, don de la Société des
Amis d'Orsay Pho 1988-8

47. *The Floods of 1856, Brotteaux Quarter of Lyons*,
1856
Salted paper print from paper negative
33.2 × 44.4 cm (13¹⁄₈ × 17¹⁄₂ in.)

Facsimile signature stamp on mount lower right, below photograph
Musée d'Orsay, Paris, dépôt des Archives de la Bibliothèque de la Manufacture de Sèvres Do 1983.150

48. *The Floods of 1856, Brotteaux Quarter of Lyons*, 1856
Two salted paper prints from paper negatives
31.2 × 85.9 cm (12¼ × 33⅞ in.)
Ex coll.: Léon Bourquelot
Gilman Paper Company Collection
PH89.1388(a–b)

49. *The Floods of 1856, Avignon*, 1856
Salted paper print from paper negative
30.4 × 43.8 cm (12 × 17¼ in.)
Inscribed in the negative lower left, "Villeneuf les Avignon."; lower center, "Nº 92"; lower right, "EB"
Ex coll.: Léon Bourquelot
Simon Lowinsky Gallery, New York

50. *The Floods of 1856, Avignon*, 1856
Salted paper print from paper negative
30.6 × 43.6 cm (12 × 17⅛ in.)
Inscribed in the negative lower left, "Avignon (Inondations."; lower center, "Nº 82"; lower right, "E. Baldus."
Ex coll.: Léon Bourquelot
Collection Suzanne Winsberg, New York

51. *The Floods of 1856, Avignon*, 1856
Salted paper print from paper negative
30.5 × 43.9 cm (12 × 17¼ in.)
Inscribed in the negative lower left, "Avignon (Inondation de 1856)"; lower center, "Nº 81"; lower right, "E Baldus"
Ex coll.: Léon Bourquelot
Musée d'Orsay, Paris, don de la Société des Amis d'Orsay Pho 1988-9

52. *Ramparts of Avignon*, 1856
Salted paper print from paper negative
31.9 × 44.5 cm (12½ × 17½ in.)
Inscribed in the negative lower left, "Les Remparts d'Avignon."; lower center, "Nº 84."; lower right, "E Baldus."; facsimile signature stamp on mount

lower right, below photograph
École Nationale Supérieure des Beaux-Arts, Paris PH311

53. *Group at the Château de la Faloise*, 1857
Salted paper print from glass negative
27.8 × 38.2 cm (11 × 15 in.)
Ex coll.: Georges Sirot
Gilman Paper Company Collection PH78.363

54. *Group at the Château de la Faloise*, 1857
Salted paper print from glass negative
29 × 40.8 cm (11⅜ × 16⅛ in.)
Musée d'Orsay, Paris, don de la Fondation Kodak-Pathé Pho 1983-165-2

55. *The Madeleine, Paris*, mid-1850s
Salted paper print from paper negative
33.6 × 44 cm (13¼ × 17⅜ in.)
Inscribed in the negative lower left, "Madeleine"; lower center, "Nº 29."; lower right, "E. Baldus."
Ex coll.: Léon Bourquelot
Musée Carnavalet, Paris PH 2906

56. *Notre-Dame, Paris*, ca. 1857
Salted paper print from paper negative
43.9 × 34.7 cm (17¼ × 13⅝ in.)
Ex coll.: Léon Bourquelot
Musée Carnavalet, Paris PH 2900

57. *The Pantheon, Paris*, ca. 1856
Salted paper print from glass negative
33.5 × 44.4 cm (13¼ × 17½ in.)
Ex coll.: Léon Bourquelot
Musée Carnavalet, Paris PH 2905

58. *Portal, Chartres*, ca. 1855
Salted paper print from paper negative
44.6 × 34.7 cm (17½ × 13⅝ in.)
Inscribed in the negative lower left, "Chartres Nº 1."; lower right, "E Baldus."
Musée d'Orsay, Paris, dépôt des Archives de la Bibliothèque de la Manufacture de Sèvres Do 1983.146

59. *Church of Saint-Étienne, Caen*, 1858
Albumen silver print from glass negative
33.8 × 44.1 cm (13¼ × 17⅜ in.)

Inscribed in the negative lower left, "Nº 114."; facsimile signature stamp on mount lower right, below photograph
Canadian Centre for Architecture, Montreal PH1980:0041

60. *Church of Saint-Pierre, Caen*, 1858
Albumen silver print from glass negative
44.4 × 33.7 cm (17½ × 13¼ in.)
Inscribed in the negative lower left, "Nº 115"; facsimile signature stamp on mount lower right, below photograph
École Nationale Supérieure des Beaux-Arts, Paris PH1483

61. *Apse of the Church of Saint-Pierre, Caen*, 1858
Albumen silver print from glass negative
44.4 × 34.3 cm (17½ × 13½ in.)
Inscribed in the negative lower left, "Nº 117."; facsimile signature stamp on mount lower right, below photograph
Canadian Centre for Architecture, Montreal PH1982:0627

62. *Notre-Dame, Rouen*, 1858
Albumen silver print from glass negative
43.2 × 33.8 cm (17 × 13¼ in.)
Facsimile signature stamp on mount lower right, below photograph
Museum Folkwang, Essen 100/8/72

63. *Cathedral of Reims*, ca. 1860
Albumen silver print from glass negative
31.5 × 40.9 cm (12⅜ × 16⅛ in.)
Facsimile signature stamp on mount lower right, below photograph
Museum Folkwang, Essen 100/5/80

64. *Allevard*, ca. 1859
Albumen silver print from paper negative
32.5 × 43.8 cm (12¾ × 17¼ in.)
Inscribed in the negative lower left, "Allevard (Dauphiné)/Nº 119"; facsimile signature stamp on mount lower right, below photograph
Collection Roger Thérond, Paris

65. *Pont en Royans*, 1854–59
Salted paper print from paper negative
43.2 × 33.9 cm (17 × 13³/₈ in.)
Ex coll.: Marquis de Rostaing (?)
The Metropolitan Museum of Art, Louis V. Bell
Fund, 1992 1992.5003

66. *Source of the Aveyron River*, ca. 1859
Albumen silver print from paper negative
33.3 × 42.2 cm (13¹/₈ × 16⁵/₈ in.)
Facsimile signature stamp on mount lower right,
below photograph
Canadian Centre for Architecture, Montreal
PH1986:0054:004

67. *Valley of Grésivaudan*, ca. 1859
Albumen silver print from paper negative
32.5 × 43.9 cm (12¹/₂ × 17¹/₄ in.)
Facsimile signature stamp on mount lower right,
below photograph
Ex coll.: Léon Bourquelot
The Art Museum, Princeton University. Museum
purchase, gift of the Florence J. Gould Foundation
X1989-2

68. *Hastingues Bridge*, 1861
Albumen silver print from glass negative
31.7 × 42.2 cm (12¹/₂ × 16⁵/₈ in.)
Facsimile signature stamp on mount lower right,
below photograph
Canadian Centre for Architecture, Montreal
PH1987:0549

69. *Al-Kantara Bridge, Constantine, Algeria*, 1864
Albumen silver print from paper negative
43.5 × 32.8 cm (17¹/₈ × 12⁷/₈ in.)
Facsimile signature stamp on mount lower right,
below photograph
Ex coll.: Georges Sirot
Bibliothèque Nationale de France, Paris

70. *Aqueduct at Roquefavour*, late 1850s
Salted paper print from paper negative
34.1 × 44.5 cm (13³/₈ × 17¹/₂ in.)
Canadian Centre for Architecture, Montreal
PH1981:0379

71. *La Mulatière Bridge, Lyons*, ca. 1861
Albumen silver print from glass negative
27.5 × 44.3 cm (10⁷/₈ × 17¹/₂ in.)
Stamped on mount lower left, below photograph,
"PONT DE LA MULATIERE"; facsimile signature stamp
lower right, below photograph
Canadian Centre for Architecture, Montreal
PH1981:0816:005

72. *Saint-Jean Quarter, Vienne*, ca. 1861
Albumen silver print from glass negative
31.3 × 41.8 cm (12³/₈ × 16¹/₂ in.)
Stamped on mount lower left, below photograph,
"VIENNE. Sᵗ JEAN"; facsimile signature stamp lower
right, below photograph
Canadian Centre for Architecture, Montreal
PH1981:0816:012

73. *Tunnel, Vienne*, ca. 1861
Albumen silver print from glass negative
33 × 42.9 cm (13 × 16⁷/₈ in.)
Stamped on mount lower left, below photograph,
"VIENNE. SOUTERRAIN"; facsimile signature stamp
on mount lower right, below photograph
Gilman Paper Company Collection
PH85.1159 (14)

74. *Roman Theater, Orange*, ca. 1861
Albumen silver print from glass negative
42.4 × 33.9 cm (16³/₄ × 13³/₈ in.)
Stamped on mount lower left, below photograph,
"ORANGE. THÉÂTRE ANTIQUE"; facsimile signature
stamp lower right, below photograph
Canadian Centre for Architecture, Montreal
PH1981:0816:022

75. *Viaduct at La Voulte*, 1861 or later
Albumen silver print from glass negative
30.3 × 43.7 cm (11⁷/₈ × 17¹/₄ in.)
Stamped on mount lower left, below photograph,
"VIADUC DE LA VOULTE."; facsimile signature stamp
lower right, below photograph
Canadian Centre for Architecture, Montreal
PH1981:0816:018

76. *Viaduct Across the Durance*, 1855–58
Salted paper print from two paper negatives
49.7 × 104.1 cm (19⁵/₈ × 41 in.)
Signed in gouache on photograph lower right,
"E. Baldus"
École Nationale des Ponts et Chaussées, Paris
PH 8 (1)
Only the right half of this panorama appears in the
PLM album.

77. *Amphitheater, Arles*, ca. 1859
Albumen silver print from paper negative
33.7 × 43.1 cm (13¹/₄ × 17 in.)
Stamped on mount lower left, below photograph,
"ARLES. AMPHITHÉÂTRE"; facsimile signature stamp
lower right, below photograph
Canadian Centre for Architecture, Montreal
PH1976:0013

78. *Entrance to the Donzère Pass*, ca. 1861
Albumen silver print from glass negative
33.4 × 43.3 cm (13¹/₈ × 17 in.)
Stamped on mount lower left, below photograph,
"ENTRÉE DE ROBINET."; facsimile signature stamp
lower right, below photograph
Gilman Paper Company Collection
PH85.1159 (20)

79. *La Nerthe Tunnel, near Marseilles*, ca. 1861
Albumen silver print from paper negative
33.1 × 43.4 cm (13 × 17¹/₈ in.)
Stamped on mount lower left, below photograph,
"SOUTERRAIN DE LA NERTHE"; facsimile signature
stamp lower right, below photograph
Canadian Centre for Architecture, Montreal
PH1976:0009:017

80. *Cloister of Saint-Trophime, Arles*, ca. 1861
Albumen silver print from glass negative
33.9 × 43.0 cm (13³/₈ × 16⁷/₈ in.)
Stamped on mount lower left, below photograph,
"ARLES. CLOITRE Sᵗ TROPHIME"; facsimile signature
stamp lower right, below photograph
Canadian Centre for Architecture, Montreal
PH1981:0816:045

81. *La Ciotat*, ca. 1860
Albumen silver print from paper negative
32.3 × 42.9 cm (12³/₄ × 16⁷/₈ in.)
Stamped on mount lower left, below photograph,
"LA CIOTAT."
Gilman Paper Company Collection
PH85.1159 (62)

82. *"The Eagle's Beak," La Ciotat*, ca. 1860
Albumen silver print from paper negative
32 × 41.7 cm (12⁵/₈ × 16³/₈ in.)
Stamped on mount lower left, below photograph,
"LA CIOTAT. BEC DE L'AIGLE"
Gilman Paper Company Collection
PH85.1159 (63)

83. *Bandol*, ca. 1860
Albumen silver print from paper negative
33.1 × 42.9 cm (13 × 16⁷/₈ in.)
Stamped on mount lower left, below photograph,
"BANDOL."
Gilman Paper Company Collection
PH85.1159 (65)

84. *"The Monk," La Ciotat*, ca. 1860
Albumen silver print from paper negative
33.4 × 42.9 cm (13¹/₈ × 16⁷/₈ in.)
Stamped on mount lower left, below photograph,
"LE MOINE."
Collection François Lepage, Paris

85. *Ollioules Gorge, near Toulon*, ca. 1860
Albumen silver print from paper negative
32.4 × 41.9 cm (12³/₄ × 16¹/₂ in.)
Stamped on mount lower left, below photograph,
"GORGES D'OLLIOULES"
Gilman Paper Company Collection
PH85.1159 (68)

86. *Toulon*, 1861 or later
Albumen silver print from glass negative
27.9 × 43.4 cm (11 × 17¹/₈ in.)
Stamped on mount lower left, below photograph,
"TOULON"; facsimile signature stamp lower right,
below photograph
Canadian Centre for Architecture, Montreal
PH1976:0009:023

APPENDIX 1
SIGNATURES AND STAMPS

Baldus signed or stamped his photographs in a variety of ways. Several examples of his signature and all his known stamps are reproduced below, actual size.

1. Pencil signature, on mount, below bottom right corner of photograph; found occasionally on prints from 1852 to 1854, rarely thereafter.

2. Signature in negative, 1853.

3. Signature in negative, 1855.

4. Signature on document, 1858.

5. Facsimile signature stamp, on mount, below bottom right corner of photograph, in either black or blue ink; used beginning about 1854, frequently from 1855 to 1858, less frequently thereafter.

6. Facsimile signature stamp, on mount, below bottom right corner of photograph, in black ink; used beginning about 1858 and on nearly all prints after 1860, except on those where the printed name (7) appears.

7. Printed name, on mount, below bottom right corner of photograph, in black ink; used beginning early 1860s, found most often on small-format views.

8. Artist stamp, in black ink, rarely used; found almost exclusively on the verso of stereographs.

9. Etched name, frequently found on photogravures from the 1860s to the 1880s.

Baldus's numbering system is not straightforward. The order of numbers inscribed on individual negatives and listed on his stock list does not correspond to a rigid order of negative date, region, subject type, or title alphabetization. Negatives from a single campaign may bear widely divergent numbers, or some may be numbered and others not. In one case, three negatives that form contiguous sections of a panorama of the flooded Avignon plain (pls. 49, 50, and 51) are numbered 92, 82, and 81. Furthermore, several negatives may bear the same number, whether or not they represent the same subject.

During the years 1852 to 1855 Baldus appears to have inscribed his negatives routinely (if not altogether consistently) with the title and location, usually in the lower left corner, and signed them, usually in the lower right corner, without numbering them. As his stock grew Baldus decided to number his negatives, and in 1855 or 1856 he numbered his existing negatives apparently without regard to their order, mixing Parisian scenes with monuments of the Midi, landscapes of the Auvergne, cathedrals of the north of France, and various other subjects; approximately eighty large-format paper negatives (approximately 35 × 45 cm) were included in this inventory. He inscribed numbers (e.g., "Nº 25") along the lower center edge of each or at the lower left, following the title; these inscribed numbers are often noticeably different in intensity and hand from the rest of the inscriptions on the negative.

Numerous images that almost always bear an inscribed negative number are not yet numbered in the album presented to Queen Victoria in 1855. A few photographs of Amiens that are numbered in the queen's album were renumbered later (e.g., the view of Amiens [pl. 32] bears the number "4" on the print in the queen's album but "Nº 32" on all later prints).

The ten numbered pictures of the June 1856 floods are numbered consecutively (with one gap) from 81 to 92, suggesting that they were added to the stock after the first eighty had already been numbered. With a few exceptions, the numerical order reflects a loose chronology of Baldus's production from that point forward.

In July 1858, however, Baldus was reminded that the negatives of the flood had been commissioned and paid for by the state and were not part of his stock, and Baldus was directed to deliver them immediately to the Office of Fine Arts. Shortly thereafter Baldus reassigned the flood negative numbers to glass-plate negatives of the various pavilions of the New Louvre and other Parisian monuments. He also reassigned certain other numbers, perhaps of negatives no longer in good condition.

Finally, he assigned identical numbers to new glass negatives that represented the same subject as old paper negatives in his stock. If inscribed at all, these glass negatives usually bear only the number (or occasionally the artist's signature as well), but very rarely the title of the image; more commonly, there are no inscriptions on the negative and the mount is imprinted with the title, stock number, and artist's facsimile signature stamp.

This copy of Baldus's printed stock list of about 1863 is in the library of the Victoria and Albert Museum. It bears handwritten notes regarding the price and size of prints.

PHOTOGRAPHIE BALDUS

Rue d'Assas, 25, Paris

CATALOGUE

EPREUVES FORMAT GRAND-MONDE, à

Pavillon Sully.	Arc de triomphe de l'Etoile.
— Richelieu.	Porte de la Bibliothèque (quai).
— Turgot.	Le Départ (grand trophée).
— de l'Horloge.	

Size of print 60 x 80

The set of 8 for 200 — *mounted on Bristol 1 m 20 x 80*

price 30 each

VUES PANORAMIQUES FORMAT COLOMBIER, à

Palais des Tuileries (côté du jardin).
Panorama de la Cité.
— du Louvre.

Size of print 60 x 20 8 each

VUES FORMAT GRAND RAISIN, à

1. Vue générale d'Avignon	**Vaucluse.**	22. Eglise Saint-Germain-l'Auxerrois	**Paris.**	
2. Arc antique d'Orange	—	23. Eglise d'Issoire	**Puy-de-Dôme.**	
3. Eglise Saint-Trophyme (façade), à Arles	**Bouch.-du-Rhône.**	24. Pavillon de Rohan (grand détail)	**Paris.**	
4. Portail principal de la cathédrale de Chartres	**Eure-et-Loir.**	25. Hôtel des Invalides	—	
5. Fontaine de Nimes	**Gard.**	26. Amphithéâtre romain, à Nimes	**Gard.**	
6. Saint-Etienne-du-Mont	**Paris.**	27. Palais de l'Industrie	—	
7. Tour Magne à Nimes	**Gard.**	28. Eglise de Brioude	**Haute-Loire.**	
8. Pont du Gard, près Nimes	—	29. Eglise de la Madeleine	**Paris.**	
9. Maison Carrée, à Nimes	—	30. Palais-Royal	—	
10. Notre-Dame de Paris (côté latéral)	**Paris.**	31. Palais des Tuileries (côté de la place du Carrousel)	—	
11. Pavillon de l'Horloge (Louvre)	—	32. Panorama d'Amiens	**Somme.**	
12. Tour Saint-Jacques	—	33. Eglise Saint-Germain-l'Auxerrois (détail)	**Paris.**	
13. Panthéon	—	34. Notre-Dame de Paris (façade)	—	
14. Hôtel-de-Ville	—	35. Place de la Concorde	—	
15. Eglise Saint-Gilles	**Gard.**	36. Abside de la cathédrale d'Amiens	**Somme.**	
16. Cloître Saint-Trophyme (intérieur), à Arles	**Bouch.-du-Rhône.**	37. Eglise Saint-Eustache	**Paris.**	
17.		38. La Sainte-Chapelle	—	
18.		39. Eglise Saint-Gervais	—	
19. Galerie d'Apollon	**Paris.**	40. Eglise Saint-Vulfram, à Abbeville	**Somme.**	
20. Palais des Papes, à Avignon	**Vaucluse.**	41. Cathédrale d'Amiens (porte de la Vierge).		
21. Porte du château d'Anet	**Paris.**	42. — (porte principale)		

Size of print 45 x 35 prices each separate 12 for 72 — mounted 63 x 48

43. Cath. d'Amiens (porte de la Vierge dorée)	**Somme.**	102. Pavillon Denon	**Paris.**
44. Les Aliscamps, à Arles	**Bouch.-du-Rhône.**	103. Porte de la Bibliothèque, rue de Rivoli	—
45. Eglise Saint-Vulfram (porte), à Abbeville.	**Somme.**	104. — (détail)	—
46. Palais-de-Justice	**Paris.**	105. Intérieur de cour au Louvre	—
47. Pavillon Turgot (détail)	—	106. Porte de la Bibliothèque, quai (détail).	—
48. — Colbert id.	—	107. Vue générale du nouveau Louvre	—
49. Eglise de Saint-Riquier	**Somme.**	108. Voreppe, vue du ravin (paysage)	**Isère.**
50.		109. — arbre id.	—
51. Eglise de Saint-Denis, près Paris	**Seine.**	110. Eglise de Saint-Maurice, à Vienne	—
52. Pavillon Colbert	**Paris.**	111. Paysage à Vienne	—
53. Eglise Sainte-Clotilde	—	112.	—
54. Pont Saint-Jean (paysage), à Thiers	**Puy-de-Dôme.**	113.	—
55.		114. Eglise Saint-Etienne, à Caen	**Calvados.**
56.		115. Eglise Saint-Pierre	—
57.		116. — abside (détail)	—
58. Pont-en-Royant (paysage)	**Isère.**	117. — clocher	—
59. Vallée de Chorange	—	118. La Grande Chartreuse	**Isère.**
60. Viaduc de Chaumont	**Haute-Marne.**	119. Allevard (paysage)	—
61. Le Creux de l'Enfer, à Thiers (paysage).	**Puy-de-Dôme.**	120. Chamounix	**Haute-Savoie.**
62. Cour du vieux Louvre	**Paris.**	121. Vallée de Chamounix	—
63. Eglise Sainte-Clotilde (détail)	—	122. Mer de Glace	—
64. Pont de la Sainte (paysage)	**Haute-Loire.**	123. Source de l'Aveyron	—
65. Rocher de Saint-Michel id.	—	124. Port de Marseille	**Bouch.-du-Rhône.**
66. Le Puy	—	125.	—
67. Ruines du château de Polignac (paysage).	**Puy-de-Dôme.**	126.	—
68. — Pouzolles id.	—	127. Le bout du Monde, à Allevard (paysage)	**Isère.**
69. — Espailly id.	—	128. Théâtre romain (intérieur)	**Bouch.-du-Rhône.**
70. Cascades à Thiers	id.	129. — (extérieur)	—
71.		130. Arènes d'Arles (intérieur)	—
72. Royat	id.	131. Cloître St-Trophyme (extérieur), à Arles	—
73. Chaîne des Monts-Dore	id.	132. Eglise d'Auvers	**Seine-et-Oise.**
74. Colonnade du Louvre	**Paris.**	133. Gorges d'Ollioules, près Toulon	**Var.**
75. Porte de la Bibliothèque (quai)	—	134. Pavillon des Tuileries (côté du jardin).	**Paris.**
76. Pavillon Richelieu (détail)	—	135. Vue de Périgueux	**Dordogne.**
77. — Rohan	—	136. Arènes d'Arles (extérieur)	**Bouch.-du-Rhône.**
78. — Turgot	—	137. Cloître St-Trophyme (intérieur), à Arles	—
79. — Richelieu	—	138. Lyon sur la Saône	**Rhône.**
80. Vieux Louvre (quai)	—	139. Roquefavour (aqueduc)	**Bouch.-du-Rhône.**
81. Arc de triomphe du Carrousel	—	140. Eglise Saint-Jean, à Lyon	**Rhône.**
82. Panorama de Paris, pris du Pont-Neuf.	—	141. Hôtel-de-Ville, à Lyon	—
83. — Pont-Royal.	—	142. Château de Blois, porte Louis XII	**Loir-et-Cher.**
84. Remparts d'Avignon	**Vaucluse.**	143. — (intér. de la cour)	—
85. Arc de triomphe de l'Etoile	**Paris.**	144. Château de Blois (grand escalier)	**Loir-et-Cher.**
86. — (grand trophée : le Départ).		145. — (façade François Ier).	—
87. — (id le Triomphe).		146. Notre-Dame de Poitiers	**Vienne.**
88. Pavillon Sully (vue de côté)	—	147. Fontaine Saint-Michel	**Paris.**
89. — (grand détail)	—	148. Cathédrale de Reims (façade)	**Marne.**
90. Pavillon Mollien	—	149. — (porte)	—
91. — de l'Horloge (face)	—	150. (id latérale)	—
92. — Sully (face)	—	151. — (ensemble)	—
93. Palais du Luxembourg (côté du jardin)	—	152. Théâtre romain, à Orange (extérieur)	**Vaucluse.**
94. Eglise Saint-Ouen à Rouen	**Seine-Inférieure.**	153. — (intérieur)	—
95. Palais-de-Justice (tourelle Pasquier) id.	—	154.	
96. — (escalier) id.	—	155.	
97. Notre-Dame de Rouen (façade)	—	156.	
98. Eglise N.-D.-de-Bon-Secours, près Rouen.	—	157.	
99. Sassenage, cascade (paysage)	**Isère.**	158.	
100. — id.	—	159.	
101. Place Napoléon	**Paris.**	160.	

Vierge au voile....................	**Raphaël.**	Mort de saint François d'Assises..........	**L. Benouville.**
— aux ruines..................	—	Alexandre et Diogène...............	**P. Puget.**
Sainte Famille	—	Prisonnier endormi	**Michel-Ange.**
Adam et Ève.......................	—	Prisonnier	—
Vierge au silence	**Carrache.**	Bouclier de Minerve........	**Simard.**
La Famille pauvre	**Tassart.**	Vénus de Milo....................	**Antique.**
Les Danseurs espagnols	**E. Giraud.**	Les trois Grâces.................	**Germain Pilon.**
Vaches et chèvres	**Brascassat.**		

PETIT FORMAT, à

Vierge aux ruines..................	**Raphaël.**	Neptune et Amphitrite................	**J. Romain.**
— au voile.......................	—	Vierge au trône...................	**André del Sarte.**
— au livre.......................	—	Transfiguration..................	**Raphaël.**
— au silence.....................	**Carrache.**	Vierge...........................	—
— à la chaise....................	**Raphaël.**	Lucrèce au travail................	**Guido Reni.**
La Madeleine......................	**Corrége.**	Le Taureau.......................	**Brascassat.**

VUES DE PARIS, à

1. Pavillon Rohan.	35. Porte Saint-Denis.
2. — Turgot (place Napoléon).	36. Saint-Gervais.
3. — Richelieu.	37. Panorama, vue prise du Pont-Neuf.
4. — Colbert.	38. — Carrousel.
5. — Sully.	39. Puits artésien.
6. — Daru.	40. Fontaine de la rue du Regard.
7. — Denon.	41. Hôtel-de-Ville.
8. — Mollien.	42. Institut.
9. Place Napoléon.	43. Champ-de-Mars.
10. Pavillon Turgot (place du Carrousel).	44. École militaire.
11. Ensemble du nouveau Louvre.	45. Place de la Concorde.
12. Palais des Tuileries (côté de la place du Carrousel).	46. Vieux Louvre (quai).
13. Intérieur de la cour.	47. Porte d'Anet.
14. Bibliothèque, rue de Rivoli.	48. — de Gaillon (face).
15. Arc de triomphe du Carrousel.	49. — (trois quarts).
16. Pavillon de l'Horloge.	50. Palais de l'Industrie.
17. Cour du vieux Louvre.	51. — des Thermes (Musée de Cluny).
18. Arc de triomphe de l'Étoile.	52. Panorama de la Cité.
19. — — (grand trophée, *le Départ*).	53. La Madeleine.
20. — — (id. *le Triomphe*).	54. Saint-Eustache.
21. — — (id. *la Résistance*).	55. Corps Législatif.
22. — — (id. *la Paix*).	56. Pont de Solferino.
23. Invalides.	57. La Bourse.
24. Panthéon.	58. Gare du chemin de fer de Strasbourg.
25. Église Saint-Étienne-du-Mont.	59. Pavillon Lesdiguières.
26. Notre-Dame (façade).	60. Porte Saint-Martin.
27. La colonnade du Louvre.	61. Fontaine du Luxembourg.
28. La tour Saint-Jacques.	62. — Palmir.
29. La Sainte-Chapelle.	63. Palais-de-Justice et Conciergerie.
30. Colonne Vendôme.	64. Fontaine des Innocents.
31. Saint-Germain-l'Auxerrois.	65. Fontaine des Innocents (détail).
32. Colonne de Juillet.	66. Palais-de-Justice (façade).
33. Le Luxembourg (côté du jardin).	67. Maison de François Ier.
34. Saint-Vincent-de-Paul.	68. École de médecine.

Size of print 30 × 20

2² each separate

25 for 40.

69. La Sorbonne.		85. Notre-Dame (Abside).	
70. Fontaine Saint-Michel.		86.	
71. — (détail).		87.	
72. Porte de la Bibliothèque du Louvre (quai).		88.	
73. Chevaux de Marly, par Coustou.		89.	
74. Statue de Henri IV.		90.	
75. — Démosthène (antique).		91.	
76. Fontaine Saint-Sulpice.		92.	
77. — Louvois.		93.	
78. — Molière.		94.	
79. — Cuvier.		95.	
80. Place Saint-Germain-l'Auxerrois.		96.	
81. Pavillon de l'Horloge (Tuileries).		97.	
82. Fontaine Gaillon.		98.	
83. Eglise Sainte-Clotilde.		99.	
84. Galerie d'Apollon (Louvre).		100.	

101. Eglise Saint-Trophyme (façade), à Arles.	**Bouch.-du-Rhône.**	131. Eglise Saint-Rémy, à Reims	**Marne.**
102. Cloître St-Trophyme (intérieur),	—	132. Porte romaine de Mars, à Reims......	—
103. Arènes (intérieur),	—	133. Théâtre romain, à Orange (intérieur)..	**Vaucluse.**
104. Théâtre romain (extérieur),	—	134. — (extérieur)..	—
105. — (intérieur),	—	135. Villeneuve-lès-Avignon..............	**Gard.**
106. Avignon (vue générale)............	**Vaucluse.**	136. Théâtre d'Avignon.................	**Vaucluse.**
107. Arènes (intérieur), à Nîmes.	**Gard.**	137. Fontaine de Vaucluse.............	—
108. — (extérieur), —	—	138. Arc romain, à Saint-Rémy........	**Bouch.-du-Rhône.**
109. Maison Carrée, —	—	139. Tombeau romain, à Saint-Rémy......	—
110. Tour Magne, —	—	140. Cloître Saint-Trophyme (extérieur), à Arles..................	—
111. Fontaine Pradier, —	—	141.	
112. Temple de Diane, —	—	142.	
113. Abbaye de Montmajour, —	**Bouch.-du-Rhône.**	143.	
114. Les Aliscamps, à Arles.	—	144.	
115.		145.	
116. Porte romaine (d'Auguste), à Nîmes...	**Gard.**	145.	
117. Cour d'honneur, à Fontainebleau.	**Seine-et-Marne.**	146.	
118. Cour ovale et Baptistère Louis XIII, à Fontainebleau.	—	147.	
119. Baptistère Louis XIII, à Fontainebleau.	—	148.	
120. Vue générale du château,	—	149.	
121. Galerie François Ier.	—	150.	
122. Pont Saint-Bénezet, à Avignon.	**Vaucluse.**	151.	
123. Château du roi René, à Tarascon.	**Bouch.-du-Rhône.**	152.	
124. Pont du Gard, près Nîmes.	**Gard.**	153.	
125. Aigues-Mortes (remparts).	—	154.	
126. Arènes d'Arles (extérieur)...........	**Bouch.-du-Rhône.**	155.	
127. Roquefavour (aqueduc).	—	156.	
128. Arc antique, à Orange...........	**Vaucluse.**	157.	
129. Cathédrale de Reims (façade).	**Marne.**	158.	
130. — (porte).	—	159.	
		160.	

COLLECTION D'ÉPREUVES STÉRÉOSCOPIQUES.

Anc. Mon Bénard. — Seringe Frères et Poitevin, place du Caire, 2. — Poitevin, à Besançon.

APPENDIX 3
SALON SUBMISSIONS

The following table, drawn from documents in the Archives du Louvre (KK^{12-22}, KK^{35-45}), shows Baldus's submissions to the Salon of painting and sculpture. Listed are the submission number, title exactly as recorded, dimensions (height preceding width, in meters), and action of the jury in accepting or rejecting each for exhibition. The Salon of 1848 was unjuried; all submissions were exhibited.

1841

313	La Vierge et l'Enfant Jésus	.95	.70	rejected
960	La Vierge et l'Enfant Jésus	1.05	.80	rejected
961	Portrait de M. de P.	.78	.66	rejected
2645	Portrait de M. T.	.75	.60	rejected

1842

| 3208 | Prométhée délivré par Hercule | 2.60 | 2.60 | rejected |
| 3209 | Vierge et l'Enfant Jésus | .80 | .70 | accepted |

1843

| 2025 | La Vierge, l'Enfant Jésus, et St. Jean | 1.04 | .82 | rejected |

1844

| 2407 | Prométhée délivré par Hercule | 2.20 | 2.70 | rejected |

1845

| 1588 | La Vierge et l'Enfant Jésus | .74 | .60 | rejected |
| 1589 | Prométhée délivré par Hercule | 2.35 | 2.65 | rejected |

1846

| 2936 | Une Glaneuse | .80 | .78 | rejected |
| 2937 | La Vierge et l'Enfant Jésus | .74 | .58 | rejected |

1847

| 4035 | La Vierge et Jésus | .70 | .60 | rejected |
| 4036 | Tête d'enfant | .52 | .48 | accepted |

1848

3211	La Vierge et l'Enfant Jésus	.68	.58	
3212	Jeune fille jouant avec des roses	1.12	.94	
3213	Portrait de Mme. C.	1.08	.74	

1849

| 2458 | Jeune fille | .85 | .65 | rejected |

1850

| 3515 | La Vierge et l'Enfant Jésus | 1.90 | 1.30 | accepted |

1851/1852

| 2971 | Portrait de M. D. | 2.50 | 2.00 | rejected |

APPENDIX 4
THE MISSION HÉLIOGRAPHIQUE, 1851

The following list of sites to be photographed by Baldus was printed in *La Lumière* (July 20, 1851). Titles are given as listed, without correction. Brackets surrounding a title indicate a view not specified on the itinerary but for which a negative exists. Images for which a positive print from the period exists are marked with an asterisk.

The first column of numbers indicates whether the view is composed of a single negative or is formed by joining two or more negatives together to make a larger picture or a panorama. If no negatives survive for the specified view, no number is given. If duplicate negatives exist for a single view, the number of negatives is shown in parentheses. All surviving negatives are on deposit at the Musée d'Orsay, Paris. The second column lists the three-digit number written by hand on the negative after delivery to the Historic Monuments Commission. The third column lists the four- and five-digit inventory number assigned later by the Historic Monuments Commission.

Seine-et-Marne

Château de Fontainebleau			
vue d'une cour interieur	1	256	7577
vue de la porte qui donne accès dans cette cour;			
la porte est ornée de deux têtes antiques	1	255	7576
[oval court] *	1	215	7578
[unidentified]	1		16397

Yonne

Galerie de la préfecture d'Auxerre *	1		7619
Eglise de Vezelay, porche des catéchumènes en grand détail			
Église de Saint-Peré-sous-Vezelay la façade	1	246	7618
Église Notre-Dame d'Auxerre, la façade			
Salle synodale de Sens, vue prise du Marché *	1	247	7617
	1	249	12376
[Palais Archevechale, Auxerre]	1 (2)	248	7619

Côte-d'Or

Eglise Notre-Dame de Semur, porte latérale et abside [fig. 7] *	2		15998
Château de Semur			
Eglise Saint-Thibaut, porche	1	257	7463
Eglise de Beaune			
abside	1 (2)	239	7461
façade [pl. 6]	2	238	7462

Saône-et-Loire

Porte Saint-André, à Autun	1 (2)	241/553	7565
Porte d'Arroux, à Autun	1		7564
Eglise de Paray-le-Monial	1	245	7566
[bell tower] *	1	243	7567
[facade]	2	244	15985
Eglise de Saint-Philibert de Tournus			
vue latérale			
vue de la tour du milieu, prise des terrasses			

Rhône

Eglise cathédrale de Saint-Jean, à Lyon			
façade			
abside			
Eglise de Belle-Ville-sur-Saône			

Isère

Église Saint-Maurice, à Vienne			
façade latérale	1		7490
[west facade]	1		7489
[portal]	1	252	7491
Musée de Vienne, Temple d'Auguste et Livie, deux façades	1	254	12372
	1	253	12373
Eglise Saint-Antoine à Saint-Marcellin, façade *	1	242	7488

Drôme

Eglise Saint-Bernard de Romans			
portes			

bas-reliefs d'Adam et d'Eve, à l'abside

[unidentified] (2) 524/561 15994

Eglise Saint-Paul-Trois-Châteaux

Église de Saint-Restitut

 porche latéral } [fig. 10] 2 233 7465

 chapelle des Pénitents } 1 232 7466

[unidentified] 1 15993

Vaucluse

Théâtre romain d'Orange [interior] 2 7597–8

2 534 15991–2

[exterior] 1 231 7596

Arc de triomphe d'Orange [pl. 7] * 1 221 7601

[fig. 11] 1 540 15990

Chapelle Saint-Quénin à Vaison 1 225 7600

Pont romain sur l'Ouvèze, à Vaison 1 222 7599

Remparts d'Avignon, une vue [pl. 5] * 1 230 7604

Palais des papes à Avignon * 2 219 7605

Pont Saint-Bénézet, à Avignon 2 7603

[view of Avignon] 1 214 7602

Abside de l'ancienne cathédrale de Cavaillon

Cloître de la même église, à Villeneuve-lez-Avignon

Copie du tableau du roi René, Couronnement de la Vierge, à
 la Chartreuse de Villeneuve

Portrait de la marquise de Ganges, à la Chartreuse
 de Villeneuve

Tour de Villeneuve 1 228 7471

Bouches-du-Rhône

Pont de Saint-Chamas

Église des Saintes-Maries

Église de Martigues

Var

Château de l'île Saint-Honorat (îles Sainte-Marguerite)
 et monuments divers de l'île

Fréjus

 amphithéâtre

 remparts

 ruines romaines

Retour par Bouches-du-Rhône

Saint-Trophyme, à Arles

 façade [fragment] 1 15988

 [unidentified] 1 15984

 cloître 1 (2) 420/520 15989

 [pl. 1; no negatives survive] * 10? 237

Théâtre antique d'Arles

Amphithéâtre d'Arles 4 15986–7

Église des Aliscamps (Saint-Honorat), à Arles

Petite chapelle à Montmajour

Gard

Eglise de Saint-Gilles, façade, à Nîmes

Amphithéâtre de Nîmes [exterior] 2 7467

 [interior] [fig. 9] * 3 224 12369–71

La Tour-Magne

Le Temple de Diane 1 227 7470

La Porte d'Auguste 1 7468

La Maison carrée [fig. 12] * (3) 216 7469

Le Pont du Gard * 2 229 12367

APPENDIX 5
VILLES DE FRANCE PHOTOGRAPHIÉES AND SUBSEQUENT GOVERNMENT PURCHASES

The following lists present the contents and dates of Baldus's annual delivery of photographs to the government, beginning in 1852 with the *Villes de France photographiées* and continuing until 1860.

The *Villes de France photographiées*, as originally proposed, was to consist of sixty prints in-folio (approximately 38 cm [15 in.] in height). However, all but four of the photographs that Baldus delivered were larger in format (approximately 35 × 45 cm; 13³/₄ × 17³/₄ in.), so that each was counted as two prints in fulfilling the subscription. The following list provides the installment number, photograph number, and title of each photograph as given in archival documents. The four smaller prints are marked with an asterisk.

Delivered June 13, 1853:

1	1.	Notre Dame de Paris [pl. 8]
	2.*	Invalides, Paris
2	3.	Église St. Trophîme à Arles [fig. 14]
	4.*	Théâtre Romain à Arles (intérieur) [pl. 3]

Delivered January 8, 1854:

3	5.	Cloître de St. Trophîme à Arles
	6.*	Théâtre Romain à Arles (extérieur)
4–7	7.	Arc de Triomphe de l'Étoile
	8.	Louvre, Pavillon de l'Horloge [pl. 9]
	9.	Panthéon [fig. 85]
	10.	St. Étienne du Mont
	11.	Tour St. Jacques [pl. 11]
	12.	Hôtel de Ville de Paris [pl. 10]

Delivered January 13, 1855:

8–9	13.	Cloître de St. Trophîme à Arles
	14.	Église de St. Gilles
	15.	Fontaine à Nîmes
10–11	16.	Maison Carrée à Nîmes [fig. 13]
	17.	Tour Magne à Nîmes [pl. 15]
	18.	Arc d'Orange [pl. 13]
12	19.	Avignon (vue générale)

	20.*	Palais des Papes, Avignon
13–14	21.	St. Germain l'Auxerrois [fig. 81]
	22.	Porte d'Anet
	23.	Église d'Issoire [fig. 22]

Delivered January 8, 1856:

15–16	24.	Château de Polignac
	25.	Rocher de St. Michel au Puy [pl. 21]
	26.	Amiens (panorama) [pl. 32]
17–18	27.	St. Gervais, Paris
	28.	Ste. Chapelle
	29.	Chartres [pl. 58]
19–20	30.	St. Ricquier
	31.	Amiens, cathédrale
	32.	Amiens, Porte de la Vierge Doré

Although *Villes de France photographiées* was complete with the twentieth installment, Baldus continued to sell photographs to the Ministry of State at approximately the same rate in the years that followed.

In addition to "cinquante épreuves photographiques, vues diverses des inondations" at 10 francs each (two prints from each of the twenty-five negatives, for which Baldus was also paid), the delivery of February 26, 1857, included "trente-six photographies représentant des vues de Reims" at 2 francs each (presumably small-format work) and "cent-vingt photographies des Villes de France" at 10 francs each. It is not known which images were included in this last group.

Baldus's delivery of photographs the following year also included prints from the flood negatives:

Twenty copies of each image, at 10 francs per print
Delivered January 26, 1858:

Les Remparts d'Avignon [pl. 52]

Les Remparts Renversées
Lyon—St. Pothin [fig. 51]
Lyon—Chemin des Charpennes
Lyon—Maison renversée [pl. 47]
Lyon—rue de l'Hospice
Lyon—rue Comte

In May and June 1858 Baldus delivered three hundred photographs of the New Louvre to the Ministry of State for the Office of Fine Arts:

Twenty copies of each image, at 10 francs per print
Delivered May 12, 1858:
 Vue du Pavillon Denon
 Vue du Pavillon Sully
 Vue du Pavillon Sully (grand détail)
 Vue du Pavillon Mollien
 Vue du Pavillon Richelieu
 Vue du Pavillon Turgot
 Vue du Pavillon Turgot (grand détail)
 Vue de l'intérieur des Cours des Écuries (grand détail)
Delivered June 18, 1858:
 La Colonnade du Louvre
 Arc de Triomphe du Carrousel
 Porte de la Bibliothèque, rue Rivoli [pl. 41]
 Place Napoléon
 Porte de la Bibliothèque sur le quai (grand détail)
 Pavillon Rohan (grand détail) [pl. 42]
 Galerie du Louvre (quai)

Baldus's annual deliveries of prints to the government in 1859 and 1860 were made under the title *Monuments de France*. Rather than constituting a separate series, these groups of photographs were a continuation of the annual government purchases that began with the *Villes de France photographiées*.

Twenty copies of each image, at 10 francs per print
Delivered February 12, 1859:
 Galerie d'Appollon
 Cour du vieux Louvre
 Cherbourg, côté du môle
 Vue de Cherbourg et de la digue [fig. 57]
 Église de St. Étienne à Caen [pl. 59]
 Église de St. Pierre à Caen [pl. 60]
 Grand détail de la flèche (même église)
 Grand détail de l'abside (même église) [pl. 61]

Twenty copies of each image, at 10 francs per print
Delivered December 31, 1860:
 Cathédrale de Rouen (façade) [pl. 62]
 Palais de Justice de Rouen (façade)
 Palais de Justice de Rouen (côté de l'escalier)
 Église de St. Ouen de Rouen (façade)
 Cathédrale de Périgueux [possibly fig. 59]
 Arènes d'Arles (extérieur) [pl. 77]
 Théâtre Romain d'Arles (intérieur)
 Théâtre Romain d'Arles (façade restaurée)

The information listed in this appendix is drawn from documents in the Archives Nationales, Paris (F²¹ 62 dossier 38).

APPENDIX 6
ALBUM PRESENTED TO QUEEN VICTORIA

Queen Victoria and Prince Albert made a state visit to France August 18–27, 1855. The royal couple arrived in Boulogne and traveled to Paris by train along the Chemin de Fer du Nord. Before the queen's departure, Baron James de Rothschild presented her with a lavish album that included fifty photographic views of the towns and stations along the route between Paris and the English Channel.

Titles as inscribed in the album:

1. Gare de Paris (Est) [fig. 35]
2. Train Royale *§
3. Tuileries [pl. 38]
4. Ste Chapelle
5. Abbaye de Saint Denis * [pl. 22]
6. Enghien [pl. 25]
7. Château de la Princesse Mathilde * [pl. 24]
8. Gare d'Enghien * [pl. 23]
9. Gare de Pontoise * [pl. 27]
10. Eglise d'Auvers [pl. 26]
11. Isle-Adam *
12. Château de Boran *
13. Eglise de St-Leu* [pl. 28]
14. Montataire
15. Creil * [fig. 39]
16. Gare de Clermont [fig. 36]
17. Ruines du Château de Boves [pl. 29]
18. Gare de Longueau *
19. Gare d'Amiens * [pl. 30]
20. Amiens (Vue Générale) [pl. 32]
21. Cathédrale d'Amiens* [south side]
22. Cathédrale d'Amiens [south transept rose window]
23. Cathédrale d'Amiens [apse]
24. Portail de la Cathédrale d'Amiens * [south portal of west facade]
25. Cathédrale d'Amiens * [north side, Porte de la Vierge Doré]
26. Cathédrale d'Amiens [pl. 31]

27. Beffroi d'Amiens *
28. Amiens (Sortie du Tunnel)*
29. Ailly sur Somme * [from tracks]
30. Ailly sur Somme * [town and church]
31. Gare de Picquigny * [pl. 34]
32. Abbaye du Gard
33. Longpré * [Long-sur-Somme; pl. 33]
34. Cathédrale d'Abbeville [south side]
35. Cathédrale d'Abbeville [portal]
36. Cathédrale d'Abbeville* [facade]
37. Eglise de Saint Riquier *
38. Saint Valéry (vue du Port)* [pl. 35]
39. Saint Valéry *
40. Gare d'Etaples [fig. 38]
41. Boulogne (Décoration) * [fig. 32]
42. Gare de Boulogne (Pignon côté de Paris) *
43. Gare de Boulogne *
44. Boulogne (Entrée du Port) * [pl. 37]
45. Boulogne (Vue du Port) * [view of quay]
46. Boulogne (Yacht Royal) [imperial yacht *Ariel*]
47. Boulogne (Vue du Port) * [pl. 36]
48. Boulogne (Vue du Port) * [town and cliffs beyond pier]
49. Machine du Train Royal *§
50. Wagon Royal *§

* These photographs are covered by carbon-print copy photographs made in 1890.
§These photographs are probably not by Baldus.

APPENDIX 7
THE FLOODS OF 1856

Baldus made twenty-five negatives in Lyons, Avignon, and Tarascon in early June 1856, showing the effects of the flooding of the Rhone River. The negatives are on deposit at the Musée d'Orsay, Paris. For each, the following information is given: the inventory number and title assigned by the Historic Monuments Commission, Baldus's inscriptions on the negative (where appropriate), and a description of the image.

Historic Monuments Commission inventory number and title
Inscriptions, exactly as written
[Description of the image]

7621 Vues des quartiers des Brotteaux pendant les inondations de 1856.
[Rooftops in Lyons, tall building at left]

7622 and 7623 Vues des quartiers des Brotteaux pendant les inondations de 1856. [Two-part panorama of the Brotteaux quarter of Lyons with the hills of Fourvière and Sainte-Claire in the background, taken from the avenue des Martyrs; pl. 48]

7624 Vues des quartiers des Brotteaux pendant les inondations de 1856.
Lyon. (Les Brotteaux.)/Inondation 1856. N° 87 E. Baldus
[Ruined houses in front of the Church of Saint-Pothin; fig. 51]

7625 Vues des quartiers des Brotteaux pendant les inondations de 1856.
Lyon (Inondations) N° 91 EB.
[Ruined houses, with furniture in foreground]

7626 Vues des quartiers des Brotteaux pendant les inondations de 1856.
[Collapsed roof in foreground; church and trees in background; pl. 46]

7627 Vues des quartiers des Brotteaux pendant les inondations de 1856.
Lyon. Inondations. N° 90 EB
[Ruined houses and debris, avenue des Martyrs; "vol menuisier" on building]

7628 Vues des quartiers des Brotteaux pendant les inondations de 1856.
[Ruined house and debris, reflected in water; pl. 45 and fig. 50]

7629 Vues des quartiers des Brotteaux pendant les inondations de 1856.
Lyon. (les Brotteaux)/Inondation. N° 88 EB
[Ruined houses; three figures seated on rubble right of center; pl. 47]

7630 Vues des quartiers des Brotteaux pendant les inondations de 1856.
Lyon. (Les Brotteaux) / Inondations 1856 N° 89. EB.
[Flooded view of the rue Dunoir; collapsed houses in foreground; hills visible in distance]

7631 Avignon. Le quartier Saint-Pierre.
[Perspective view of park road, with trees left and right; Hôtel de Ville tower in distance, left of center]

7632 Vue générale d'Avignon prise de la Barthelasse.
[River and flooded Île-de-Barthelasse seen from Villeneuve; towers of Avignon on the horizon]

7633 Vue générale d'Avignon prise de la Barthelasse.
Avignon N° 1. EB.
[Principal buildings of the old city, seen from the Île-de-Barthelasse]

* 7634 Vue générale prise du Palais des Papes—Pont St. Bénézet.
[View of the Rhone; Pont Saint-Bénézet left foreground, Tour Philippe-le-Bel across the river]

* 7635 Vue générale prise du Palais des Papes—Pont suspendu.
[Looking north along the Rhone, with suspension bridge in background and Saint-Bénézet Bridge in right foreground]

7636 Vue générale d'Avignon. Palais des Papes. Notre-Dame des Doms. Remparts.
[Main features of Avignon, from the Île-de-Barthelasse]

7637 Avignon. Remparts.
Les remparts d'Avignon N° 84 E. Baldus.
[Ramparts reflected in floodwaters; pl. 52]

7638 Avignon. Remparts.
Remparts renversé / par l'inondation / Avignon. N° 83 E. Baldus.
[City walls; fallen section in foreground]

* 7639 Vue prise d'Avignon, vers le Rhône.
Avignon (inondations de 1856) N° 81 E Baldus.
[Looking south along the flooded Île-de-Barthelasse; house at left, barges at right; pl. 51]

*7640 Vue prise d'Avignon, vers le Rhône.
Avignon (Inondations. No. 82. E. Baldus.
[View across the Rhone, with the citadel of Villeneuve-les-Avignon in the distance at left; pl. 50]

§7641 Vue prise d'Avignon, vers le Rhône.
[Railroad viaduct at Tarascon; Beaucaire in the distance]

*7642 Vue prise d'Avignon, vers le Rhône.
[Looking south along the Rhone; quay at right]

*7643 Vue générale prise du Palais des Papes—Villeneuve-les-Avignon.
Villeneuf les Avignon. N° 92 EB
[Flooded Île-de-Barthelasse; citadel of Villeneuve-les-Avignon in the distance at right; pl. 49]

7644 Vue prise d'Avignon, vers le Rhône.
[Flooded plain; Tarascon and Beaucaire visible on the horizon]

7645 Ancien Remparts (en 1856).
Tarascon. N° 86. EB.
[View along ramparts of Tarascon; flood-marked buildings at left]

* A panorama of the flooded Avignon plain (fig. 54) is formed by six negatives joined in the following order:
7635–7634–7643–7640–7639–7642
(92) (82) (81)

§Although numbered and titled (albeit incorrectly) with the flood negatives by the Historic Monuments Commission, this view of the railroad viaduct at Tarascon shows no signs of the flood. It would seem to date from the same campaign as Baldus's panorama of the same bridge, his panorama of the Durance viaduct, and his view of the viaduct at Saint-Chamas (see p. 91).

APPENDIX 8
THE PLM ALBUM

The album *Chemins de Fer de Paris à Lyon et à la Méditerranée* contains sixty-nine images, including two two-part panoramas. The title of each photograph is printed on the mount, below the bottom left corner of the print; titles may vary slightly from one copy of the album to another, but the most frequently found title is given here. A few monuments or views are represented in some albums by variant images, as indicated. Most images are approximately 35 × 45 cm or slightly smaller; an asterisk indicates small-format photographs, approximately 21 × 28 cm. The location of each site is shown on map (fig. 61).

1. LYON [view of the Saône]
2. LYON. HOTEL DE VILLE.
3. LYON. GARE DE PERRACHE
4. PONT DE LA MULATIERE [fig. 64]
5. PONT DE LA MULATIERE [pl. 71]
6. LYON. VIADUC DU RHONE [full span]
7. LYON. VIADUC DU RHONE [single arch]
8. GIVORS. VIADUC [full span]
9. GIVORS. VIADUC [single arch]
10. VIENNE. SOUTERRAIN [northern entrance of the short tunnel]
11. VIENNE. ST COLOMBE [view from Vienne across Rhone to Saint-Colombe]
12. VIENNE. ST JEAN [pl. 72]
13. VIENNE. ST. MAURICE [facade of the Church of Saint-Maurice]
14. VIENNE. SOUTERRAIN [pl. 73]
15. VIADUC DE L'ISER
16. LA VOULTE [viaduct under construction; two-page panorama]
17. VIADUC DE LA VOULTE [full span]
18. VIADUC DE LA VOULTE [pl. 75]
19. VIVIERS [fig. 68]
20. ENTRÉE DU ROBINET [pl. 78]
21. ORANGE. ARC ANTIQUE* [pl. 13 (variant)]
22. ORANGE. THÉÂTRE ANTIQUE [pl. 74]
23. ORANGE. THÉÂTRE ANTIQUE [exterior]
24. AVIGNON [view from Villeneuve-les-Avignon]
25. AVIGNON. PONT ST BÉNEZET* [fig. 65]
26. AVIGNON [view from the Île-de-Barthelasse]
27. VILLENEUVE LES AVIGNON [Tour Philippe-le-Bel]
28. AVIGNON. PALAIS DES PAPES
29. VAUCLUSE* [Fontaine de Vaucluse, from surrounding hills; similar, with dark cliff at right (variant)]
30. SAINT-REMY* [Roman arch]
31. SAINT-REMY* [Roman mausoleum]
32. PONT DU GARD [fig. 66]
33. DURANCE. VIADUC [right half of pl. 76]
34. TARASCON. VIADUC [full span, Beaucaire in background]
35. TARASCON. VIADUC [single arch]
36. TARASCON. CHÂTEAU*

37. MAISON CARRÉE À NÎMES [fig. 13]
38. NIMES. AMPHITHÉÂTRE
39. NIMES. FONTAINE
40. NIMES. TEMPLE DE DIANE*
41. NIMES. TOUR MAGNE [pl. 15]
42. NIMES. PORTE D'AUGUSTE*
43. AIGUES-MORTES [ramparts]
44. ST. GILLES [facade of the church]
45. ARLES. ST. TROPHIME [facade of the church, after restoration; before restoration (variant)]
46. ARLES. CLOITRE ST TROPHIME [pl. 80]
47. ARLES. CLOITRE ST TROPHIME [north gallery]
48. ARLES. AMPHITHÉÂTRE [pl. 77]
49. ARLES. AMPHITHÉÂTRE [interior]
50. ARLES. THÉÂTRE ROMAIN
51. MONTMAJOUR [abbey]
52. VIADUC DE ST. CHAMAS
53. ROQUEFAVOUR [aqueduct]
54. SOUTERRAIN DE LA NERTHE [pl. 79]
55. MARSEILLE [rail yards]
56. MARSEILLE [fig. 62]
57. MARSEILLE [fig. 63]
58. MARSEILLE [Fort Saint-Jean]
59. MARSEILLE [Fort Saint-Jean and quai de la Tourette]
60. MARSEILLE [southern outer harbor and Bassin de la Joliette]
61. MARSEILLE [Port Napoléon; two-part panorama]
62. LA CIOTAT [pl. 81]
63. LA CIOTAT. BEC DE L'AIGLE [pl. 82]
64. LE MOINE [pl. 84]
65. BANDOL [pl. 83]
66. VIADUC DE BANDOL
67. ST. NAZAIRE [now called Sanary]
68. GORGES D'OLLIOULES [pl. 85]
69. TOULON [pl. 86]

A more fully descriptive catalogue raisonné of images in the PLM album is provided in Daniel, "Railway Albums," pp. 527–613.

APPENDIX 9
EXHIBITION HISTORY

Baldus exhibited his photographs widely during the 1850s and 1860s, in France and elsewhere in Europe. Following is a list, as can best be reconstructed at present, of the work shown at each exhibition; in a few cases Baldus's participation in a particular exhibition is documented, but the specific titles are not. Where exhibition catalogues were not published or do not survive, titles or descriptions are drawn from reviews. Titles are presented here exactly as given in the original source; spelling has not been corrected.

Photographic Society of London, 1854

As listed in the exhibition catalogue:
Eglise de St. Trophime in Arles [fig. 14]
Amphitheatre at Nimes
Le Tour Magne à Nimes [pl. 15]
Le Tour de St Jacques [pl. 11]
The Louvre, Paris
La Fontaine de Nimes par Pradier
Cloisters of St Trophimus at Arles
Cloisters of St Trophimus
Roman Arch at Orange [pl. 13]
Notre Dame, Paris [pl. 8]
Avignon
La Maison Carre, Nismes [fig. 13]
Arch de l'Etoile, Paris
The Church of St Gilles

Tentoonstelling van Photographie en Heliographie gehouden door de Vereeniging voor Volksvlijt, Amsterdam, April–June 1855

As listed in the exhibition catalogue:
De Mont d'Or
De kerk Nôtre Dame te Parijs [pl. 8]
De brug la Sainte
Le Trou de l'Enfer [fig. 24]
4 Heliographische gravuren

Exposition Universelle, Paris, 1855

As listed in reviews of the exhibition:
From gelatinized paper negatives

Le Lac [1.3 meters wide, formed of three negatives]
Le Pavillon de l'Horloge, Louvre
Les Arènes d'Arles
Les Arènes de Nîmes
L'Arc de Triomphe de l'Étoile
Pont de la Sainte
Moulin à eau

Gravures héliographiques
[after old engravings, including Lepautre]

Baldus was awarded a silver (first class) medal.

1st Annual Exhibition of the Photographic Society of Scotland, Edinburgh, 1856

As listed in the exhibition catalogue:
Fountain at Nismes
The Tuileries, Paris [probably pl. 38 or fig. 76]

Manchester Photographic Society, Exhibition of Photographs at the Mechanics' Institution, 1856

As listed in the exhibition catalogue:
Exhibited by R. P. Greg
Paysage, South of France

Exhibited by J. Lomax
Bas Relief
Bas Relief

Exhibited by J. C. Grundy
Le Puy [possibly pl. 21]

Chateau de Polignac

Place de Carrousal, Paris

Cloisters at Nismes

Tuilleries, Paris [probably pl. 38 or fig. 76]

Cheaumieres, Murolle [pl. 18]

Bibliothèque Imperiale du Louvre [possibly pl. 41]

Swiss Cottage [pl. 25]

Les Invalides, Paris

Palazzo Resonica, Venice *

Ducal Palace, Giant's Staircase, Venice *

Abbaye de Jumiege *

Eglise St. Lotheri, Lyons * * [fig. 51]

Ramparts d'Avignon après l'Inondation [probably pl. 52]

The Inundation, Lyons

Avenue, Abbaye de Jumiege *

The Inundation, Lyons

* There is no record anywhere else of Baldus having made pictures in Italy. Similarly, no other trace exists of photographs by Baldus of Jumièges. It seems likely that the exhibitor mistakenly attributed the work of others to Baldus.
** There is no Church of St. Lotheri in Lyons. This is probably a misreading of "Eglise de St. Pothin," inscribed on one of Baldus's flood scenes.

Exposition Instituée par l'Association pour l'Encouragement et le Développement des Arts Industriels en Belgique, Brussels, 1856

As listed in the exhibition catalogue:

Panorama de Paris (pont Neuf)

Panorama de Paris (pont Royal)

Hôtel de ville

Nouveau Louvre (pavillon d'angle)

Nouveau Louvre (pavillon du milieu)

Nouveau Louvre (pavillon de l'empereur)

Nouveau Louvre (pavillon de Rohan)

Ancienne bibliothèque (porte)

Nouvelle bibliothèque impériale (porte) [possibly pl. 41]

Paysage à Thiers

Grand détail du nouveau Louvre

Inondation, vue prise à Lyon

Deuxième Exposition Annuelle, Société Française de Photographie, 1857

As listed in the exhibition catalogue:

From collodion-on-glass negatives

Pavillon Richelieu, au Louvre

Pavillon Denon, au Louvre

Pavillon Turgot, au Louvre

Pavillon Turgot, au Louvre

Château de la Faloise [probably pl. 53 or 54]

From paper negatives

Scène de l'Inondation de Lyon

Scène de l'Inondation de Lyon

Exposition Instituée par l'Association pour l'Encouragement et le Développement des Arts Industriels en Belgique, Brussels, 1857

As listed in the exhibition catalogue:

Deux grandes vues du pavillon du Louvre

Grand portail de l'église de Sainte-Clotilde

Grand portail du Louvre, dans les cours des écuries

Paysage

Architectural Photographic Association, London, January 7–February 24, 1858

As listed in the exhibition catalogue:

31 × 23 in.:

Arc de l'Etoile, Paris

Pavillon Richelieu, Louvre

Pavillon Sully, Louvre

24 × 11 in. [panoramas]:

View of the Louvre from Tuileries

View of Louvre and River

About 18 × 16 in.:

La Sainte Chapelle, Paris

Notre Dame, Paris, West Façade [pl. 56]

Fountain at Nismes

The Tower St. Jacque de la Boucherie [fig. 80]

Church of the Invalides, Paris

Place de la Concorde, Paris

Palais de l'Industrie

Hotel de Ville, Paris

Arc de l'Etoile

View of Louvre from Tuileries

Place Napoleon

Upper Portion of Louvre

243

Tuileries, from Place Napoleon
Pavillon Colbert, Louvre
Pavillon Richelieu, Louvre
Pavillon Denon, Louvre
Pavillon Molière, Louvre
St. Germain l'Auxerrois
Notre Dame, Paris, South-east View
Church of St. Gilles
Arc de l'Etoile
Place Napoleon
St. Germain l'Auxerrois
Notre Dame
Church of St. Gilles

Photographic Society of London, Fifth Year, 1858

As listed in the exhibition catalogue:
From collodion-on-glass negatives
Pavillon Richelieu (Nouveau Louvre)
Pavillon Sully (Nouveau Louvre)
Pavillon Napoleon (Nouveau Louvre)

Architectural Photographic Association, Second Annual Exhibition, London, December 17, 1858–early 1859

As listed in the exhibition catalogue:
Approximately 18 × 13 in.
East End of St. Pierre, Caen [pl. 61]
Spire of St. Pierre, Caen
North-east view of St. Pierre, Caen [pl. 60]
South-east view of St. Etienne, Caen [pl. 59]
View of interior of Court-yard, Louvre
Fragment placed in the façade of the Chateau d'Arnet
Pavillion d'Horloge—Louvre
View of Tuilleries
Palais du Luxembourg
The New parts of the Louvre
Gallerie d'Apollon—Paris
Church at Vienne—(Dauphiné)

Troisième Exposition de la Société Française de Photographie, April 15–July 1, 1859

As listed in the exhibition catalogue:

From wet collodion negative
Détail de la porte de la bibliothèque du vieux Louvre

Exhibition of photographs, Aberdeen, 1859

As described in a review of the exhibition:
"Some large photographs"

Architectural Photographic Association, Third Annual Exhibition, London, February 9–March 10, 1860

As listed in a review of the exhibition:
Porch of St. Germain l'Auxerrois
St. Vincent de Paul
Court of the Louvre
Staircase of the Palais de Justice, Rouen

Exposition Photographique d'Amsterdam, closed March 18, 1860

Architectural Photographic Association, Fourth Annual Exhibition of English and Foreign Photographs, London, January 15–March 14, 1861

As listed in the exhibition catalogue:
17 × 13 inches
Nismes, Fountain at

11 × 8 inches
Paris, Fountain of Leda, Rue de Vaugiraud
Paris, Allegorical Sculpture from the Arc de l'Etoile
Paris, Allegorical Sculpture from the Arc de l'Etoile
Paris, Allegorical Sculpture from the Arc de l'Etoile
Paris, Allegorical Sculpture from the Arc de l'Etoile

Quatrième Exposition de la Société Française de Photographie, May 1–August 31, 1861

As listed in the exhibition catalogue:
From paper negatives
Bas-relief de l'arc de Triomphe. Le départ
Bas-relief de l'arc de Triomphe. Le triomphe
Panorama de Paris

Panorama des Tuileries et du Louvre —Ce panorama embrasse une
 vue de 200 degrés
La Vierge au linge, d'après dessin de Raphaël
La Sainte Famille, d'après dessin de Raphaël
Le Bout du Monde (vue du Dauphiné)
Cascade de Sassenage (vue du Dauphiné)
Paysage aux environs d'Alvard (Dauphiné) [pl. 64]
Paysage à Vorepp (Dauphiné)
Chamounix
Mer de Glace
Vue d'Avignon

Exposition de la Société Photographique de Marseille, 1861

As listed in a review of the exhibition:
 Le Pavillon Richelieu

International Exhibition of Industry and Art, London, 1862

As described in reviews of the exhibition:
 Albums (including views of the Dauphiné and Savoie)
 Nine large framed sheets, including:
 Louvre
 Tuileries
 Pavillon de Flore [possibly fig. 43]

 Bas-relief of the Arc de Triomphe de l'Etoile

Awarded medal for "large views of monuments, views from nature,
reproductions, &c."

Exposition Universelle, Paris, 1867

Huitième Exposition de la Société Française de Photographie, May 1–October 31, 1869

As listed in the exhibition catalogue, nos. 106–20:
 Spécimens de son procédé de gravure héliographique.—Épreuves d'après
 nature et reproductions d'après Marc-Antoine, Albert Durer, Van Leyden,
 Andelgraver, de Brye, etc., etc.

Exposition de la Société Photographique de Marseille, 1871

Welt-Ausstellung, Vienna, May 1–October 31, 1873

Dixième Exposition de la Société Française de Photographie, May 1–July 31, 1874

As listed in the exhibition catalogue, nos. 11–19:
 Héliogravures

Listed below are publications in which Baldus's photographs appeared, either as salted paper prints or as photogravures, and the editions of his facsimile gravures.

1. Vitraux de l'Église Sainte-Clotilde, 1853

Title page reads:

VITRAUX / DE / L'ÉGLISE SAINTE-CLOTILDE / COMPOSÉS ET DESSINÉS / PAR / AUGUSTE GALIMARD / ET PHOTOGRAPHIÉS PAR / E. BALDUS. / — / PARIS, / CHEZ L'AUTEUR, RUE CASSETTE, 22, / Et chez les principaux Marchands d'Estampes. / — / MDCCCLIII.

A second title page reads:

ART CHRÉTIEN. / PEINTURE MONUMENTALE. / — / VITRAUX / DE / L'ÉGLISE SAINTE-CLOTILDE, / COMPOSÉS ET DESSINÉS / PAR / AUGUSTE GALIMARD, / AUTEUR DE LA DÉCORATION GÉNÉRALE DU CHOEUR DE L'EGLISE SAINT-LAURENT, / ET / PHOTOGRAPHIÉS / PAR / ÉDOUARD BALDUS. / — / Ouvrage honoré de la souscription du Ministère d'État et de celle des Souverains étrangers. / — / PARIS / CHEZ L'AUTEUR, 22, RUE CASSETTE, / CHEZ LES PRINCIPAUX MARCHANDS D'ESTAMPES / AINSI QU'A TOUTES LES LIBRAIRIES RELIGIEUSES. / — / 1854

Contains one circular photograph (approximately 13.5 cm in diameter) showing five angels, and ten photographs (approximately 16 × 6.5 cm) each showing a single saint.

2. Histoire des artistes vivants, 1853

Wrapper of the first installment reads:

HISTOIRE / DES / ARTISTES VIVANTS / FRANÇAIS ET ÉTRANGERS / PEINTRES, SCULPTEURS, ARCHITECTES, GRAVEURS, PHOTOGRAPHES. / ÉTUDES D'APRES NATURE / PAR / THÉOPHILE SILVESTRE / PORTRAIT DES ARTISTES ET REPRODUCTION DE LEURS PRINCIPAUX OUVRAGES / PAR LA PHOTOGRAPHIE. / [...] / COROT, PEINTRE / E. BLANCHARD, ÉDITEUR-LIBRAIRE, ANCIENNE MAISON HETZEL, / 78 rue de Richelieu. / — / 1853 / ARTISTES FRANÇAIS. NUMÉRO D'ORDRE DES LIVRAISONS: 1.

The plates by Baldus are: portraits of Chenavard, David d'Angers, and Jeanron and reproductions after Delacroix's *Christ en croix*, *Noce juive au Maroc*, *Liberté*, *Danté et Virgile*, *Massacre de Scio*, and *Femmes d'Alger*, Courbet's *Desmoiselles de village*, Corot's *Vue du port de la Rochelle*, and Ingres's *Françoise de Rimini*. All are Dépôt Légal 1853 (Seine).

3. Réunion des Tuileries au Louvre, 1857

Title page reads:

REUNION / DES / TUILERIES AU LOUVRE / 1852–1857. / — / RECUEIL DE PHOTOGRAPHIES / PUBLIE PAR ORDRE DE S. EXC. Mr. ACHILLE FOULD. / MINISTRE D'ETAT ET DE LA MAISON DE L'EMPEREUR.

Each set is composed of four volumes of photographs.

4. Recueil d'Ornements, 1866

Title page reads:

RECUEIL / D'ORNEMENTS / d'après / LES MAÎTRES / Les plus célèbres / DES / XV XVI XVII et XVIII^e / Siècles / HÉLIOGRAVURE / par EDOUARD BALDUS. / Paris, Rue d'Assas, 25. / 1866 / PARIS / V^VE A. MOREL ET C^IE, LIBRAIRES ÉDITEURS / 13, RUE BONAPARTE, 13 / Déposé. Tous droits reservés.

The volume contained one hundred plates in-folio, at a cost of 100 francs. Reproduced are works by Aldegrever, Master IB, Beham, Boyvin, de Bry, Delanne, Dürer, Ducerceau, Holbein, Jansz, Lepautre, van Leyden, Marot, Solis, Vico, Woeiriot.

A copy in the Fondation Jacques Doucet, Bibliothèque d'Art et d'Archéologie, Paris (F^O EST 12), was published in 1869 by J. Baudry, Paris.

5. Oeuvre de Marc-Antoine Raimondi, 1867

Title page reads:

OEUVRE / DE / MARC-ANTOINE REIMONDI / — / Héliogravure par E. Baldus / Paris. Rue d'Assas, 25

Publication notice on the back of a wrapper for *Les Monuments principaux de la France* reads:

OEUVRES DE MARC-ANTOINE RAIMONDI / Les plus belles gravures de cet illustre Maître / d'après RAPHAEL, MICHEL-ANGE et l'antique / Reproduites par l'héliogravure de E. BALDUS / 40 planches in-folio sur papier de Hollande / Prix: 80 francs.

6. Oeuvre de Jacques Androuet dit Du Cerceau, ca. 1869

Title page of the Meubles series reads:

OEUVRE / DE / Jacques Androuet / DIT / DU CERCEAU / —— / MEUBLES / HÉLIOGRAVURE / par Edouard Baldus / PARIS, RUE D'ASSAS, 17. / Ancien 25. / Imp. Delâtre, rue St. Jacques 303, Paris.

The Meubles series contained 52 plates in-folio at a cost of 52 francs.

Title page for the Petites Arabesques series reads:

OEUVRE / DE / Jacques Androuet / DIT / DU CERCEAU / —— / 62 PETITES ARABESQUES / Série Complête. / HÉLIOGRAVURE / par Edouard Baldus. / PARIS, RUE D'ASSAS, 17. / Ancien 25.

Published in-folio for 62 francs; published in-quarto for 55 francs.

Title page for the Grandes Arabesques series reads:

OEUVRE / DE / Jacques Androuet / DIT / DU CERCEAU / —— / 35 GRANDES ARABESQUES / Série Complête. / HÉLIOGRAVURE / par Edouard Baldus. / PARIS, RUE D'ASSAS, 17. / Ancien 25.

Published in-folio for 35 francs.

An advertisement provides the following information for the Cheminées series:

QUATRIÈME SÉRIE DE L'OEUVRE DE A. DUCERCEAU / CHEMINÉES / 20 planches in-folio, sur papier de Hollande / Prix: 20 francs.

Title page for a volume combining the Meubles and Cheminées series reads:

OEUVRE / DE JACQUES / ANDROUET-DUCERCEAU / REPRODUIT / PAR LES PROCÉDÉS DE L HÉLIOGRAVURE / DE / EDOUARD BALDUS / —— / MEUBLES & CHEMINÉES / —— / PARIS / E. BALDUS, 17, RUE D'ASSAS, 17 / ET LA LIBRAIRIE ARTISTIQUE ET INDUSTRIELLE EUG. DEVIENNE, ÉDITEUR / 396, RUE SAINT-HONORÉ, 396 / —— / 1869.

Title page for a series on various ornaments reads:

OEUVRE / DE / Jacques Androuet / DIT / DU CERCEAU / —— / COUPES 14 PL. 14 Sujets / VASES 27 PL. 53 [Sujets] / TROPHÉES 13 PL. 37 [Sujets] / CARTOUCHES 33 PL. 33 [Sujets] / FLEURONS 12 PL. 12 [Sujets] / BALUSTRADES 20 PL. 41 [Sujets] / FERRONNERIE 15 PL. 64 [Sujets] / 134 PLANCHES. 254 Sujets / —— / HÉLIOGRAVURE / par Edouard Baldus.

7. Palais du Louvre et des Tuileries, 1869–71

Title page of the first edition reads:

PALAIS DU LOUVRE ET DES TUILERIES / MOTIFS DE DÉCORATIONS / tirés des Constructions / exécutées au NOUVEAU LOUVRE et au PALAIS des TUILERIES / sous la direction de M^R H. LEFUEL / Architecte de l'EMPEREUR / HÉLIOGRAVURE PAR E. BALDUS / 17, Rue d'Assas. PARIS.

A variant text on the original wrapper for an installment in a private collection, Brussels, reads:

PALAIS DU LOUVRE / ET DES TUILERIES / MOTIFS DE DÉCORATION INTÉRIEURE ET EXTÉRIEURE / TIRÉS DES CONSTRUCTIONS EXÉCUTÉES / AU NOUVEAU LOUVRE ET AU PALAIS DES TUILERIES / SOUS LA DIRECTION DE M. LEFUEL / ARCHITECTE DE L'EMPEREUR / REPRODUITS PAR LES PROCÉDÉS PERFECTIONNÉS DE L'HÉLIOGRAVURE / DE E. BALDUS / —— / PARIS / HÉLIOGRAVURE DE E. BALDUS, RUE D'ASSAS, N^O 17 / J. E. OGIER, CHARGÉ SPÉCIALEMENT DE LA VENTE / —— / Déposé. —— Tous droits réservés.

Published in-folio. The series of interior decoration was issued in four installments of twenty-five prints, costing 37.50 francs; the series of exterior decoration was issued in five installments of twenty prints, costing 30 francs.

A second edition, including a third volume, was issued in 1875. The title page reads:

PALAIS / DU LOUVRE / ET / DES TUILERIES / MOTIFS DE DÉCORATION / INTÉRIEURE ET EXTÉRIEURE / REPRODUITS PAR LES PROCÉDÉS D'HÉLIOGRAVURE / DE E. BALDUS / —— / I^RE PARTIE —— DÉCORATIONS INTÉRIEURES [II^E PARTIE—DÉCORATIONS EXTÉRIEURES; III^E PARTIE —— DÉCORATIONS INTÉRIEURES ET EXTÉRIEURES] / CENT PLANCHES / [Morel imprimatur] / PARIS / V^E A MOREL & C^IE, LIBRAIRES-ÉDITEURS / 13 - RUE BONAPARTE - 13 / Déposé - Tous droits réservés.

8. Palais de Versailles, early 1870s

Title page of first edition reads:

PALAIS / DE / VERSAILLES / —— / MOTIFS DE DÉCORATIONS / —— / REPRODUITS EN HÉLIOGRAVURE / PAR / E. BALDUS / 17, Rue d'Assas. / PARIS.

Title page of second edition reads:

PALAIS / DE / VERSAILLES / GRAND ET PETIT TRIANON / MOTIFS DE DÉCORATION INTÉRIEURE ET EXTÉRIEURE / REPRODUITS PAR LES PROCÉDÉS D'HÉLIOGRAVURE / DE / E. BALDUS / [Morel imprimatur] / PARIS / V^E A. MOREL ET Cie, LIBRAIRES-ÉDITEURS / 13, RUE BONAPARTE, 13 / —— / 1877 / Déposé. Tous droits réservés.

9. Les principaux monuments de la France, early 1870s

Title page of first edition reads:

LES PRINCIPAUX / MONUMENTS / DE / LA FRANCE / —— / REPRODUITS EN HÉLIOGRAVURE / PAR / E. BALDUS / 17, Rue d'Assas / PARIS.

Intended to consist of three installments of twenty prints each, at the price of 80 francs per installment. All extant copies contain only forty-five prints (see appendix 11).

247

Title page of second edition reads:

LES / MONUMENTS / PRINCIPAUX / DE LA FRANCE / REPRODUITS EN HÉLIOGRAVURE / PAR / E. BALDUS / [Morel imprimatur] / PARIS / Ve A MOREL ET Cie, LIBRAIRES-ÉDITEURS / 13, RUE BONAPARTE, 13 / 1875.

10. Reconstruction de l'Hôtel de Ville de Paris, 1884

Title page reads:

RECONSTRUCTION / DE / L'HOTEL DE VILLE DE PARIS / PAR / T. BALLU / Membre de l'Institut, Architecte en chef, / ET / DE PERTHES / Architecte / — / MOTIFS DE DÉCORATION EXTÉRIEUR / SOIXANTE PLANCHES EN HELIOGRAVURE / PAR / E. BALDUS / [Imprimatur of the Librairie Centrale d'Architecture] / PARIS / LIBRAIRIE CENTRALE D'ARCHITECTURE / DES FOSSEZ ET Cie, ÉDITEURS / 13, RUE BONAPARTE, 13 / 1884.

Some copies have the same title page but contain seventy plates rather than sixty.

The title page of a two-volume set containing one hundred plates, in the Avery Architectural and Fine Arts Library, Columbia University, New York, reads:

RECONSTRUCTION / DE / L'HOTEL DE VILLE DE PARIS / PAR / T. BALLU / Membre de l'Institut, Architecte en chef / ET / DE PERTHES / Architecte / — / ENSEMBLES, DÉTAILS ET MOTIFS DE DÉCORATION / REPRODUITE PAR L'HÉLIOGRAVURE / DE / E. BALDUS / Ire PARTIE [IIE PARTIE] / EXTÉRIEURS [INTÉRIEURS] / Soixante-dix planches [] / PARIS / LIBRAIRIE DES IMPRIMERIES RÉUNIES / 13, RUE BONAPARTE, 13.

The tenth print in each of the last three installments is a chromolithograph.

APPENDIX 11
LES PRINCIPAUX MONUMENTS DE LA FRANCE

The following list of titles is taken from the installment wrappers on the copy of *Les principaux monuments de la France*
in the library of the Victoria and Albert Museum.

1. Amphithéâtre romain (Nîmes)
2. Tribunal de Commerce de Paris (cour intérieure)
3. Église de Saint-Pierre à Caen (abside)
4. Saint-Germain l'Auxerrois (Paris)
5. Palais de Justice (façade sur le quai)
6. Palais de Justice (Tour de l'Horloge)
7. Palais de Justice (Salle des Pas Perdus)
8. La Sainte-Chapelle de Paris (façade)
9. La Sainte-Chapelle (flèche)
10. La Sainte-Chapelle (façade latérale)
11. Fontaine de l'Esplanade (Nîmes)
12. Théâtre romain à Orange (intérieure)
13. Notre-Dame de Poitiers (façade)
14. Tribunal de Commerce de Paris (façade sur le quai)
15. Bibliothèque du Louvre (Porte sur le quai)
16. Église de Issoire
17. Église de Saint-Julien de Brioude
18. Notre-Dame de Paris (face latérale)
19. Notre-Dame de Paris (porte latérale)
20. Église de Saint-Pierre à Caen (flèche)
21. Le départ (Arc de Triomphe de l'Etoile, Paris)
22. Cathédrale de Reims (façade principale, portail)
23. Louvre, Colonnade (Paris)
24. Château de Blois (façade sur la cour)
25. Place de la Concorde
26. Cathédrale de Reims (façade latérale)
27. Académie Nationale de Musique
28. Palais de Justice à Rouen
29. La Trinité (Paris)
30. Palais de Justice (façade sur la place Dauphine)
31. Pavillon de l'Horloge (Louvre, Paris)
32. Église de Saint-Gilles
33. Académie Nationale de Musique (façade latérale)
34. Cathédrale de Chartres (façade principale, portail)
35. Grande grille de la Cour d'Honneur. (Palais de Justice de Paris)
36. Cathédrale de Chartres (flèches)
37. Notre-Dame de Paris (transept côté sud)
38. Notre-Dame de Paris
39. Pavillon Sully (Louvre, Paris)
40. Hôtel des Invalides (Paris)
41. Église de Saint-Trophîme (à Arles)
42. Porte de la bibliothèque (rue de Rivoli)
43. Arc de Triomphe de l'Étoile (Paris)
44. Palais des Tuileries (avant l'incendie de 1871)
45. Arc de Triomphe du Carrousel (Paris)

APPENDIX 12
CONCOURS DE PHOTOGRAPHIE

In May 1852 Baldus published a short treatise outlining his process for making negatives and positives employed the previous year on the *mission héliographique*. The text is given here in translation.

Memorandum submitted to the secretariat of the Society of
Encouragement for National Industry
Containing the procedures
By which the principal monuments of the south of France were
Reproduced at the behest
Of the minister of the interior
By Édouard Baldus, painter

PARIS
Victor Masson, Bookseller/Publisher
Place de l'École-de-Médicine
May 27, 1852

The author of this work reserves the right to translate it or have it translated into any and all languages. By virtue of the international laws, decrees, and treaties, he will prosecute any and all infringements of his copyright and any and all unlicensed translations.
The copyright of this work was registered in Paris on May 27, 1852, and all the formalities prescribed by the treaties have been carried out in various countries with which France has concluded treaties on literary property.

FOREWORD

Several articles have already been published about photography on paper and on glass, but we believe that it would be no less useful to acquaint the public with our own research. Our goal is to obtain on paper sharpness and clarity of the images, promptness of execution (when promptness is necessary), a fairly durable fixing of the negative, and finally, a convenient arrangement of the equipment.

The minister of the interior assigned us the task of photographically reproducing on paper a number of historic monuments of France; and so, in the course of a long journey, we worked in highly diverse conditions of light, temperature, and climate. Having always achieved good results in both negatives and positives, we are now confidently presenting artists and amateurs with the procedures that helped us to accomplish our mission—persuaded as we are that by following our instructions scrupulously and with a bit of perseverance, they will have the satisfaction of enjoying the same successes that we have had.

THE PRACTICE
OF
PHOTOGRAPHY ON PAPER

Paper

Unfortunately, we do not as yet possess the intuitive knowledge that enables a few photographers to obtain, as they affirm, beautiful prints on any kind of paper.

Quite the contrary: We are obliged to caution amateurs to pay the strictest attention when choosing paper, above all for negatives. And this concern is all the more necessary in that the paper makers themselves admit that it is difficult for them to guarantee that any two reams of paper are of exactly the same quality.

It is true that none of those manufacturers had undertaken any sustained experiments to produce paper that would be specifically appropriate for photography. Instead, photographers were forced to turn to England and Germany for paper that was not to be found in France. Eventually, however, Messrs. Blanchet Frères et Kléber, of Rives, tried to produce a very special paper, and they are now able to furnish the paper necessary for photography. They will, no doubt, keep improving their product by the careful selection of materials and the perfection of their work.

The nature of the paper must vary according to what the photographer wishes to do. Until now, paper sized with resin and gelatin (English paper is of this sort) has been slow in being penetrated by the action of light, but such paper is firmer and makes a better showing for itself in the various baths. It is

therefore preferable for shooting monuments and landscapes. Paper sized with starch is far more sensitive, hence more suitable for a portrait.

We can make sure of the quality of paper by impregnating it with wax[1] and examining it against the light; it has to have the effect of a piece of thin gelatin. But this is only a rough appraisal, since the grain of a sheet of paper is often greatly modified in usage. For a closer gauging of the paper one wishes to try out, one should complete several negatives and, for even greater certainty, one positive as well.

1. For this operation, see below.

FIRST PREPARATION OF PAPER
FOR NEGATIVES[1]

I. Paper for Landscapes, Monuments, Statues, etc.

First take:

 Distilled water 500 grams
 White gelatin 10

Melt the gelatin in a double saucepan inside a porcelain basin, and when the gelatin has melted fully, add five grams of potassium iodide and mix with a glass stick until the liquid is thoroughly blended. Once the blend is complete, add the following little by little while simultaneously mixing with the stick: 25 grams of acetonitrate, the composition of which is on page 15 [Second Operation]. The liquid will now have a yellowish tint; keep heating it and mixing it for another ten minutes or so. Once this first preparation is implemented, it is ready to use.

To this end, take a bowl kept warm in the double saucepan and pour the liquid into it. Then take hold of the corners of a sheet of paper: first place the middle of the sheet[2] on the liquid and lower the two corners gradually in order to force out any air bubbles that may form and which would prevent the adherence of the liquid to the paper. Once the paper has been thus placed, leave it until it presents a very smooth surface; this phase usually takes six to ten minutes, depending on the thickness of the paper.

Then remove the paper, hang it up to dry by attaching one corner to a taut cord. To make certain there is no excessive liquid in the corner opposite the one attached to the cord, take a small piece of blotting paper and apply it to that corner; this facilitates the run-off of the final drops.

When the sheets of paper thus prepared are thoroughly dry, soak both sides of each sheet in a solution of:

 Distilled water 100 grams
 Potassium iodide 1 gram

Start by dipping the side that has received the first preparation, turn the paper over, avoiding air bubbles, and leave the sheet for six to ten minutes, depending on the temperature. Dry the paper again, and place all the dry sheets in a box; they can be stored for a very long time.

The rest of the gelatin liquid can be reused after being heated and filtered.

This first preparation leaves a layer of completely insoluble gelatin in the paper; it closes up the pores of the paper while simultaneously forming another thin layer of gelatin on the surface; this thin layer is loaded with non-precipitated silver iodide and is already a bit sensitive to light. The second dipping in potassium iodide increases the sensitivity of the paper. The side of the paper that has received the first preparation takes on a pale yellow hue.

II. Negative Paper for Portraits

For portraits, one must necessarily choose the most beautiful and most consistent paper, sized in starch.

Prepare the liquid with:

 Distilled water 100 grams
 Ammonium iodate 1 gram
 Ammonium bromate 1 decigram

Immerse the paper fully in the liquid and leave it there for five to ten minutes, depending on the temperature and the thickness of the paper; then remove it for drying.

The ammonium iodate must be white or very slightly yellowish when used. Any coloring indicates an excess of iodine, which slows the operation.

With this procedure correctly applied, one can obtain the same speed as on the [daguerreotype] plate. These two kinds of preparations can be done in daylight, so long as it is not too bright.

The following operations can be applied in the same manner to sheets of paper prepared by either of the two methods that we have just outlined.

1. Any reproduction of this chapter (pages 10 to 14) is strictly prohibited in any form whatsoever and will be prosecuted as an infringement of copyright.

2. Both sides of the sheet could be immersed; in this case, the paper would last longer when one wishes to work dry.

SECOND OPERATION[1]

Treatment with Acetonitrate of Silver

When one wishes to make the paper sensitive to light, first prepare a solution of:

Distilled water 100 grams
Silver nitrate 6 grams
Glacial acetic acid 12 grams

Pour this liquid into a tray or on glass, forming a layer two millimeters deep. Then, holding two opposite corners, take a prepared sheet of paper and, first placing the middle, gradually lower the two corners. Make sure the entire sheet adheres to the liquid and that no air bubbles remain. At this moment, there will be inconsistencies in color, which often look like spots; but as the solution takes effect, the entire surface of the paper assumes a uniform hue. At this point, one must remove the paper and place it in the plate holder.

This overall reaction usually takes five to six minutes, depending on the thickness of the paper.

While leaving the sheet on the acetonitrate, prepare a sheet of thick white paper, slightly larger than that of the negative. Plunge it fully into the distilled water and soak it thoroughly; then place it on the glass inside the plate holder of the camera. Next, upon this sheet of wet paper place the sheet removed from the acetonitrate (the back side down, of course). Making sure that the two sheets adhere perfectly to each other, one can wait several hours before working, or even until the next day if the temperature is not too high. In that case, to make absolutely sure, dip the lining paper in a light decoction of linseed instead of ordinary water.

Using this latter method, we have obtained good results within two days. If one wishes to work with dry paper, remove the sheet from the acetonitrate of silver (in which both sides have been dipped). Pass the sheet rapidly through distilled water to remove the excess nitrate, and then hang the paper up to dry.

Naturally, in order to make a proof with dry paper, you must place the sheet between two glass plates in the holder.

We do not like this second method, for we have noticed that proofs obtained by working between two glass plates have far less purity.

1. Observation: The second, fourth, and fifth operations must be performed in a darkroom by the light of a small lamp.

THIRD OPERATION

Placement in the Camera

Once the sheets of paper are appropriately placed in the plate holder, put the latter inside the camera. The length of exposure cannot be indicated in advance; it depends on the intensity of the light, the quality of the lens, and its focal length.

For views and monuments that are generally made with a simple lens having a slightly long focus, one must count on three to five minutes of exposure for paper prepared for a landscape (first type). If the objects are yellow or black, one must expose the negative longer.

Portrait paper (second type) requires no more than from five to sixty seconds, depending on the light and the location. Once the paper is in the plate holder, one must work as quickly as possible.

FOURTH OPERATION

Immersion in Gallic Acid

A solution of saturated gallic acid must be prepared well in advance and at a temperature of 18 to 20 degrees [centigrade].

Pour this solution into a tray, forming a layer two or three millimeters deep and of the same surface area as the sheet of paper.

Next, remove the paper from the plate holder and, with the side that has received the image first, place it on the layer of gallic acid. An instant later, turn the paper over so that both sides are thoroughly soaked. After several minutes the image starts to appear, and all its parts will emerge successively. If it was exposed for the necessary length of time, it should be complete within about half an hour.

Now if the image is faint, one can add a few drops of acetonitrate of silver to the bath, mixing well to make sure the paper is fully covered; this greatly reinforces the blacks. In the same bath, one can also add a bit of pyrogallic acid and ammonium acetate to the gallic acid. However, be sparing with these components since the image is often lost if they are used; the contrast between the whites and the blacks nearly always becomes too strong, and the print will look harsh and unharmonious.

A good negative should be able to be completed in gallic acid *alone*.

FIFTH OPERATION

Fixing the Image

Once the image is completed in the gallic acid, wash the positive in filtered water; the positive can be left in the water for as long as fifteen minutes, which makes it stronger and removes all the gallic acid.

Prepare a solution of:

Distilled water 100 grams
Potassium bromide 3

Pour this solution into a tray and plunge the paper all the way in. If the bath now takes on a greenish tint, the paper has not been sufficiently cleansed in the filtered water. In that case, simply renew the bromide bath.

The paper must remain in the bath for at least half an hour.

Next, the print must be washed very carefully in several water baths; otherwise, the negative is not properly fixed and will soon fade when one tries to reproduce it. The print is dried by hanging on a line.

The print can also be fixed with a solution of:

Water 100 grams
Hyposulfite of soda 7 grams

When using this solution, add *one* gram of pure acetic acid. Operate absolutely in the same manner with the immersion and with the careful washing procedures.

There is another good method for fixing the print, especially a portrait. Use a solution of saturated sodium chloride; the washing procedures are the same.

SIXTH OPERATION

Waxing the Negative

Some people have advised against waxing the negative when it is weak or its color pale.

We believe that, on the contrary, this operation is always necessary, even with thin paper. A negative that cannot endure waxing must be regarded as mediocre and will never provide good positives. The wax not only increases the transparency, it also stops up all the tiny interstices in the paper, producing a more consistent surface. The wax protects the negative more effectively by preserving its humidity.

Place several sheets of blotting paper on a plate or a table and put the negative on top, completely flat, to prevent the formation of creases, which cannot be subsequently removed.

Spread a layer of white wax on a moderately hot iron and then iron the photograph with gentle pressure to make the wax penetrate it throughout.

Or else prepare in advance some blotting paper saturated with wax. Place it on the print and iron the blotting paper in order to make the wax pass into the print. With either method, if the print contains too much wax, place it between two sheets of unwaxed blotting paper and press it with the hot iron, so that any excess wax passes into the sheets of blotting paper.

SEVENTH OPERATION

Preparing the Positive Paper

Prepare a solution of:

Distilled water 100 grams
Pure sodium chloride . . . 4.5 grams

Pour this solution into a tray, to a depth of five to ten millimeters.

After marking each sheet of paper with a sign, spread them out, one after another, on the liquid. Leave each one in for five to eight minutes, depending on the thickness, and then dry them by hanging them up by a corner.

In this way, a rather large number of sheets can be prepared in advance and in broad daylight.

When the sheets are dry, place them face to face in a box, where they can be stored for a long time. Just avoid leaving them in a damp area.

Meanwhile, prepare another solution:

Distilled water 100 grams
Silver nitrate 15 to 18 grams

Soak each sheet, with the salted side on the nitrate, for five or six minutes. Then dry the paper thoroughly.

This latter operation must be performed in the dark or by the light of a lamp or candle. It is best to work in the evening in order to use the paper the next day. Do not prepare more than you intend to use, because even when carefully stored, the paper begins to yellow after two days, and this tint intensifies quite rapidly. Images printed on such colored paper do not have the strength or beauty of images obtained on paper that is still white or slightly yellowed.

EIGHTH OPERATION

Printing the Positive

Place the negative on the glass of the printing frame, with the stronger side up. Cover it with a paper prepared for the positive, with the nitrated side on the negative. Avoid any crease and let the edges of the positive paper extend slightly to judge the intensity of the light according to the color they take on. Then close the printing frame and turn the screws slightly to make sure the two sheets adhere properly together.

One can usually judge the time necessary in the printing frame, especially by examining the color of the margins to see how far along it is. But it is better to look at the image itself, opening only one side of the printing frame to avoid disturbing it.

In general, one should allow the image to become stronger and darker than it should be, because it will be weakened by the hyposulfite bath.

Ordinarily one can tell that it is time to remove the print when the light parts begin to cloud over.

Furthermore, care alone is not enough to achieve fine prints. Above all, the *cliché*, or negative, must be perfectly executed in its harmony of tones and purity of lines.

NINTH OPERATION

Fixing the Positive

Prepare a solution of:

 Distilled water 100 grams
 Hyposulfite of soda 12 grams

Pour this liquid into a tray and entirely immerse the positive right after removing it from the printing frame. Make sure there are no air bubbles, since they would leave spots by preventing the hyposulfite from adhering equally everywhere.[1]

Leave the positive in the bath until the light areas are quite clear. Here, too, experience is required for carefully judging the right moment, since the image always becomes a little stronger after drying.

When removing the positive from the hyposulfite, one must rewash it, leaving it in the water as long as five or six hours in order to remove all the hyposulfite. Without this precaution, the image would yellow more and more, perhaps even fading away altogether.

After removing the print from its last water bath, hang it up to dry.

By using the hyposulfite solution, one obtains rather unpleasant reddish tones. To avoid this, add a bit of newly precipitated silver chloride (half a gram per 100 grams of liquid). After finishing, filter the used hyposulfite into a flask. It can then be reused if one always replaces part of the old bath with a small amount of new solution. This liquid, which is advantageous to the color of the print, can be reused indefinitely.

Positive paper sized with starch provides the finest black tones.

1. Several prints can be put in the bath simultaneously, provided there is enough liquid, so that they will not stick together.

Translated from the French by Joachim Neugroschel.

Notes

AL Archives du Louvre, Paris
AN Archives Nationales, Paris
AP Archives de Paris
BN Bibliothèque Nationale, Paris
MC Minutier Central

Édouard Baldus, artiste photographe
BY MALCOLM DANIEL

1. AP, D 11 U³ 1270, no. 1748. I am grateful to Anne McCauley for this reference.

2. AN, MC, XVIII/1354, no. 309.

3. Paul Nadar, "Sur les papiers positifs et négatifs Eastman: Chassis à rouleaux et porte-membrane pour leur emploi," *Bulletin de la Société Française de Photographie*, 2d ser., 3, no. 2 (1887), pp. 46–52. The photo-interview was published in *Le Journal Illustrée*, Sept. 5, 1886.

4. AN, BB¹¹ 655.

5. Johann Peter Baldus (Jan. 25, 1774–March 12, 1858) and Elisabeth Weber (1791–Aug. 5, 1851), the latter originally of Mudersbach, were married on March 5, 1810. The children of Johann Peter and Elisabeth Baldus were: Katharina Margarete (b. Jan. 13, 1811); Eduard (b. June 5, 1813); Augustina (b. Dec. 30, 1815); Jakob (b. Oct. 14, 1818); Mina (b. Jan. 21, 1821); Alwina (b. May 22, 1824); Heinrich (b. June 9, 1827); and Johanna (b. May 21, 1832). I am grateful to Hartwig Honecker, pastor at the Church of Saint Michael in Kirchen, for having communicated this information, culled from various church records, in a letter of January 29, 1990.

6. Baldus has frequently been referred to in modern photographic literature as Édouard-Denis Baldus, even by this writer. Upon review, however, I find no instance in which Baldus or others used this appellation during his lifetime. Even in legal documents (including birth records, marriage contract, naturalization papers, bankruptcy declaration, and death certificate) he is consistently named Édouard Baldus. The only contemporary occurrence of "E.-D.," perhaps the origin of the confusion, is found in the official listing of medals for the 1855 Exposition Universelle (*La Lumière*, Dec. 15, 1855, p. 197; and *Le Globe Industriel, Agricole et Artistique*, Dec. 30, 1855, p. 144), where the artist is identified as "Baldus (E.-D.)."; this, however, may simply be a typographical error, for he is identified in the provisional list (published in *La Lumière* one week earlier, Dec. 8, 1855, p. 189) as "BALDUS (Ed.)." To my knowledge, the earliest use of Édouard-Denis Baldus is in André Jammes, *Die Kalotypie in Frankreich: Beispiele der Landschafts-, Architektur- und Reisedokumentationsfotografie*, exh. cat., Museum Folkwang (Essen, 1965).

7. Taufbuch 1806–1937 der katholischen Pfarrei St. Michael, Kirchen (Sieg), p. 99. I am grateful to Hartwig Honecker for a copy of this document.

8. Henry Lauzac, "Baldus (Édouard), peintre d'histoire, photographe, Chevalier de la Légion d'Honneur," in *Galerie historique et critique du dix-neuvième siècle* (Paris: Bureau de la Galerie Historique, 1861–62), vol. 3, pp. 25–27:

> Édouard Baldus was born on June 5, 1815, in Westphalia, Germany. After coming to France, where foreign artists, especially talented ones, have always been welcomed, he settled here permanently, acquiring French citizenship. His first career had been in the Prussian Army: after joining the artillery, he became an officer. But a pronounced interest in painting suddenly emerged, leading him to give up the military.
>
> Baldus did not belong to any school. He studied painting entirely on his own, with nature as his sole mentor. His great aptitude for drawing and his experiences with perspective smoothed out the difficulties in this genre, for which he became known in Belgium. After having exhibited with success for several years in Antwerp, he decided to go to the United States in 1837. In New York, where he painted portraits, his work was favorably received, and his gift for capturing likenesses enabled him to go on an agreeable and productive tour throughout America. (Édouard Baldus est né le 5 juin 1815, en Westphalie. Par la suite, venu dans notre pays, où les artistes étrangers sont toujours bien reçus surtout quand ils ont du talent, il s'y est définitivement fixé et a été naturalisé Français. M. Baldus avait d'abord embrassé la carrière des armes. Entré dans l'artillerie, il se trouvait officier de cette arme, au service de Prusse, lorsqu'un goût prononcé pour la peinture, qui se manifesta subitement chez lui, le détermina à abandonner l'état militaire.
>
> M. Baldus n'appartient à aucune école. Il a appris la peinture tout seul, et la nature a été son unique maître. Une grande aptitude pour le dessin et une certaine expérience en perspective lui ont toutefois aplani les difficultés de cet art, dans lequel il s'est fait connaître en Belgique. Après avoir, avec succès, exposé pendant plusieurs années à Anvers, en 1837, il se décida à aller aux États-Unis. A New-York, il peignit le portrait, fut accueilli avec faveur, et son talent à saisir la ressemblance lui permit de voyager agréablement et avec fruit dans toute l'Union américaine.)

Baldus must have recounted a similar story to the photographer Friedrich Wilde, with whom he was friends in the mid-1860s. Wilde, some thirty-five years later, wrote, "I was friends with a Lieutenant Baldus who, for love of photography, had given up his military career and emigrated to Paris. He made only photographs of architecture; I think they were the most outstanding achievements in that genre at the time." ("Ich war zu diesem Zweck befreundet mit einem Leutnant Baldus, der aus Liebe zur Photographie seine Militärlaufbahn aufgegeben hatte und nach Paris übergesiedelt war. Er machte nur Aufnahmen von Architekturen; ich glaube, es waren die hervorragendsten Leistungen dieses Genres aus jener Zeit.") (Friedrich Wilde, "Bemerkungen zur

Papierfrage, gestützt auf eigene Erfahrungen während fünfzigjähriger Praxis," *Photographische Chronik, Beiblatt zum Atelier des Photographen, Zeitschrift für Photographie und Reproduktionstechnik*, no. 32 [April 16, 1899], p. 214.) Lauzac, rather than Wilde, must be correct in saying that Baldus abandoned the military long before he embarked on a photographic career.

9. The birth date given by Lauzac, June 5, 1815, would seem to have come from the artist himself. The incorrect year—1815 instead of 1813—conforms to that given consistently by Baldus when he submitted paintings to the Salon, but the specific date did not appear in those or other records Lauzac would have been likely to see.

10. Baldus's name appears neither in the "Index to Passenger Lists of Vessels Arriving at New York 1820–1846" (New York Public Library, *ZI–80) nor in *Longworth's American Almanach, New York Register and City Directory, New York* during the decade 1831 to 1841. This in itself does not entirely discount Lauzac's story, since passenger lists sometimes included only those arriving as immigrants; Baldus's itinerary might explain his absence from *Longworth's City Directory*.

No reference to Baldus is found in *The National Museum of American Art's Index to American Art Exhibition Catalogues from the Beginning Through the 1876 Centennial Year* (Boston: G. K. Hall, 1986). Nor does any listing for Baldus appear in the *Inventories of American Painting and Sculpture* database, National Museum of American Art, Smithsonian Institution, Washington, D.C.

It is difficult to imagine that Lauzac's account of these early years is made from whole cloth, but equally difficult to give full weight to it when his details about Baldus's later years contradict more reliable evidence (see note 24).

11. AL, KK[14–22].

12. AN, BB[11] 655. "M. Baldus, Édouard, forty-three years of age, was born in Prussia. Having come to France in 1838 to study painting, he made himself known for ten years as a history painter." ("M. Baldus, Édouard, âgé de 43 ans, est né en Prusse. Venu en France en 1838 pour y cultiver la peinture, il s'est fait connaître pendant dix ans comme peintre d'histoire.")

13. AL, KK[12–22]; KK[35–45].

14. AL, *LL[3], *LL[6–8], *LL[13], *LL[17], *LL[18], *LL[39].

15. Baldus declared his intention to seek citizenship June 5, 1845 (AN, BB[11] 655).

Élisabeth-Caroline Étienne, ten years Baldus's junior, was the daughter of the late Théodore Étienne, who had served under Napoléon I as infantry battalion chief and had been named officer of the Legion of Honor. Élisabeth's mother, Caroline-Virginie Labitte, living in Saint-Germain-en-Laye, provided the couple with a steady, if minimal, guaranteed income by adding nearly 11,000 francs to her daughter's dowry of 11,500, stipulating that the couple invest 15,000 of the total in state bonds or other secure investments. The couple was wed by contract signed in Paris September 18, 1845, and by civil ceremony in Saint-Germain-en-Laye four days later (AN, MC, XVIII/1227, no. 287; AD, Yvelines, 4 E 2789, no. 70).

16. Marie-Joséphine-Valentine Baldus was born July 15, 1846; James-Édouard-Théodore Baldus, March 21, 1848; and Marie-Adélaïde Baldus, April 4, 1849.

17. The first commission was for a copy of Titian's *Entombment* (see Philippe Néagu and Françoise Heilbrun, "Baldus: Paysage, architecture," *Photographies*, no. 1 [Spring 1983], p. 61. The original documents regarding this commission are no longer in the

dossiers cited by Néagu and Heilbrun). A later document (AN, F[21] 486 III) records that a painting by Baldus, entitled *Le Christ*, probably this canvas, was sent to Montoldre (Allier) in 1850.

Baldus's second commission, for 800 francs, was for a copy of Leonardo's *Holy Family*, but on November 18, 1851, he received permission to substitute a religious painting of his own design in place of the copy (AN, F[21] 62 dossier 36); it was probably this painting, now lost, that was sent to the church of Gargenville (Seine et Oise) in 1852 (AN, F[21] 486 III).

The final painting commission, a copy of Murillo's *Virgin and Child* (also called *Madonna of the Rosary*), was awarded on April 15, 1852, a full year after Baldus's photographic career had been launched by his work on the *mission héliographique* (discussed below). It is possible that Baldus secured a commission for work already complete; a notation in the registry of copies, on the page for Murillo's *Madonna of the Rosary* (AL, *LL[26], p. 136), reads: "1851 X[bre] [December] 14 . . . Baldus . . . terminé." This painting, a competent if uninspired copy of the original, was sent to the Church of Saint-Mamert, Gard, where it remains (see fig. 2).

Aside from this copy, only one painting—a small sketch of a figure, perhaps allegorical—has been attributed to Baldus, on the basis of signed initials "EB" (Néagu and Heilbrun, "Baldus," p. 76).

18. Jules Janin, "Le Daguerotype [sic]," *L'Artiste*, Nov. 1838–April 1839, pp. 145–48; excerpt reprinted in André Rouillé, ed., *La photographie en France: Textes et controverses. Une Anthologie 1816–1871* (Paris: Macula, 1989), pp. 46–51: "Jamais le dessin des plus grands maîtres n'a produit de dessin pareil."

19. Ibid.

20. Louis-Désiré Blanquart-Evrard, *Procédés employés pour obtenir les épreuves de photographie sur papier, présentés à l'Académie des Sciences* (Paris: C. Chevalier, 1847). See also idem, *Traité de photographie sur papier* (Paris: Roret, 1851). For a full discussion of Blanquart-Evrard and his processes and production, see Isabelle Jammes, *Blanquart-Evrard et les origines de l'édition photographique française: Catalogue raisonné des albums photographiques édités 1851–1855* (Geneva: Librairie Droz, 1981).

21. Gustave Le Gray, *Traité pratique de photographie sur papier et sur verre* (Paris: Germer Baillière, June 1850); idem, *Nouveau traité théorique et pratique de photographie sur papier et sur verre* (Paris: Lerebours and Secretan, July 1851); idem, *Photographie: Traité nouveau théorique et pratique des procédés et manipulations sur papier-sec, humide et sur verre au collodion, à l'albumine* (Paris: Lerebours and Secretan, [1852]).

22. Niépce de Saint-Victor's processes using glass negatives with albumen coatings were communicated to the Academy of Sciences on October 25, 1847, and June 12, 1846, and are reprinted in his book *Recherches photographiques: Photographie sur verre. Héliochromie. Gravure héliographique. Notes et procédés divers* (Paris: Alexis Gaudin et Frère, 1855), pp. 25–32.

23. Frederick Scott Archer, "The Use of Collodion in Photography," *The Chemist*, no. 2 (1851), pp. 257–58.

24. Lauzac, "Baldus," p. 25: "He returned to France in 1849, and it is four years later that he began his interest in photography. In this new direction, his initial studies were directed solely toward chemical research. But he did not abandon painting, for in 1848 we see two canvases by M. Édouard Baldus at the Salon." ("Il revint en France en

1849, et c'est quatre ans plus tard qu'il commença à s'occuper de photographie. Dans cette nouvelle voie, ses premières études furent uniquement employées à des recherches chimiques. Mais il n'abandonna pas la peinture; car, en 1848, nous voyons deux tableaux de M. Édouard Baldus figurer au Salon.")

The date 1849 must be a typographical error (for 1839, perhaps) for Lauzac's passage to make sense. Even then, it is difficult to give full credence to the account, for his dating is incorrect throughout the article (e.g., Lauzac cites only the Salon of 1848, though Baldus exhibited before and after that; his description of an 1849 campaign clearly refers to the 1851 *mission héliographique*).

Documents from 1856, related to Baldus's naturalization, state that he took up photography in 1848 (BB[11] 655).

25. Édouard Baldus, *Concours de photographie: Mémoire déposé au secrétariat de la Société d'Encouragement pour l'Industrie Nationale, contenant les procédés à l'aide desquels les principaux monuments historiques du Midi de la France ont été reproduits par ordre du Ministre de l'Intérieur par Édouard Baldus, peintre* (Paris: Victor Masson, May 27, 1852), p. 5: "[nos propres recherches] ont eu pour but d'obtenir sur papier la finesse et la netteté des images, la promptitude dans l'exécution (quand elle devient nécessaire), le fixage bien durable des épreuves négatives, enfin l'agencement commode des appareils."

26. Ibid., pp. 18–19.

27. We know of only two students by name, Wilhelm von Herford and Fortuné-Joseph Petiot-Groffier, though we know that at the height of his activity Baldus employed a dozen assistants. Wilhelm von Herford, however, wrote that "in Paris, photography is the fashion of the day. People from the most distinguished families, even of nobility, have been students of my teacher." ("In Paris ist die Photographie die Mode des Tages. Aus den vornehmsten Familien, selbst fürstliche Personen sind Schüler meines Lehrers gewesen.") (Wilhelm von Herford, letter to Fritz von Herford, Dec. 31, 1853. I thank Bodo von Dewitz for a transcription of this and all other letters by Herford cited here, still in the possession of the family.) A group of recently discovered Baldus photographs are said to have come from the descendants of the marquis de Rostaing, and several photographs at George Eastman House, Rochester, N.Y., though signed by Baldus, also bear the marquis's name; this suggests that he may also have been a student of Baldus, and it is perhaps to him that Herford refers.

28. Ernest Lacan, "Revue photographique," *La Lumière*, Dec. 17, 1853, pp. 202–3: ". . . les clichés de M. Baldus, qui sont sur papier, ont toute la netteté du verre, et . . . les positifs ont cette profondeur, cette vigueur de ton que les connaisseurs apprécient tout particulièrement."

29. Stéphane Geoffray, "Notes sur la fabrication des papiers et les procédés améliorateurs," *La Lumière*, June 16, 1855, p. 95: "Qui ne s'est demandé . . . en considérant les admirables épreuves de Notre-Dame, du Panthéon et beaucoup d'autres de M. Baldus, si elles n'avaient pas été obtenues sur verre! . . . Absence totale de grenu, vigueur et transparence des ombres, éclat des lumières, telles sont les qualités qui recommandent les belles épreuves de l'habile photographe."

30. Charles Baudelaire, "Salon de 1859: Le public moderne et la photographie," *Le Boulevard*, Sept. 14, 1862, reprinted in Rouillé, *La photographie en France*, p. 328: "Comme l'industrie photographique était le refuge de tous les peintres manqués, trop mal doués ou trop paresseux pour achever leurs études, cet universel engouement portait non

seulement le caractère de l'aveuglement et de l'imbécillité, mais avait aussi la couleur d'une vengeance."

31. Jules-Claude Ziégler, *Compte rendu de la photographie à l'Exposition Universelle de 1855* (Dijon: Douillier, 1855), p. 6: "M. Baldus a fait ses preuves comme peintre d'histoire. Je connais de M. Bayard certains paysages qui font penser à Ruysdael."

32. Ibid.: "Le choix d'un point de vue, de l'heure précise où ce point de vue est le mieux éclairé, la pose d'un modèle vivant, la détermination des ombres d'une statue, exigent le coup d'oeil et le sentiment de l'artiste, et l'on peut reconnaître aisément une épreuve faite par un homme qui a pratiqué les beaux-arts ou qui est doué de dispositions naturelles."

33. *La Lumière*, Feb. 9, 1851, p. 2. The first issue of *La Lumière* published the bylaws of the Société Héliographique: "ARTICLE PREMIER. Les fondateurs se proposent, par l'association, de hâter les perfectionnements de la photographie. ART. 2. L'objet des réunions est: 1° la communication réciproque des oeuvres; 2° l'échange volontaire des oeuvres et des procédés; 3° la confidence toute facultative des découvertes. . . . ART. 14. Le photographe, le peintre, le littérateur, le savant, le sculpteur, l'architecte, l'opticien, le graveur, se consultent et se rendent des services mutuels."

34. For a fuller discussion of the origins of the *missions héliographiques* and the means by which the photographers were selected, see Philippe Néagu et al., *La mission héliographique: Photographies de 1851*, exh. cat. (Paris: Sitecmo, 1980); and Philippe Néagu, "1851: La mission héliographique," *Bulletin*, no. 1, supplement to *La Revue Photographique* (1984), pp. 11–21.

35. "Procès-verbaux de la Commission des Monuments Historiques, séance du vendredi 10 janvier 1851," vol. 7, p. 145; quoted in Néagu et al., *Mission*, p. 17. Le Secq suggested a price of 6 francs per print or 50 francs for ten.

36. "Procès-verbaux de la Commission des Monuments Historiques, séance du vendredi 15 janvier 1851," vol. 7, p. 150; quoted in Néagu et al., *Mission*, p. 17.

37. Wilhelm von Herford, in a letter from Paris, Sept. 8, 1853: "Ehe ihm die Regierung einen so wichtigen und weitreichenden Auftrag erteilte, hatte sie eine Konkurrenz ausgeschrieben, unter denen, welche sich gemeldet, die fünf besten ausgewählt und dann jeden derselben mit 3,000 Fr. Reisegeld ausgestattet. Nach der Rückkehr musste jeder vorlegen, was er gearbeitet."

38. AN, BB[11] 655.

39. In addition to the print in the Canadian Centre for Architecture, Montreal (pl. 2), cropped prints of this image exist in the Musée d'Orsay, Paris, and in a private collection, Los Alamos.

40. Despite the inscribed date, numerous factors suggest that the negative may date from 1853; it is consistent in subject, location, size, medium, composition, and inscriptions (except for the date) with other photographs of monuments, both antique and medieval, made by Baldus in Nîmes, Arles, Orange, Avignon, and elsewhere in the Midi that year.

The formulation and placement of the inscription—"Chapelle de St. Croix / à Montmajour." [lower left]; "No. 51" [lower center]; "E. Baldus fc. / 1849" [lower right]—parallels the inscriptions on photographs dating from 1853. Baldus's negatives from 1851 and 1852 are not inscribed in this manner.

Furthermore, the inclusion of the number, written lower center on the negative, in a

slightly lighter hand, is far from being evidence of the photograph's survival from an extensive early campaign; rather, it is almost certain proof that—whatever the date of the original negative—the print dates to 1856 or later (see appendix 2), when Baldus numbered his existing stock of negatives in a seemingly haphazard order, intermixing negatives of the Midi with negatives of Paris, the Auvergne, and northern France.

Most troublesome for a date of 1849 is the size of the negative; the Canadian Centre for Architecture photograph at 33.3 × 43 cm (13¹/₈ × 16⁷/₈ in.) is consistent with the 1853 series and larger than any Baldus negative securely dated earlier than mid-1852. The surviving negatives from Baldus's *mission héliographique* are consistently smaller, approximately 26 × 36 cm (10¹/₄ × 14¹/₈ in.), requiring Baldus to join negatives together to achieve a larger print. That Ernest Lacan found the large size of Baldus's 36 × 45 cm (14¹/₈ × 17³/₄ in.) negatives worthy of mention in September 1853 (*La Lumière*, Sept. 24, 1853, p. 154) casts further doubt on the likelihood that Baldus had been capable of producing negatives of that size four years earlier. Indeed, to my knowledge, no French photographer made negatives this large before 1851.

The inscribed date, 1849, thus presents a conundrum. Was the inscription added later (it was reinforced at some point), with an unintentionally or intentionally incorrect date? Did Baldus mean to signal that this negative replaced a similar one made in 1849? Did he purposely backdate the negative in order to establish some prior claim to having photographed in the region? And is it meaningful that the bottom of the image, including the inscription, is trimmed off two of the three surviving prints?

One hypothesis that resolves the conflicting claims of both photograph and inscription—and a hypothesis it remains—is that Baldus rephotographed in large format a smaller positive from 1849. Perhaps he wanted to include this monument among his 1853 views of Provence but was not able to visit the site; or perhaps he exposed a negative in 1853 but it was unsuccessful or destroyed. By rephotographing an earlier positive and inscribing the copy negative with the date of the original, Baldus could have produced a print consistent in scale with his 1853 series without falsely presenting it as having been made on the same campaign. Such an enlarged, second-generation print would likely exhibit the grainy surface and relative lack of middle tones evident in all three prints of this image.

41. The view of the Roman theater at Arles, signed on the mount in pencil, is a salted paper print from a paper negative, 15.9 × 20.3 cm (6¹/₄ × 8 in.), in the collection of the J. Paul Getty Museum, Malibu (acc. no. 84.XM.348.22). The genre scene, signed in ink, is a small-format (13.8 × 19 cm [5³/₈ × 7¹/₂ in.]) salted paper print in a more primitive process than normally associated with Baldus; it is in the collection of the Bibliothèque Nationale, Paris.

42. "Procès-verbaux de la Commission des Monuments Historiques, séance du vendredi 28 février 1851," vol. 7, pp. 163–64; quoted in Néagu et al., *Mission*, p. 17.

43. "Missions du Comité des Monuments Historiques confiées à divers membres de la Société Héliographique: M. Baldus," *La Lumière*, July 20, 1851, p. 94.

44. Baldus's *mission héliographique* negatives are housed in the Musée d'Orsay, Paris, on deposit from the Archives Photographiques du Patrimoine.

45. Eugenia Janis has written of the relationship between the *Voyages pittoresques* and the early architectural work of French calotypists, particularly with regard to the *missions héliographiques* of 1851. A similar appreciation for France's Gothic past, a desire to form a visual archive of endangered monuments, and, Janis suggests, a Romantic spirit can be found at the heart of both projects (André Jammes and Eugenia Janis, *The Art of French Calotype, with a Critical Dictionary of Photographers, 1845–1870* [Princeton: Princeton University Press, 1983], pp. 48–52).

Taylor's first volume, on the monuments of Normandy, appeared in 1820, and publication continued through 1878, encompassing perhaps three thousand lithographs in twenty volumes representing nine regions. He sought the aid of the best draftsmen of the day, both French and British, and enlisted the Romantic novelist Charles Nodier and the architect Alphonse de Cailleux to compose the accompanying text. Among the more than one hundred fifty artists who contributed to the collection during more than five decades were the painters Géricault and Ingres, the artist-printmakers Huet, Isabey, and Charlet, the architect and medievalist Viollet-le-Duc, the scene painter and future pioneer photographer Daguerre, the British lithographers Bonington, Boys, and Harding, and the topographic illustrators Ciceri, Dauzats, and Chapuy, as well as a host of lesser figures long forgotten.

For a full discussion of the *Voyages pittoresques*, see Michael Twyman, *Lithography 1800–1850: The Techniques of Drawing on Stone in England and France and Their Application in Works of Topography* (London: Oxford University Press, 1970), pp. 226–53; and Anita Louise Spadafore, "Baron Taylor's *Voyages pittoresques*" (Ph.D. diss., Northwestern University, 1973); see also Jean Adhémar, *Les lithographies de paysage en France à l'époque romantique* (Paris: Armand Colin, 1938); and Joseph Pennell and Elizabeth Robins, *Lithography and Lithographers* (London: T. F. Unwin, 1898).

46. *Porte d'Arroux à Autun* and *Église de Saint-Père-sous-Vézelay* are reproduced in Néagu et al., *Mission*, pp. 35–36.

47. It was probably a print of this panorama that Baldus exhibited in London in January 1854, along with his more recent views of the Midi and Paris. *The Art Journal*, Feb. 1, 1854, pp. 48–50, reported: "M. Baldus exhibits several most interesting photographs of scenes hallowed by historical associations, amongst others the amphitheatre at Nimes, is on many accounts a remarkable production. This picture is by far the largest in the room, and certainly one of the largest photographs which has yet been executed. The positive now exhibited is copied from three negatives . . . [but] the joining has been so skilfully contrived that it is scarcely possible to detect the points of union."

48. For a short but insightful analysis of the various French photographic societies, journals, and critics of the period 1851 to 1865, and of their interrelationships, rivalries, and biases, see Janet Buerger, *French Daguerreotypes* (Chicago and London: University of Chicago Press, 1989), pp. 139–49; for Lacan, see ibid., pp. 145–46.

49. "Réunion photographique," *La Lumière*, April 24, 1852, pp. 71–72: ". . . la vieille cité chrétienne, avec son château des papes, grand comme une ville de guerre, son pont en ruines, ses deux fleuves jumeaux, sa ceinture crénelée, ses clochers, ses faubourgs, encadrés dans une épreuve de 50 centimètres par M. Baldus. . . .

"[M. Baldus] nous disait, en refermant son portefeuille, que tout ce qu'il venait de nous montrer n'était rien auprès de ce qu'il allait faire dans un prochain voyage; nous le croyons, malgré notre étonnement; il a assez de talent et de foi dans son art pour atteindre mieux encore que le beau."

50. Baldus certainly made several exposures at many of the sites, as is seen by the survival of three nearly identical negatives of the Maison Carrée. Despite this, positive prints of

the images are almost unknown, suggesting that Baldus made no prints from the negatives once they were delivered to the Commission. The issue has been confused by the widespread misidentification of Baldus's 1853 images as dating to his 1851 *mission* (e.g., *Catalogue sommaire illustré des nouvelles acquisitions du Musée d'Orsay, 1980–1983* [Paris: Éditions de la Réunion des Musées Nationaux, 1983], pp. 150–53).

51. AN, F²¹ 62 dossier 38. Baldus presented himself in his letter of May 6, 1852, to the minister of the interior as "having already been commissioned by the Historic Monuments Commission for a photographic mission which I fulfilled to the great satisfaction of all of the members of that commission" ("ayant été déjà chargé par la Commission des Monuments historiques d'une mission photographique que j'ai remplie à la grande satisfaction de tous les Membres de cette commission").

 For a discussion of Nègre's *Midi de la France*, including a comparison of Nègre's pictures of 1853 and Baldus's pictures of 1851 and 1853, see Françoise Heilbrun, *Charles Nègre, photographe, 1820–1880*, exh. cat., Musée d'Orsay (Arles: Éditions de la Réunion des Musées Nationaux, 1980), pp. 131–201.

52. As a point of comparison, one might note that the average daily wage for a cabinetmaker or ironsmith in Paris, in 1855, was 4 francs, for a mason 4.75 francs, and for a carpenter 5 francs. In Amiens, people in the same occupations earned only 2.25 francs per day, and in the southwestern town of Pau, still farther from the building boom of Napoléon III, they earned only 1.50 to 1.75 francs per day. In Paris, a half-kilo of beef cost 62 centimes, a half-kilo of bread 25 centimes, and a dozen eggs 76 centimes (AN, F²⁰ 715). Finally, one might also note that each installment of the *Voyages pittoresques*—itself considered outrageously expensive—cost 15.50 francs, half the sum Baldus proposed for his publication.

53. AN, F²¹ 166 dossier 27. Charles Nègre, "Le Midi de la France photographié," reprinted in James Borcoman, *Charles Nègre 1820–1880*, exh. cat., National Gallery of Canada (Ottawa, 1976), pp. 6–7.

54. AN, F²¹ 62 dossier 38. Neither bound copy has been located, but a complete set is held by the Musée d'Orsay on deposit from the Archives de la Bibliothèque de la Manufacture de Sèvres. Many of the individual prints are common in public collections.

55. All but three of the images in the initial seven installments of the *Villes de France photographiées* were approximately 35 × 45 cm (13¾ × 17¾ in.), and Baldus counted each as two photographs. These first seven installments included three small-format and nine large-format prints, for a total of twelve images rather than the twenty-one anticipated. No one objected to the substitution. See appendix 5.

56. Lacan, "Revue photographique," Sept. 24, 1853, p. 154.

57. Wilhelm von Herford, letter to Karl von Herford, Sept. 24, 1853.

58. Néagu et al., *Mission*, p. 45. The piles of stones visible in this photograph are most likely connected with the lowering of the surrounding road.

59. AN, F²¹ 166 dossier 27. Thus, at Saint-Trophîme, Nègre made more than a dozen negatives, including views of the facade, the portal, the tympanum and jamb figures, and women in local costume in the cloister.

60. Lacan, "Revue photographique," Dec. 17, 1853, p. 202: "C'est le monument lui-même, mais isolé, dégagé de tout ce qui distrait le regard ou la pensée."

61. Herford, like Baldus, was German. He had left his civil-service job in 1846 to travel for five years and study languages in preparation for a job in the diplomatic corps. While waiting for an appointment, he traveled again in 1853, journeying to Paris with the specific intention of learning photography. Herford met Baldus shortly after he arrived and quickly apprenticed himself to the master. He read a manual on photographic practice (Baldus's *Concours de photographie*, no doubt), ordered a camera, and observed Baldus's procedures in preparation for the trip to the Midi with his teacher (Erich Stenger, "Wilhelm von Herford: Ein Amateurphotograph der Frühzeit und seine Lehrmeister," *Photographische Korrespondenz* 80, nos. 3–4 [March–April 1944], pp. 21–28).

62. Several of Herford's photographs from this campaign, including views of the Maison Carrée and the arch at Orange, are reproduced in Bodo von Dewitz and Reinhard Matz, eds., *Silber und Salz: Zur Frühzeit der Photographie im deutschen Sprachraum 1839–1860*, exh. cat., Agfa Foto-Historama (Cologne and Heidelberg: Edition Braus, 1989), pp. 340–43.

63. Wilhelm von Herford, letter to Karl von Herford, Sept. 24, 1853: "Meine beiden Reisegefährten, weniger an den Süden gewöhnt als ich, leiden an Schlaf- und Appetitlosigkeit, denn gerade die heißesten Mittagsstunden sind am günstigsten für die Photographie, und zu dieser Zeit Stunden lang im Freien zuzubringen, ist bei der jetzigen Wärme immer noch eine Anstrengung."

64. Following are the images datable to this trip, with their numbers and titles as given on Baldus's stock list: 1. Avignon; 2. Arc Antique à Orange; 3. Saint-Trophîme à Arles; 5. Fontaine de Nîmes; 7. Tour Magne à Nîmes; 8. Le Pont du Gard; 9. Maison Carrée à Nîmes; 15. Église Saint-Gilles; 17. Théâtre Romain à Arles; 26. Amphithéâtre de Nîmes; 44. Cimétière Romain, Arles; 50. Pont Saint-Bénézet à Avignon.

 Three additional titles should probably be included in this list, though it is unclear which images they refer to: 16. Cloître Saint-Trophîme à Arles; 20. Palais des Papes à Avignon; 27. Arènes d'Arles.

 Finally, as discussed in note 40, one additional image may have been made on the 1853 trip: 51. Chapelle de Saint-Croix à Montmajour.

65. Ch[arles] G[audin], "Exposition photographique," *La Lumière*, Feb. 25, 1854, p. 29: "Ces vues . . . captivent l'attention du public, comme elles ont attiré celle de la reine et du prince Albert, lors de leur visite à l'exposition." Gaudin also cited Baldus's views of Avignon, the cloister of Saint-Trophîme, Saint-Gilles, and the triumphal arch at Orange. For a list of Baldus's submissions to the exhibition, see appendix 9.

66. Lacan, "Revue photographique," Dec. 17, 1853, p. 202: "M. Baldus s'est tracé un plan vaste dont la réalisation rendra d'éminents services à l'art. Il veut réunir dans ses cartons les vues des monuments qui représentent, en France, les divers styles d'architecture. Ainsi il pourra, quand son oeuvre sera complète, offrir à l'architecte, au peintre, à l'archéologue, une collection de tous les types de construction, depuis les lourds édifices que les colonies romaines ont laissés dans nos villes anciennes, jusqu'aux constructions bâtardes du siècle dernier. Tout aura sa place dans cette galerie historique et artistique à la fois."

67. Ibid.: "Les *vues* que M. Baldus a rapportées cette année de son voyage dans le Midi dépassent tout ce qu'il a fait jusqu'à ce jour."

68. William Henry Fox Talbot, "Some Account of the Art of Photogenic Drawing," *The Philosophical Magazine* 14 (1839), p. 208.

69. Janin, "Le daguerotype [*sic*]," excerpt reprinted in Rouillé, *La Photographie en France*,

p. 50: "Il est destiné à populariser chez nous, et à peu de frais, les plus belles oeuvres des arts dont nous n'avons que des copies coûteuses et infidèles; avant peu . . . on enverra son enfant au musée, et on lui dira: 'Il faut que dans trois heures tu me rapportes une tableau de Murillo ou de Raphaël.'"

70. Ponce, "*Les Horaces*, estampe gravée par M. Morel d'après le tableau de M. David," *Le Moniteur Universel*, March 20, 1810, p. 318: "Comme l'idiome de la gravure a moins de resources que celui de la peinture, et que la variété des couleurs enrichit beaucoup la langue de cette dernière, la graveur habile, quoiqu'obligé de se conformer strictement aux contours de son original, surtout lorsqu'ils sont corrects . . . , est obligé quelquefois de faire des changemens [*sic*] dans l'harmonie du tableau qu'il traduit, afin d'approcher davantage de l'effet général, en détachant un objet de dessus un autre, par un ton différent, lorsqu'ils ne se détachent dans le tableau que par la variété des couleurs qui ne produisent quelquefois que des tons de même valeur."

71. See appendix 10. Copies of the album are in the Bibliothèque Nationale, Paris (Ad 123), and the Bibliothèque Doucet, Paris (4° 1 64). The heavy retouching of these prints, all from paper negatives, is now clearly visible as the photographs themselves have faded severely.

 The publication, in-quarto, was available by subscription from Galimard, who had conceived and published it, or from dealers in prints or religious books. The Ministry of State subscribed to twenty-five copies of the publication at 33 francs each, delivered February 23, 1854 (AN, F^{70} 237, exercise 1854).

72. Charles Desolme, *Europe Artiste*, Jan. 15, 1854, quoted in *Vitraux de l'Église de Sainte-Clotilde . . . : Prospectus* (Paris: J. Caron Noël, 1854), p. 5 (Bibliothèque de l'Institut, Paris, M d 819 [f]): "Opposant la vérité pure et simple à l'ignorance ou à la fantaisie, la photographie a prouvé qu'elle peut tout reproduire et qu'elle seule est inimitable. La belle collection photographiée par M. Baldus . . . est une nouvelle manifestation de la supériorité de cet art reproducteur. Jamais la photographie n'avait été aussi loin dans la fidélité du clair-obscur et dans la précision des détails; c'est une véritable miracle."

73. Surely it is this book of hours that is referred to mistakenly by Lacan (and probably by Baldus) as a missal. The manuscript (BN, Manuscrits, Fonds Latin, no. 9474), made in the first decade of the sixteenth century, contains sixty-three full-page paintings and nearly three hundred fifty floral studies in the outside margins of its text pages. This highly celebrated manuscript was translated and reproduced by means of chromolithography in 1841 (*Le livre de la reine Anne de Bretagne traduit du latin et accompagné de notices inédites par M. l'abbé Delaunay* [Paris: Curmer, 1841]). In 1852 the manuscript was transferred from the Bibliothèque Nationale to the Musée des Souverains in the Louvre, where it remained until being returned in 1872.

 Wilhelm von Herford, writing to his brother Karl on December 12, 1853, from Dijon, after having departed Paris, included a reference to the manuscript: "The two pictures of saints, which I have designated for the sisters-in-law, are copied out of a missal of Anne de Bretagne. These objects are to be counted among the best miniatures left to us from the Middle Ages." ("Die beiden Heiligenbilder, welche ich den Schwägerinnen bestimmt habe, sind Kopien aus einem Messbuch der Anne de Bretagne. Diese Sachen gehören zu den besten Miniaturen, welche das Mittelalter hinterlassen hat.")

74. Charles Gaudin, "Réunion d'artistes photographes," *La Lumière*, March 25, 1854,

p. 45: "Tous ceux qui ont pu voir ces naïves vignettes, si lourdement empâtées de couleurs éclatantes et de dorures, comprendront combien leur reproduction présentait de difficultés."

75. AN, F^{21} 62 dossier 37. The arrête, or purchase authorization, dated September 20, 1853, and marked "très urgent," allots 30 francs each for twenty negatives. A note refers to these as "essais pour la publication sur l'ornementation."

76. AN, F^{21} 62 dossier 37. The arrête, dated April 1, 1854, allots 300 francs for eight plates. Another arrête, dated June 26, 1854, ordered the purchase of three photogravure plates at 100 francs each, and an undated note indicates the purchase of a further three at the same price; the subject of these photogravures is not indicated.

77. Gaudin, "Réunion," pp. 45–46.

78. The publication was issued in two formats—in-folio with photographs or in-quarto with wood engravings after the photographs. Each installment was to contain eight pages of text and four illustrations. The cost per installment was 20 francs for the large version with photographs, one franc for the smaller version with wood engravings. One hundred installments were anticipated, covering the work of fifty French and fifty foreign artists; only about ten were issued.

 Other photographers included in the realized installments were Victor Laisné, the Bisson Frères, and Le Secq; the prospectus also listed Le Gray, Louis Georges, and Louis Macaire as contributing photographers.

 A copy of the edition in-folio is in the Bibliothèque Nationale (G 1479). Portraits of the following artists are included: Barye, Courbet, Delacroix, Chenavard, Corot, David d'Angers, Jeanron, Daumier, and Gigoux. Copies of the edition in-quarto are common, with portraits of Ingres, Delacroix, Corot, Chenevard, Decamps, Barye, Diaz, Courbet, Préault, and Rude.

 In his famous illustrated parody of photographic achievement, "À bas la photographie!!!" (*Journal Amusant*, Sept. 6, 1856, pp. 1–5), Marcelin mocked the photographic portraits in Silvestre's collection, likening Laisné's depiction of Ingres to "a constipated grocer" and his portrait of Préault to "a Polish madman."

79. The self-portrait is in the Bibliothèque Nationale (Eo 8 v.1). Its format, style, and inscribed title—"E. BALDUS/photographe" in pencil below the image, as if a model for the engraver—suggest that it was a mock-up for a planned but unrealized installment of Silvestre's book.

80. The project is known to us only through its mention in *La Lumière*; publication was announced in the issue of April 8, 1854 (p. 54): "M. Baldus is preparing at this time a publication that will be of great interest; it is the photographic reproduction of the most famous paintings by contemporary artists. We will give an account in our next issue of the first installment, which will appear in a few days." ("M. Baldus prépare en ce moment une publication qui aura un grand intérêt; c'est la reproduction par la photographie, des tableaux les plus renommé des artistes contemporains. Nous rendrons compte, dans notre prochain numéro, de la première livraison qui va paraître dans quelques jours.")

 The next (and final) mention of this series appears nearly three months later and implies that the project was well under way (Lacan, "Revue photographique," July 1, 1854, pp. 103–4): "We announced a short while ago that M. Baldus had undertaken the photographic reproduction of works by contemporary artists. Today, his collection

already includes a great number of remarkable plates, and, despite difficulties that would have discouraged many others, he has achieved a complete and indisputable success." ("Nous avons annoncé, il y a quelque temps, que M. Baldus avait entrepris la reproduction par la photographie des oeuvres des artistes contemporains. Aujourd'hui, sa collection renferme déjà un grand nombre de pages remarquables, et, malgré les difficultés qui auraient découragé beaucoup d'autres, il est arrivé à une réussite complète et incontestable.")

Only a few plates are mentioned by name: a landscape by de Mercey, a farm scene by Brascassat, Benouville's *Saint François d'Assise mourant, bénissant sa ville natale*, and Meissonier's *Buveur de bière*.

81. Lacan cited the title *Chefs d'oeuvres de la statuaire antique et de la Renaissance* ("Revue photographique: M. Baldus," June 24, 1854, p. 99) and discussed in depth a handful of individual images, including the *Venus de Milo*, *Gladiator*, and *Diana*, all antique; Michelangelo's *Prisoners*, Germain Pilon's sculptures for the tomb of Henri II and Catherine de Medici, Pierre Puget's *Milon of Croton* and his bas-relief *Alexander and Diogenes*; and a small ivory of Bacchus after François le Flamand ("Revue photographique," July 1, 1854, p. 103). It is unclear if the collection was issued as a whole, in parts, or merely as single prints in the photographer's stock. Several of those mentioned by Lacan appear as individual photographs on the early 1860s stock list (appendix 2).

Lacan (ibid.) praised Baldus's artistic sensitivity in choosing the lighting conditions (direction, intensity) that best suited the character of each work reproduced, and used almost the same language to describe the photograph of the Venus as he had used to describe the facade of Saint-Trophîme: "Never have we seen the *Venus de Milo* as well as in the print by M. Baldus. It is of marble and of flesh; it is the masterpiece itself, but isolated, seen such that it may be studied and admired wholly and without distraction." (". . . jamais nous n'avions aussi bien vu la *Vénus de Milo* que dans l'épreuve de M. Baldus. C'est du marbre et c'est du chair, c'est le chef-d'oeuvre lui-même, mais isolé, sous le regard qui peut l'étudier, l'admirer sans distraction et sans partage.")

82. Ibid., p. 104: "En somme, M. Baldus a entrepris une oeuvre gigantesque, et dont la portée est immense. En réunissant ainsi, dans des reproductions de cette valeur, les grandes choses que le passé nous a léguées et celles qui se produisent de nos jours, il écrit, par la photographie, une histoire de l'art dans tous les temps, et sous ses trois grandes formes, architecture, statuaire et peinture."

Baldus's stock list of the early 1860s (appendix 2) also included photographic reproductions of the paintings of Raphael, Correggio, Carracci, Giulio Romano, Andrea del Sarto, and Guido Reni.

83. Lacan, "Revue photographique," June 24, 1854, p. 99.

84. I am grateful to Mlle Richefort of the archival service of the Ministry of Agriculture for having searched for this work in the library and archives of the ministry; no trace of the commissioned photographs was found.

The print cited, now in a private collection, Paris, was found with other Baldus prints and negatives in the collection of Fortuné-Joseph Petiot-Groffier, with whom Baldus traveled soon after photographing on the Champ de Mars. The print quality is consistent with other Baldus photographs of 1854.

Disdéri's photographs of the same event were reproduced as wood-engravings in *L'Illustration*, June 17, 1854, pp. 379–82.

85. Fortuné-Joseph Petiot-Groffier was born in 1788 in Chalon-sur-Saône, the son of Jean-Joseph Petiot. He studied law in Dijon, became a lawyer, and was named to the bench. In 1810 he married Olympe Groffier, daughter of Pierre Groffier, a well-known doctor and surgeon and former inspector general of the medical service of the Grande Armée. A few years later he abandoned the robe to devote himself to industry. Colonel in the National Guard in 1830, he was chosen as mayor of Chalon in 1832 and sent to the Chamber of Deputies in 1834, where he served until his retirement in 1842. Father of Chalonnaise industry, Petiot-Groffier applied steam power to the river traffic and town mill, and established a sugar refinery—later transformed by him into a distillery—at Les Alouettes near his home in Chatenoy-le-Royal, two miles from Chalon. He died March 26, 1855. (I am grateful to Paul Jay for providing me with a transcription of a manuscript found among family papers, prepared by friends of Petiot-Grofier after his death for publication in the *Panthéon de la Légion d'Honneur*.) Bills, correspondence, and laboratory notebooks attest to Petiot-Groffier's practice of daguerreotypy as early as 1840.

86. Now in the collection of Musée Nicéphore Niépce, Chalon-sur-Saône (inv. 20.12.75 no. 277).

87. The print signed by both Baldus and Petiot-Groffier is *Millstream in the Auvergne, with Camera* (fig. 23). The following images exist in prints signed by Baldus and also in prints signed by Petiot-Groffier: *"Le Creux d'Enfer"* (fig. 24); *Pont de la Sainte*; (fig. 18); *Chapel of Saint-Michel, Le Puy* (pl. 21); *Château de Polignac*; and *Wooden Bridge, Thiers*.

Shortly before his death in March 1855, Petiot-Groffier presented fifteen prints to the Société Française de Photographie, thirteen of which derived from his voyage with Baldus. Of those that survive, several duplicate images are signed by Baldus. As listed in the *Bulletin*, the prints given by Petiot-Groffier were:

1. *Monticule dans le village de Murol*
2, 3. *Papeterie dans la vallée de Thiers*
4, 5. *Ancienne papeterie*
6. *Rocher et Église de Saint-Michel*
7. *Château d'Espailly*
8. *Château de Polignac, près le Puy*
9. *Royat, près Clermont*
10. *Pont, près d'Issingeaux (route de Saint-Étienne au Puy)*
11. *Vue prise dans la vallée de Royat*
12. *Château de Bouzol, près du Puy*
13. *Trou de l'Enfer, dans la vallée de Thiers*
14, 15. *Intérieur de la Distillerie des Alouettes, près Chalon-sur-Saône*

"Procès-verbaux de la séance du 16 mars 1855," *Bulletin de la Société Française de Photographie*, April 1855, pp. 61–62.

Further, Auvergne negatives attributed to Baldus, including *Rocks in the Auvergne* (pl. 19), were among Petiot-Groffier's belongings at the time of his death. Some of these negatives were included in the 1961 Rauch auction (*La photographie des origines au début du XXe siècle*, sale cat. [Geneva: Nicolas Rauch S.A., June 13, 1961], lots 77 and 81); they are now among a group in the collection of the Agfa-Foto Historama, Cologne (FH 5784–86, FH 7037–42). In addition to negatives made during their trip together, Baldus must have given Petiot-Groffier duplicate negatives of other subjects,

since negatives of the Louvre, the fountain at Nîmes, Saint-Trophîme, Lyons, and the Hôtel de Ville, Paris, also figured in Petiot-Groffier's estate (Rauch auction, lots 74–76, 78–80, and 82).

88. Paul Périer, "Nécrologie: M. Petiot-Groffier," *Bulletin de la Société Française de Photographie*, April 1855, p. 87: "Ami de l'éminent photographe M. Baldus, qu'il le comptait parmi ses meilleurs élèves. . . ."

89. Ernest Lacan, "De la photographie et de ses diverses applications aux beaux-arts et aux sciences," *La Lumière*, Jan. 20, 1855, p. 12: "Ces pierres informes et noircies, qui se confondent avec le sombre rocher qui les porte. . . ."

90. Ibid.: "Voyez comme l'herbe qui couvre le sentier est sèche et courte, comme cette cabane se blottit sous son toit de chaume épais, pour que le vent des hautes régions ne la balaye pas d'un souffle. Là le bruit du monde expire, la végétation cesse, la vie s'arrête."

91. Ibid. Lacan's review of the Auvergne campaign was reprinted in his volume *Esquisses photographiques à propos de l'Exposition Universelle et de la guerre d'orient: Historique de la photographie, développements, applications, biographies et portraits* (Paris: Alexis Gaudin et Frères, 1856), pp. 26–29: "Si vous êtes poëte, si vous aimez les grands aspects de la nature, le bruit des torrents sur les laves éteintes, le silence des solitudes alpestres; si vous écoutez avec une religieuse émotion l'hymne éternel que la terre chante à Dieu; suivez M. Baldus au milieu des sites grandioses de l'Auvergne. Il est peintre, il sait choisir les points de vue et diriger votre admiration. Chacune de ses épreuves est un poëme, tantôt sauvage, imposant, fantastique, comme une page d'Ossian; tantôt calme, mélancolique, harmonieux, comme une méditation de Lamartine."

92. Ernest Lacan, "Exposition Universelle: Photographie, 2me article," *La Lumière*, Sept. 22, 1855, p. 149: "Qu'on se figure un lac de plusieurs lieues de circonférence creusé dans la lave, au milieu de volcans éteints depuis des siècles. . . . Sur les eaux calmes et profondes, quelques îles qui ressemblent à des oasis; puis, tout là-bas, les sommets lumineux du Mont-Dore que l'on prendrait pour de grands nuages immobiles à l'horizon."

93. "Exposition Universelle: Liste officielle des récompenses accordées à la photographie," *La Lumière*, Dec. 15, 1855, p. 197. Baldus's first-class medal was silver; gold medals, "grandes médailles d'honneur," were reserved in 1855 for Talbot and Niépce's nephew, Niépce de Saint-Victor.

94. Victoria, Queen of Britain, *Leaves from a Journal: A Record of the Visit of the Emperor and Empress of the French . . . , 1855*, reprint (New York: Farrar, Straus and Cudahy, 1961), p. 97.

95. The album presented to Queen Victoria and the later album *Chemin de Fer du Nord, ligne de Paris à Boulogne: Vues photographiques* (edition of 25) have often been described in the literature of photographic history as being one and the same. In fact, the contents of the later album differs from that of the queen's, and numerous photographs in it, once assumed to be by Baldus, are actually the work of Hippolyte-Auguste Collard, Furne fils and H. Tournier, and others. The distinction between the two albums and the attribution of photographs in the later album are discussed extensively in Malcolm Daniel, "Édouard-Denis Baldus and the *Chemin de Fer du Nord* Albums," *Image* 35, nos. 3–4 (Fall–Winter 1992), pp. 2–37.

96. The arrival of the *Victoria and Albert* in Boulogne is recorded in a group of pho-

tographs attributed to Disdéri in the collection of the Musée de l'Armée, Paris.

97. "The Queen's Visit," *The Illustrated London News*, Aug. 25, 1855, p. 242. According to Blanchard ("Arrivée de S. M. la reine d'Angleterre à Boulogne," *L'Illustration, Journal Universel*, Aug. 25, 1855, p. 134), the orchid bouquet presented by Baron James cost more than 1,000 francs (this at a time when 1,000 francs was the starting annual salary for clerks and laborers in the Compagnie du Chemin de Fer du Nord).

98. "The Queen's Visit," p. 242:

> In front of the entrance to the station was a triumphal arch, 75 feet in height, formed of trellis-work of gold in the Moorish style Nothing could be more elegant in fancy, more exquisite in proportion, more perfect in design. It was the realisation of the Eastern palaces of our dreams—an open-air Alhambra in itself. . . . The arch, the verandahs, the outer windows of the station, were everywhere adorned with the Royal arms, and everywhere by clusters of tri-colors and the national flags of the Allied Powers in every possible arrangement. . . . On entering [the station] through a door surmounted by the Royal arms, and covered with crimson velvet studded with golden bees and stars, the spectator found himself opposite to a large arched window. . . at the top of which was a drapery of crimson velvet curtains, looped up with golden cord, and fringed with white lace. . . . To the right was a door having crimson velvet curtains deeply fringed with gold, which opened into the private boudoir of her Majesty. . . .
>
> The Queen's boudoir . . . was a master specimen of French taste. The walls were covered with fluted white and rose-coloured drapery, reaching from the ceiling to the floor. The curtains of the window, and the drapery of the door consisted of the most exquisite Gobelins work, relieved by an undercurtain of the finest lace. The chimney-piece was of pure white marble of the chastest character, surmounted by a mirror of elegant design. The carpet of the boudoir, woven in one piece, is said to be one of the most exquisite pieces of work which ever left the manufactory of the Gobelins. *Cassolettes* in gilded white porcelain, with cherubs holding wax lights, were suspended by floral wreaths from the ceiling, the light being entirely artificial. The chairs, sofas, and *portières*, were all white and gold, covered with Gobelins tapestry; while throughout the apartment rare exotica added to the beauty of the scene. Such was the almost fairy scene presented to the spectators at the entrance to the railway station.

Aside from noting the "tremendous crowd," Victoria made no mention in her diary of the decorations at the Boulogne train station.

99. Louis Maurice Jouffroy, *L'ère du rail* (Paris: A. Colin, 1953), p. 41; Alfred de Foville, *La transformation des moyens de transport et ses conséquences économiques et sociales* (Paris: Guillaumin et Cie., 1880), p. 13. The queen's return trip, nonstop from Paris to Boulogne, was accomplished in slightly under five hours.

100. Richard de Kaufmann, *La politique française en matière de chemins de fer*, trans. Frantz Hamon (Paris: Ch. Béranger, 1900), pp. 59–61; "Chemin de fer," *La grande encyclopédie* (Paris: H. Lamirault et Cie., n.d.), p. 1027; Kimon A. Doukas, *The French Railroads and the State* (New York: Columbia University Press, 1945), pp. 22–26; Jacques Lajard de Puyjalon, *L'influence des saint-simoniens sur la réalisation de l'isthme de Suez et des chemins de fer* (Paris: L. Chauny et L. Quinsac, 1926), pp. 126–30.

101. *Grande encyclopédie*, p. 1027; Doukas, *French Railroads*, p. 32.

102. Blanchard, "Arrivée de S. M.," p. 134.

103. Company records show payment of 20,000 francs to MM. Lheureux and Reinhet, *tapissiers*, for the decoration of the Boulogne train station for this occasion (AN, 48 AQ 67, "Procès-verbaux du comité de direction, séance du 9 oct. 1855," p. 211). The triumphal arch erected at the Boulogne station by railroad company and town cost the tremendous sum of £5,000 (125,000 francs), according to the *Illustrated London News* ("The Queen's Visit," p. 242).

104. AN, 48 AQ 12, "Procès-verbaux du conseil d'administration, séance du 7 septembre 1855," p. 4: "Ces préparatifs qui avaient été faits à Boulogne et aux autres gares de votre Ligne, soit pour l'arrivée, soit pour le départ, la rapidité du trajet et la regularité de toutes les mesures que vous avez prises dans cette circonstance solennelle ont vive-ment frappé Sa Majesté."

105. Victoria, *Leaves*, p. 25: "I have been looking over my beautiful Album d'Eu, which brought all the past vividly back to my memory."

106. Édouard-Henri-Théophile Pingret, *Voyage de S. M. Louis Philippe I^{er} roi des Français au Château de Windsor* (Paris and London, 1846).

107. Nadar, *Quand j'étais photographe* (Paris: Flammarion, 1899), p. 203.

108. Victoria, *Leaves*, p. 118: "The Emperor was much pleased by two stereoscopic views of the visit to Sydenham, when he and the Empress were there, which I gave him"; p. 149: "After dinner . . . we sat with the Emperor, Prince Napoléon, and the children, talking and looking at some of my photographs of the officers, &c., in the Crimea, which I had brought on purpose."

109. [Ernest Lacan], "Album offert à S. M. la reine Victoria," *La Lumière*, Sept. 1, 1855, p. 134: "Pendant que Sa Majesté la reine Victoria visitait Paris, plusieurs de nos pho-tographes les plus habiles étaient envoyés sur la route que la gracieuse souveraine avait parcourue, avec mission de reproduire les monuments et les vues les plus remarquables de Paris à Boulogne-sur-Mer. L'oeuvre n'était pas sans difficultés, car, ces épreuves étant destinées à composer un album qui devait être offert à S. M. avant son départ, il fallait en deux ou trois jours faire le voyage, prendre les vues et tirer les positifs. Nous ne savons si les autres artistes ont obtenu des résultats satisfaisants, mais nous pouvons affirmer que M. Baldus a rapporté de ce voyage, commandé, des épreuves pouvant rivaliser avec ses plus belles productions. Grâce à son activité et à son talent, l'album a donc pu être offert à la reine. Il présente trop d'intérêt pour que nous ne nous fassions pas un devoir d'en rendre compte dans notre prochain numéro."

110. Another photographic album, made for the emperor some five years later and contain-ing photographs by Baldus and others, was apparently kept in the imperial parlor car. That album, showing scenes along the route from Paris to Compiègne, was given to the Musée de la Voiture et du Tourisme, Compiègne, in 1934, when the imperial parlor car in which it was kept was donated by the Chemin de Fer du Nord. See Daniel, "*Chemin de Fer du Nord* Albums," passim.

111. The title page is signed, illegibly, "St. Mille" or "A. Mille"; the maps are signed "E. Langlumé"; the photographs on the maps are reduced prints of Baldus's views that appear in large format in the album.

112. The new Gare du Nord was under construction, so a short spur line was built on short notice to convey the imperial train from the Nord tracks to the Gare de Strasbourg, terminus for Chemin de Fer de l'Est. Entry by the Gare de Strasbourg also allowed Napoléon III to direct the queen's celebratory entry into the heart of the city by way of the newly constructed boulevard de Strasbourg and the *grands boulevards*.

113. The *Impartial de Boulogne-sur-Mer: Journal politique, littéraire, commercial et maritime de l'arrondissement* reported on August 9, 1855, on its front page, that all doubt about the queen's port of arrival had been set aside with the arrival of an official order to keep twenty horses ready for the service of the queen from August 16 to August 18.

114. G[audin], "Exposition photographique," p. 29.

115. The final installments of *Villes de France photographiées*, delivered to the Office of Fine Arts on January 8, 1856, included five photographs that appear in the queen's album: *Amiens, Panorama*; *Sainte Chapelle*; *Saint-Riquier*; *Amiens, Cathédrale*; and *Amiens, Porte de la Vierge doré* (see appendix 5).

116. The other image which, by its title, might seem to have been necessarily photographed during the royal visit is *Boulogne (Yacht Royal)*, identified in the later edition of Chemin de Fer du Nord albums as *Vue de l'Ariel: Yacht de S. M. Britannique (Port de Boulogne)*. In fact, the *Ariel* was one of the imperial yachts of Napoléon III; the British royal couple traveled to Boulogne aboard the new, and much larger, steamer *Victoria and Albert*.

117. Collection Musée de l'Armée, Paris. Two views of the Gare de Strasbourg figure among the eleven photographs in this series; the decoration of the station is different in the two, and it is thus assumed that one shows the queen's arrival and one her depar-ture. Given the late hour of her arrival, the murkier of the two photographs, with the clock reading 6:15 and anxious crowds filling the foreground, must record the British sovereign's entry into Paris.

118. "The Queen's Visit," p. 243.

119. Ibid.

120. This heavily retouched photograph (BN, Est., Eo 8) was published as a double-page wood engraving in *Le Monde Illustré*, May 9, 1857, pp. 8–9.

121. "The Queen's Visit," p. 227.

122. Ibid.

123. For example, Hippolyte-Auguste Collard, *Chemin de Fer du Bourbonnais: Moret–Nevers–Vichy, 1860–1863* (George Eastman House, Rochester, N.Y., acc. no. 79:0038; J. Paul Getty Museum, Malibu, acc. no. 84.XO.393), and *Chemin de Fer du Bourbonnais*, ca. 1867 (J. Paul Getty Museum, acc. no. 84.XM.407); Victor Masse, *Chemin de Fer de Paris à Lyon: Photographie* (George Eastman House, acc. no. 73:0010); and Duclos, *Lignes de Bretagne et de Vendée: Vues des principaux ouvrages d'art*, ca. 1866 (Canadian Centre for Architecture, Montreal, acc. no. PH 1979:0623).

An emphasis on the engineering structures is also more characteristic of the later edition of Nord albums, with the addition of Collard's photographs of the bridges and viaducts along the Chantilly branch of the Paris–Boulogne line (see Daniel, "*Chemin de Fer du Nord* Albums," pp. 2–37).

The same was true of the major lithographic albums produced in Great Britain in the second quarter of the century, the period of railroad expansion analogous to that in France during the third quarter of the century. The most impressive of these are John C. Bourne and John Britton, *Drawings of the London and Birmingham Railway*, 1839; and John C. Bourne, *The History and Description of the Great Western Railway: Includ-*

ing Its Geology, and the Antiquities Through which It Passes . . ., 1846 (Yale Center for British Art, New Haven, L 398 folio and L 399 folio). See also J. R. Abbey, *Life in England, in Aquatint and Lithography* (London: Curwen, 1956), nos. 398–411.

124. For the British, one immediate objective of the reciprocal state visits was to persuade Napoléon III not to set out immediately to head the joint armies fighting in the Crimea. British authorities were reluctant to relinquish command of their own troops and to place them under the orders of the French emperor. For a brief background to the exchange of visits, see Jasper Ridley, *Napoléon III and Eugénie* (London: Constable, 1979), pp. 374–86; and Raymond Mortimer's introduction to Victoria, *Leaves,* pp. 11–22.

125. "Queen Victoria's Journal," quoted in Theodore Martin, *The Life of His Royal Highness the Prince Consort* (London: Smith, Elder, and Co., 1878), vol. 3, pp. 337–38.

126. "The Queen's Visit," p. 226.

127. Victoria, Queen of Great Britain, *The Letters of Queen Victoria: A Selection from Her Majesty's Correspondence Between the Years 1837 and 1861*, eds. Arthur Christopher Benson and Viscount Esher (London: John Murray, 1907), vol. 3, p. 175.

128. Charles Duveyrier, *Moyen de donner du travail aux ouvriers et la paix à tout le monde—chemin de fer du Havre à Marseille* ([Paris?]: Religion Saint-Simonienne, [1832]), p. 3: ". . . cette communication rapide . . . serait une protestation éloquent du désir des Français de faire alliance intime et définitive avec l'Angleterre."

129. "The Queen's Visit," p. 230.

130. Royal Archives, "Queen Victoria's Journal," Aug. 18, 1855; quoted in Frances Dimond and Roger Taylor, *Crown and Camera*, exh. cat., Queen's Gallery (London: Penguin, 1987), p. 122. The text of Victoria's manuscript journal varies slightly from that printed by her order in *Leaves.*

131. Lacan, "Exposition Universelle," p. 149: "Il y a . . . un panorama d'Amiens, qui est une des merveilles de la photographie; c'est l'épreuve la plus complète que nous ayons jamais vue."

132. Lacan, "Exposition Universelle," p. 149: ". . . soutint en présence de plusieurs artistes que c'était la reproduction d'un tableau, et non de la nature."

133. Other prints of this image, printed later on albumen paper (now frequently yellowed), lack the very qualities of color and surface that are central to the picture's content.

134. AN, 64 'AJ 69.

135. AN, 64 AJ 55, no. 649: "Conformément à vos instructions verbales, j'ai fait exécuter pour être fournise à Sa Majesté, la vue perspective des façades des constructions neuves et de celle du Vieux Louvre réstaurée sur les places Napoléon et du Carrousel. . . . J'ai pensé qu'il était utile de faire également relever par la procédé photographique les façades actuelles du Vieux Louvre."

136. AN, 64 AJ 55, no. 783: "Je prie Votre Excellence de vouloir bien approuver cette dépense et m'autoriser à confier ce travail à M. Baldus qui consent à s'en charger en ne demandant que la somme de quinze francs par chaque clichet [*sic*] et celle de 75c. pour chaque épreuve."

137. Ernest Lacan, "Exposition photographique, 2ᵉ article," *Le Moniteur de la Photographie,* June 15, 1861, p. 49: "Quand on a copié pierre à pierre tout le nouveau Louvre . . ."

138. This vast font of documents and photographs was transferred in 1971 from the Archives de l'Agence d'Architecture du Louvre to the Archives Nationales, Département des Cartes et Plans.

139. Quoted in A. T. L., "Le Nouveau Louvre et la photographie," *La Lumière,* March 15, 1856, p. 43: "Dans l'intérêt de l'art et afin de conserver à l'histoire les modèles, au nombre de plus de 800, qui ont été exécuté pour les sculpteurs du nouveau Louvre, j'ai chargé l'architecte d'en faire la reproduction par la *photographie.* Ces dessins, classés avec ordre, permettront, à quelque époque que se soit, et avec l'aide de la partie graphique exécutée dans les bureaux des études, de faire sur les travaux du Louvre un ouvrage complet qui sera du plus haut intérêt pour l'histoire des arts."

140. La Gavinie, "Chronique," *La Lumière,* July 17, 1858, p. 115: ". . . une petite baraque sur la terrasse du bord de l'eau . . ."

141. AN, 64 AJ 55, no. 978: "Votre Excellence n'a pas oublié que dès le principe des Travaux du Louvre lors surtout qu'ont commencé les sculptures, j'ai eu soin de faire reproduire par la Photographie tous les motifs de sculpture tant statuaire que d'ornements qui décorent les constructions nouvelles.

"Vous avez autrefois . . . autorisé les frais nécessités par la façon de ces photographies et les résultats que nous avons obtenues sont certes loin de faire regretter la depense effectuée, ainsi nous avons presentement un recueil qui par l'extension même qu'il a prise est devenu à tous points de vue extrêmement intéressant.

"Vous avez pensé . . . que nous pourrions d'après les clichés qui sont entre nos mains tirer un certain nombre d'exemplaires qui classés avec ordre et reliés en volume formeraient un corps d'ouvrage réunissant assez d'intérêt et présentant une valeur assez grande pour qu'il pût être offert en cadeau par S. M. l'Empereur, lors de la Cérémonie d'inauguration que vous avez prévue pour le 14 Août prochain. . . .

"Si vous approuviez en principe l'opération que j'ai l'honneur de vous proposer je pourrais en donner immédiatement des ordres être certain d'arriver pour l'époque précitée."

142. The list of recipients was as follows: Prince Jérome Napoléon; Prince Napoléon; Princesse Mathilde; the emperor of the Russians; Queen Victoria; the king of Bavaria; the king of Prussia; the king of Württemberg; the presidents of the Corps Législatif; the Senate; and the Council of State; the ministers of: foreign affairs; war; finance; the navy and colonies; education and religions; justice; interior; state and the imperial household; agriculture, commerce, and public works (AN, F²¹ 488, II, 2).

Twenty-five copies of the albums were made (AN, F⁷⁰ 279). Twenty are accounted for in this list, and at least one must have been kept by the emperor himself. The albums were distributed to the imperial family on December 31, 1857, to foreign potentates in the first two weeks of 1858, and to the government officials on January 2, 1858.

Copies of the albums are in the Bibliothèque Nationale; the Bibliothèque Historique de la Ville de Paris; the J. Paul Getty Museum, Malibu; and a private collection, Paris.

143. AN, 64 AJ 57. In a letter to Lefuel on February 23, 1858, the minister of state approved the production of eleven additional sets of Louvre albums and asked for a recommendation for their distribution. Lefuel responded three days later suggesting that two copies be sent to the Bibliothèque Impériale (now the Bibliothèque Nationale); one copy each to libraries of the imperial palaces of the Louvre, Fontainebleau, and Compiègne; and one each to the municipal libraries of Lyons, Bordeaux, Toulouse, Rouen, Valenciennes, and Versailles.

144. For the organizational structure of the albums, see Bergdoll, in the present volume, p. 113.

145. The following table (AN, 64 AJ 87–90, 801, 802) of payments to Baldus for photographic work at the Louvre gives an indication of his involvement in this project over the course of a number of years:

Fiscal year	Francs
1855	8,505
1856	6,345
1857	23,738
1858	12,766
1859	8,870
1860	1,435

146. AN, F²¹ 62 dossier 38. See appendix 5.

147. Ernest Lacan, "Exposition photographique de Bruxelles, XI," *La Lumière*, Nov. 22, 1856, p. 181: "... elles surpassent tout ce que l'éminent photographe a fait connaître jusqu'à ce jour. Il est impossible que la photographie aille plus loin: c'est la perfection. Si l'on étudie, par exemple, le fragment du pavillon de Richelieu, qu'il a intitulé *Grand détail du nouveau Louvre*, on y trouvera à la fois toutes les qualités, tous les luxes de la photographie: exquise finesse de détails, transparence aérienne dans les ombres, modelé parfait dans les figures, richesse, ampleur, puissance dans les effets de lumière et de relief, enfin tout ce qui suffit isolément pour faire remarquer une épreuve, se trouve réuni dans cette page splendide."

148. Louis Figuier, *La photographie au Salon de 1859* (Paris: Hachette, 1860), p. 33: "C'est sans doute par une sorte de coquetterie de maître que M. Baldus n'avait envoyé qu'une seule page à l'exposition; il est vrai que cette page résume toutes les qualités de cet éminent artiste. Dans sa *Porte de la Bibliothèque du vieux Louvre*, on retrouve cette puissance de touche, cette vigueur, cette perfection de détails, cette harmonie d'ensemble qui distinguent les oeuvres de M. Baldus."

149. For information about Garilla's camera, see *Panoramas: Photographies 1850–1950. Collection Bonnemaison*, exh. cat. (Arles: Rencontres Internationales de la Photographie/Actes Sud, 1989), pp. 20–21.

150. M.-A. Gaudin, "Nouvel appareil panoramique de M. Garilla: Employé par M. Baldus," *La Lumière*, Jan. 15, 1858, p. 9.

151. Collection École des Beaux-Arts, Paris. Reproduced in *La photographie comme modèle: Aperçu du fonds de photographie ancienne de l'École des Beaux-Arts*, exh. cat., École Nationale Supérieure des Beaux-Arts [Paris, 1982], pl. 55. Because the image shows the quai Malaquais prior to the construction of the galleries of the École des Beaux-Arts, it was made before 1858.

An inventory of 1858 also indicates that Baldus owned a panoramic camera (AN, MC, XVIII/1285, no. 140).

152. "Exposition universelle de photographie à Bruxelles," *Revue Photographique*, Oct. 5, 1856, p. 179: "Les reproductions monumentales de MM. Bisson et Baldus sont extrêmement remarquables, et ont déjà acquis à leurs auteurs une réputation bien méritée."

153. Lacan, "Exposition Universelle," p. 149: "Le regard est arrêté tout d'abord par des cadres de dimensions phénoménales: ce sont ceux de MM. Baldus et Bisson frères."

154. Louis Figuier, *Salon de 1859*, pp. 32–33: "La photographie monumentale ... a atteint aujourd'hui les limites du possible ... [et elle] était représentée à l'exposition de 1859 par des envois d'artistes connus depuis longtemps du public: tout le monde a nommé MM. Baldus, Le Gray et Bisson frères."

155. Ibid., pp. 33–34.

156. Paul Périer, "Exposition Universelle, 4ᵉ article: Photographes français. Science. Monuments et vues panoramiques," *Bulletin de la Société Française de Photographie* (Aug. 1855), pp. 218–19: "On retrouve à côté de MM. Bisson frères le seul photographe qui, jusqu'à ce jour, puisse être considéré comme aspirant à leur disputer la prééminence dans la reproduction des monuments. Nous avons nommé M. Baldus. ... Il nous sera donc permis de protester contre l'appréciation comparative qu'on a faite des oeuvres exposées par MM. Baldus et Bisson."

157. Ibid.: "Il est étrange que, pour une solennité pareille, M. Baldus n'ait pas choisi plus heureusement ses épreuves positives. ... Ces épreuves sont poussées trop loin au tirage, ou retirées trop tôt des bains fixateurs; de là des ombres d'une intensité telle, qu'elles restent complétement en dehors de la gamme de ton générale, et n'offrent plus que des taches noires, ternes et sourdes, impénétrables à la pensée comme à l'oeil, et qui ne laissent rien deviner dans leurs ténèbres."

Périer's criticism of Baldus's prints as dark and lifeless, and his technical explanation as to why this was so, was echoed almost precisely in a review by Aimé Girard, a chemist and founding member of the Société Française de Photographie, in "Arts chimiques: 26ᵉ classe, 4ᵉ section. Photographie," *Le Globe Industriel, Agricole, et Artistique*, Sept. 9, 1855, pp. 293–96.

158. Ibid., p. 219: "Il suffit de regarder les voûtes intérieures de *l'Arc de l'Étoile*, les maisons au pourtour, les portes arcades au-dessous du *Pavillon de l'Horloge*, etc., pour vérifier que nous n'exagérons rien, et que, soit dit en termes d'atelier, entre les *vigueurs* que nous critiquons et notre critique elle-même ce sont les premières seules qui sont *féroces*."

159. Lacan, "Exposition Universelle," p. 149: "... il y a de délicatesse dans les détails et de transparence dans les ombres."

160. Lacan, *Esquisses*, p. 84: "... une sobriété de lumière, une gravité d'aspect, une austérité de ton, qui conviennent admirablement à ce vieux et magnifique chef-d'oeuvre de la Renaissance." "... trop coquette et trop parée."

161. Telegraph from the prefect of Lyons to the minister of the interior (or the minister of public works), May 31, 1856, 5:30 P.M., quoted in Maurice Champion, *Les inondations en France depuis le VIᵉ siècle jusqu'à nos jours* (Paris: Dunod, 1862), vol. 4, p. cxxv: "Les Charpennes, les Brotteaux et la Guillotière sont envahis par les eaux. Les maisons de pisé en grand nombre s'écroulent d'instant en instant. ... Cette crue du Rhône dépasse celle de 1840, la plus forte connue jusqu'à ce jour."

162. *Salut Public*, June 1, 1856; reprinted in *Moniteur Universel: Journal Officiel de l'Empire Français*, June 3, 1856, p. 607: "La moitié de la ville était submergée, et la foule se promenait avec stupeur aux abords de ces lagunes limoneuses, qui avaient, sur certains points, presque l'impétuosité du torrent. Pourtant, si désolante que fut la situation de la ville proprement dite, ce n'était rien, si l'on pense aux affreux malheurs de la rive gauche ... dans toute la longueur de la ville, ce ne sont que des ruines ... les Charpennes n'existent plus. ... On imaginerait difficilement la quantité de bois, de matériaux, de meubles, de toute espèce du charriait, non pas tant le fleuve, coulant encore dans son lit, que le torrent débordé qui couvrait un si large espace. Des chevaux, des bestiaux et autres animaux ont peri."

163. Charles Robin, ed., *Inondations de 1856: Voyage de l'empereur* (Paris, 1856), pp. 50, 58.

Salut Public, on June 2, 1856, estimated the number left homeless at twenty thousand.

164. [Jean-Joseph-Bonaventure] Laurens, "Rupture du chemin de fer à Tarascon," *L'Illustration, Journal Universel*, June 21, 1856, pp. 419–20: "Avant huit heures et demie, on n'observait dans la ville que d'insignifiantes flaques d'eau produites par les infiltrations du Rhône, dont la pression devait agir fortement; mais, un moment après, un bruit sourd et sinistre comme celui du vent qui précède l'orage, annonça la venue des eaux du Rhône.

"Je les ai vues se précipiter avec une violence inimaginable dans les rues de la ville, et j'ai failli être emporté en roulant sauter sur le premier jet pour entrer dans une maison hospitalière où j'ai vu, dans l'espace d'un quart d'heure, arriver l'eau à la hauteur de 3 mètres. . . .

"La plaine des environs de Tarascon n'est plus qu'une vaste mer."

The article is accompanied by a wood engraving after a drawing by Laurens showing the broken rail line and flooded plain of Tarascon.

165. *Moniteur Universel*, June 3, 1856, p. 605; June 4, 1856, p. 609; June 5, 1856, p. 614.

166. For dates and length of stay, see Ernest Lacan, "Photographie historique," *La Lumière*, July 21, 1856, p. 97; and the same author's fuller discussion in *Esquisses*, pp. 184–90. A document in the Archives Nationales (F^{21} 62 dossier 38) indicates reimbursement of 600 francs for travel expenses for two people in regard to this project. Not all the images survive as positive prints, but all twenty-five negatives are extant, at the Musée d'Orsay, Paris, on deposit from the Archives Photographique du Patrimoine.

167. *Courrier de Lyon*, June 4, 1856, quoted in the *Moniteur Universel*, June 5, 1856, p. 615: ". . . pauvres gens, les larmes aux yeux, fouill[ant] pour en retirer les objets les plus indispensables à leurs besoins journaliers."

168. Lacan, *Esquisses*, pp. 190–93.

169. Ernest Lacan, "Les inondations de 1856: Épreuves de M. Baldus," *La Lumière*, Aug. 9, 1856, p. 125.

170. Ibid.

171. Lacan, "Photographie historique," p. 97: "C'est avec un sentiment de profonde tristesse que l'on examine ces vues . . . qui représentent, avec une exactitude malheureusement trop éloquente, les rues changées en torrents, les maisons renversées, les remparts détruits, les champs ravagés et transformés en marais. Ce sont de bien tristes pages, mais belle aussi dans leur tristesse!"

172. AN, F^{21} 62 dossier 38. On February 6, 1857, Baldus was reimbursed for the expenses of travel, paid 40 francs each for the twenty-five negatives and 10 francs apiece for two prints of each image.

On January 1, 1858, the minister of state authorized 1,400 francs for the purchase of twenty copies each of seven of the flood scenes: *Les Remparts d'Avignon; Les Remparts Renversées; Lyon — St. Pothin; Lyon — Chemin des Charpennes; Lyon — Maison renversée; Lyon — Rue de l'Hospice; Lyon — Rue Comte.* Baldus delivered the prints later the same month.

Six months later, someone in the ministry recognized that the negatives were the property of the government, and an informal note of July 3, 1858, asking, "M. Baldus has kept the negatives of these photographs of the floods; should he be made to turn them over?" was answered, succinctly, "Yes." Baldus was sent a letter on July 7, reading, "Sir, it is my honor to invite you to deliver as soon as possible, to the Office of

Fine Arts, the twenty-five photographic negatives representing various views of the floods of 1856, sold by you to the Administration on February 23, 1857." ("M. Baldus a conservé chez lui les clichés de ces photographies des Inondations, faut-il les lui reélancer? Oui." "Monsieur, j'ai l'honneur de vous inviter à livrer le plus promptement possible, à la Division des Beaux Arts les vingt-cinq clichés photographiques représentant des vues diverses—Inondations de 1856 vendus par vous, à l'Administration, le 23 février 1857.")

173. Lacan, *Esquisses*, p. 200: "[La photographie] enregistre tour à tour sur ses tablettes magiques les événements mémorables de notre vie collective, et chaque jour elle enrichit de quelque document précieux les archives de l'histoire."

174. During the brief period between January 1 and March 13, 1858, for example, sales by such dealers amounted to nearly 2,300 francs, a considerable sum; and more than 6,000 francs was still owed to Baldus (largely by foreign representatives) for sales prior to the first of the year. AN, MC, XVIII/1285, no. 140:

M. Baldus déclarient 1ent qu'il lui est dû pour ventes arrivées au premier janvier dernier:

1° Par M. Daziaro, boulevard des Italiens	906
2° Par M. Simondeti à Turin	203
3° Par M. Ripamonti à Milan	292
4° Par M. Fuchs de Hambourg	304
5° Par M. Manche à Florence	194
6° Par M. Munster à Venise	388
Ensemble	2287
7° Par M. Stamler à Vienne	930

M. Baldus fait observer que cette dernière créance est d'un recouvrement très incertain.*

* 8° et par M. Delarue à Londres dont le correspondent est à Paris, rue Hautefeuille [. . .] 3000. M. Baldus fait également observer que cette créance est d'un recouvrement très douteux.

2ent Qu'il lui est dû pour ventes depuis le premier janvier dernier:

1° Par Mrs. Goupil et Cie	416
2° Par M. Daziaro boulevard des Italiens	24
3° Par M. Giroux boulevard des Capucines	109
4° Par M. Legoupy boulevard de la Madeleine	97.50
5° Par M. Ledot jeune rue de Rivoli	106
6° Par M. Hautecour, rue de Rivoli	479
7° Par M. Ledot aîné rue de Rivoli	199
8° Par Mrs. Bohne et Schultz, rue de Rivoli	54
9° Par Mrs. Moul et Cie, rue Vivienne	49
10° Par M. Victor Delarue à Londres	60
11° Par M. Fuchs à Hambourg	169
12° Par M. Regnauld inspecteur des ports	25
13° Par M. Sauty doreur	30
14° Par M. Delarue rue Jean Jacques Rousseau	111
15° Par M. Beauvalet à Nîmes	360
Ensemble	2288.50

Que de plus il a des dépôts chez divers marchands dénommés ci-dessus mais que ces dépôts faits à titre de spécimen ne peuvent représenter aucune valeur, attendu soit l'ancienneté des épreuves déposées, soit leur détérioration, soit l'obligation de les remplacer.

175. AN, BB11 655.

176. The course of government support for the arts in nineteenth-century France is made confusing by the frequent shifts of bureaucratic responsibility. The Office of Fine Arts was created at the time of the Revolution as part of the Ministry of the Interior, and remained such from 1790 to 1832. In 1832 it was shifted to the Ministry of Commerce and Public Works, before being returned to the Ministry of the Interior in 1834. In 1853 the Office of Fine Arts became part of the Ministry of State and of the Imperial Household, remaining, after the Ministry was split, with State. In 1863 a new Ministry of the Imperial Household and the Fine Arts was formed, lasting until January 2, 1870, when a separate Ministry of Fine Arts was created. That lasted only until May, when it was transformed into a Ministry of Letters, Sciences, and Fine Arts, even more short-lived. On August 23, 1870, responsibility for the fine arts shifted to the Ministry of Education.

177. The five photographs are in the collections of the Musée d'Orsay, Paris (pl. 54), the Gilman Paper Company (pl. 53), the Canadian Centre for Architecture, Montreal (fig. 55), and two in a private collection, Paris. Although unsigned, some bear an inscription by Georges Sirot on the verso, affirming that a print of the same image with Baldus's facsimile signature stamp existed in his collection.

I thank François Lepage, Paris, for making available to me the findings of his research linking the Château de la Faloise and Frédéric Bourgeois de Mercey.

178. Frédéric Bourgeois de Mercey, *Étude sur les beaux-arts depuis leur origine jusqu'à nos jours* (Paris: Arthus Bertrand, 1855), vol. 1, p. 26.

179. AN, BB11 655.

180. AN, MC, XVIII/1285, no. 140. "Third floor" refers to the European third floor, the fourth floor in the United States.

181. Ibid. Specifically, the paintings were as follows: two religious paintings; three portrait heads of women and children; two children and a dog; a girl and a cat; the head of a young man; a seller of eggs; a flower seller; a young girl with a lamb; the head of a woman; the head of a girl; a grape picker; an old man in a ruff collar; a Virgin and Child. They may well have been the work of Baldus himself.

182. Ibid.

183. The initial papers for the purchase of the house were drawn up on November 3, 1857. Settlement took place on December 16, 1857, with Baldus paying 5,000 francs toward the 40,000-franc purchase while waiting for the title search. Rue d'Assas was renumbered in 1868, and the property changed from No. 25 to No. 17.

Located near the rue de Rennes, in the same neighborhood that Baldus had lived in for nearly twenty years, the house was bounded on two sides by a Carmelite convent and on the third by another residence. It was a four-story building with a garden and courtyard in front and a second courtyard in back; the rear court was flanked by two three-story buildings. The entire property measured approximately 2,550 square feet (AN, MC, XVIII/1407, no. 162).

184. AN, MC, XVIII/1285, no. 140.

185. AN, F^{21} 62 dossier 38.

186. AN, F^{21} 2284^2.

187. Furne and Tournier, for example, produced eight large prints and a set of seventy-two stereo cards entitled *Souvenirs de Cherbourg (août 1858)*.

188. *L'Illustration* published a special volume, reassembling all their illustrations and news accounts of the imperial progress, under the title *Voyage de l'Empereur et l'Impératrice dans les départements de l'ouest. août 1858* (BN, Est., Qe.36.t. Pet.fol.).

189. Although described in *La Lumière* (Lacan, "Revue photographique," Oct. 16, 1858, p. 166), these seascapes have not previously been identified; in fact, two are in the collection of the École des Beaux-Arts, inscribed "Voyage de la reine d'Angleterre," and mistakenly assumed to represent the arrival of Queen Victoria at Boulogne in 1855. (Cf. *La photographie comme modèle: Aperçu du fonds de photographie ancienne de l'École des Beaux-Arts*, exh. cat., École Nationale Supérieure des Beaux-Arts [Paris, 1982], pl. 69; and Catherine Mathon et al., *Les chefs-d'oeuvre de la photographie dans les collections de l'École des Beaux-Arts*, exh. cat., École Nationale Supérieure des Beaux-Arts [Paris, 1991], pp. 50–51.) The coast and breakwater shown in one of the École des Beaux-Arts photographs (fig. 57) are clearly those of Cherbourg rather than Boulogne (cf. the view of Cherbourg in the *Illustration* supplement, p. 21, or Furne and Tournier's stereo no. 54, *Les flottes réunies le 5 août 1858: Vue prise de la place d'Armes*).

Baldus's annual delivery of photographs to the Office of Fine Arts in February 1859, by that date under the series title *Monuments de France*, included two images entitled *Cherbourg, côte du mole* and *Vue de Cherbourg et de la digue*, those in the École des Beaux-Arts (AN, F^{21} 62 dossier 38).

190. Lacan, "Revue photographique," Oct. 16, 1858, p. 166: "En passant par la bonne ville de Caen, cet habile artiste n'a pu résister au désir d'ajouter à sa collection de monuments la reproduction des deux magnifiques églises que possède la vieille cité normande."

191. Ibid.

192. Baldus included views of Saint-Étienne and Saint-Pierre in his 1859 installment of *Monuments de France*. Views of Rouen were included under the same series title the following year (see appendix 5).

193. Thierry Boisvert, "Bonjour, Monsieur Baldus," *Le Journal du Périgord*, Fall 1992, pp. 69–74. I thank Thierry Boisvert for generously sharing his research on Baldus's photographs of Périgueux.

The paper negatives survive in poor condition at the Musée du Périgord (acc. no. 1364^{A-M}); a full series of prints is in the Bibliothèque de Périgueux (acc. no. Ph A19–A30); and nearly two full sets are in the library of the Institut Catholique, Paris.

Baldus's stock list (appendix 2) includes one photograph from this series, no. 135, *Vue du Périgueux*.

194. Marc-Antoine Gaudin, "Exposition de la Société Française de Photographie (2e article)," *La Lumière*, May 30, 1861, p. 38.

195. Charles Gaudin, "Exposition de la Société Française de Photographie (3e et dernier article)," *La Lumière*, June 15, 1861, p. 41: "M. Baldus va même beaucoup plus loin: il s'est avisé quelquefois de supprimer des chaînes de montagnes pour produire un effet plus artistique, à son idée; il a même ajouté au beau milieu des glaciers des arbres à la fois grotesques et gigantesques qui sont un monument de maladresse. Sans la condition

imposée aux exposants de ne présenter que des épreuves sans retouches, nous aurions vu ces monstruosités où l'art prétend corriger la nature."

196. Ernest Lacan, "Exposition photographique, 2ᵉ article," *Moniteur de la Photographie*, June 15, 1861, pp. 49–50: "Baldus est resté fidèle à son procédé au papier sec, et l'on ne peut que l'en féliciter. . . . Il y a, entre autres, un certain coin perdu qu'il a été chercher dans les montagnes du Dauphiné et qui constitue bien le plus splendide tableau qu'on puisse voir. C'est une gorge resserrée entre deux murailles de verdure qui s'écartent pour laisser voir les premiers sommets des Alpes à l'horizon. Un torrent, que traverse au second plan un pont étroit et périlleux, anime cette solitude."

197. Lajard de Puyjalon, *L'Influence des saint-simoniens*, pp. 105–6.

198. The average speed of the *messageries*, including stops, was only 9.5 km per hour (5³/₄ mph) in 1848—up from 2.2 km per hour (1¹/₃ mph) in the seventeenth century and 3.4 km per hour (2 mph) at the end of the eighteenth century (De Foville, *Moyens de transport*, pp. 7–9). De Foville's figures are derived from *Documents statistiques sur les routes et ponts* (Paris: Ministère des Travaux Publics, 1873).

199. Ibid.

200. *Nouveau guide de Paris à Lyon et à la Méditerranée* (Paris: Napoléon Chaix et Cie, 1853), p. 25: "On arrive [à Lyon] après trois nuits d'insomnie, quatre jours de famine, quatre siècles de tourments!"

201. Mathieu-Georges May, "L'histoire du chemin de fer de Paris à Marseille," *Revue du Géographie Alpine* 19 (1931), p. 476.

202. Honoré de Balzac, *Un debut dans la vie*, in *Oeuvres complètes* (Paris: Louis Conard, 1912), vol. 2, pp. 307–8.

203. *Nouveau guide*, p. 22: "Il y a des villages moins peuplés qu'une diligence."

204. *Conseils aux voyageurs* (Paris: Napoléon Chaix et Cie, 1854), pp. 35–37.

205. Victor Hugo, "1839: Lettre vingt-neuvième, Strassbourg," in *Le Rhin: Lettres à un ami*, vol. 2 (Paris: Imprimerie Nationale, 1985), p. 115: "Au moment du départ, tout va bien, le postillon fait claquer son fouet, les grelots des chevaux babillent joyeusement, on se sent dans une situation étrange et douce, le mouvement de la voiture donne à l'esprit de la gaîté et le crépuscule de la mélancolie. . . .

"Ce n'est plus une route, c'est une chaîne de montagnes . . . deux mouvements contraires s'emparent de la voiture, la secouent avec rage comme deux énormes mains: un mouvement d'avant en arrrière et d'arrière en avant, et un mouvement de gauche à droite et de droite à gauche, le tangage et le roulis. A dater de ce moment-là, on n'est plus dans une voiture, on est dans un tourbillon, on saute, on danse, on rebondit, on rejaillit contre son voisin. De là, un cauchemar sans pareil."

206. For information on Saint-Simon, see Keith Taylor, trans. and ed., *Henri de Saint-Simon (1760–1825): Selected Writings on Science, Industry, and Social Organisation* (London: Croom Helm, 1975). For an introduction to the role of Saint-Simon's followers in the development of the French railroad system, see Marc Baroli, *Le train dans la littérature française*, 3d ed. (Paris: Éditions N. M., 1969), pp. 11–23; Baroli cites a number of primary Saint-Simonian texts for further reference. See also Lajard de Puyjalon, *L'Influence des saint-simoniens*.

207. Michel Chevalier, "Système de la Méditerranée," *Le Globe*, Feb. 12, 1832, cited in Baroli, *Le train*, p. 16: "le symbole le plus parfait de l'association universelle."

208. Chevalier, quoted in "Chemin de fer," in *Grand dictionnaire universel du XIXᵉ siècle* (Paris: Administration du grand dictionnaire universel [ca. 1870]), p. 1146: "Quand un voyageur, parti du Havre de grand matin, pourra venir déjeuner à Paris, dîner à Lyon, et rejoindre le soir même à Toulon le bateau à vapeur d'Alger ou d'Alexandrie . . . ; de ce jour un immense changement sera survenu dans la constitution du monde; de ce jour, ce qui maintenant est une vaste nation sera une province de moyenne taille."

209. Taylor, *Henri de Saint-Simon*, p. 54.

210. Baroli, *Le train*, p. 26 n. 1; and Doukas, *French Railroads*, p. 17. Inaugurated on August 26, 1837, the Paris–Saint-Germain railroad drew 37,286 passengers in its first week and 59,513 in its second (Baroli, *Le train*, p. 35).

211. J[ules] J[anin], "Inauguration du Chemin de Fer de Paris à Saint-Germain," *Le Moniteur Universel*, Aug. 26, 1837, p. 2013: "Assis sur ce tapis, vous pensez où vous voulez aller, et vous y êtes."

212. George Reverdy, *Histoire des grandes liaisons françaises* (Paris: Revue Générale des Routes et des Aérodromes, 1982), vol. 2, pp. 104–5. Since Roman times the definitive land route had followed the right bank from Lyons to Vienne and the left bank from there to Avignon. Aside from the bridge at Vienne, no other bridge spanned the Rhone except a pontoon bridge far to the south, at Arles.

213. Stendahl, *Mémoires d'un touriste*, quoted in May, "Paris à Marseille," p. 474: "Le nombre des chevaux qui périssent sur la route, et dont on voit les tristes débris, est fort considérable. . . . Tous les savons, toutes les huiles, tous les fruits secs, dont le Midi approvisionne Paris et le Nord, sillonnent ce chemin. . . . C'est donc sur ce point de France qu'il faudrait commencer les chemins de fer."

214. Charles Dollfus and Edgar de Geoffroy, *Histoire de la locomotion*, p. 95. Talabot was among the greatest figures in French railroad history—a follower of Saint-Simon, a consummate engineer, and director of the PLM company for twenty-five years.

215. May, "Paris à Marseille," p. 477.

216. Ibid., pp. 484–87. One could travel from Paris to Châlon via Dijon in eight hours fifteen minutes by night express or ten hours by day express; from there one traveled twelve hours by boat to Lyons; the next 124 miles to Avignon still had to be traversed by diligence before rejoining the railroad for the final 75 miles from Avignon to Marseilles.

217. Wilhelm von Herford wrote to his brother Karl from Orange on September 24, 1853, "In two days I have covered the distance from Paris via Dijon, and Chalons, to Lyons by railroad and the distance to Saint-Esprit by steamship." ("Von Paris habe ich in 2 Tagen den Weg über Dijon, Chalons, u. Lyon mit Eisenbahn u. Dampfschiff den Weg bis St. Esprit zurückgelegt.")

218. *Conseils aux voyageurs*, p. 33: "Partout où la machine à vapeur s'élance sur le railway, les voitures de l'ancien régime se retirent honteuses, et vont s'élancer sur d'autres points où la vapeur est inconnue. Mais la vapeur, cette reine conquérante des sociétés modernes, gagne du terrain chaque jour de proche en proche, et, dans cette retraite quotidienne des Messageries, on peut déjà assigner le jour et l'heure où elles seront mortes en France."

Indeed, by 1870 there were virtually no active posthouses left, and those remaining were closed in 1873 (Paul Charbon, *Au temps des malle-poste et des diligences: Histoire des transports publics et de poste du XVIIᵉ au XIXᵉ siècle* [n.p.: Jean-Pierre Gyss, 1979], p. 10).

219. Kaufmann, *La politique française*, p. 63. By the law of July 8, 1852, the Compagnie du

Chemin de Fer de Lyon à la Méditerranée was formed from the Lyons–Avignon, Avignon–Marseilles, Alès–Beaucaire, Alès–Grand'Combe, Montpellier–Cette, Montpellier–Nîmes, Rognac–Aix, and newly conceded Marseilles–Toulon lines.

220. May, "Paris à Marseille," p. 487.

221. AN, 77 AQ 180. The Paris-Lyon and Lyon-Méditerranée companies were fused on April 11, 1857. The two Administrative Councils were joined five years from that date.

222. AN, 77 AQ 144, p. 79, July 19, 1861: "Le Directeur met sous les yeux du Conseil un projet de marché préparé par Mr. l'Ingénieur en Chef de la Construction pour l'execution par M. Baldus, d'une collection de vues photographiées des divers ouvrages et environs de la ligne de Lyon à Marseille et à Toulon. Le Conseil, après avoir entendu les explications de M. le Directeur, approuve ce marché et autorise pour son execution l'ouverture d'un premier crédit de 20,000 francs."

223. The archives of the Compagnie du Chemin de Fer du Nord survive in more complete form than those of any other of France's great lines; there are hundreds of registers and thousands of boxes of documents, providing a very full picture of administrative meetings, correspondence, financial records, construction reports, and the like. Yet no trace of the album presented to Queen Victoria or the later edition of *Chemin de Fer du Nord* albums is to be found among these documents. Paradoxically, the PLM archives survive only in extremely fragmentary form but contain a clear record of the initial commission for the PLM album.

224. For Molard, see Malcolm Daniel, "The Photographic Railway Albums of Édouard-Denis Baldus" (Ph.D. diss., Princeton University, 1991), p. 217.

225. Eight copies of the full album and three copies of an abridged version are known today. Full copies of the PLM album, containing sixty-nine plates (two of which are double-page panoramas), are to be found in the following collections: The J. Paul Getty Museum, Malibu (2 copies, acc. nos. 84.XO.401 and 84.XO.734); the Canadian Centre for Architecture, Montreal (acc. no. PH1981:0816); Gilman Paper Company (acc. no. PH85.1159); George Eastman House, Rochester, N.Y. (acc. no. 74:0055); Kunstakademiets Bibliotek, Copenhagen (acc. no. 9/64); École Nationale des Ponts et Chaussées, Paris (acc. no. Ph 98-A). The contents of another incomplete album have been dispersed; part is in the Canadian Centre for Architecture, part in a private collection, New York, and part in a private collection, San Francisco.

Three copies of a shorter version of the album, containing thirty-four, thirty-six, and thirty-eight prints, are also known. One is in the École Nationale des Ponts et Chaussées (acc. no. Ph 444-A), another in the Musée Nicéphore Niépce, Chalons-sur-Saône (acc. no. 81.13), and a third, though broken up, remains largely in a private collection in San Francisco. These three albums are bound in a form nearly identical to that of the full version, but with different endpapers and with the title properly spelled on the spine. (On the spine of the full version the title reads, incorrectly, "Méditeran-née.") The shorter albums differ from the full version in that all three are overwhelmingly weighted toward rail imagery; only five of twenty-four rail images in the large album are dropped, while twenty-three of thirty-nine architectural or town views and four of six landscapes are dropped. For a concordance of the full and abridged albums, see Daniel, "Photographic Railway Albums," appendix M, pp. 455–58.

Only in the case of the two copies of the PLM album in the École des Ponts et Chaussées do we have any indication of provenance. The first of these was given to the school by the PLM company on December 22, 1869; the other was part of a larger gift by M. Nordling, engineer in chief for the Chemin de Fer d'Orléans, and it bears the inscription: "Offert en souvenir de son ami Molard, Ingénieur en chef de la ligne de Lyon à Avignon. Paris, le 6 février 1904."

Extrapolating from the number of surviving albums, and estimating the purchasing power of 20,000 francs (if indeed that constituted the full cost of the project), one might guess that as many as forty PLM albums were made.

226. There is a certain amount of variation among the surviving copies of the full PLM album; in a number of instances Baldus substituted one image of a monument for another. For example, one copy shows the facade of Saint-Trophîme at Arles in its unrestored state, while another shows it after restoration; some copies include Baldus's 1853 paper-negative photograph of the triumphal arch at Orange, while others use a small-format glass-plate negative photograph of the same monument from the early 1860s. There is no particular logic or consistency to these variations, and it is most likely that they were simply a result of how many copies in each format or of each view were already in his inventory.

227. *Grand dictionnaire*, vol. 3, pp. 1130–64.

228. Ibid., p. 1130: "l'une de ces oeuvres grandioses que le génie antique semblait avoir léguées comme un exemple à la civilisation moderne.

"'J'allai voir le pont du Gard: c'était le premier ouvrage des Romains que j'eusse vu. . . . L'objet passa mon attente . . . Il n'appartenait qu'aux Romains de produire cet effet. L'aspect de ce simple et noble ouvrage me saisit d'autant plus qu'il est au milieu d'un désert où le silence et la solitude rendent l'objet plus frappant. . . . On se demande quelle force a transporté ces pierres énormes si loin de toute carrière, et a réuni les bras de tant de milliers d'hommes dans un lieu où il n'en habite aucun. . . .'

"Que dirait le grand philosophe, s'il lui était donné de contempler ce pont immense de Nogent-sur-Marne avec ses quatre arches en plein cintre, de 50 m. d'ouverture chacune, construit pour livrer passage à la ligne de Paris à Mulhouse? Que dirait-il encore à la vue des ponts en fer, sur le Rhin, à Kehl, sur la Garonne, à Bordeaux, et enfin à la vue du tunnel des Alpes? S'il y a eu, pendant plus de mille ans, une période de sommeil pour les grands travaux, nous nous efforçons depuis le commencement de ce siècle de regagner le temps perdu."

229. Alfred Picard, *Les chemins de fer: Aperçu historique, résultats généraux de l'ouverture des chemins de fer, concurrence des voies ferrées entre elles et avec la navigation* (Paris: H. Dunod et E. Pinat, 1918), p. 256: "Les routes sont les voies de l'agriculture; les canaux, les rivières sont les voies du commerce; les chemins de fer sont les voies de la puissance, des lumières et de la civilisation."

230. Eugène Flachat, *Les chemins de fer en 1862 et en 1863* (Paris: Hachette, 1863), p. 80: "On était donc Breton, Gascon, Normand, Picard, Lorrain, Alsacien, Provençal; mais ce n'était que dans les hautes professions, dans les grandes villes, à l'armée, sur la flotte qu'on comprenait et qu'on aimait la France."

231. Ibid.: "Les chemins de fer ont répandu partout une vie politique plus égale. De tous côtés surgissent dans la province des aspirations aux institutions et aux établissements propres à accélérer la marche de la civilisation."

232. In 1859 the 10,000 miles of conceded rail lines compared with 22,000 miles of national roads and 30,000 miles of departmental roads.

233. Gustave Poujard'hieu, *Solution de la question des chemins de fer: De l'estension des réseaux et des nouvelles conventions* (Paris: Hachette, 1859), p. 9.

234. According to Eugen Weber (*Peasants into Frenchmen: The Modernisation of Rural France, 1870–1914* [London: Chatto and Windus, 1977], p. 67), 8,381 of France's 37,510 communes—a quarter of the nation's population—spoke no French. For a discussion of the persistence of local weights, measures, and currencies, see ibid., chap. 3.

235. Adolphe Meyer, *Promenade sur le chemin de fer de Marseille à Toulon* (Marseilles: Alexandre Gueidon, 1859), p. 228: "Il est à supposer que le caractère profondément original des habitants de cette partie de notre contrée sera bientôt altéré par suite de l'établissement de la voie de fer. Le calme, la poésie et le bonheur que les populations rurales trouvent dans la vie isolée, disparaîtront sans doute bientôt avec les vieilles coutûmes, les préjugés, —si l'on veut,—et les traditions des ancêtres."

236. At the time Baldus received the PLM commission, the viaduct at La Voulte was the only such structure still to be built on the route from Lyons to Marseilles (M. R. Morandière, *Traité de la construction des ponts et viaducs en pierre, en charpente et en métal pour routes, canaux et chemins de fer* [Paris: Dunod, 1880], p. 625; *Grand dictionnaire*, vol. 3, p. 1133). The PLM album includes a two-page panorama of the viaduct under construction, a view of the entire viaduct completed, and this view of a single arch.

237. A watercolorist, draftsman, and lithographer of portraits, architecture, and landscape, Laurens was self-taught but accomplished, contributing frequently to *L'Illustration* and the *Magasin Pittoresque*, as well as to the *Voyages pittoresques et romantiques*. He cannot be counted among the highly original artists who contributed to the aesthetic revolutions that characterized Parisian painting in the 1850s and 1860s; rather, Laurens was an exemplary practitioner of traditional topographic and picturesque views.

 For a complete biography of Laurens, see *Une vie artistique: Laurens, Jean-Joseph-Bonaventure (14 juillet 1801–29 juin 1890), sa vie et ses oeuvres . . . par XXX* (Carpentras: J. Brun et Cie, 1899).

238. The full title on Laurens's first set in this series reads: *Album du chemin de fer de Lyon à la Méditerranée: Recueil de dessins de sites, monuments, costumes, etc. étudiés dans le parcours de cette voie et exécutés sur pierre par J.-B. Laurens. Première excursion 1857* (BN, Est., Ve. 1461).

 Une vie artistique (p. 584) provides the following information concerning these series: 1857, *Premier album du Chemin de Fer de Lyon à la Méditerranée* (30 plates); 1859, *Deuxième album du Chemin de Fer de Lyon à la Méditerranée* (28 plates); 1860–61, *Troisième album du Chemin de Fer de Lyon à la Méditerranée* (28 plates); 1865–66, *Quatrième album du Chemin de Fer* (30 plates); 1871, *Cinquième album du Chemin de Fer* (30 plates).

 For further comparisons between Laurens's and Baldus's treatment of subjects along the PLM line, see Daniel, "Railway Albums," pp. 223–34.

239. Henry Sturgis Drinker, *Tunneling, Explosive Compounds, and Rock Drills* (New York: John Wiley and Sons, 1893), pt. 2, pp. 1114–21. Even with twenty-four vertical shafts to permit work along the entire length simultaneously, the tunnel at La Nerthe took from 1844 to 1847 to complete. At 4,638.8 m (2¾ mi.) long, 8 m (26 ft.) wide, and 7.5 m (24½ ft.) high it was the longest tunnel in France at the time, and at a total cost of 10,467,559 francs, it remained for decades to come the most expensive in France.

240. William Thackeray, quoted in Michael Adas, *Machines as the Measure of Men: Science, Technology, and Ideologies of Western Dominance* (Ithaca, N.Y., and London: Cornell University Press, 1989), p. 222.

241. May, "Paris à Marseille," pp. 489–90. The concession for the Toulon–Nice line was granted in 1859, and the concession from Nice to Vintimille, on the Italian frontier, was promised by conventions in 1862 and granted in 1863.

242. Baldus also had hired help to care for the children and manage the household. The inventory after Mme Étienne's death (AN, MC, XVIII/1313, no. 327) indicates that a cook, a maid for Mme Étienne, and a nursemaid for the children were employed.

243. The eldest of Baldus's children, Marie-Joséphine-Valentine, married Charles-Albert Waltner on September 15, 1868 (AN, MC, XVIII/1354, no. 322). For more information on Waltner, see Henri Beraldi, *Graveurs du XIX^e siècle* (Paris: Librairie L. Conquet, 1892), vol. 12, pp. 254–69; and idem, "Les graveurs du XX^e siècle: Waltner," *Revue de l'Art Ancienne et Moderne* 17 (1905), pp. 101–4, 180.

 A year later, on August 11, 1869, Marie-Adélaïde, youngest of the three children, married Louis-Jean-Jacques-Alexandre Vignes-Villa, a medical doctor in Soisy-sous-Étiolles (Seine et Oise) (AN, MC, XVIII/1360, no. 289).

 James-Édouard-Théodore Baldus was described in 1870 (at age twenty-two) as an "artiste peintre," residing at his father's home on rue d'Assas, though no evidence exists to suggest a sustained artistic career (AN, MC, XVIII/1365, no. 251). A document from 1875 describes him as a soldier in the 16th Line Infantry Regiment, garrisoned at the Colombier fort in Lyons (AN, MC, XVIII/1408, no. 241).

244. Stereographs by Baldus are extremely rare, which suggests that few were made. Fifty-seven, including some duplicates, are in the collection of Pierre-Marc Richard, Paris; one is in the collection of the Musée Nicéphore Niépce, Chalons-sur-Saône (acc. no. 81.4.42); two are in the collection of the Metropolitan Museum of Art (acc. no. 1994.179.1,2). All forty-one known images show sites in the southeast of France; all have printed titles similar to those found on Baldus's mounts; some are numbered. Following is a list of the locations shown in Baldus's known stereographs: one image of Lyons (unnumbered); one of Orange (unnumbered); six of Avignon (including no. 4); one of Saint-Rémy (no. 10); sixteen of Arles (including nos. 14, 16–18, 22, 24, 26); four of Montmajour (nos. 27–29, 31); nine of Nîmes (including nos. 33–36, 38, 39); two of the Pont du Gard (nos. 43, 44); and one of Aigues-Mortes (no. 46). All would seem to date from a single excursion of about 1864.

 Some stereographs are stamped on the verso with an artist's stamp seldom seen elsewhere (see appendix 1), and several bear a label on the verso for the Parisian print and photograph merchant Baptiste Guérard.

245. Gisèle Excoffen and Jean Michel, "L'École des Ponts et Chaussées et la photographie 1857–1907," *Photogénies* (Sept. 1983) [unpaginated]; Michel Yvon, "L'École Nationale des Ponts et Chaussées," *Photographies*, no. 5 (1984), pp. 76–83.

246. École des Ponts et Chaussées, "Procès-verbaux de la séance du Conseil de l'École . . . ," April 12, 1858: "[La photographie] est, dès à présent, employée sur plusieurs Chantiers, non seulement pour relever les détails, mais même pour constater l'état d'avancement des constructions."

247. The following albums are found in the collection of the Bibliothèque Historique de la Ville de Paris: *Le Pont Saint-Michel: Vues photographiques des phases principales des travaux de reconstruction de ce pont, exécutés en 1857; Pont de Solferino: Vues pho-*

tographiques prises pendant l'exécution des travaux en 1859; *Le Pont Louis-Philippe et le Pont Saint-Louis: reconstruction de ces ponts, exécutés en 1860, 1861, 1862*; *Le Pont au Change: Vues photographiques des phases principales des travaux de reconstruction de ce pont, exécutés en 1858, 1859 et 1860*; *Le Pont de Bercy: Vues photographiques . . . 1863 et 1864*; *Chemin de Fer de Ceinture de Paris (Rive Gauche) Pont-Viaduc sur la Seine au Point-du-Jour*; *Album des ponts de Paris construits ou reconstruits depuis 1852* (1867).

248. The *Chemin de Fer du Bourbonnais: Moret–Nevers–Vichy. 1860–1863* (J. Paul Getty Museum, Malibu, acc. no. 84.XO.393; George Eastman House, Rochester, N.Y., acc. no. 79:0038) comprises thirty-two views of the line from Moret to Nevers and eleven views along the branch to Vichy. The photographs vary in size, measuring up to approximately 22.5 × 31.5 cm (8⅞ × 12⅜ in.).

The *Chemin de Fer du Bourbonnais* (J. Paul Getty Museum, acc. no. 84.XM.407) comprises ninety-one photographs—nineteen depicting the line from Villeneuve-Saint-Georges to Montargis; thirty-one, the line from Roanne to Lyons via Tarare; thirty, the line from Roanne to Lyons via Saint-Étienne; and eleven, the Montbrison branch. (The Getty copy lacks two of the ninety-one images listed in the index.) The photographs measure approximately 25 × 35 cm (9¾ × 13¾ in.). The portfolio itself is undated, but individual photographs bear dates ranging from October 1865 to September 1867.

Neither publication names the patron or intended audience, though it is safe to assume that the railroad company itself commissioned the photographs.

249. Another copy of this image is in the Bibliothèque Nationale, stamped with the artist's facsimile signature and inscribed on the mount: "Pont de Hastingues: Vue générale du chantier, prise de l'extrémité occidentale de la butte de ce nom, sur la rive gauche (situation des travaux au 20 juillet 1861)." One photograph (pl. 68), without printed titles but with a Baldus facsimile signature stamp on the mount (lower right below the image), is in the Canadian Centre for Architecture, Montreal.

Four other photographs from the series, inscribed but unsigned, are in the École Nationale des Ponts et Chaussées: "Pont de Hastingues: Vue générale à grande échelle (situation des travaux au 20 juillet 1861)," a double-page panorama; "Pont de Hastingues: Vue prise à l'aral, (Rive droite) (situation des travaux au 20 juillet 1861)"; "Pont de la Bidouze: (En trois arches de 21m.00 d'ouverture chacune) vue prise des premières maisons du village de Guiche (situation des travaux au 21 juillet 1861)"; "Pont de l'Aran: (En trois arches de 17m. d'ouverture chacune) (situation du travaux au 21 juillet 1861)." These last three are also found, with facsimile signature stamps but no titles, in a private collection, Paris. All are albumen prints from glass negatives; on some, portions of the negative have been masked with a thin tissue overlay.

250. The only known copies of these five photographs are in the collection of the École des Ponts et Chaussées, Paris (acc. no. Ph 45). Each of the photographs bears the series title *Chemin de Fer de Rennes à Brest, Côtes-du-Nord* above the image on the mount. Below the image, on the mount, are found the following inscribed titles: *Viaduc en fonte sur rails (Broons)*; *Viaduc du Saint-Brieuc*; *Viaduc du Gouët*; *Viaduc en fonte sous rails (Saint-Brieuc)*; *Viaduc de Guingamp*. All are albumen prints from glass negatives, partially masked with tissue overlays. Their dimensions (in the order given above) are: 27.4 × 42.7 cm; 29.9 × 40.3 cm; 25.7 × 42.1 cm; 28.2 × 43.9 cm; and 31 × 42.7 cm (10¾ × 16¾ in.; 11¾ × 15⅞ in.; 10⅛ × 16⅝ in.; 11⅛ × 17¼ in.; 12¼ × 16¾ in.).

All are stamped (lower right) with Baldus's facsimile signature stamp.

No documents related to this work have been found. The Rennes to Guingamp section of the line, along which these bridges lie, was opened September 7, 1863, and the photographs were given to the school by the engineer in chief of the line on January 19, 1864; thus, the photographs must date from sometime around the opening of the line, mid- to late 1863.

251. No written documents concerning this project have been found. Although the subject is not a railroad viaduct per se, Baldus's work on the PLM album just before might account for his having been sent to document the extraordinary construction in Constantine. The bridge linked the railroad station and the town by spanning a ravine nearly four hundred feet deep, and was constructed in masonry and cast iron by Georges Martin, of the family responsible for many of the PLM viaducts photographed by Baldus.

252. BN, Est., Eo 8a. There are seven prints of the Al-Kantara bridge, including two of one image. All are albumen prints from paper negatives approximately 33 × 44 cm (13 × 17⅛ in.). Two of the seven prints bear Baldus's small facsimile signature stamp on the mount at the lower right.

253. The masonry sections at each end of the bridge had been completed, but the iron span was not yet in place. The unusual means used to place the 188-foot-wide iron arches—a wooden trestle and temporary work bridge suspended by anchor chains—are visible in the photographs. Construction statistics and dates for the Al-Kantara bridge are given in: Félix Lucas and Victor Fournie, *Routes et ponts*, vol. 1 of *Les travaux publics de la France*, ed. Léonce Reynaud (Paris: J. Rothschild, 1876), pl. XLI. The collotype in the *Travaux publics*, not by Baldus, shows the bridge after completion.

254. These Parisian scenes are usually mounted, with titles, series number, and artist's facsimile signature stamp printed on the mount, below the photograph.

The dépôt légal copies of the views of Paris, in the Bibliothèque Nationale, Seine 1864, nos. 12784–12874 and Seine 1865 nos. 154–57, were deposited December 22, 1864, and January 12, 1865, under the collective title "Vues diverses des monuments de Paris." A number of these images, however, are found in an album bound in leather and stamped in gold "PARIS PHOTOGRAPHIÉ 1862" (George Eastman House, Rochester, N.Y., acc. no. 76:312), suggesting that the series of small-format Paris views was built up over time and deposited only when complete. Baldus's printed stock list (appendix 2) gives individual titles for the first eighty-five, with one hundred numbers allotted for views of Paris. At two francs each, or twenty-five prints for 40 francs, these small-format photographs cost less than a third as much as his large-format work.

255. See, for example, Louis-Désiré Blanquart-Evrard, *Photographie: Ses origines, ses progrès, ses transformations* (Lille: Danel, 1870), p. 46.

256. *Recueil d'ornements d'après les maîtres les plus célèbres des XV^e, XVI^e, XVII^e, et XVIII^e siècles* (see appendix 10).

257. *Oeuvres de Marc-Antoine Raimondi: Les plus belles gravures de cet illustre maître d'après Raphael, Michel-Ange et l'Antique* (see appendix 10). Plates from this series were mentioned in *La Lumière* and reproduced by Blanquart-Evrard, but no complete copies of the publication, which comprised forty plates, are known. An engraved title page (with a title that varies slightly from that cited in archival documents) and the following ten

prints are in the collection of the Société Française de Photographie: *Venus and Amor*; *Hope*; *Adam and Eve*; *Lucretia*; *Justice*; *Prudence*; *Fortitude*; *Two Fauns Carrying an Infant*; *The Virgin*; and one unidentified subject.

Baldus solicited government subscription to his gravure publications through an unidentified friend in an uncharacteristically familiar letter of April 29, 1867: "My dear friend, I've come again to bother you about our gravure project. Do try to find a moment to see to it since you know just how important it is to me. Best wishes, E. Baldus." ("Mon cher ami, Je viens encore vous tourmenter pour notre affaire de gravure. Taitrez donc de trouver un moment pour le faire car vous savez combien c'est important pour moi. Bien à vous, E. Baldus.") Exactly six months later the Ministry of the Imperial Household and the Fine Arts agreed to subscribe to one hundred copies each of forty plates in the Marcantonio series (at three francs per print), one hundred plates in the ornaments series (at one franc per print), and ten plates in a series of landscapes (at two francs per print) (AN, F^{21} 116 dossier 10).

258. See appendix 10. The *Meubles* series, at least, enjoyed government subscription, again for one hundred copies. Baldus wrote to the comte de Nieuwerkerke, superintendent of fine arts, on August 16, 1869, requesting subscription "as you have so kindly done until now for the other reproductions." ("comme vous avez eu la bonté de le faire jusqu'à ce jour pour les autres reproductions.") The series was described as complete by that date. The purchase was approved August 25, 1869; delivery was made shortly thereafter, and payment authorized September 18, 1869 (AN, F^{21} 116, dossier 11).

259. The first edition was issued in installments beginning in late 1869, and the series was complete by the end of 1871. Two volumes, each with one hundred plates, focused on interior and exterior decoration.

The publication was first offered for sale by two Paris booksellers, Eugène Devienne and Baudry, in advertisements in the *Bibliographie de France* late in 1869 (Richard Yanul, letter to Robert Sobieszek, June 3, 1977, files at George Eastman House, Rochester, N.Y.).

In a letter to the minister of state, dated December 15, 1871, Baldus presented a copy of the completed series and requested a government subscription, indicating that it contained two hundred plates at 1.5 francs each (AN, F^{21} 311). Dépôt légal of the first two volumes was not made until August 5, 1874 (Seine 1874, nos. 1911–1912).

Because of the success of the first two volumes, a third, showing both interior and exterior motifs, was produced, and the three-volume set was published by Morel in 1875. Morel announced publication of the first two installments of the third series in the *Bibliographie de France* on March 20, 1875, and the third and final installments on October 2, 1875 (Richard Yanul, letter to Robert Sobieszek, June 22, 1977, files at George Eastman House).

260. For magnified detail views of photogravures and photolithographs by Baldus, Nègre, Poitevin, and Niépce de Saint-Victor, see Gerardo F. Kurtz and Isabel Ortega, *150 años*

de fotografía en la Biblioteca Nacional (Madrid: Ediciones el Viso and Ministerio de Cultura, 1989), pp. 144–46.

261. The documentation files at the Musée d'Orsay contain a photocopy of a photograph said to be by Baldus, showing the ruins of the central pavilion of the Tuileries Palace. I have not examined the original. In any case, Baldus never published this or similar images, as did his contemporaries Marville, Liébert, Franck, Andrieu, Braquehais, and others.

262. *Palais de Versailles, Grand et Petit Trianon: Motifs de décoration intérieur et extérieur* (see appendix 10).

263. As with the *Palais du Louvre et des Tuileries*, Baldus first published *Les principaux monuments de la France* himself and later issued it through Morel.

The full contents are shown in appendix 11. According to information printed on the back of the portfolio in which the first installment was delivered (private collection, Los Angeles), the publication was to be issued in three installments of twenty prints each, at the price of 80 francs per installment. It is unclear whether the sixty prints were issued in full; all extant copies (e.g., Canadian Centre for Architecture, Montreal, acc. no. PH1984:0010, Victoria and Albert Museum Library, London, acc. no. 106.0.23, and the Avery Architectural and Fine Arts Library, Columbia University, New York, AA 1041 B19 classics ff) contain only forty-five prints, and pasted to the title page of the copy in the Victoria and Albert Museum are lists of the prints in each installment—twenty, twenty, and five. A copy in the Buffalo and Erie County Public Library, listed as having fifty-nine plates, is missing and its contents cannot be confirmed.

Some of the gravures in this series appear in correct orientation, and others appear in reverse. This seems unrelated to the medium of the negative (i.e., gravures from glass negatives appear in correct and incorrect orientation, as do gravures from paper negatives).

264. *Reconstruction de l'Hôtel de Ville de Paris* (see appendix 10).

265. AN, MC, XXIX/1448, no. 767.

266. AN, MC, XLIV/1299, Aug. 6, 1884. Baldus retained the right to live in the house until July 1, 1890.

267. AP, D 11 U^3 1270, no. 1748.

268. "Registre des actes de l'état-civile de la commune d'Arcueil-Cachan pour l'année 1889," no. 192; and Étude XXIX, April 25, 1893, no. 257. No inventory was taken after the death of Baldus.

269. Cemetery of Cachan, division K, no. 30.

270. James-Édouard Baldus died at the age of forty-two on July 6, 1889 (AP, V.4.E. 5828, p. 91, no. 1773). Marie-Joséphine Baldus and Charles Waltner filed for divorce on December 4, 1893 (Répertoire of Étude XXIX). Marie-Adélaïde Vignes (née Baldus) died at the age of fifty on February 21, 1900, "séparée de corps et de biens" from her husband, and was buried alongside her parents in the cemetery of Cachan.

A Matter of Time: Architects and Photographers in Second Empire France
BY BARRY BERGDOLL

1. *Encyclopédie d'architecture* 2 (1852), p. 62: "Nous sommes certain que les architectes, pour lesquels le daguérreotype semble avoir été tout exprès inventé, apprécieront à sa valeur cette rare qualité d'exécution et pourront trouver dans ces tableaux, où la nature est venue se peindre elle-même, d'utiles renseignements sur les monuments de l'antiquité, et de précieux matériaux pour leurs études." The article is in fact referring to prints from paper negatives, but the vocabulary of photography was very fluid still in the early 1850s.

2. See the typed inventory of the vast archives of the Agence de Travaux du Nouveau Louvre et des Tuileries at the Archives Nationales, Paris (AN, 64 AJ).

3. *Académie d'architecture, catalogue des collections*, vol. 1, *1750–1900* (Paris: Académie d'Architecture, 1987). (The Académie d'Architecture is the successor to the Société Centrale des Architectes.) There is also a photograph of the completed Commercial Court of Paris on the Île-de-la-Cité in the collection of the Canadian Centre for Architecture, Montreal, dedicated by the architect Bailly to his teacher Duban.

4. See Molly Nesbit, "What Was an Author?" *Yale French Studies* 73 (1987), pp. 229–57; and Anne McCauley, "Of Entrepreneurs, Opportunists, and Fallen Women: Commercial Photography in Paris, 1848–1870," in Peter Walch and Thomas F. Barrow, eds., *Perspectives on Photography: Essays in Honor of Beaumont Newhall* (Albuquerque: University of New Mexico Press, 1986), p. 73.

5. As the photographs of Baldus and others entered the collections of newly formed historical museums in the nineteenth century, such as the Musée Carnavalet, Paris, they were carefully catalogued by subject matter, not photographer. See Françoise Reynaud, "Le Musée Carnavalet et la photographie," in *Paris: Portrait d'une capitale de Daguerre à William Klein*, exh. cat., Musée Carnavalet (Paris, 1992), p. 13.

6. On this controversy, see Neil Levine, "The Romantic Idea of Architectural Legibility: Henri Labrouste and the Néo-Grec," in Arthur Drexler, ed., *The Architecture of the École des Beaux-Arts* (New York: New York Graphic Society, 1977), pp. 325–416; and Barry Bergdoll, *Léon Vaudoyer: Historicism in the Age of Industry* (New York: The Architectural History Foundation, 1994), especially chaps. 2 and 3.

7. Charles Blanc, *Les artistes de mon temps* (Paris, 1876), p. 3: "Si la photographie pouvait saisir les couleurs comme elle reproduit les formes et les reliefs, elle ne serait pas plus précise, ni d'une expression plus juste, ni d'une vérité plus frappante." Blanc's comments refer to the exhibition of Duban's drawings held after his death at the École des Beaux-Arts in 1872.

8. Larry J. Schaaf, *Tracings of Light: Sir John Herschel and the Camera Lucida, Drawings from the Graham Nash Collection* (San Francisco: The Friends of Photography, 1989). See also Helmut and Alison Gernsheim, *The History of Photography from the Camera Obscura to the Beginnings of the Modern Era* (New York: McGraw-Hill, 1969), p. 29.

9. Léon Vaudoyer, letter to A.-L.-T. Vaudoyer, April 4, 1827, collection Mme Daphné Doublet-Vaudoyer, Paris: "La Camera lucida . . . serait je crois un instrument entièrement inutile à qui ne saurait pas dessiner."

10. "D'hiéroglyphes réels" rather than "hiéroglyphes fictifs." François Arago, *Rapport de M. Arago sur le daguérreotype, lu à la séance de la Chambre des Deputés, le 3 juillet 1839, et à l'Académie des Sciences, séance du 19 août* (Paris: Bachelier, 1839).

11. By the late 1840s the camera itself would find its way into the French Academy in Rome with Alfred Normand, a leader of the second generation of romantic architects. See Caisse Nationale des Monuments Historiques et des Sites, *Alfred Normand, Photographies d'Italie, de Grèce et de Constantinople: Calotypes 1851–52*, exh. cat. (Paris, 1978). See also André Jammes and Eugenia Parry Janis, *The Art of the French Calotype, with a Critical Dictionary of Photographers, 1845–1870* (Princeton: Princeton University Press, 1983), pp. 228–29.

12. See André Chastel, "La notion de patrimoine," in Pierre Nora, ed., *Les lieux de mémoire: La nation, II* (Paris: Gallimard, 1986), pp. 407–50.

13. See Françoise Bercé, "Séance du 30 mars 1839," *Les premiers travaux de la Commission des Monuments Historiques, 1838–1848* (Paris: Picard, 1979), p. 40.

14. For an in-depth study of the *mission héliographique* see, in particular, Philippe Néagu et al., *La mission héliographique: Photographies de 1851*, exh. cat. (Paris: Sitecmo, 1980); the excellent summary in André Jammes and Eugenia Parry Janis, *The Art of the French Calotype*, pp. 48–52; and for the details concerning Baldus's participation, see Daniel, in the present volume pp. 22–28.

15. Prosper Mérimée, *Correspondance générale*, vol. 3, *1841–1843* (Paris: Le Divan, 1943), p. 440: "Vous avez un grand rival en daguérréotypie. Duban que nous avons chargé d'étudier la restauration du château de Blois, en a fait une cinquantaine des vues. L'architecture vaut toujours mieux que le paysage, mais jusqu'à ce que vous avez trouvé le moyen de substituer du papier à vos plaques métalliques, vous aurez toujours une teinte froide qui ne me revient pas."

16. On the duc de Luynes's involvement with photography, most notably the famous prize he offered for advances in the technology of converting photographic images into printable images, see André Rouillé, ed., *La photographie en France: Textes et controverses. Une anthologie, 1816–1871* (Paris: Macula, 1989), pp. 310–17. I have not been able to consult the archives of the de Luynes family to ascertain if there is evidence of the use of photography on the château at Dampierre in the 1840s or 1850s.

7. Although Mérimée refers in his letter to Staufer (see note 15 above) to some fifty views, a note on the back of one of the three surviving daguerreotypes by Bayard held by the Société Française de Photographie (inv. no. 24.323) mentions only twenty: "twenty diverse views were made for the use of the restoration project of M. Duban, architect" ("20 vues diverses ont été prises pour servir au projet de restauration de M. Duban, architecte"). See Jean-Claude Gautrand, *Hippolyte Bayard: Naissance de l'image photographique* (Amiens: Trois Cailleux, 1986), pp. 41, 233. In addition there is in the collections of the Musée des Beaux-Arts in the Château de Blois a photograph by Mieusement with the inscription "no. 393, Blois château escalier dit de François Ier avant restauration, Mai 1846," which is probably a reproduction after an earlier daguerreotype, perhaps by Bayard.

18. Quoted in Paul Léon, *Mérimée et son temps* (Paris: Presses Universitaires de France,

1962), pp. 295–96: "Proscrire l'imagination, est le premier devoir de l'archéologue. Il faut remplacer la divination par l'analyse scientifique qui doit permettre aux sciences historiques autant de progrès qu'elle en a apporté aux sciences naturelles."

19. Henry Sirodot, "Escalier de l'aile de François Ier au Château de Blois: Vue photographique," *Revue Générale de l'Architecture* 14 (1856), pp. 215–16: "Les fines arabesques qui grimpent capricieusement sur la face des contreforts se lisent tout aussi facilement que l'appareil de la construction. Avec un peu d'attention, en examinant à la loupe, on distingue même, au ton de la pierre, à la netteté des arrêtes, les parties qui remontent à la construction de celles qui remontent à la restauration." The 1856 issue also included an early example of photomechanical images, a view of Baltard's new Central Markets under construction, produced with Poitevin's process. On the interest in photography of the magazine's editor, César Daly, see Hélène Lipstadt, "The Building and the Book in César Daly's *Revue Générale de l'Architecture*," in Beatriz Colomina, ed., *Architectureproduction: Revisions* 2 (New York: Princeton Architectural Press, 1988), pp. 25–55; and Marc Saboya, *Presse et architecture au XIXe siècle: César Daly et la "Revue Générale de l'Architecture"* (Paris: Picard, 1991).

20. Yvan Christ, "Mérimée, Viollet-le-Duc et les premiers daguerréotypes de Notre Dame," *Terre d'Images*, no. 5 (Sept.–Dec. 1964). Christ notes in his preface to Néagu, *Mission* (p. 1), that bills from 1842 for these daguerreotypes have been found in the Archives Nationales. Cited also by Jean-Michel Leniaud, *Jean-Baptiste Lassus (1807–1857): Ou le temps retrouvé des cathédrales* (Paris: Arts et Métiers Graphiques, 1980), p. 99. Lerebours is most famous, of course, for his publication of the *Voyages daguerriennes*.

21. From an unpublished treatise on perspective (BN, Manuscrits, N.a.f.24021, fol. 297); cited by Leniaud, *Lassus*, p. 99: ". . . cette merveilleuse découverte de notre époque, ce procédé admirable qui force la lumière même à reproduire l'image des objets et à la fixer sur une plaque de métal, sur du verre ou du papier. . . ." Although the manuscript is undated, it is most likely a relatively early appreciation, since Lassus died in 1856.

22. From a letter to the minister of the interior, June 1849 (AN, F^{19} 7679); quoted by Leniaud, *Lassus*, p. 105: "J'ai vu disparaître des parties importantes, des fragments de draperie, des mains et même une tête. Je possède des daguerréotypes faits à différentes époques, et qui donnent une idée de la rapidité du mal."

23. Quoted by Gautrand, *Hippolyte Bayard*, pp. 18–19; he does not give the precise source or date.

24. Mérimée, letter to Léon de Laborde, June 30, 1851, in Maurice Parturier, ed., *Prosper Mérimée, correspondance générale* (Paris, 1947), vol. 6, p. 223: "Viollet n'emporte plus de crayons. . . ."

25. Ministère de l'Instruction Publique et des Cultes, *Instruction pour la rédaction des projets, l'exécution des travaux, et la rédaction des mémoires concernant les édifices religieux* (Paris, July 25, 1848): "Il serait même à propos de produire autant que possible, des vues prises au daguerréotype des principaux aspects du bâtiment à réparer."

26. "Vues photographiques," *Encyclopédie d'architecture* 2 (1852), p. 16: "Il n'est plus permis aujourd'hui de faire un projet de restauration d'un édifice sans avoir sous les yeux une photographie."

27. Viollet-le-Duc, "Restauration," in *Dictionnaire raisonné de l'architecture* (Paris: A. Morel, 1866), vol. 8, pp. 33–34, quoted in Barry Bergdoll, ed., and Kenneth White-
head, trans., *Viollet-le-Duc: The Foundations of Architecture* (New York: Braziller, 1990), p. 225: ". . . présente cet avantage de dresser des procès-verbaux irrécusables et des documents que l'on peut sans cesse consulter, même lorsque les restaurations masquent des traces laissés par la ruine. La photographie a conduit naturellement les architectes à être plus scrupuleux encore dans leur respect pour les moindres débris d'une disposition ancienne, à se rendre mieux compte de la structure, et leur fournit un moyen permanent de justifier leurs opérations. Dans les restaurations, on ne saurait donc trop user de la photographie, car bien souvent on découvre sur une épreuve ce que l'on n'avait pas aperçu sur le monument lui-même."

28. *Monographie de Notre-Dame de Paris et de la nouvelle sacristie de MM Lassus et Viollet-le-Duc: 63 planches gravées par MM Hibon, Ribault, Normand, etc., 12 planches photographiques de MM Bisson frères, 5 planches chromolithographiques de M. Lercier . . .* (Paris: A. Morel, n.d. [ca. 1860]).

29. *Monographie de Notre-Dame de Paris*, p. 2: ". . . ensemble rempli de variétés comme la nature . . ."

30. Despite the claims made by many historians of photography that architects were indifferent to this important threshold for the new art of photography, there is evidence that architects took notice. César Daly, publisher of France's first sustained architectural periodical, advocated that architects make photographers aware of monuments in peril, so that they might at least be captured in photographs. In this he endorsed an editorial demand voiced in *La Lumière*, which he read regularly and cited from time to time in his magazine. See "Nouvelles et faits divers: *La Lumière*," *Revue Générale de l'Architecture* 9 (1851), p. 206.

31. Joel Herschman has illustrated this same approach in Baldus's early Parisian views. See Cervin Robinson and Joel Herschman, *Architecture Transformed: A History of the Photography of Buildings from 1839 to the Present* (Cambridge, Mass.: MIT Press, 1987), p. 6.

32. Ernest Lacan, "Revue photographique," *La Lumière*, Dec. 17, 1853, p. 202: "[Baldus] veut réunir dans ses cartons les vues des monuments qui représentent, en France, les divers styles d'architecture. Ainsi il pourra, quand son oeuvre sera complète, offrir à l'architecte, au peintre, à l'archéologue, une collection de tous les types de construction, depuis les lourds édifices que les colonies romaines ont laissés dans nos villes anciennes, jusqu'aux constructions bâtardes du siècle dernier. Tout aura sa place dans cette galerie historique et artistique à la fois."

33. For favorable comments on photography in the *Annales Archéologiques*, see, for example: 14 (1854), pp. 66–67; 15 (1855), pp. 65–66; and 16 (1856), p. 196.

34. See Hippolyte Fortoul, *De l'art en Allemagne* (Paris, 1841); Albert Lenoir and Léon Vaudoyer, "Études d'architecture en France," *Magasin Pittoresque* 7–14 (1839–52). On César Daly's theory of architecture, see Marc Saboya, *Presse et architecture*.

35. See appendix 5.

36. In 1849 Berger had commissioned a sequence of views of the demolitions of Paris from Henri Le Secq, today in the collection of the Bibliothèque Historique de la Ville de Paris; see Eugenia Parry Janis, "Demolition Picturesque: Photographs of Paris in 1852 and 1853 by Henri Le Secq," in Walch and Barrow, *Perspectives on Photography*, pp. 33–66.

37. Baldus similarly edited his views of more recent monuments, such as the Church of Saint-Sulpice, with its grandiose eighteenth-century colonnade front, and the recently completed Church of Saint-Vincent de Paul. Concerning Constant-Dufeux's view of

the work to be done at Sainte-Geneviève, see Barry Bergdoll, "Le Panthéon/Sainte-Geneviève au XIXᵉ siècle: La monumentalité à l'épreuve des révolutions idéologiques," in Barry Bergdoll, ed., *Le Panthéon: Symbole des révolutions* (Paris: Picard, 1989), pp. 175–233.

38. Baldus's continued role in this regard is attested to by his commission in 1858, a year after the completion of the first phase of the Louvre project, to document "the main events of the emperor's and empress's trip to Normandy" (AN, F²¹ 2284²).

39. Malcolm Daniel, "'Stone by Stone': Édouard-Denis Baldus and the New Louvre," *History of Photography* 16, no. 2 (Summer 1992), p. 116; and p. 57 in the present volume.

40. From 1857 Collard worked as a photographer for the Administration of Bridges and Roadways, and courses in photography were offered in the administration's school. In 1858–59 he recorded the construction of the Pont au Change in Paris in an album, a copy of which was sent to the U.S. government engineer Montgomery C. Meigs (Library of Congress, Washington, D.C., lot 8500, album H). For Durandelle I have used the early date that Ulrich Keller advances in "Durandelle, the Paris Opera, and the Aesthetic of Creativity," *Gazette des Beaux-Arts* 111 (Jan. 1988), p. 108.

41. Malcolm Daniel in his research reveals that the earliest written mention is by Lefuel in a letter of October 14, 1854; but there Lefuel begins his remarks by talking of "your verbal instructions." Daniel also reproduces remarks from an 1856 report to the emperor in which Fould claims, "J'ai chargé l'architecte d'en faire la reproduction par la photographie" ("I ordered the architect to reproduce it by photography"). Daniel, "Stone by Stone," p. 116.

42. Ernest Lacan, *Esquisses photographiques à propos de l'Exposition Universelle et de la guerre d'orient: Historiques de la photographie, développements, applications, biographies et portraits* (Paris: A. Gaudin et Frères, 1856), p. 31: "Il serait à désirer que, à mesure que chacune des parties du nouveau Louvre sera terminée, elle fût reproduite ainsi, afin que les habitants de la province et des pays étrangers puissent connaître et admirer comme nous, les merveilleuses beautés de ce gigantesque monument, qui sera le chef-d'oeuvre collectif des premiers artistes de notre temps, inspirés par la patriotique et grande pensée qui préside à ces travaux."

43. *Discours, messages, lettres et proclamations de S. M. Napoléon III, empereur des Français, 1849–1861* (Paris, 1861), pp. 138–39: "Ainsi, l'achèvement du Louvre, auquel je vous rend grâce d'avoir concouru avec tant de zèle et d'habileté n'est pas le caprice d'un monument, c'est la réalisation d'un plan conçu pour la gloire et soutenu par l'instinct du pays pendant plus de trois cents ans." The emperor's speech was frequently reprinted; see, for example, "Inauguration du nouveau Louvre," *Moniteur des Architectes* 11 (Sept. 1857), cols. 97–103.

44. Archival references for the distribution of the albums have been surveyed in Daniel, "Stone by Stone," p. 121 n. 7; and Daniel, nn. 142 and 143 in the present volume.

45. The chronicle that follows is based on my reconstruction of the relationship between architect and photographer drawn from evidence in the archives of the Agence de l'Architecte du Louvre (64 AJ) at the Archives Nationales, and in the albums themselves preserved at the Bibliothèque Nationale and in the Archives Nationales.

46. Mairie-France Lemoine-Molinard, "Le décor extérieur du nouveau Louvre sous Napoléon III: La série des hommes illustres," *Revue du Louvre*, nos. 5–6 (1978), pp. 374–79.

47. Duret: "La France prospère entourée de tous ses enfants qu'ont groupé en son sein la Paix et l'Abondance, appelle l'histoire pour qu'elle écrive et célèbre les bienfaits qu'elle a réçus de Napoléon III et charge les arts d'en éterniser la mémoire."
Simart: "Napoléon III fort de ses destinées et de l'appui que lui donne la reconnaissance des français pour les bienfaits de Napoléon Iᵉʳ, clot l'ère des révolutions et des discordes viles, rappelle la concorde et l'union, invoque la Paix, convie la France à l'exécution des vastes entreprises qui doivent illustrer son règne."

48. Quoted in Marius Vachon, *Le Louvre et les Tuileries: Histoire monumentale nouvelle* (Lyons, 1926), p. 210: "Le caractère de la nouvelle architecture sera emprunté religieusement au vieux Louvre." From the legend to Rudolph Pfnor's 1853 engraving "Vue perspective de la réunion des palais du Louvre et des Tuileries."

49. Ibid.: "L'architecte fera abnégation de tout amour propre pour conserver à ce monument son caractère initial."

50. See "Modèles de sculpture exécutés 1854–1857. Registre" (AN, 64 AJ 64*), "Modèles en plâtre déposés dans les magasins des travaux de réunion des Tuileries au Louvre, 1854–1856" (AN, 64 AJ 63*), and individual sculptors' dossiers (AN, 64 AJ 273).

51. See Bruno Foucart, "Portrait d'un édifice, à vocation lyrique," in *L'Opéra de Paris* (Paris: Centre National de la Photographie, 1985); Elvire Perego, "Delmaet et Durandelle ou 'La Rectitude des Lignes': Un atelier du XIXᵉ . . . ," in *Photographies*, no. 5 (July 1984), pp. 55–75; and Keller, "Durandelle," pp. 109–18.

52. "Album de photographies des principaux motifs de sculpture exécutés à la nouvelle cathédrale de Marseille par Messieurs Cantini et Galini entrepreneurs, annexé aux décomptes de ces entreprises." This account book, begun in 1871, the year before Vaudoyer's death and used until the completion of the cathedral in 1893 by Henri Revoil, is held among the official archives of the cathedral of Marseilles in the Archives Nationales (AN, F¹⁹ 7744). On the political symbolism of the building, see Barry Bergdoll, "La cathédrale de Marseille: Fonctions politiques d'un monument éclectique," *Bulletin de la Société d'Histoire de l'Art Français*, 1986 (publ. 1988), pp. 129–43.

53. "Rapport d'Achille Fould, ministre d'état, sur les travaux du Louvre," *Moniteur Universel, Journal Officiel de l'Empire Français*, Feb. 18, 1856, p. 1: "Dans l'intérêt de l'art et afin de conserver à l'histoire les modèles au nombre de plus de 800, qui ont été exécutés pour les sculptures du nouveau Louvre, j'ai chargé l'architecte d'en faire la reproduction par la photographie. . . . Ces modèles . . . pourront être addressés aux principales écoles de dessin des départements où s'instruit la classe laborieuse; ils y seront d'autant plus utiles que la plupart de ces modèles sont inspirés de la plus belle époque d'architecture dont s'en orgueillit la France." In his 1854 report on drawing instruction in French secondary schools, Félix Ravaisson had already recommended that the state underwrite the acquisition and distribution of photographs to serve as models for students of important works of art in collections they could not visit in Paris and other cities. See Félix Ravaisson, *De l'enseignement du dessin . . .* (Paris, 1854). For further information on the use of photographs in the Écoles de Dessin, see Rouillé, *Photographie en France*, p. 191.

54. Daniel, "Stone by Stone," p. 121 n. 8, citing a document of Feb. 26, 1858 (AN, 64 AJ 57); n. 143 in the present volume.

55. César Daly, *Motifs historiques d'architecture et de sculpture d'ornement. Choix de fragments empruntés à des monuments français du commencement de la Renaissance à la fin de*

Louis XVI (Paris: A. Morel, 1869). Daly's first two volumes on exteriors were published by A. Morel in 1869; a second set of two volumes on interiors appeared in 1880, published by Ducher. Of Sauvageot's many books one might cite *Palais, châteaux, hôtels et maisons de France*, 4 vols. (Paris: A. Morel, 1867).

56. As the Société noted in 1865, "The more photography approaches perfection, the more evident it becomes that the real goal toward which its applications are moving is printing by ordinary methods" ("Plus la photographie s'approche de la perfection, plus il devient évident que le but veritable vers lequel tendent ses applications est l'impression par les procédés ordinaires"). *Bulletin de la Société Française de la Photographie* 11 (1865), p. 279.

57. *Recueil d'ornements d'après les maîtres les plus célèbres des XV, XVI, XVII, et XVIII^e siècles* (Paris, 1866).

58. É. Baldus, *Oeuvre de Jacques Androuet dit Du Cerceau: Meubles. Héliogravure* (Paris, [1869]), single page of text: "Au moment où notre époque donne un grand essor à l'ornamentation, et quand le goût se reporte avec ardeur aux productions des XV^e, XVI^e, XVII^e et XVIII^e siècles, qui comptaient tant d'habiles graveurs et de si grands architectes, nous apportons notre tribut de recherches, en offrant au public studieux la série des gravures représentant les meubles et ornements d'après les précieux dessins de Jacques Androuet dit du Cerceau, que nous reproduisons au moyen du procédé de gravure héliographique . . ."

59. *Le Napoléonum: Monographie du Louvre et des Tuileries donnant les plans, élévations, détails des Palais du Louvre et des Tuileries, depuis Charles V jusqu'à son achévement par Napoléon III* (Paris: A. Grim, 1856). For Nègre's proposition, see document AN, F^21 485 dossier 6. It is likely that Baldus knew of this project, since it was made to his friend and frequent patron De Mercey, director of the Office of Fine Arts.

60. Baldus published two different editions of the Louvre book; see appendix 10.

61. Several of the copies of Baldus's albums of photogravures in the collection of Avery Architectural and Fine Arts Library, Columbia University, New York, for example, come principally from the working libraries of late-nineteenth-century American architects. The same library's copy of the first edition of Baldus's *Palais de Versailles: Motifs de décorations reproduits en héliogravure* was first owned by Adolf Hoffmann, a court sculptor in Berlin at precisely this period when the public buildings of France were so often the point of departure for the grand new buildings required in the capital of newly united Germany. It was later owned by the Library of the General Society of Mechanic Tradesmen in New York.

62. As mentioned in Molly Nesbit, *Atget's Seven Albums* (New Haven: Yale University Press, 1992), p. 51.

63. For a history of this collection, see Anne de Mondenard, *Photographier d'architecture 1851–1920: Collection du Musée des Monuments Français*, exh. cat. (Paris: Musée National des Monuments Français, 1994).

64. On Durandelle's role at Sacré-Coeur, where between four and five hundred photographs were taken, see Claude Laroche, *Paul Abadie, architecte, 1812–1884*, exh. cat. (Paris: Réunion des Musées Nationaux, 1988), pp. 261–63. A particularly revealing album of the construction photographs is held by the Canadian Centre for Architecture (acc. no. PH1991:0061), where it will be featured in an exhibition in 1995 on construction photography.

65. *Reconstruction de l'Hôtel de Ville de Paris par T. Ballu, membre de l'Institut, architecte en chef, et Deperthes, architecte: Motifs de décoration extérieur. Soixante planches en héliogravure* (Paris: Librairie Centrale des Architectes, 1884). On the Hôtel de Ville, see Anne Pingeot, "La statuaire du nouvel Hôtel de Ville," in *Livre du centenaire de la reconstruction de l'Hôtel de Ville, 1882–1982*, exh. cat. (Paris: Ville de Paris, Bibliothèque Administrative, 1982), pp. 59–67.

66. A number of these collages exist in the archives of the Pantheon. For the increasing use of photographs on the construction site at the very end of the century, see *Des grands chantiers . . . hier, photographie, dessin: Outils de l'architecte et l'ingénieur autour de 1900*, exh. cat. (Paris: Mairie de Paris, Direction des Affaires Culturelles, 1988).

BIBLIOGRAPHY

MANUSCRIPT SOURCES

ARCHIVES NATIONALES, PARIS

Minutier Central

XVIII/1227, no. 287, Sept. 18, 1845. Marriage contract between Édouard Baldus and Élisabeth-Caroline Étienne.

XVIII/1285, no. 140, March 26, 1858. Inventory after the death of Mme Baldus.

XVIII/1313, no. 327, June 5, 1862. Inventory after the death of Mme Étienne, mother-in-law of Baldus.

XVIII/1354, no. 309, Sept. 3, 1868. Request by Marie-Joséphine-Valentine Baldus for her father's consent to marry.

XVIII/1354, no. 322, Sept. 15, 1868. Marriage contract between Marie-Joséphine-Valentine Baldus and Charles-Albert Waltner.

XVIII/1360, no. 289, Aug. 11, 1869. Marriage contract between Marie-Adélaïde Baldus and Louis-Jean-Jacques-Alexandre Vignes-Villa.

XVIII/1365, no. 251, July 2, 1870. Division and settlement of the estates of Mme Baldus and Mme Étienne.

XVIII/1407, no. 162, May 11, 1875. Loan of 30,000 francs to Baldus by the Crédit Foncier de France.

XVIII/1408, no. 241, July 19, 1875. Final execution of the settlement of the estates of Mme Baldus and Mme Étienne.

XXIX/1448, no. 767, Oct. 20, 1885. Loan of 1,500 francs to Baldus by his son-in-law Charles-Albert Waltner.

XLIV/1299, Aug. 6, 1884. Sale of house at 17, rue d'Assas by Baldus to Charles-Joseph Guasco.

XXIX, no. 257, April 25, 1893. Act after the death of Baldus (provisionally housed at the Chambre Interdépartementale des Notaires Parisiens, Paris).

Répertoires of Étude XXIX (retained in the offices of the Étude).

XCIII/842, May 21, 1886. Sale of house at 17, rue d'Assas by M. and Mme Guasco to M. Josso.

Ministère de Justice

BB11 655. Naturalization papers.

Administration des Beaux-Arts

F^{21} 62 dossier 36. Commission to copy Leonardo's *Holy Family*.

F^{21} 62 dossier 37. Commission to make photographs and photogravures after Lepautre.

F^{21} 62 dossier 38. Subscription to *Villes de France photographiées*; subsequent purchases of photographs, including floods, Louvre, *Monuments de France*.

F^{21} 62 dossier 39. Commission to copy Murillo's *Virgin and Child*.

F^{21} 116 dossier 10. Subscription to *Recueil d'ornements*; gravures after Marc-antonio; landscapes.

F^{21} 116 dossier 11. Subscription to *Oeuvre de Ducerceau (série des meubles)*.

F^{21} 311. Subscription to *Palais du Louvre et des Tuileries*.

F^{21} 486, III. Baldus painting *Le Christ* sent to Montoldre (Allier).

F^{21} 488, II, 2. Distribution of Louvre albums.

F^{21} 2284^2. Commission to photograph imperial visit to Cherbourg, 1858.

Ministère d'État

F^{70} 237–38 (1853–56). Subscriptions to *Vitraux de l'église de Sainte-Clotilde* and *Villes de France photographiées*.

F^{70} 279. Twenty-five copies of Louvre albums.

F^{70} 115. Legion of Honor awarded to Baldus.

Dépôt Légal

F^{18}*. Registers of submissions for copyright registration.

Agence de l'Architecte du Louvre

64 AJ. Correspondence, contracts, accounts, etc., related to the construction of the New Louvre. Plans and photographs.

Compagnie du Chemin de Fer du Nord

48 AQ. Minutes of the meetings of the General Assembly, Administrative Council, and Committee of Direction; correspondence, accounts, etc.

Compagnie des Chemins de Fer de Paris à Lyon et à la Méditerranée

77 AQ 144. Minutes of the meetings of the Administrative Council for the Southern Region (July 19, 1861), p. 79. Approval of commission for PLM album.

ARCHIVES DE PARIS

D II U³ 1270, no. 1748, Feb. 25, 1887. Baldus bankruptcy.

ARCHIVES DÉPARTEMENTALES, YVELINES

4 E 2789, no. 70, Sept. 22, 1845. Marriage of Édouard Baldus and Élisabeth-Caroline Étienne.

MAIRIE D'ARCUEIL (VAL DE MARNE)

Registres des actes de l'État-Civil pour l'année 1889, no. 172, Dec. 22, 1889. Death of Baldus.

ARCHIVES DU LOUVRE, PARIS

KK¹²⁻²² and KK³⁵⁻⁴⁵. Salon records, 1841–52.

*LL²⁶. Register of copies (Baldus copy after Murillo).
P³⁰ Baldus. Requests for commissions to copy paintings, 1847.

ÉCOLE DES PONTS ET CHAUSSÉES, PARIS

Lettres de l'inspecteur.
Procès-verbaux des séances du Conseil de l'École.
Procès-verbaux des séances du Conseil de Perfectionnement de l'École.

ANDRÉ JAMMES, PARIS

Studio notebook of Fortuné-Joseph Petiot-Groffier.
Studio notebook of Charles Nègre.

COMPREHENSIVE CHRONOLOGICAL LIST OF REFERENCES TO BALDUS IN PERIODICAL LITERATURE, 1851–74

1851

Jules Ziégler. "Des sociétés en général et de la Société Héliographique en particulier." *La Lumière*, Feb. 9, 1851, pp. 1–2. Baldus among founding members of Société Héliographique.

[Untitled]. *La Lumière*, June 29, 1851, p. 83. Announcement of *missions héliographiques*.

"Missions du Comité des Monuments Historiques confiées à divers membres de la Société Héliographique: M. Baldus." *La Lumière*, July 20, 1851, p. 94. Baldus itinerary for *mission héliographique*.

1852

[Untitled]. *La Lumière*, March 15, 1852, p. 47. Journal will soon describe Baldus process in detail.

"Réunion photographique." *La Lumière*, April 24, 1852, pp. 71–72. View of Avignon, 50 cm wide.

Nicolas-Paymal Lerebours. "Plaque, papier, ou verre? (2ᵉ article)." *La Lumière*, May 1, 1852, pp. 75–76.

"Séance du lundi 7 juin 1852." *Comptes rendus hebdomadaires des séances de l'Académie des Sciences*, p. 882. M. Seguier shows Baldus prints to Academy.

A. Maronnier. "Académie des Sciences . . . Mission de M. Baldus." *La Lumière*, June 19, 1852, pp. 102–3. Photographs and treatise submitted to Academy; commissioned by minister of the interior to reproduce monuments of Paris.

"Photographie et nouvelles du jour." *Cosmos*, June 20, 1852, p. 169.

"Publications photographiques." *La Lumière*, June 26, 1852, p. 108. Formula for positive prints, excerpted from Baldus's *Concours de photographie*.

"Photographie et nouvelles du jour." *Cosmos*, June 27, 1852, pp. 193–97.

1853

"Réunion photographique." *La Lumière*, May 28, 1853, pp. 87–88. Baldus "vue gigantesque" of Notre-Dame.

"Portraits des artistes vivants et reproduction de leurs principaux ouvrages par la photographie." *La Lumière*, Aug. 27, 1853, pp. 139–40. Review of Théophile Silvestre's *Histoire des artistes vivants*.

A.-T. L. "Papier photogénique." *La Lumière*, Sept. 24, 1853, p. 154. Call for specially manufactured paper.

Ernest Lacan. "Revue photographique." *La Lumière*, Sept. 24, 1853,

pp. 154–55. Paris monuments, reproductions of paintings, windows of Sainte-Clotilde.

Ernest Lacan. "Revue photographique." *La Lumière*, Dec. 17, 1853, pp. 202–3. Photographs of the Midi.

[Untitled]. *La Lumière*, Dec. 17, 1853, p. 204. Notice for *Concours de photographie*.

1854

A.-T. L. "Ce qu'ont fait les photographes en 1853." *La Lumière*, Jan. 7, 1854, p. 2. Baldus reproducing various styles of architecture.

"Exposition de la Société Photographique de Londres." *La Lumière*, Jan. 14, 1854, p. 5 [reprinted in translation from the London *Morning Post*]. *Amphithéâtre de Nîmes* attracts royal attention.

"The Exhibition of the Photographic Society." *The Art Journal*, Feb. 1, 1854, pp. 48–50. *Amphitheater at Nîmes*, formed of three negatives.

"The Exhibition of Photographs and Daguerreotypes, by the London Photographic Society." *Liverpool Photographic Journal*, Feb. 11, 1854, pp. 17–19. *Amphitheater at Nîmes*, 42 in. wide.

Charles Gaudin. "Exposition photographique." *La Lumière*, Feb. 25, 1854, pp. 29–30. Submissions to London Photographic Society exhibition.

Charles Gaudin. "Réunion d'artistes photographes." *La Lumière*, March 25, 1854, pp. 45–46. Missal of Anne of Brittany; gravure reproductions after Lepautre.

Ernest Lacan. "Héliotypographie ou gravure héliographique reproduite en relief par la paniconographie." *La Lumière*, April 1, 1854, pp. 49–50. Excellence of Baldus photogravures.

[Untitled]. *La Lumière*, April 8, 1854, p. 54. Reproductions of contemporary paintings.

"Gravure héliographique." *La Lumière*, April 15, 1854, p. 58. Baldus photogravure process for intaglio or relief printing.

"Gravure héliographique." *La Lumière*, April 29, 1854, pp. 66–67. Baldus/Gillot process for photo-relief printing, with illustration.

Ernest Lacan. "Revue photographique: MM. Disdéri, Moulin." *La Lumière*, June 17, 1854, p. 95. Mentioned in review of Disdéri at the agricultural exhibition.

Ernest Lacan. "Revue photographique: M. Baldus." *La Lumière*, June 24, 1854, p. 99; July 1, 1854, pp. 103–4. Photographs of animals at the agricultural exhibition; photographs of sculpture; reproductions of contemporary painting.

Ernest Lacan. "Une page du *Cosmos*." *La Lumière*, Sept. 2, 1854, pp. 137–38. Baldus has just returned from Burgundy and the Auvergne.

[Untitled.] *La Lumière*, Sept. 16, 1854, pp. 146–47. Petiot-Groffier views of the Auvergne.

1855

Ernest Lacan. "De la photographie et de ses diverses applications aux beaux-arts et aux sciences." *Moniteur Universel*, Jan. 12, 1855; reprinted in *La Lumière*, Jan. 20, 1855, p. 11–12; Jan. 27, 1855, pp. 15–16; Feb. 3, pp. 20–21. Photographs of the Auvergne, the New Louvre, and the agricultural exhibition; facsimile gravures after Lepautre.

Ernest Conduché. "Sur une nouvelle application de la photographie." *La Lumière*, Feb. 10, 1855, p. 23. Auvergne photographs reveal geology of region.

Charles Gaudin. "Réunion photographique." *La Lumière*, Feb. 24, 1855, p. 29. Auvergne pictures will be subject of future article.

Paul Périer. "Nécrologie: M. Petiot-Groffier." *Bulletin de la Société Française de Photographie*, April 1855, p. 87. Petiot-Groffier obituary.

Stéphane Geoffray. "Notes sur la fabrication des papiers et les procédés améliorateurs." *La Lumière*, June 16, 1855, p. 95. Technical excellence of Baldus's paper negatives.

"Exposition photographique d'Amsterdam." *La Lumière*, June 23, 1855, p. 97. Baldus awarded silver medal.

[Ernest Lacan]. "Album offert à S. M. la reine Victoria." *La Lumière*, Sept. 1, 1855, p. 134. Album of Baldus photographs of sites along the Chemin de Fer du Nord.

Aimé Girard. "Arts Chimiques: 26ᵉ Classe, 4ᵉ Section. Photographie." *Le Globe Industriel, Agricole, et Artistique: Journal Illustré des Expositions*, Sept. 9, 1855, pp. 293–96.

Ernest Lacan. "Exposition Universelle: Photographie. 2ᵐᵉ article." *La Lumière*, Sept. 22, 1855, p. 149; "3ᵐᵉ article," Sept. 29, 1855, p. 153. Photographs of the Auvergne and Paris on exhibition; photographs along the Chemin de Fer du Nord described; work of the Bisson Frères compared with that of Baldus.

Périer, Paul. "Exposition Universelle: 3ᵉ article. Photographes français." *Bulletin de la Société Française de Photographie*, July 1855, pp. 187–200; "4ᵉ article. Photographes français. Science. Monuments et vues panoramiques." August 1855, pp. 213–28. Work of Baldus compared with that of the Bisson Frères; criticized for harshness of tone.

Ch.-P. Magne. "Exposition Universelle de 1855: Galerie des dessins industriels—photographie, gravure et lithographie—éventails, parures, fantaisies, etc., etc." *L'Illustration, Journal Universel*, Nov. 17, 1855, pp. 330–31. Panoramic views by Baldus and the Bisson Frères cited.

Ernest Lacan. "Exposition Universelle: Récompenses accordées à la photographie." *La Lumière*, Dec. 1, 1855, p. 189. Baldus awarded silver (first class) medal.

"Exposition Universelle: Liste officielle des récompenses accordées à la photographie." *La Lumière*, Dec. 15, 1855, p. 197. Baldus awarded silver (first class) medal.

1856

A.-T. L. "Le Nouveau Louvre et la photographie." *La Lumière*, March 15, 1856, pp. 43–44; reprinted in *Revue Photographique*, April 5, 1856, p. 83. As official photographer of the New Louvre, Baldus has already made more than 1,200 pictures.

[Édouard Baldus]. "Publications photographiques." *La Lumière*, June 26, 1856, p. 108. Formula for positive prints.

"Photographie historique." *Revue Photographique*, July 5, 1856, pp. 129–30. Photographs of the floods.

Ernest Lacan. "Photographie historique." *La Lumière*, July 21, 1856, p. 97. Photographs of the floods.

Ernest Lacan. "Les inondations de 1856: Épreuves de M. Baldus." *La Lumière*, Aug. 9, 1856, p. 125. Photographs of the floods more fully described.

Mus Dulcis. "Une visite à l'Exposition des Arts Industriels." *Uylenspiegel*, Aug. 24, 1856, pp. 6–7. Perfect modulation of tone in Louvre photographs likened to paintings of Ingres.

"Exposition universelle de photographie à Bruxelles." *Revue Photographique*, Oct. 5, 1856, p. 179. Large scale of Baldus and Bisson prints.

Ernest Lacan. "Exposition photographique de Bruxelles, XI." *La Lumière*, Nov. 22, 1856, pp. 181–82. Photographs of the Auvergne, the Louvre, and the floods; permanence of Baldus prints.

"Exposition photographique de Bruxelles. Liste des récompenses." *La Lumière*, Dec. 13, 1856, p. 201. Baldus awarded medal in highest category.

Ernest Lacan. "La photographie en Angleterre." *La Lumière*, Dec. 27, 1856, p. 201. "Gigantesques" views of architecture at Sydenham.

1857

Liverpool and Manchester Photographic Journal, Jan. 1, 1857, p. 1. Mention of "the monster photographs of Baldus."

"Soirée photographique de King's College." *Revue Photographique*, Jan. 5, 1857, p. 226. Mention of the "monuments gigantesques de M. Baldus."

"Exposition Universelle des Arts Industriels de Bruxelles." *Revue Photographique*, Jan. 5, 1857, pp. 228–30. Baldus awarded medal in highest category.

"Exposition de la Société Française de Photographie. Premier article." *Revue Photographique*, Feb. 5, 1857. Mention of Baldus views of Louvre.

Illustrated London News, cited in *La Lumière*, March 21, 1857, p. 46. *Pavillon Richelieu* cited as masterpiece of this genre.

"Documents officiels pour servir à l'histoire de la photographie: Extrait des rapports du jury mixte international de l'Exposition Universelle. XXVIe classe. Photographie." *La Lumière*, April 25, 1857, p. 67.

"Rapport sur l'exposition ouverte par la Société en 1857." *Bulletin de la Société Française de Photographie*, Sept. 1857, pp. 250–72; Oct. 1857, pp. 273–313. Baldus's submissions to exhibition.

H. H. "La photographie en province." *La Lumière*, Nov. 1, 1857, pp. 177–78. Mention of Baldus in discussion of Crespon photographs of the Midi.

1858

Marc-Antoine Gaudin. "Nouvel appareil panoramique de M. Garilla: Employé par M. Baldus." *La Lumière*, Jan. 16, 1858, p. 9. Baldus panoramas.

"Architectural Photographic Exhibition." *The Building News*, Jan. 29, 1858, p. 97. Views of Paris in exhibition of Architectural Photographic Association.

Bulletin de la Société Française de Photographie, March 1858, p. 83. Baldus awarded medal at 1857 Brussels exhibition.

La Gavinie. "Chronique." *La Lumière*, July 17, 1858, p. 115. Nearby studio for Louvre work.

Georges d'Apremont. [Untitled]. *La Lumière*, Aug. 21, 1858, pp. 133–34. Baldus among photographers at Cherbourg.

Ernest Lacan. "Revue photographique." *La Lumière*, Oct. 16, 1858, pp. 166–67. Reprinted as "Chronique: Photographies des fêtes de Cherbourg." *Revue Photographique*, Nov. 1, 1858, pp. 157–59. Excerpted in translation as "Photography at Cherbourg." *The Photographic News*, Oct. 15, 1858, p. 62. Baldus in Cherbourg for imperial visit; photographs of Caen.

1859

"Exhibition of the Architectural Photographic Association." *The Photographic News*, Jan. 7, 1859, pp. 207–8. Views of Paris described as Baldus's poorest to date.

Vernier *fils*. "Méthode de photographie rapide sur papier." *Revue Photographique*, Feb. [?], 1859, pp. 69–73. Reprinted in translation as "Paper versus Collodion." *The Photographic News*, Feb. 25, 1859, pp. 289–90. Baldus's process for paper negatives gives "more artistic" result than collodion.

Ernest Lacan. "Revue photographique." *La Lumière*, April 2, 1859, pp. 55–56. Baldus photographs of the Midi mentioned in review of work by the Bisson Frères.

Ernest Lacan. "Exposition photographique, cinquième article." *La Lumière*, Aug. 6, 1859, p. 125. Baldus submits single work.

1860

"Architectural Photographic Association. Third Annual Exhibition." *The Photographic News*, March 2, 1860, pp. 307–8; March 9, 1860, pp. 319–20. Color of prints criticized.

Ernest Lacan. "Nouvelles publications photographiques." *La Lumière*, March 31, 1860, p. 49. Views of the Dauphiné.

J. A. van Eyk. "Exposition photographique d'Amsterdam." *La Lumière*, March 31, 1860, pp. 49–50. Baldus among exhibitors.

Echo de Vésone, May 8, 1860. Baldus called to Périgueux by prefect to document buildings slated for destruction.

Ernest Lacan. "Quelques mots d'actualité." *La Lumière*, Sept. 1, 1860, p. 137. Baldus awarded Legion of Honor.

1861

"Mr. Burges, On the Photographs in the Architectural Photographic Exhibition of 1861." *The Building News*, March 22, 1861, pp. 261–62. Mention of Baldus's submissions.

Marc-Antoine Gaudin. "Exposition de la Société Française de Photographie (2^e article)." *La Lumière*, May 30, 1861, pp. 38–39. Baldus now surpassed by others. Works criticized as too hard. *Le Bout du Monde* confirms excellence of paper negatives for landscape.

Charles Gaudin. "Exposition de la Société Française de Photographie (3^e et dernier article)." *La Lumière*, June 15, 1861, pp. 41–42. Baldus photographs compared unfavorably to those of Dominique Roman. Baldus criticized for retouching negatives.

Ernest Lacan. "Exposition photographique, 2^e article." *Le Moniteur de la Photographie*, June 15, 1861, pp. 49–50. Praise for Baldus's views of the Dauphiné and Savoy.

"Société Photographique de Marseille." *Le Moniteur de la Photographie*, Nov. 1, 1861, pp. 121–22. *Pavillon Richelieu* exhibited.

Georges Robert. "Exposition photographique." *Revue Photographique*, pp. 197–99. Despite excellence of Baldus monuments and landscapes, reviewer prefers prints from glass negatives.

1862

P. Liesegang. "Quelques observations sur la photographie à l'Exposition Internationale de Londres." *Le Moniteur de la Photographie*, June 1, 1862, pp. 42–43. Large architectural photographs are masterpieces; landscapes hard compared to those of British.

Ernest Lacan. "La photographie à l'Exposition Internationale de Londres." *Le Moniteur de la Photographie*, Sept. 15, 1862, pp. 97–98. Monumental *Louvre*, *Tuileries*, *Pavillon de Flore*.

E. Fierlants. "Exposition Universelle de Londres. France. II." *Le Moniteur de la Photographie*, Nov. 1, 1862, pp. 121–22. Works on view demonstrate why Baldus so highly acclaimed.

1866

Ernest Lacan. "Revue photographique." *Le Moniteur de la Photographie*, Dec. 15, 1866, pp. 145–46. Baldus's photogravure process.

Marc-Antoine Gaudin. "Appareil panoramique de M. Martens." *La Lumière*, June 15, 1866, no. 11, p. 2. Mention of Baldus's use of Garilla's panoramic camera in 1858.

1867

Ernest Lacan. "Revue photographique." *Le Moniteur de la Photographie*, Feb. 15, 1867, pp. 177–78. Baldus's photogravure process.

"Gravure héliographique (extrait du rapport de la commission chargée de décerner le prix fondé par M. le duc de Luynes)." *Le Moniteur de la Photographie*, June 1, 1867, p. 45. Baldus's photogravure process.

"Exposition Universelle de 1867." *Le Moniteur de la Photographie*, Aug. 15, 1867, p. 81. Photogravure facsimiles after Marcantonio.

1868

Léon Vidal. "Société Photographique de Marseille: Compte rendu de la séance du 1^er avril 1868." *Le Moniteur de la Photographie*, June 1, 1868, pp. 45–46. Baldus photogravure specimens sent to Société.

1869

Ernest Lacan. "Exposition Photographique. III^e article." *Le Moniteur de la Photographie*, Aug. 1, 1869, pp. 73–74. Photogravures after old master prints.

1870

Louis-Désiré Blanquart-Evrard. "La photographie: Ses origines, ses progrès, ses transformations." *Le Moniteur de la Photographie*, Jan. 15, 1870, pp. 165–68; June 15, 1870, pp. 55–56. [Extracts from publication of the same title.] Praise for Baldus photogravures.

1874

Ernest Lacan. "Exposition photographique II." *Le Moniteur de la Photographie*, Aug. 15, 1874, p. 121. Photogravures in Société Française de Photographie exhibition.

Le Moniteur de la Photographie, Aug. 15, 1874, p. 128. Baldus awarded medal for photogravures.

Bulletin de la Société Française de Photographie, 1874, pp. 154, 178. Baldus awarded medal for his photogravures in Société Française de Photographie exhibition.

Baldus and Photographic Issues in Nineteenth-Century Sources

"Appel de la Société Anglaise de Photographie Architecturale aux photographes Français." *Revue Générale de l'Architecture et des Travaux Publics* 18 (1860), pp. 75–76.

Arago, François. *Rapport de M. Arago sur le daguerréotype, lu à la séance de la Chambre des Députés, le 3 juillet 1839, et à l'Académie des Sciences, séance du 19 août.* Paris: Bachelier, 1839.

Archer, Frederick Scott. "The Use of Collodion in Photography." *The Chemist*, no. 2 (1851), pp. 257–58.

Baldus, Édouard. *Concours de photographie: Mémoire déposé au secrétariat de la Société d'Encouragement pour l'Industrie Nationale, contenant les procédés à l'aide desquels les principaux monuments historiques du Midi de la France ont été reproduits par ordre du Ministre de l'Intérieur par Édouard Baldus, peintre.* Paris: Victor Masson, May 27, 1852.

Baudelaire, Charles. "Salon de 1859: Le public moderne et la photographie." *Le Boulevard*, Sept. 14, 1862. Excerpted in Rouillé, *La photographie en France*, pp. 326–29.

Belloc, Auguste. *Les quatre branches de la photographie.* Paris, 1855.

Blanchère, Henri de la. *Répertoire encyclopédique de photographie comprenant par ordre alphabétique tout ce qui a paru et paraît en France et à l'étranger depuis la découverte par Niépce et Daguerre de l'art d'imprimer au moyen de la lumière, et les notions de chimie, physique et perspective qui s'y rapportent.* 2 vols. Paris: Bureau de la Rédaction, d'Abonnement et de Vente, 1864.

Blanquart-Evrard, Louis-Désiré. *Procédés employés pour obtenir les épreuves de photographie sur papier, présentés à l'Académie des Sciences.* Paris: C. Chevalier, 1847.

———. *Traité de photographie sur papier.* Paris: Roret, 1851.

———. *Photographie: Ses origines, ses progrès, ses transformations.* Lille: Danel, 1870.

Catalogues des expositions organisées par la Société Française de Photographie, 1857–1876. 2 vols. Ed. Guy Durier and Jean Michel Place. Paris: Éditions Place & Durier, 1985.

Claudet, Antoine. "Des rapports de la photographie avec les beaux-arts." *Bulletin de la Société Française de Photographie* 6 (Oct. 1860), pp. 263–77.

Daly, César. "Une société internationale de photographie d'architecture." *Revue Générale de l'Architecture et des Travaux Publics* 22 (1864), pp. 254–56.

Davanne, Louis Alphonse. "Rapport de la commission chargée de décerner le prix de 8000 francs, fondé par M. le duc de Luynes pour l'impression à l'encre grasse des épreuves photographiques." *Bulletin de la Société Française de Photographie*, April 1867, pp. 89–112.

Delacroix, Eugène. *Journal.* Paris, 1893–95, entry for Dec. 15, 1850.

Figuier, Louis. *La photographie au Salon de 1859.* Paris: Hachette, 1860; reprint, New York: Arno, 1979.

———. "La photographie." In *Les merveilles de la science ou description populaire des inventions modernes.* Paris: Furne, Jouvet, 1869; reprint, New York: Arno, 1979.

Janin, Jules. "Le daguerotype [*sic*]." *L'Artiste*, Nov. 1838–April 1839, pp. 145–48. Excerpted in Rouillé, *La photographie en France*, pp. 46–51.

Ken, Alexander. *Dissertations historiques, artistiques et scientifiques sur la photographie.* Paris: Librairie Nouvelle, 1864; reprint, New York: Arno, 1979.

Lacan, Ernest. *Esquisses photographiques à propos de l'Exposition Universelle et de la guerre d'orient: Historique de la photographie, développements, applications, biographies et portraits.* Paris: Alexis Gaudin et Frères, 1856; reprint, New York: Arno, 1979.

Laussedat, A. "Mémoire sur l'emploi de la photographie dans la levée des plans." *Bulletin de la Société Française de Photographie* 6 (Jan. 1860), pp. 27–28.

Lauzac, Henry. "Baldus (Édouard)," in *Galerie historique et critique du dix-neuvième siècle: Essai de sociologie et d'esthétique.* Vol. 3, pp. 25–27. Paris: Bureau de la Galerie Historique, 1861–62.

Le Gray, Gustave. *Traité pratique de photographie sur papier et sur verre.* Paris: Germer Baillière, 1850.

———. *Nouveau traité théorique et pratique de photographie sur papier et sur verre.* Paris: Lerebours et Secretan, 1851.

———. "Note sur un nouveau mode de préparation du papier photographique négatif." *Comptes Rendus Hebdomadaires des Séances de l'Académie des Sciences*, Dec. 8, 1851, pp. 643–44.

———. *Photographie: Traité nouveau théorique et pratique des procédés et manipulations sur papier-sec, humide et sur verre au collodion, à l'albumine.* Paris: Lerebours et Secretan [1852].

Nadar [Félix Tournachon]. *Quand j'étais photographe.* Paris: Flammarion, 1899.

Niépce de Saint-Victor, Claude-Marie-François. *Recherches photographiques: Photographie sur verre. Héliochromie. Gravure héliographique. Notes et procédés divers.* Paris: Alexis Gaudin et Frère, 1855; reprint, New York: Arno, 1979.

"Nouvelles et faits divers: *La Lumière.*" *Revue Générale de l'Architecture et des Travaux Publics* 9 (1851), pp. 205–6.

"Procès-verbaux de la séance du 16 mars 1855." *Bulletin de la Société Française de Photographie*, April 1855, pp. 61–62.

Talbot, William Henry Fox. *Some Account of the Art of Photogenic Drawing, or the Process by Which Natural Objects May Be Made to Delineate Themselves*

Without the Aid of the Artist's Pencil. London: R. and J. E. Taylor, 1839.

Vitraux de l'église de Sainte-Clotilde . . . : Prospectus. Paris: Imprimerie de J. Caron Noël, 1854.

Wey, Francis. "Comment le soleil est devenu peintre." *Musée des Familles*, June–July 1853, pp. 257–65, 289–300.

Wilde, Friedrich. "Bemerkungen zur Papierfrage, gestützt auf eigene Erfahrungen während fünfzigjähriger Praxis." *Photographische Chronik. Beiblatt zum Atelier des Photographen. Zeitschrift für Photographie und Reproduktionstechnik*, no. 27 (March 29, 1899), pp. 179–80; no. 32 (April 16, 1899), pp. 213–15; no. 34 (April 23, 1899), pp. 225–27.

Ziégler, Jules-Claude. *Compte rendu de la photographie à l'Exposition Universelle de 1855*. Dijon: Douillier, 1855.

Baldus and Photographic Issues in Twentieth-Century Sources

À l'origine de la photographie: Le calotype au passé et au présent. Paris: Bibliothèque Nationale, 1979.

Baier, Wolfgang. *Quellendarstellungen zur Geschichte der Fotografie*. Munich: Schirmer/Mosel [1977].

Berg, Charles I. "Photography." In *A Dictionary of Architecture and Building*, vol. 3, pp. 128–32. Ed. Russell Sturgis. London and New York: Macmillan, 1902.

Boisvert, Thierry. "Bonjour, Monsieur Baldus." *Le Journal du Périgord*, Fall 1992, pp. 69–74.

Bonnemaison, Joachim. *Panoramas: Photographies 1850–1950. Collection Bonnemaison*. Exh. cat., Rencontres Internationales de la Photographie. Arles, 1989.

Borcoman, James. *Charles Nègre, 1820–1880*. Exh. cat., National Gallery of Canada. Ottawa, 1976.

Bramsen, Henrik, Marianne Brøns, and Bjørn Ochsner. *Early Photographs of Architecture and Views in Two Copenhagen Libraries*. Copenhagen: Thaning & Appel, 1957.

Brettell, Richard. *Paper and Light: The Calotype in France and Great Britain, 1839–1870*. Exh. cat., Art Institute of Chicago. Boston: Godine, 1984.

Buerger, Janet. *The Era of the French Calotype*. Exh. cat., International Museum of Photography at George Eastman House. Rochester, 1982.

———. *French Daguerreotypes*. Chicago and London: University of Chicago Press, 1989.

Catalogue sommaire illustré des nouvelles acquisitions du Musée d'Orsay, 1980–1983. Paris: Éditions de la Réunion des Musées Nationaux, 1983.

Chevrier, Jean-François. "Modernisme et beauté industrielle." *Photographies*, no. 5 (1984), pp. 19–31.

Chomer, Gilles. "Les inondations de Lyon: Sinistres et images." *Cahiers d'Histoire: Lyon-Grenoble-Clermont-Saint-Étienne-Chambéry* 35, nos. 3–4 (1990), pp. 321–32.

Christ, Yvan. "Mérimée, Viollet-le-Duc et les premiers daguerréotypes de Notre Dame." *Terre d'Images*, no. 5 (Sept.–Dec. 1964).

———. *L'âge d'or de la photographie*. Paris: Vincent Fréal, 1965.

———. *Les métamorphoses de la Côte d'Azur*. Paris: Balland, 1971.

———. "La photographie auxiliare de l'archéologie." *Archéologica*, no. 44 (Jan.–Feb. 1972), pp. 54–63.

Daniel, Malcolm. "Édouard Baldus: Les albums du Chemin de Fer du Nord." *La Recherche Photographique*, no. 8 (Feb. 1990), pp. 82–89.

———. "The Photographic Railway Albums of Édouard-Denis Baldus." Ph.D. diss., Princeton University, 1991.

———. "'Stone by Stone': Édouard-Denis Baldus and the New Louvre." *History of Photography* 16, no. 2 (Summer 1992), pp. 115–22.

———. "Édouard-Denis Baldus and the Chemin de Fer du Nord Albums." *Image* 35, nos. 3–4 (Fall–Winter 1992), pp. 2–37.

Des grands chantiers . . . hier, photographie, dessin: Outils de l'architecture et l'ingénieur autour de 1900. Paris: Mairie de Paris, Direction des Affaires Culturelles, 1988.

Dewitz, Bodo von, and Reinhard Matz, eds. *Silber und Salz: zur Frühzeit der Photographie im deutschen Sprachraum, 1839–1860*. Exh. cat., Agfa Foto-Historama. Cologne and Heidelberg: Braus, 1989.

Dimond, Frances, and Roger Taylor. *Crown and Camera*. Exh. cat., The Queen's Gallery. London: Penguin, 1987.

Elwall, Robert. "'The Foe-to-graphic Art': The Rise and Fall of the Architectural Photographic Association." *The Photographic Collector* 5, no. 2 (1985), pp. 142–63.

Excoffen, Gisèle, and Jean Michel. "L'École des Ponts et Chaussées et la photographie 1857–1907." *Photogénies*, Sept. 1983.

Freund, Gisèle. *La photographie en France au dix-neuvième siècle: Essai de sociologie et d'esthétique*. Paris: La Maison des Amis des Livres, 1936.

Gautrand, Jean-Claude, and Michel Frizot. *Hippolyte Bayard: Naissance de l'image photographique*. Amiens: Trois Cailloux, 1986.

Gernsheim, Helmut. *Focus on Architecture and Sculpture*. London: Fountain Press, 1949.

Gernsheim, Helmut and Alison. *L. J. M. Daguerre: The History of the Diorama and the Daguerreotype*. New York: Dover, 1968.

Goldschmidt, Lucien, and Weston Naef. *The Truthful Lens: A Survey of the Photographically Illustrated Book, 1844–1914*. Exh. cat., Grolier Club. New York, 1980.

Grad, Bonnie, and Timothy Riggs. *Visions of City and Country: Prints and Photographs of Nineteenth-Century France*. Exh. cat., National Gallery of Art. Washington, D.C., 1982.

Heilbrun, Françoise. *Charles Nègre, photographe, 1820–1880*. Exh. cat., Musée d'Orsay. Arles: Éditions de la Réunion des Musées Nationaux, 1980.

———. "Le paysage dans la photographie française au XIX^e siècle et ses rapports avec la peinture du réalisme à l'impressionnisme." *L'impressionnisme et le paysage français*. Exh. cat., Grand Palais. Paris: Réunion des Musées Nationaux, 1985. English version: "The Landscape in French Nineteenth-Century Photography." *A Day in the Country: Impressionism and the French Landscape*, pp. 349–62. Exh. cat., Los Angeles County Museum of Art. Los Angeles, 1984.

———. *Les paysages des impressionnistes*. Paris: Hazan and Éditions de la Réunion des Musées Nationaux, 1986.

Henry, Jean-Jacques, et al. *Photographie: Les débuts en Normandie*. Exh. cat., Maison de la Culture. Le Havre, 1989.

Herschman, Joel A., and William W. Clark. *Un Voyage Héliographique à Faire: The Mission of 1851. The First Photographic Survey of Historical Monuments in France*. Exh. cat., Queens College. New York, 1981.

Hochreiter, Otto. *Bauten, Blicke*. Exh. cat., Österreichisches Fotoarchiv im Museum Moderner Kunst. Vienna, 1988.

Humbert, Jean-Marcel, et al. *Photographies anciennes 1848–1918: Regard sur le soldat et la société*. Paris: Musée de l'Armée, 1985.

Jammes, André. *Die Kalotypie in Frankreich: Beispiele der Landschafts-, Architektur und Reisedokumentationsfotographie*. Exh. cat., Museum Folkwang. Essen, 1965.

Jammes, André and Marie-Thérèse. *La photographie des origines au début du XX^e siècle*. Sale cat., June 13, 1961. Geneva: Nicolas Rauch, 1961.

Jammes, André, and Eugenia Parry Janis. *The Art of French Calotype, with a Critical Dictionary of Photographers, 1845–1870*. Princeton: Princeton University Press, 1983.

Jammes, André, and Robert Sobieszek. *French Primitive Photography*. Introduction by Minor White. Exh. cat., Philadelphia Museum of Art. Millerton, N.Y.: Aperture, 1969.

Jammes, André, et al. *De Niépce à Stieglitz: La photographie en taille-douce*. Exh. cat., Musée de l'Élysée. Lausanne, 1982.

Jammes, Isabelle. *Blanquart-Evrard et les origines de l'édition photographique française: Catalogue raisonné des albums photographiques édités 1851–1855*. Geneva: Librairie Droz, 1981.

Janis, Eugenia Parry. "Photography." In *The Second Empire (1852–1870): Art in France Under Napoleon III*, pp. 401–44. Exh. cat., Philadelphia Museum of Art. Philadelphia, 1978.

———. "Demolition Picturesque: Photographs of Paris in 1852 and 1853 by Henri Le Secq." In *Perspectives on Photography, Essays in Honor of Beaumont Newhall*, pp. 33–66. Ed. Peter Walch and Thomas F. Barrow. Albuquerque:

University of New Mexico Press, 1986.

———. *The Photography of Gustave Le Gray*. Chicago: The Art Institute of Chicago and The University of Chicago Press, 1987.

Keller, Ulrich. "Durandelle, the Paris Opera and the Aesthetics of Creativity." *Gazette des Beaux-Arts* 111 (Jan.–Feb. 1988), pp. 109–18.

Lecuyer, Raymond. *Histoire de la photographie*. Paris: Baschet et Cie, 1945.

Lemagny, Jean-Claude, and André Rouillé, eds. *Histoire de la photographie*. Paris: Bordas, 1986.

Loyrette, Henri. "Apprendre à voir l'architecture." *Monuments Historiques*, no. 110 (1980), pp. 4–8.

———. "Ingénieurs et photographes." *Photographies*, no. 5 (July 1984), pp. 12–18. For English translation, see pp. 122–25.

Marbot, Bernard. *Une invention du XIX^e siècle. Expression et technique. La photographie: Collections de la Société Française de Photographie*. Exh. cat., Bibliothèque Nationale. Paris, 1976.

Marbot, Bernard, and Weston Naef. *After Daguerre: Masterworks of French Photography (1848–1900) from the Bibliothèque Nationale*. Exh. cat., The Metropolitan Museum of Art. New York, 1980.

Mathon, Catherine, et al. *Les chefs-d'oeuvres de la photographie dans les collections de l'École des Beaux-Arts*. Exh. cat., École Nationale Supérieure des Beaux-Arts. Paris, 1991.

McCauley, Elizabeth Ann. *A. A. E. Disdéri and the Carte de Visite Portrait Photograph*. New Haven: Yale University Press, 1985.

———. "Of Entrepreneurs, Opportunists, and Fallen Women: Commercial Photography in Paris, 1848–1870." In *Perspectives on Photography, Essays in Honor of Beaumont Newhall*, pp. 67–97. Ed. Peter Walch and Thomas F. Barrow. Albuquerque: University of New Mexico Press, 1986.

Meyer, Adolphe. *Promenade sur le chemin de fer de Marseille à Toulon*. Marseilles: Alexandre Gueidon, 1859; reprint with introduction on Baldus by Yvan Christ, Paris: Éditions du Palais Royal, 1974.

Mondenard, Anne de. *Photographier l'architecture 1851–1920: Collection du Musée des Monuments Français*. Exh. cat., Musée National des Monuments Français. Paris, 1994.

Néagu, Philippe. "Sur la photographie d'architecture au XIX^e siècle." *Monuments Historiques*, no. 110 (1980), pp. 28–31.

———. "1851: La mission héliographique." *Bulletin*, no. 1, supplement to *La Revue Photographique*, 1984, pp. 11–21.

Néagu, Philippe, and Jean-François Chevrier. "La photographie d'architecture aux XIX^e and XX^e siècles." In *Images et imaginaires d'architecture*, pp. 93–101. Ed. Jean Dethier. Paris: Centre National d'Art et de Culture Georges Pompidou, 1984.

Néagu, Philippe, and Françoise Heilbrun. "Baldus: Paysages, architectures."

Photographies, no. 1 (Spring 1983), pp. 56–77.

Néagu, Philippe, and Jean-Jacques Poulet-Allamagny. *Anthologie d'un patrimoine photographique 1847–1926*. Paris: Caisse Nationale des Monuments Historiques et des Sites, 1980.

Néagu, Philippe, et al. *La mission héliographique: Photographies de 1851*. Exh. cat., traveling exhibition, Direction des Musées de France. Paris, 1980.

Nesbit, Molly. "What Was an Author?" *Yale French Studies* 73 (1987), pp. 229–57.

Pare, Richard. *Photography and Architecture 1839–1939*. Exh. cat., Canadian Centre for Architecture. Montreal, 1982.

Perego, Elvire. "Delmaet et Durandelle ou 'La rectitude des lignes.'" *Photographies* 5 (July 1984), pp. 55–75.

Phillips, Christopher. "A Mnemonic Art? Calotype Aesthetics at Princeton." *October*, no. 26 (1983), pp. 34–62.

La photographie comme modèle: Aperçu du fonds de photographie ancienne de l'École des Beaux-Arts. Exh. cat., École Nationale Supérieure des Beaux-Arts. Paris, 1982.

Poulet-Allamagny, Jean-Jacques, and Philippe Néagu. "Archives photographiques des monuments historiques." *Monuments Historiques*, no. 110 (1980), pp. 53–67.

Reilly, James. *The Albumen and Salted Paper Book: The History and Practice of Photographic Printing, 1840–1895*. Rochester, N.Y.: Light Impressions, 1980.

Rice, Shelley. "Parisian Views." *Views*, Supplement, 1986, pp. 7–13.

Robinson, Cervin, and Joel Herschman. *Architecture Transformed: A History of the Photography of Buildings from 1839 to the Present*. Cambridge, Mass.: M.I.T. Press, 1987.

Rouillé, André. *L'Empire de la photographie: Photographie et pouvoir bourgeois, 1839–1870*. Paris: Le Sycomore, 1982.

———. "La photographie française à l'Exposition Universelle de 1855." *Le Mouvement Social*, no. 131 (1985), pp. 87–103.

———, ed. *La photographie en France: Textes et controverses. Une anthologie 1816–1871*. Paris: Macula, 1989.

Sachsse, Rolf. *Architekturfotografie des 19. Jahrhunderts an Beispielen aus der Fotografischen Sammlung des Museum Folkwang*. Stationen der Fotografie, 6. Berlin: Nishen, 1988.

Un siècle de photographie: De Niépce à Man Ray. Exh. cat., Musée des Arts Décoratifs. Paris, 1965.

Sobieszek, Robert. *Édouard Denis Baldus: "Quintessentially Second Empire."* Exh. handout, Daniel Wolf Gallery. New York, 1978.

———. *Masterpieces of Photography from the George Eastman House Collections*. New York: Abbeville, 1985.

———. "Quintessentially Second Empire: The Photography of Édouard-Denis Baldus." *Newsletter of the Friends of Photography*, Dec. 1985.

———. *"This Edifice Is Colossal": 19th-Century Architectural Photography*. Exh. cat., International Museum of Photography at George Eastman House. Rochester, N.Y., 1986.

Stenger, Erich. "Wilhelm von Herford: Ein Amateurphotograph der Frühzeit und seine Lehrmeister." *Photographische Korrespondenz* 80, nos. 3–4 (March–April 1944), pp. 21–28.

Trains: Voyages en chemin de fer au 19ème siècle. Exh. cat., Musée Nicéphore Niépce. Chalon-sur-Saône, 1984.

Travis, David. *The First Century of Photography, Niépce to Atget: From the Collection of André Jammes*. Exh. cat., Art Institute of Chicago. Chicago, 1977.

Van Haaften, Julia. *From Talbot to Stieglitz: Masterpieces from the New York Public Library*. New York: Thames and Hudson, 1982.

Wagstaff, Samuel J., Jr. *A Book of Photographs from the Collection of Sam Wagstaff*. [New York?]: Gray Press, 1978.

Yvon, Michel. "L'École Nationale des Ponts et Chaussées." *Photographies*, no. 5 (July 1984), pp. 76–83.

Architecture

Berty, Adolphe. "De la gravure architecturale et archéologique." *Moniteur des Architectes* 7 (1856), pp. 396–99, 423–29.

Foucart, Bruno. "Portrait d'un édifice, à vocation lyrique." In *L'Opéra de Paris*. Paris: Centre National de la Photographie, 1985.

Jacquin, Emmanuel. "La réunion du Louvre au Tuileries." In *Louis Visconti 1791–1853*, pp. 220–39. Ed. Françoise Hamon. Paris: DAAVP, 1992.

———. "La Second République et l'achèvement du Louvre." *Bulletin de la Société d'Histoire de Paris et de l'Île de France 1987*, 1988, pp. 375–401.

Laroche, Claude. *Paul Abadie, architecte, 1812–1884*. Paris: Éditions de la Réunion des Musées Nationaux, 1988.

Lipstadt, Hélène. "The Building and the Book in César Daly's *Revue Générale de l'Architecture*." In *Architectureproduction (Revisions 2)*, pp. 25–55. Ed. Beatriz Colomina. New York: Princeton Architectural Press, 1988.

Livre du centenaire de la reconstruction de l'Hôtel de Ville, 1882–1982. Paris: Ville de Paris, Bibliothèque Administrative, 1982.

Mead, Christopher. *Charles Garnier's Paris Opera: Architectural Empathy and the Renaissance of French Classicism*. New York: The Architectural History Foundation, 1991.

Monographie de Notre-Dame-de-Paris et de la nouvelle sacristie de MM. Lassus et Viollet-le-Duc. Paris: Morel, n.d.

Reynaud, Léonce. *Les travaux publics de la France*. Paris, 1883.

Saboya, Marc. *Presse et architecture au XIXᵉ siècle: César Daly et la Revue Générale de l'Architecture*. Paris: Picard, 1991.

History and Social History

Blanchard, Ph. "Arrivée de S. M. la Reine d'Angleterre à Boulogne." *L'Illustration, Journal Universel*, Aug. 25, 1855, pp. 131–34, 139.

Champion, Maurice. *Les inondations en France depuis le VIᵉ siècle jusqu'à nos jours.* 4 vols. Paris: Dunod, 1862.

Dansette, Adrien. *Louis-Napoléon à la conquête du pouvoir.* Vol. 1 of *Histoire du Second Empire.* Paris: Hachette, 1961.

Gille, Bertrand. *Histoire de la maison Rothschild.* 2 vols. Geneva: Librairie Droz, 1965–67.

———. "Inventaire du fonds 132 AQ." Typescript, Archives Nationales, Paris.

Laurens, J.-B. "Rupture du chemin de fer à Tarascon." *L'Illustration, Journal Universel*, June 21, 1856, pp. 419–20.

"The Queen's Visit to France" [title varies]. *The Illustrated London News*, Aug. 4, 1855, pp. 129–30; Aug. 11, 1855, p. 167; Aug. 18, 1855, pp. 193–94, 202, 208–9, 224; Aug. 25, 1855, pp. 225–30, 232–33, 236–37, 240–48; Sept. 1, 1855, pp. 249, 252–53, 256–58, 260–61, 265–69, 278–80; Sept. 8, 1855, pp. 288–90, 296–98, 300–301, 304–5, 308–9, 312; Sept. 15, 1855, pp. 329–30, 332–33, 336–37.

Ridley, Jasper. *Napoléon III and Eugénie.* London: Constable, 1979.

Robin, Charles, ed. *Inondations de 1856: Voyage de l'empereur.* Paris, 1856.

Victoria, Queen of Great Britain. *Leaves from a Journal: A Record of the Visit of the Emperor and Empress of the French to the Queen and of the Visit of the Queen and H.R.H. the Prince Consort to the Emperor of the French, 1855*; reprint, with introduction by Raymond Mortimer, New York: Farrar, Straus & Cudahy, 1961.

———. *The Letters of Queen Victoria: A Selection from Her Majesty's Correspondence Between the Years 1837 and 1861.* Vol. 3. Ed. Arthur Christopher Benson and Viscount Esher. London: John Murray, 1907.

Voyage de l'empereur et l'impératrice dans les départements de l'ouest, août 1858. Paris: L'Illustration [1858].

Weber, Eugen. *Peasants into Frenchmen: The Modernization of Rural France, 1870–1914.* London: Chatto and Windus, 1977.

The Print Tradition and Other Arts

Abbey, J. R. *Life in England in Aquatint and Lithography 1770–1860.* London: Curwen, 1953.

———. *Travel in Aquatint and Lithography 1770–1860.* Vol. 1. London: Curwen, 1956.

Adhémar, Jean. *Les lithographies de paysage en France à l'époque romantique.* Paris: Armand Colin, 1938.

Beraldi, Henri. "Charles Albert Waltner." In *Graveurs du XIXᵉ siècle*, vol. 12, pp. 254–69. Paris: Librairie L. Conquet, 1892.

———. "Les graveurs du XXᵉ siècle: Waltner." *La Revue de l'Art Ancienne et Moderne* 17 (1905), pp. 101–4, 180.

Durand-Grèville, E. "Nécrologie: J.-B. Laurens." *La Chronique des Arts et de la Curiosité*, Aug. 2, 1890, p. 215.

Herbert, Robert. "City vs. Country: The Rural Image in French Painting from Millet to Gauguin." *Artforum* 8, no. 6 (Feb. 1970), pp. 44–55.

Pennell, Joseph, and Elizabeth Robins. *Lithography and Lithographers.* London: T. F. Unwin, 1898.

Spadafore, Anita Louise. "Baron Taylor's *Voyages Pittoresques*." Ph.D. diss., Northwestern University, 1973.

Twyman, Michael. *Lithography 1800–1850: The Techniques of Drawing on Stone in England and France and Their Application in Works of Topography.* London: Oxford University Press, 1970.

Une vie artistique: Laurens, Jean-Joseph-Bonaventure (14 juillet 1801–29 juin 1890), sa vie et ses oeuvres . . . par XXX. Carpentras: J. Brun & Cie, 1899.

Railroads, Engineering, and Technology

Balzac, Honoré de. *Un début dans la vie.* In *Oeuvres complètes.* Vol. 2. Paris: Louis Conard, 1912.

Baroli, Marc. *Le train dans la littérature française.* 3rd ed. Paris: Éditions N. M., 1969.

———, ed. *Lignes et lettres: Anthologie littéraire du chemin de fer.* Paris: SNCF and Hachette, 1978.

Blanchard, Marcel. "La politique ferroviaire du Second Empire." *Annales d'Histoire Économique et Sociale*, 1934, pp. 529–46.

Caron, François. *Histoire de l'exploitation d'un grand réseau: La Compagnie du Chemin de Fer du Nord, 1846–1937.* Vol. 7 of *Industrie et Artisanat.* Paris and The Hague: Mouton, 1973.

Charbon, Paul. *Au temps des malles-poste et des diligences: Histoire des transports publics et de poste du XVIIᵉ au XIXᵉ siècle.* N.p.: Jean-Pierre Gyss, 1979.

"Chemin de fer." In *Grand dictionnaire universel du XIXᵉ siècle*, vol. 3, pp. 1130–64. Ed. Pierre Larousse. Paris: Administration du Grand Dictionnaire Universel [ca. 1870].

"Chemin de fer." *La grande encyclopédie: Inventaire raisonné des sciences, des lettres et des arts*, vol. 10, pp. 1026–53. Paris: H. Lamirault & Cie, n.d.

Chevalier, Michel. "Système de la Méditerranée." *Le Globe*, Feb. 7, 1832; Feb. 12, 1832.

Collignon, Édouard. *Chemin de fer.* Vol. 2 of *Les travaux publics de la France.* Paris: J. Rothschild, 1883.

Conseils aux voyageurs en chemin de fer, en bateaux à vapeur et en diligence. Paris: Napoléon Chaix et Cie, 1854.

Dauzet, Pierre. *Le siècle des chemins de fer en France.* Fontanay-aux-Roses: Imprimeries Bellenand [1948].

Dethier, Jean. *Le temps des gares.* Exh. cat., Centre National d'Art et de Culture Georges Pompidou. Paris, 1978.

Dollfus, Charles, and Edgar de Geoffroy. *Histoire de la locomotion terrestre: Les chemins de fer.* Paris: L'Illustration, 1935.

Doukas, Kimon A. *The French Railroads and the State.* New York: Columbia University Press, 1945.

Du Camp, Maxime. *Paris: Ses organes, ses fonctions, et sa vie dans la seconde moitié du XIXe siècle.* Paris: Hachette, 1869.

Flachet, Eugène. *Les chemins de fer en 1862 et en 1863.* Paris: Hachette, 1863.

Foville, Alfred de. *La transformation des moyens de transport et ses conséquences économiques et sociales.* Paris: Guillaumin et Cie, 1880.

Gastineau, Benjamin. *La vie en chemin de fer.* Paris: Dentu, 1861.

Gille, Bertrand. *Répertoire numérique des archives de la Compagnie du Chemin de Fer du Nord conservées aux Archives Nationales (48 AQ).* Paris: Archives Nationales, 1961.

Janin, Jules. "Inauguration du Chemin de Fer de Paris à Saint-Germain." *Le Moniteur Universel,* Aug. 26, 1837.

Joanne, Adolphe L. *Atlas historique et statistique des chemins de fer français.* Paris: Hachette, 1858.

Jouffroy, Louis Maurice. *L'Ère du rail.* Paris: A. Colin, 1953.

Kaufmann, Richard de. *La politique française en matière des chemins de fer.* Trans. Frantz Hamon. Paris: Ch. Béranger, 1900.

Lajard de Puyjalon, Jacques. *L'influence des saint-simoniens sur la réalisation de l'isthme de Suez et des chemins de fer.* Paris: L. Chauny & L. Quinsac, 1926.

Lipstadt, Hélène, and Harvey Mendelsohn. *Architectes et ingénieurs dans la presse: Polémique, débats, conflits.* Paris: CORDA, 1980.

May, Mathieu-Georges. "L'histoire du chemin de fer de Paris à Marseille." *Revue du Géographie Alpine* 19 (1931), pp. 473–93.

Measom, George. *Official Illustrated Guide to the Great Northern Railway of France, with Six Days in Paris.* London: W. H. Smith, 1858.

Morandière, M. R. *Traité de la construction des ponts et viaducs en pierre, en charpente et en métal pour routes, canaux et chemins de fer.* Paris: Dunod, 1880.

Nouveau guide de Paris à Lyon et à la Méditerranée. Paris: Napoléon Chaix et Cie, 1853.

Picard, Alfred. *Les chemins de fer: Aperçu historique, résultats généraux de l'ouverture des chemins de fer, concurrence des voies ferrées entre elles et avec la navigation.* Paris: H. Dunod & E. Pinat, 1918.

Pondeveaux, Léon. *Le Nord: Étude historique et technique d'un grand réseau français.* Lille: Éditions du "Mercure de Flandre," 1931.

Poujard'hieu, Gustave. *Solution de la question des chemins de fer: De l'extension des réseaux et des nouvelles conventions.* Les grands réseaux des chemins de fer, I. Paris: L. Hachette, 1859.

Reverdy, Georges. *Histoire des grandes liaisons françaises.* Vol. 2. Paris: Revue Générale des Routes et des Aérodromes, 1982.

Robiquet, Jacques, and Louis Maurice Jouffroy. "Au temps des 'railways' et des 'embarquadères': Quelques feuilles d'albums oubliées." *La Revue de l'Art Ancien et Moderne* 63 (1933), pp. 133–42.

Schivelbusch, Wolfgang. *The Railway Journey: Trains and Travel in the 19th Century.* Trans. Anselm Hollo. New York: Urizen, 1979.

Taylor, Keith, trans. and ed. *Henri de Saint-Simon (1760–1825): Selected Writings on Science, Industry, and Social Organisation.* London: Croom Helm, 1975.

Vincenot, Henri. *La vie quotidienne dans les chemins de fer au XIXe siècle.* Paris: Hachette, 1975.

Index